One Day at a Time

A Thru-hiker's Journey
On Appalachian Trail

Mei Shen

"Click"of Class 2019

Outskirts Press, Inc.
http://www.outskirtspress.com

ISBN: 978-1-9772-4545-8

Cover Photo © 2021 Mei "Click" Shen of Class 2019. All rights reserved - used with permission.

Library of Congress Control Number: 2021914540

Outskirts Press and the "OP" logo are trademarks belonging to Outskirts Press, Inc.

PRINTED IN THE UNITED STATES OF AMERICA

This book is dedicated to my mother Jing Gong. Her free spirit and optimistic nature made me who I am. Being the first daughter of hers, I always had her full acceptance and supports.

I also want to thank my father Zhenhong Shen who's adventurous genes had planted in my soul. His love of travel and maps made my journey so enjoyable.

The joy of the journey was enhanced greatly by the accompany of my loving husband Jianqiang Liu. Thank you for sharing with me a part of Appalachian Trail and the beauties within.

My thanks extend to my sons Yichin and Shiaohan Liu for their support physically and spiritually. Especially Yichin who mailed my resupply boxes during this journey and spent many hours to edit my journal for this book.

In addition, I want to thank my fellow thru-hiker "Brave Heart" who hiked with me every day in the last two states, and helped me to overcome difficult sections. I also want to thank many of my extended families and friends who acted as my trail angels while I was out there: my friends Iris Hu and her husband Hu Wang, my cousin Yuan Zhang and her husband Lin Wang, my high school classmates Bin Lin, Yun Liu, Jidong Sun, Jingyi Ma, my friend Xueyin Chen and her husband Xianliang Zhou, my cousin's family in New York, my college classmates Jizhao Ma and Ming Fang. I enjoyed every moment with you together. Thanks to my Sierra Club hiking friends who gave me so much encouragement before, during, and after my hike. You are such an inspiration to me.

Lastly, thanks to all the trail angels whom I met on the trail with names I don't even know. You are the most valuable part of the community. Your existence makes the trail the best community in the whole world.

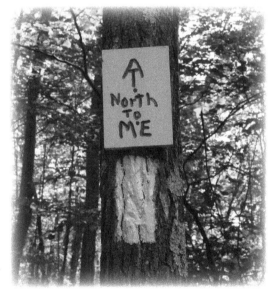

The trail is calling ...
Friday, October 26, 2018

Ever since I completed the John Muir Trail with my family 3 years ago, I set my eyes on the Appalachian Trail. I have been hiking and backpacking primarily in the western states of US, with a couple trips around the world on some of the more famous treks. But the green tunnel of the Appalachian Trail has been calling to me for quite some time. Just the thought of walking more than 2000 miles - one step at a time - made my blood pump. The allure of the legends and the passion spilled from ex-ATers' blogs pulled me closer and closer to the trail. I wanted to experience them all. I wanted to see if my body and my mind were up to the challenge.

I made up my mind to start the Appalachian Trail next spring. I have not set a finish date yet. I don't want to set one. I just want to see how far I can go. I do want to complete the whole trail in one season, to be one of the 2000-milers.

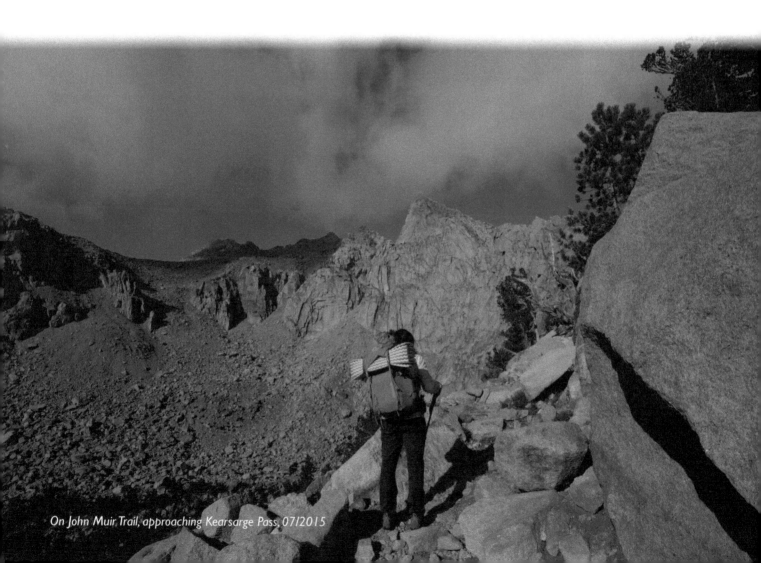

On John Muir Trail, approaching Kearsarge Pass, 07/2015

Live simple, waste less

Wednesday, October 31, 2018

In the modern world, most people live complicated lives. I am no exception. Trained as a scientist, worked in software engineering, and now managing our family business, I have been bonded to office chairs 5 days a week for decades. This is not the real me. My soul is that of a wanderer. While other kids were taking their afternoon naps, I was roaming the fields near my house to draw flowers or dig up worms. I was dreaming about the nomadic lifestyle while working towards my Ph.D. degree. I longed for a simple life, one that could allow me to stay moving and stay outdoors.

With the progress of technology, we have been creating lots of trash, burdening the earth and damaging the environment. By going back to a simple way of living, I hope I can help alleviate some of that burden, by lessening my impact on the unique planet that has been so kind to us.

Hiking the Appalachian Trail will give me the opportunity to do both.

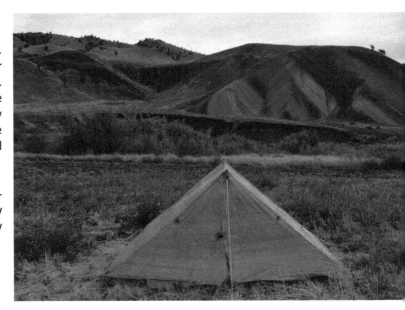

Start planning

Thursday, November 01, 2018

It's 145 days before the start of my Appalachian Trail hike. Time to gather information and start planning. Just couple of days ago, I received the trail data book, planning book and a guide book. There is a ton of information in these books. I will map out my rough itinerary in a couple of weeks. I also bought a wall hanging map of the Appalachian Trail that I put in my bedroom, to look at it from time to time. It gives me an overall feeling of the trail at large. The most challenging task is to offload my work duties to someone else, possibly multiple people so that our company will be still functioning as smooth as it is now. I have two to three months to plan this out.

Life is complicated before it can become simple.

Day 1 - 7: Appalachian Trail - Georgia

With a 32lbs backpack, my husband and I made the first step on Appalanchian Trail.
We encountered strong wind, rain and hail on the first day.
But I learned and remembered a golden rule: Rule #6 ~ Don't quit on a bad day!

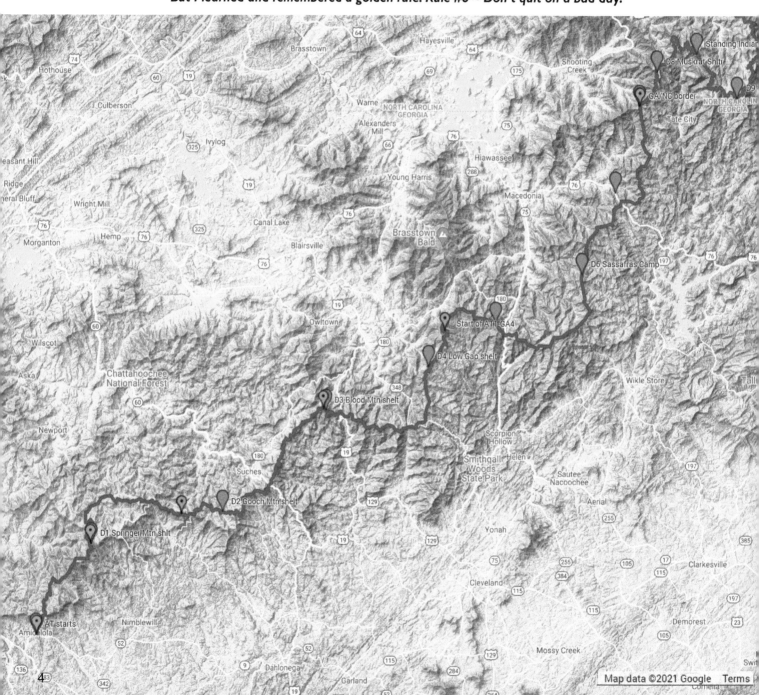

Day 1: Lots of rain, Maine is a long way away
Monday, March 25, 2019
Destination: *Springer Mountain shelter* ~ **Today's Miles:** *0.2*
Start Location: *Amicalola Falls State Park* ~ **Trip Miles:** *0.2*

No rain, no pain, no Maine. This is the motto of the Appalachian Trail. On our first day on the trail, we endured lots of rain already. The pain has already started, and Maine is still more than 2191 miles away!

We started from the beautiful Amicalola Falls State Park. Our friends Iris and Hu drove 150 miles to send us to the trailhead. Thank you so much! We are in their debt forever. I hope they will visit us in California in the near future so that I can return the favor.

At 12:20pm, we left the state park after a short orientation by a park ranger. He suggested to each one of us to pick up trash along the trail in Georgia, 5 pieces a day. Before exiting the state park, I picked up more than 7 pieces.

The approach trail was very beautiful. After a short section of flat trail, we came to the base of the 728ft Amicalola Falls, and started to climb 600 stairs to the top of the falls. It's a powerful sight to watch the water tumbling down the cliff. I was in disbelief after huffing and puffing up the steep steps only to find a large parking lot at the top.

After leaving the state park, we hiked a few ups and downs on the approach trail for 7.5 miles to the top of the Springer Mountain - the southern terminus of the Appalachian Trail. Along the way, the rain followed us, on and off. The park ranger told us, "As soon as you put on your rain jacket, it stops. As soon as you take it off, it starts again." The rain hounded us like that for about three hours before it got serious, and decided to pour nonstop for two more hours. When we finally reached Springer Mountain Shelter, the sky was so dark that we could barely see more than 15 feet. So we decided to stay overnight at Springer Mountain Shelter instead of pushing for another 2.8 miles to our anticipated stop. It proved to be a great idea - for in the next two hours, the rain turned to hail, accompanied by gusty winds. And the water just slammed at everything horizontally, while thunder and lightning lasted for 30 minutes after we set our tent up.

We are happy to get about nine miles done today, even though, officially, we are only 0.2 miles on Appalachian Trail. I loved the overall atmosphere of today's hike, especially when the rain was light, and the forest was engulfed in the thick fog. As an added bonus, once we left the large parking lot at the top of the falls, I no longer saw any trash. It's a strange feeling. I can see the city lights sparkling not too far away below us, but feel so remote in the mountains and woods.

~ Sweet dreams for now. It may still be raining tomorrow, and we plan to hike more miles.

云，浓雾弥茫抱山林，轻蹬岗，花娇瀑布长。
云，淋漓细雨望缅因，柔踏步，乔州起路集。
云，瞬息即变雹风急，下榻处，陋帐做宫寝。

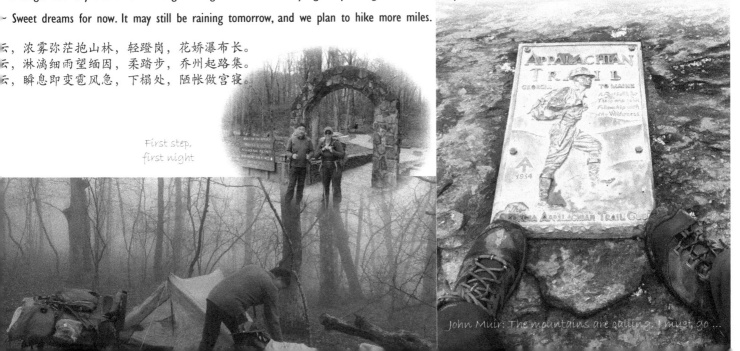

First step,
first night

John Muir: The mountains are calling, I must go ...

New bud is forming

Day 2: More rain
Tuesday, March 26, 2019
Destination: *Gooch Mountain shelter* ~ **Today's Miles:** *15.5*
Start Location: *Springer Mountain shelter* ~ **Trip Miles:** *15.7*

The wind was very strong last night. The rain didn't stop until morning. The forested campground seemed well-protected, but it's wet - wet everywhere. We use our bandanas to wipe off the water from the ceiling of our tent. If you told me it was 100% humidity, I would believe you. At 10:00am, when we starte hiking again, the weather cleared. We had nice, soft trails for the entire morning. We made good progress until our lunch break at Long Creek Falls. Alon the way, the trail crossed 3 forks, and a beautiful convergence of two wide creeks - the clear water accompanying the soft brown path, lined with verdan rain-washed leaves. When we descended below 3000ft, we found huge areas covered by rhododendron bushes. Many of them had flowering buds forming. Give another month or two, I am sure they will be very pretty.

Today's trail also crossed an army base. We heard many gunshots and saw a few helicopters flying back and forth a few times.

During our lunch break, we took almost everything out to dry. It was a nice 45 minutes break at a campsite. Making use of the small breeze and intermitter sunshine, we dried our sleeping bag, tent and ponchos nicely, and fortunately too. It was crucial to dry our gear whenever possible. By 4:00pm. It starte raining again. The rain lasted 5 hours, and is still going as I am typing this journal. We got soaked again, this time during 15 minutes of scrambling as w set up our tent. Tomorrow, we will have to hike in wet boots and clothes.

This morning I also received bad news about my 94-year-old father. He checked into the ICU last night in Beijing. I hope he can make it. While I hiked, thought about him all the time. He's my hiking and travel angel. His love of the world history, culture and nature's wonders is imprinted in my heart. Whil he's fighting for his life in hospital, I am his eyes and legs that take on the challenges on the **Appalachian Trail.** Dad, I want you to win this battle!

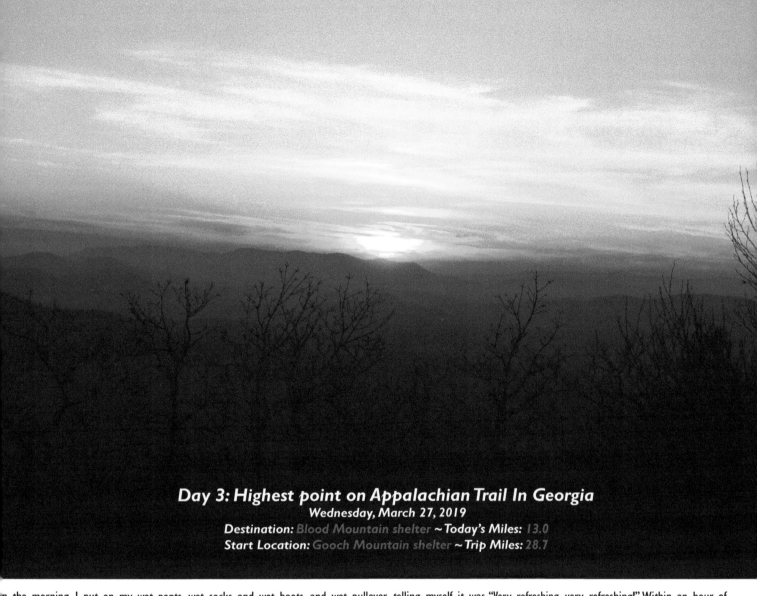

Day 3: Highest point on Appalachian Trail In Georgia
Wednesday, March 27, 2019
Destination: Blood Mountain shelter ~ **Today's Miles:** 13.0
Start Location: Gooch Mountain shelter ~ **Trip Miles:** 28.7

In the morning, I put on my wet pants, wet socks and wet boots, and wet pullover, telling myself it was "Very refreshing, very refreshing!" Within an hour of hiking, my clothes had all dried, aside from the socks, which just felt okay.

It was a bluebird-weather day all day long - lots of sunshine, but temperatures were pretty low, so it was comfortable all the way. The forest I passed through also painted the landscape with pleasant shadows.

By lunch, we reached Woody Gap trailhead, complete with picnic tables, restrooms and trash cans. We hung all of our gear out to dry, strung from tree to tree. It feels great to enjoy the sun and breeze.

In the evening, we reached Blood Mountain shelter, the highest point on the Appalachian Trail in Georgia. On the rocky top, we set up our tent and watched the beautiful Sunset. This was also the first time for me to test bear bag hanging. It was not easy.

John Muir: The mountains are calling, I must go ...

Day 4: First trail magic
Thursday, March 28, 2019
Destination: *Low Gap ~ Today's Miles: 13.9*
Start Location: *Blood Mountain shelter ~ Trip Miles: 42.6*

The wind howled pretty bad last night. It only calmed down after 5:00am. I didn't sleep much. I dreamt of my father. In it, he came back from hospital. I was happy to see him. He seemed happy to see me, too.

Blood Mountain, which consisted of large slabs of rocks, was the site of a beautiful sunrise this morning. Knowing that we'll pass through the Mountain Crossing outfitter and gift shop, we skipped breakfast to go straight there. By 10:00am, we arrived and had pizza, banana, coffee and hot cocoa. It filled us up nicely. None of us wanted lunch until after 5:00pm.

Today's trail had more rocky sections, took more focus and careful footing. Whenever my feet left the rock and got on the flat, soft sections of dirt on the trail, I felt so happy. It's funny to think how these little things can bring such joy.

The Appalachian Trail may not have the splendid grand views as on the John Muir Trail, but it's a beauty in its own way. It's more humble and subtle, and brings peace and calm to my heart. Walking in Georgia's still-leafless forest, seeing the sunlight dancing from tree to tree, discovering fanciful rock formations by surprise - I feel just as lucky as when I was on John Muir Trail.

In early afternoon, at Tesnatee Gap, we had our first experience with trail magic. I never expected it to happen so quickly on the Appalachian Trail, but here a four person crew laid out tables and lounge chairs. They offered ice-cold sugary drinks, hot chocolate and coffee, alongside all kinds of snacks, candy bars and donuts- all free to thru-hikers. And they didn't even accept any donation. They were doing this just to give thru-hikers support. Thank you, trail angels!

There was a map of the entire Appalachian Trail hanging on trees. We found the location of where we were: right near the **beginning** of the trail!

I have continued to pick up trash from the trail. Majority of the trash was near parking lots or trailheads. So, most backpackers have been doing a great job to keep the trail clean.

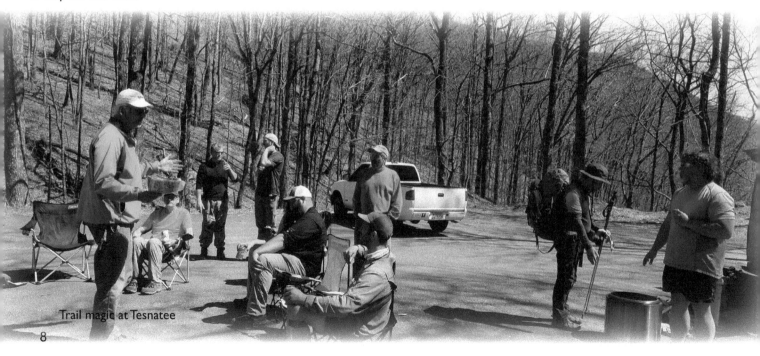
Trail magic at Tesnatee

Day 5: Short day
Friday, March 29, 2019
Destination: *Blue Mountain Shelter* ~ **Today's Miles:** *7.3*
Start Location: *Low Gap* ~ **Trip Miles:** *49.9*

We had a very short hike today in anticipation of tomorrow's two long uphill climbs. The tent was up before 2:00pm. It's good to have a slow day. Many thru-hikers also camped here, and plan to go to town of Helen tomorrow. We will skip that town and continue for two more days before recharging.

I continued to add to our trash collection - a few pieces near our campsite last night. Keeping the backpackers' promise: always leave a camp cleaner than when you arrive! Also, some plastic wrappers were actually on the trail! Hello, hikers and backpackers, please pay attention to your stuff! I know people don't litter intentionally. Most of the trash was left when they pulled something out of their pockets, and it just fell out and didn't notice. So, it is good practice to always put your trash in a place that you don't need regular access to.

While I was hiking, thinking about the differences between California's Sierra Nevada and the Appalachian, I felt the former was a place worth more to worship, while the latter was more comforting, a nice place to make a home.

I got messages from my sister that our dad condition has been improved. Still in the ICU, but not getting worse. I am very happy to hear this.

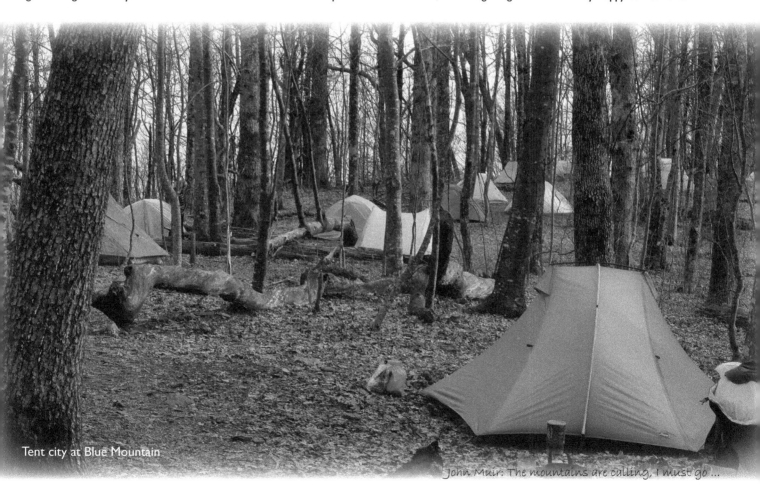

Tent city at Blue Mountain

John Muir: The mountains are calling, I must go ...

Day 6: Push on
Saturday, March 30, 2019
Destination: *Sassafras Gap* ~ **Today's Miles:** *12.8*
Start Location: *Blue Mountain Shelter* ~ **Trip Miles:** *62.7*

This morning, after we came down a steep rocky trail to Unicoi Gap, we saw the Georgia Appalachian Trail Club plaque. We also met Susie, a trail maintenance volunteer, repairing the trail. Thank you for the great work! Overall, the Appalachian Trail in Georgia is in great shape. It's all due to the effort of nice people like Susie.

Today, we had two long sections of climbing, 1100ft and 1300ft respectively. The second one went all the way up to the peak of Tray Mountain: a tiny plateau of rocks, a tight squeeze for the ten of us sharing the view. Despite this we enjoyed our well-earned breaks. After Tray Mountain, we pushed on, with an additional 500ft and 4 miles, before we stopped to camp just before 5:00pm.

By now, we have seen quite a few familiar faces: thru-hikers who are on a similar pace and stop at the same camping location each night. All are friendly people. Our camping spot feels like a village now.

We hiked four more miles than planned today, despite lots of elevation gain. This way, we will have only seven and a half miles to reach our rest/cleaning/resupply spot tomorrow. Hopefully, we will arrive at noon, leaving us more time to do all the little chores a more civilized world requires.

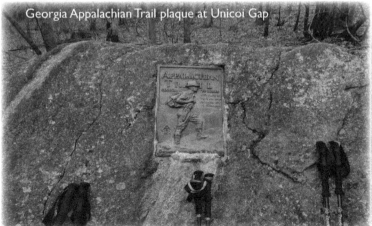

Georgia Appalachian Trail plaque at Unicoi Gap

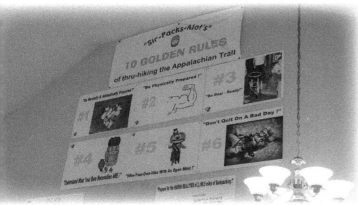

Day 7: First resupply stop
Sunday, March 31, 2019
Destination: *Top of Georgia hostel* ~ **Today's Miles: 6.5**
Start Location: *Sassafras Gap* ~ **Trip Miles: 69.2**

wind and rain came down rapidly after midnight last night. Fortunately the rain began to lighten up by morning, but the wind chill caused what little rain left to an ice-cold shower. Rather than cook breakfast, we packed up quickly and started moving. It was cold.

alked briskly in the cold strong wind, shouting "exhilarating" over and over to give myself more energy. About four miles into the hike, at a turn around a the wind stopped. The raindrops stopped. All the howling sounds disappeared. The morning sunlight peeked through cracks in the clouds. The mountains were et, and it felt like everyone stopped breathing, just observing a new world being born, ~ new, clean world.

ore noon, we walked into the Top Of Georgia hiking center: a hostel that provides beds, hot showers, laundry, breakfast and a free shuttle to the town of wassee for resupply and a nice dinner. It's a great place to stay for Appalachian Trail Thru-hikers. They have so much advice and stories for newbie like us. mpletely recharged here.

夜风急雨骤，浅睡不解梦透。频问今日程，只道径短易路。知否，知否，却是风侵入骨。

珠婆娑飘落，四哩疾风步迫。徊转一东坡，骤然晨阳云破。可歌，可歌，怎个爽字唱喔！

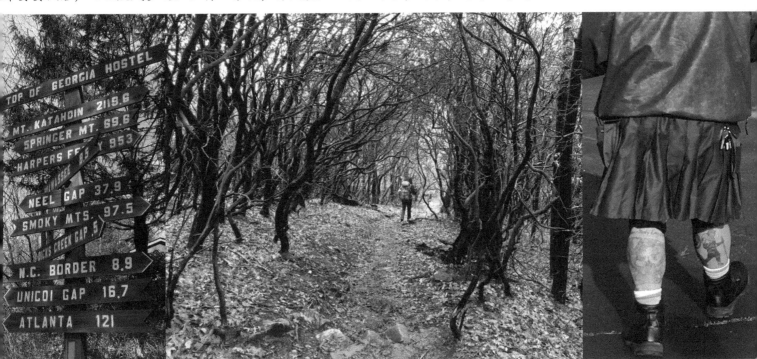

John Muir: The mountains are calling, I must go …

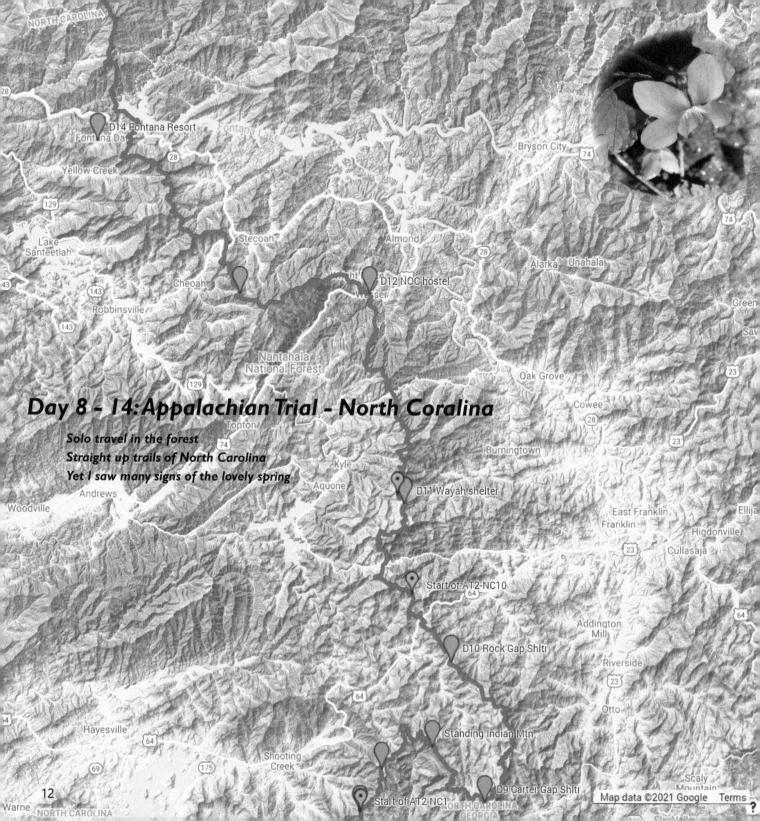

Day 8 – 14: Appalachian Trial – North Coralina

Solo travel in the forest
Straight up trails of North Carolina
Yet I saw many signs of the lovely spring

D14 Fontana Resort

D12 NOC hostel

D11 Wayah shelter

Start of AT2-NC10

D10 Rock Gap Shltr

Standing Indian Mtn

D9 Carter Gap Shltr

Start of AT2-NC1

Day 8: April fools
Monday, April 01, 2019
Destination: *Muskrat Shelter* ~ **Today's Miles:** *11.6*
Start Location: *Top of Georgia hostel* ~ **Trip Miles:** *80.8*

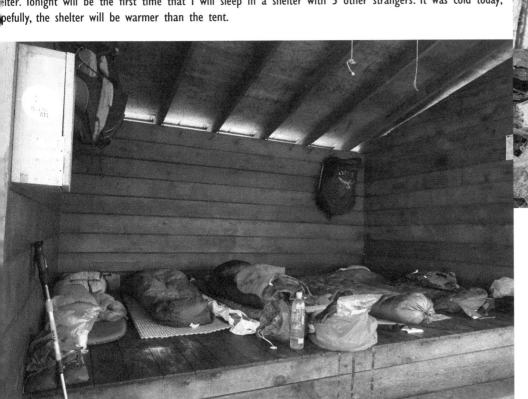

e shuttle driver dumped four of us at Dick Creek trailhead and said "Have a good hike, y'all fools!" Don't get wrong, he was a really nice guy — two-time Appalachian Trail Thru-hiker and the first one that completed e Canal thru-hike. He also gave us so much good advice. —The most important one was: try to get to Hot ings by any means! Hot Springs is a town 275 miles from the Appalachian Trail southern terminus. To get re, we'll need to pass through the challenging terrain of Great Smoky Mountains National Park.

lso said goodbye to my husband this morning. Work calls! From today, it will be my own journey! For many rs in the morning, I let my emotions run lose. The moss and leaves were my kleenex- - the trail had plenty them! I miss him a lot, but going back with him never crossed my mind. I felt very lucky that he was able do a section with me together, especially from the start, when everything on the trail was something I've only ught about on paper. I am very thankful that he allowed me to "feel the trail" with him, as my assurance.

1:15pm, I reached the border of Georgia and North Carolina. A wooden sign on a tree marked the spot. One e done, thirteen more to go! In the register paper, I wrote "I am a fool".

mediately after entering North Carolina, the trail went straight up for about two hours! What a kind of lcome was this? The going was slow. Eventually, I reached Muskrat shelter; just in time to squeeze into the lter. Tonight will be the first time that I will sleep in a shelter with 5 other strangers. It was cold today; pefully, the shelter will be warmer than the tent.

北京第三区交通委安全提醒您：
道路千万条，A.T.只一条，
挥手道离别，亲人两行泪。

愚人节里愚人行，
负重耐寒走山径。
A.T.小路长又远，
初心不改人伴影。

John Muir: The mountains are calling, I must go ...

Day 9: Standing Indian Mountain
Tuesday, April 02, 2019
Destination: Carter Gap ~ **Today's Miles:** 12.6
Start Location: Muskrat Shelter ~ **Trip Miles:** 93.4

Sleeping in the shelter on a cold night was a mistake. The gap beneath the wooden floor just sucked every bit of my body warmth away. I went into my sleeping bag with warm feet; by midnight, my feet had lost all feelings. I was restless and miserable for many hours. The lack of sleep also made today's hike even more tiresome, even though the route was not particularly difficult.

By noontime, I reached the top of the Standing Indian Mountain - the cliff top views to the south gave it the name "Grandstand of Southern Appalachians"! After the morning snow, the sun finally decided to show up when I was on top of the mountain, heating my water for lunch. The views were fantastic! There were even daffodils at the top! Someone pointed out Blood Mountain, far far away. It was amazing that I had walked this far in just a week!

Despite that small window of sunlight, this was a very cold day. I spent most of the hike bundled up. It was so cold that my phone was shutting down by itself as I was attempting to send messages. While preparing dinner, I had some trouble igniting my stove due to the cold. So I opened my back-up matchbox that I bought at a REI in South Carolina. To my surprise, there were no matches in my matchbox - only two tiny strips of striking paper. Words cannot describe how disappointed I was. Fortunately, after brute forcing the ignition on my stove, I was able to ignite it.

Tonight I will sleep in my tent for a hopefully warmer night. I'm tucked in at Carter Gap, dreaming sweet dreams.

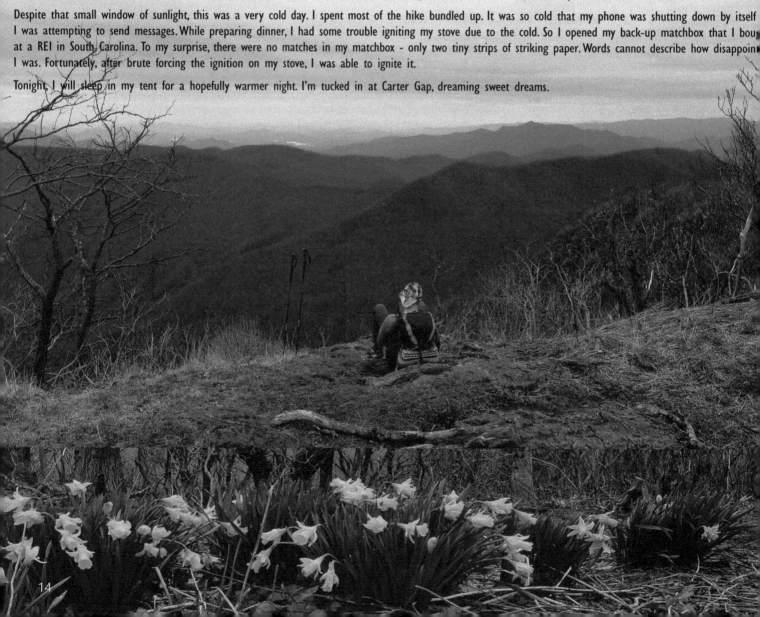

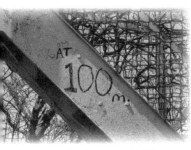

Day 10: 100 Miles!
Wednesday, April 03, 2019
Destination: *Rock Gap Shelter* ~ **Today's Miles:** *12.1*
Start Location: *Carter Gap* ~ **Trip Miles:** *105.5*

At night around 2-3am, a cold wind started to blow, like millions of racehorses passing by. The temperature dipped. By the time I started packing up early morning, it was so cold that every minute I was forced to stop packing and rub my numb fingers. I thought to myself, It was good that I slept in my tent; it was still cold, but the shelter must have been much worse.

As I left in the morning, when the sun and exercise warmed me up, I passed a cool cliff with lush moss, dripping spring water. There are lots of springs in Appalachian Trail that provided water for all hikers. The water was sweet, and especially tasty after boiled. I bet it would be the best water to make tea. However, we still need to treat the water. So far, my SteriPEN has been doing the job; I trust it more than boiling the water since it kills both viruses and bacteria.

Shortly after noon, the trail went up steeply for 0.3 mile, towards the top of Albert Mountain. It was a rocky scramble to the top. A fire watch tower is installed there, with spectacular panoramic views. Even more spectacular, at the base of the tower was the Appalachian Trail's 100 Mile marker! I reached another milestone today! Tonight I camp at Rock Gap Shelter area. It's below 4000ft. Hopefully, it will be a warm night.

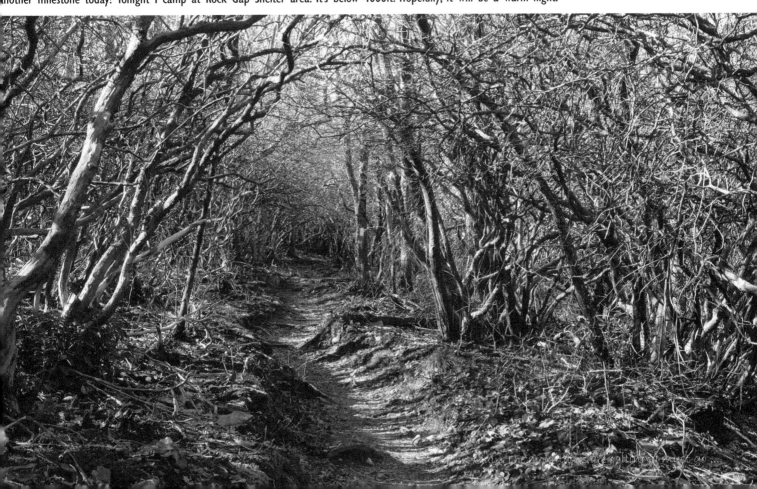

Day 11: Wayah, Wayah
Thursday, April 04, 2019
Destination: *Wayah shelter* ~ **Today's Miles:** *14.8*
Start Location: *Rock Gap Shelter* ~ **Trip Miles:** *120.3*

Today's word of the day is "Wayah" - a Cherokee word for "wolf". Wayah Gap, Wayah Bald and Wayah Shelter. The sound of Wayah was so exciting to me that I kept saying "Wayah, Wayah" all the way. The Wayahs were all places pretty far from my starting point. By the time I reached Wayah Bald's stone tower, I could not help but shout "Waaaaayaaaah!"

In the morning, there was a section that followed a singing creek. The sound of water was so pretty, I started to sing my own song:

You sing a song,
I sing a song,
The song of water.
You sing a song,
I sing a song,
The song of forest.
The morning Sun-shines warms the earth,
The birds also sing together with me.

You sing a song,
I sing a song,
The song of water.
You sing a song,
I sing a song,
The song of forest.
The morning fresh air, breath-in deeply,
And it makes me smile.

I made more friends on trail. They all helped me hang bear bags, since it took me forever to throw the rope onto the higher branches. Thanks, friends!

I also met four grandma-aged ladies on trail today - two backpackers, one thru-hiker and one day hiker. I really admire their attitude. Many of my fell Chinese ladies at their age would just stay home to take care of grandkids. Going into the wilderness by oneself is considered insane. But it is so common see senior Americans as active as the younger generations.

In the past few days, I realized that I underestimated elevation gains by about 500ft - some days even more than 1000ft. I did my initial calculations ba on the Appalachian Trail planning tables. However, when landmarks are at similar elevation, it doesn't mean the trail between them is flat. Usually, there i hill or two that needs to be climbed over. Only looking at profile charts can give the reader a better picture. Today, my old calculations showed about a 240 elevation gain. It was off by almost 1000ft! Now the trail sounds more challenging.

The forecast has rain for tonight and all day tomorrow. It will be interesting again.

For now, I just tucked myself comfortably in my tent. Sweet dreams.

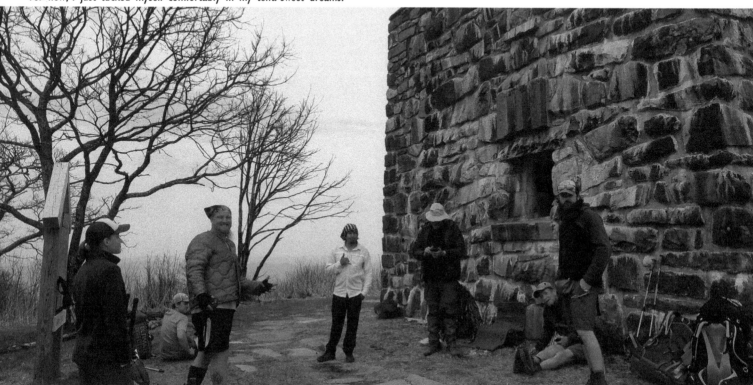

Day 12: Mud and Water
Friday, April 05, 2019
Destination: *Nantahala outdoor center ~* **Today's Miles:** *16.3*
Start Location: *Wayah shelter ~* **Trip Miles:** *136.6*

ay's theme was mud and water. Just as the forecast stated, the rain started at 9:00pm last night, and it rained until 11:00am. So the trails were full of mud
water. It took extra caution to keep my balance. There were skid marks everywhere on the trails. The balance act taxed my knees, especially in the afternoon,
en the downhill sections became steeper and I became more tired..

erall, my body had been reacting nicely to the trail. Before this trip, my biggest worry was the plantar fasciitis that had been bothered me for many years.
nks to soft dirt trail and my small blue massage ball, the pain on my foot has not gotten worse. It has actually reduced a bit since I started this hike.

aw so many wild flowers along the trail today: bunches of Bleeding Hearts at a moist location, one of my favorites.
the night, I checked into the Nantahala Outdoor Center hostel. About 10 of us hiking friends had a nice dinner in the restaurant on the river. It was always
e to have fresh cooked meals, especially with fun friends.

il Friends are: Boulder, Hot chocolate, Juicy, Flavor, Josh, Golden Walker, Special Brew, Carlos, Pizza Steve.
upplied: fuel, matches, warm pants, Shock blocks and food

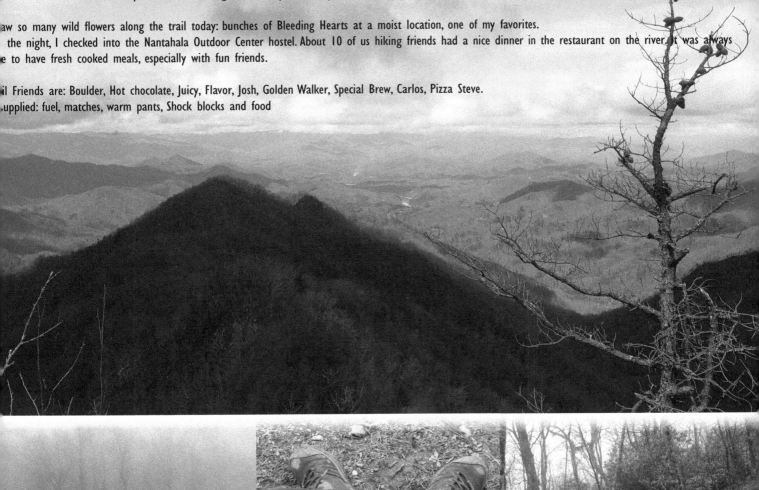

John Muir: The mountains are calling, I must go ...

Day 13: Up, up, up...
Saturday, April 06, 2019
Destination: Locust Cove Gap ~ **Today's Miles:** 10.7
Start Location: Nantahala outdoor center ~ **Trip Miles:** 147.3

I had a video call with my dad in Beijing a little after 5:00am. He looked a lot healthier. Getting up for the call was worth it. After that, I ate breakfast the River's End restaurant and shopped for more supplies while running the laundry. I left the NOC around 10:30am.

Today is all climbing - almost 4000ft - from morning until midafternoon, when I reached Cheoah Bald. In the middle of the climb, there was a section name The Jump-up~ a section of the trail that went straight up on a rocky ridge. The going was slow. My left knee still hurt this morning. Climbing was actual gentler on the knees. After I fully warmed up, the knees were feeling better. Or perhaps it was due to the ibuprofen that I took in the morning - expired years ago! I'm still being very careful to not put too much weight on my left knee.

When I finally reached Cheoah Bald, I ate a huge chewy soft cookie as an award. It says 230 calories. Sure, I'll have a 230-calorie boost, I thought. After finished it, I read the label again: 2 servings per package. I just consumed 460 calories of sugary cookie! Well, this will be part of my dinner. On the bald, t views were great. I could see the mountains we had walked before, the steep ridge that I traveled yesterday, and the Smokies I will soon reach.

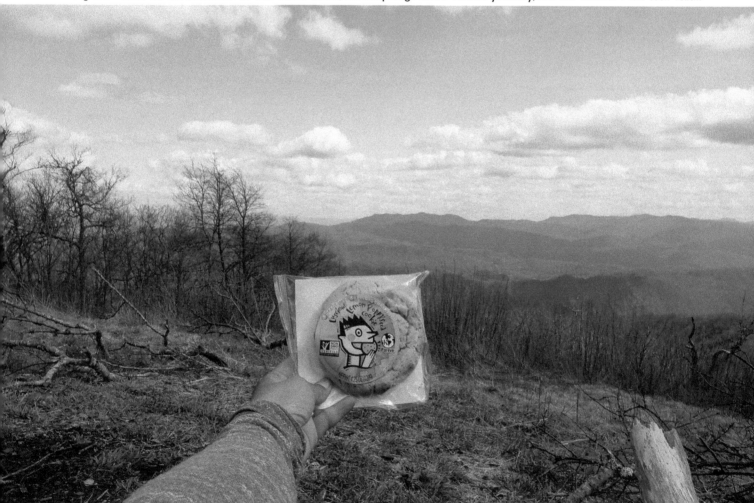

Day 14: Going to Fontana Dam
Sunday, April 07, 2019
Destination: *Fontana Dam* ~ **Today's Miles:** *17.1*
Start Location: *Locust Cove Gap* ~ **Trip Miles:** *164.4*

...m where I stayed last night, at 3700ft above sea level, to today's destination at 1800ft, the trail table showed an easy hike of only 1200ft gain. Yet in reality, ...trail gave me a hard reality check! Only the last 3 miles was consistently downhill. The rest felt like I was climbing up more than down. By the end of the ...mile hike, I was happy to take a shuttle to Fontana Village Resort with another hiker, instead of going an additional 1.5 miles to the "Fontana Hilton" - the ...tana Dam Shelter.

...en the rain started around 5:00am this morning, I was already awake. As soon as I heard the rain drops on my tent, I jumped out of the tent to get my ...r bag down. I'm not going to let it get wet by having it soak two more hours in the rain. Back in the tent, I ate my breakfast and packed as much as I ...uld. Right after the daylight was bright enough to see the trail, I started hiking.

On the long climbs, I came up the following poem:
An umbrella in the left hand,
A trekking stick in the right.
Walking over the hills I puff and huff.
Long and long is the winding path.
Expecting great scenery after another turn.
The heavy pack ~ no com-PLAINTS.
The wet clothes, just breezy-COOL.
In the rain, I walk and feel free.

When these words were said in rhythm in Chinese, it sounded pretty funny.
左手撑着伞，右手挂着杖，
呼哧带喘我登上山岗。
前面的小路长又长，
拐弯就盼着好风光。
背包重，我无怨言，
衣湿透，直喊风凉，
雨中漫步我乐逍遥！

...ring my hike today, I passed many slower hikers - people I didn't meet before. I also thought about my hiking friends in Sierra Club Day Hiking Section back ...me. Thanks to the many years hiking with them on those tough hikes, I was pretty good prepared for the long hikes like today. Thank you, Ron, Dara, Landa, ...nnie, Hailen, Piotr, Rosemary, and many other hiking leaders! I felt very lucky to be in that legendary group!

...ring today's hike, I found that if I put no weight on my trekking poles, my knees actually felt better. My weight was more centered, so that my knees didn't ...ed to do the extra work to keep me balanced.

...ar the end of my hike, it started showering on and off for couple of hours. It was only after 5:00 pm, when rays of magical sunlight shone underneath clouds ...two brief moments. In those moments, the forest glittered golden with sparkling rain drops, making the grass, leaves, and bright white & yellow flowers to ...inkle. Everything sparkled like diamonds in a spotlight. The moment came and went faster than I could adjust my camera to capture the sights. But, they were ...ly magical moments.

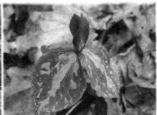

John Muir: The mountains are calling, I must go ...

Day 15 - 22: Appalachian Trial - The Great Smoky Mountains

Rains and steamy weather
Snow and icy hoarfrost
Highest point on Appalachian Trail
The great mountains of home and spirits - All in a time of an early Spring

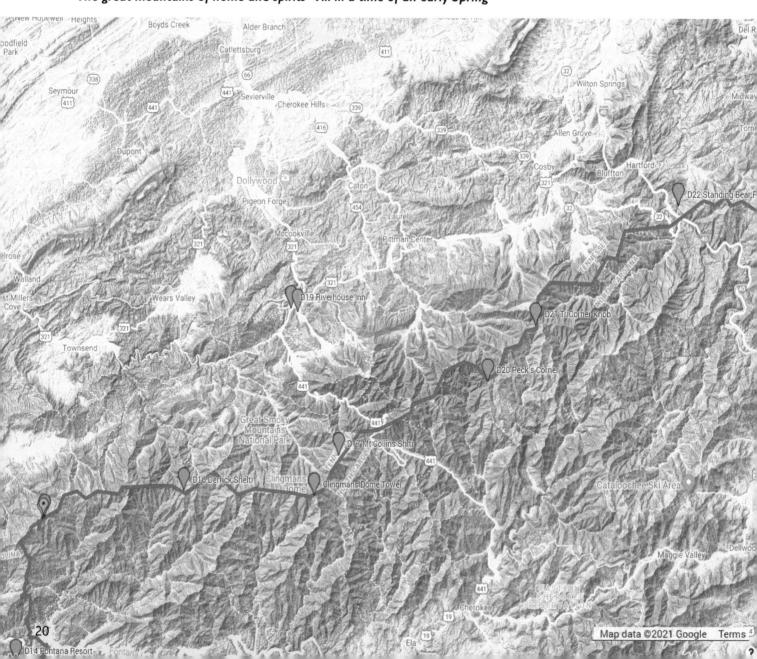

Day 15: Entering GSMNP
Monday, April 08, 2019
Destination: *Mullins Shelter* ~ **Today's Miles:** *11.0*
Start Location: *Fontana Dam* ~ **Trip Miles:** *175.4*

Entering Great Smoky Mountains National Park today! Shortly after leaving Fontana Dam visitor center, I got a taste of what it means to have "the most rainfall on the Appalachian Trail". It rained and rained and rained. I made a mistake of not wearing my poncho; the umbrella worked fine for the most of the day, until after 3:30pm when the downpour started! In just a few minutes, the entirety of my pants was wet. My boots were soaked a long time before that, since the trails had been muddy throughout the day. Now the rain just ran through my pants into my boots, as if a water faucet turned on below my knees. At any slope in the trail, a small, fast, and muddy river formed. When it flattened out into a meadow, it was like walking through a flood. Now, near the end of the day, there's still no sign of any break in the rain. Hopefully, it will stop tomorrow morning so that I can move on more easily. Mollies Shelter was designed to sleep twelve. I saw at least sixteen people squeezed in here. There are people setting up tents outside too.

Not all of today was this challenging. Just after noon, there was a small break in the rain. I had just reached the Shuckstack fire tower. It was windy, but the view at the tower was so worth it. I could see layers of mountains in the Smokies 360 degrees. The Fontana Dam and the lake formed by it were in clear view. Best of all was all the water vapor rising up from the mountains: some vertically, many others changing shapes and swirling around, like as if fairies spilled vapor all over the mountains.

In the afternoon, I passed a large section of flat land. Even though the trail was very muddy, the grassy areas on both sides of the trail were carpeted with white wild flowers, like millions of stars spread across the Milky Way.

In the past two weeks, I have experienced Georgia's gentle trails (a great introduction of Appalachian Trail), and North Carolina's "fun" trails (a good warning and testing of thru-hikers legs and wills on Appalachian Trail). Please note: the word "fun" was squeezed out of my teeth! Well, one has to make the best out of everything, right? Coming into the Smokies, I was thankful for the gentle trails again. I would be more exhausted if there were not enough switchbacks for today's sub-4000ft climb! With the muddy currents on trails, I don't know if I could ever climb up without these switchbacks.

In these two days, I met new people who had started their hike as early as 3/17, more than a week before my start day. I am looking forward to get to Newfound Gap and take my rest day from there.

In the evening "the Wizard", a thru-hiker in his thirty's, suggested that I use trail name "Click". Because he saw me walking towards the shelter in the pouring rain while I shot two pictures of the full house of people in there. I think this will do.

烟雨之中穿烟山，
白云低挂半山沿。
树静林寂听雨歌，
烟雨过后见新颜。

烟山雨急今领略，
小径成河水积潭。
登塔远望汽蒸腾，
雾霭飘渺可访仙。

雨中急行听天歌，
撑伞尤如挚玉盘。
大珠小珠声声脆，
落地繁花散林间。

John Muir: The mountains are calling, I must go ...

Day 16: Water trails
Tuesday, April 09, 2019
Destination: *Derrick Knob Shelter* ~ **Today's Miles:** *12.2*
Start Location: *Mullins Shelter* ~ **Trip Miles:** *187.6*

昼夜雨急如战鼓，满树红樱落缤纷。陋餐渴饮天宫水，湿衣烘干靠体温。
一年之际在于春，一日之时珍于晨。道路泥泞且慢行，记得春花羞啥芬。

Last night the shelter squeezed in a grand total of seventeen people. Due to this, it was very warm and I had a very comfortable sleep. The heavy rain at nig pounding on the shelter's roof sounded like drumming before a battle. It didn't stop until almost 8:00am. This made today's trail a creek. Coupled with this, trail changed from a gentle Georgia meander to challenging North Carolina climb, on top of all the water. There was no avoiding the water and mud on tra So my boots were kept wet and dirty.

On a hill before Thunderhead Mountain, there were a few big boulders. On the biggest one, someone carved their names. One was Tom, 1817, there is one 1920s , and one in 1938! I wondered who was Tom, and where he ended up. All in all, the Thunderhead Mountain was not impressive. There was only a ve small rock in the middle of the muddy trail, bearing a US Geological Survey marker.

Today, the weather was nice. After the rain stopped in the morning, the day was sunshine and clouds, alternating throughout. White, small wildflowers were abunda everywhere. When the sunlight warmed them, they smelled wonderful. I will have sweet dreams tonight just thinking about them.

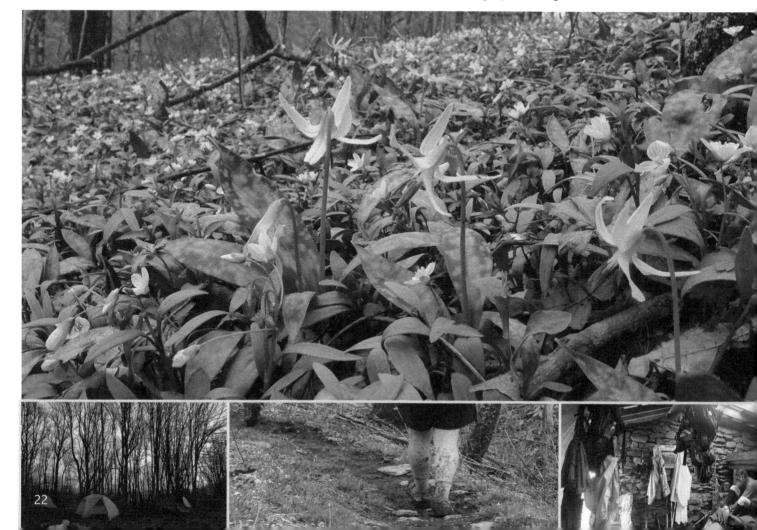

...icipation! On this beautiful sunny day, the Appalachian Trail led me to its highest point: Clingmans Dome at 6643ft.

...rall, the trail was not too hard. Yes, it was a climb of more than 3500ft and was over 13.5 miles - but the trails were drier, and the inclines were gentler. ...idn't feel exhausted at the end of the day.

...en the trail rose above 5500ft, I entered a spruce forest. These evergreen forests were wet and shady. The temperature dropped at least 10 degrees when ...stepped inside. Everything was covered by fresh-looking moss. The only browns I could see was the path the trail took. I felt like a flying little fairy was in ...nt of me, waving a magic wand to guide me through this forest on a path made of dark chocolate. I could just follow her forever. It was a forest that you ...nted to be in for a long time.

...last third of a mile to Clingmans Dome was surprisingly flat. There were many tourists up there. It had great views in all directions. I took a picture of the ...th and north — the mountains that I had been walking through, and the mountains that I still need to climb.

...I am lying in the woods in my tent, and the night fell, a few birds made the last song of the day. A lullaby for sweet dreams. My tent is sitting on a layer ...thick cushion of dried spruce.

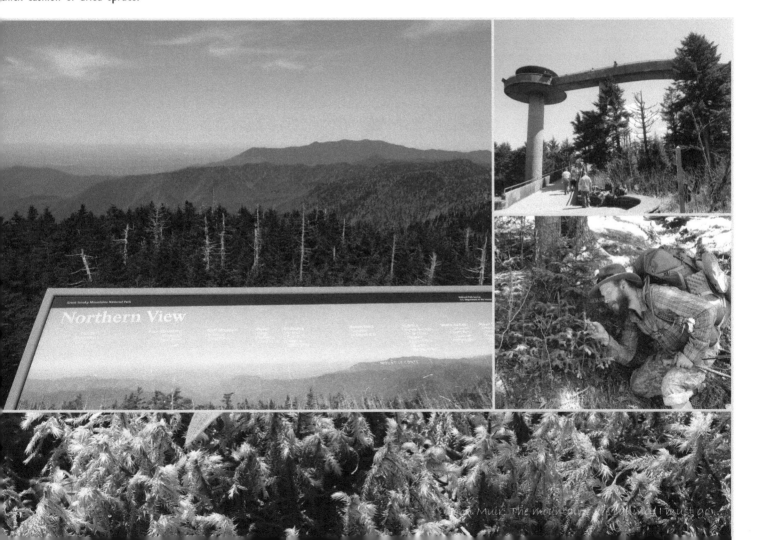

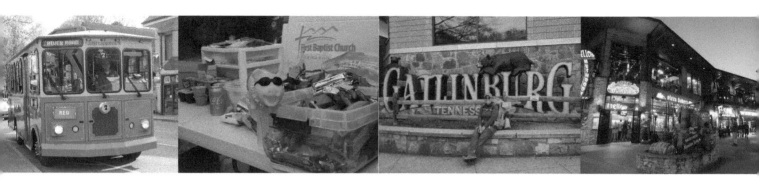

Day 18: Newfound Gap
Thursday, April 11, 2019
Destination: Gatlinburg, TN ~ **Today's Miles:** 5.0
Start Location: My. Collins Shelter ~ **Trip Miles:** 206.6

A super easy day today, because — finally - I am taking a break day at Gatlinburg, TN today and tomorrow. It's funny that just thinking about get day off in a town can occupy my mind for a whole day and night. I even dreamed of tasting great roast beef this morning. Yet, outside of my drea I'm not craving any meat. I am craving for fish.

After five miles of hiking I reached Newfound Gap, a huge parking lot with super clean restroom and a TN/NC state line marker. A van of trail ang was also there. They provided us with so much delicious food and drinks. I ate an orange, an apple, and a cookie! So full that I had to skip my lur later. They will be there every Tuesday, Thursday and Saturday for April. A shuttle from the same church will run multiple times every day in April well. Thank you so much for the support!

At this parking lot, I also saw my hiking friends again. They were about a day behind me because they took a zero day a few days ago at NOC hos Now that they caught up with me, they will be ahead of me from now on, since they don't need to stop at Gatlinburg. I wonder if I will ever see th again. They are stronger hikers than me. They pushed twenty miles yesterday! With my knee problem, I will slow down a bit, and only plan to do less than twe miles per day going forward until my knees improve.

I still consider myself lucky that I have gone this far without having any big issues. I saw one of my friends duct taped three of her fingers, and another frie had both big toes blackened and duct taped. Another hiked today with one sole of his boot falling apart and tied together with shoelaces, while the other s was half-dangling as well. I met a couple who had to turn back on their first day in GSMNP because the wife had a twisted ankle. Still, all of them had go humor and spirit. That's the thing that makes our thru-hikers so lovable!

Gatlinburg is a party town. There are so many ice-cream shops, candy stores, wine tasting rooms and breweries! I had to use lots of discipline to limit consumption of chocolate!

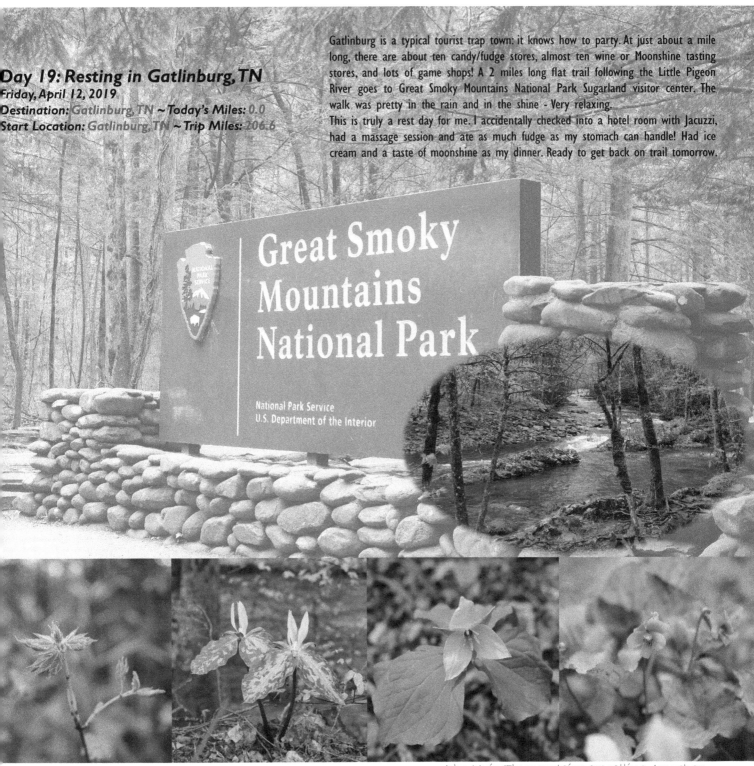

Day 19: Resting in Gatlinburg, TN
Friday, April 12, 2019
Destination: Gatlinburg, TN ~ **Today's Miles:** 0.0
Start Location: Gatlinburg, TN ~ **Trip Miles:** 206.6

Gatlinburg is a typical tourist trap town: it knows how to party. At just about a mile long, there are about ten candy/fudge stores, almost ten wine or Moonshine tasting stores, and lots of game shops! A 2 miles long flat trail following the Little Pigeon River goes to Great Smoky Mountains National Park Sugarland visitor center. The walk was pretty in the rain and in the shine - Very relaxing.

This is truly a rest day for me. I accidentally checked into a hotel room with Jacuzzi, had a massage session and ate as much fudge as my stomach can handle! Had ice cream and a taste of moonshine as my dinner. Ready to get back on trail tomorrow.

Great Smoky Mountains National Park

National Park Service
U.S. Department of the Interior

John Muir: The mountains are calling, I must go ...

Day 20: Spring rain
Saturday, April 13, 2019

Late last night I had a terrifying moment. I accidentally sat on my eyeglasses and one of the legs popped out of the frame! I'm half-blind without my glas
so I was desperately trying to fix it. With my little survival knife, persistent trying, and lots of luck, I was able to push the leg back into the small bracket
the frame. A thirty-minute struggle! I have to be more careful going forward.

I left Gatlinburg early morning in the rain, and started hiking just before 9:00 am from Newfound Gap. The church shuttle driver told us that there wa
huge fire about three years ago started by two teens playing with matches on Chimney Trail. Nine terrible days later, the fire had destroyed many structures
Gatlinburg, and nine lives were lost. I can still see the aftermath of that fire near the town - burnt trees littering the hills like pickup sticks.

Today's rain was soft and gentle. It was on and off all morning until midafternoon. It was the caring, nurturing type of rain: the rain of creation without destruct
The rain that brought lives without hurt. The rain that you can claim "I hiked in the rain" with a smile, not the one that you claim with a scream. The
spring rain has covered the mountains with fresh green colors over the fading greens of the last year's.

The trails today also brought the most spectacular views in the Smokies. In addition to the very popular Charlies Bunion, where lots of day hikers also w
there were long sections of walking along the ridges. At some places the width of the ridge was only 2-3 feet wide. If there were no trees on both sides
the ridge, it would be quite exposed. From time to time, the trees thinned out, causing views of the layers of mountains to appear. It was like a wave of b
with different shades, from darker blue nearby to light gray white blue far far away. As far as your eyes can see, the waves went on and on in all directi
Somewhere between layers of blue waves, the white steam and clouds rose up, dancing with the breezes. And then there was me, a tiny speck on the ridge t
was walking slowly under a forest green poncho. The wind filled my poncho with air. I felt like a big green balloon floating along the trail.

At one place on trail, I saw pillows of moss, different types growing interwoven with one another. There is one type of very fresh looking moss on big rocks. T
grow like pincushions. I cannot hold myself but to touch them with my fingers. Despite their freshly wet appearance, they were dry - felty, but soft.

By late afternoon, Peck's Corner shelter was full. Because it was off the main Appalachian Trail for 0.4 miles, it was relatively uncrowded. All hikers were able
find a spot in the shelter. This was very good because a strong storm will come by midnight tonight. Hope everyone stays dry and has a peaceful rest.

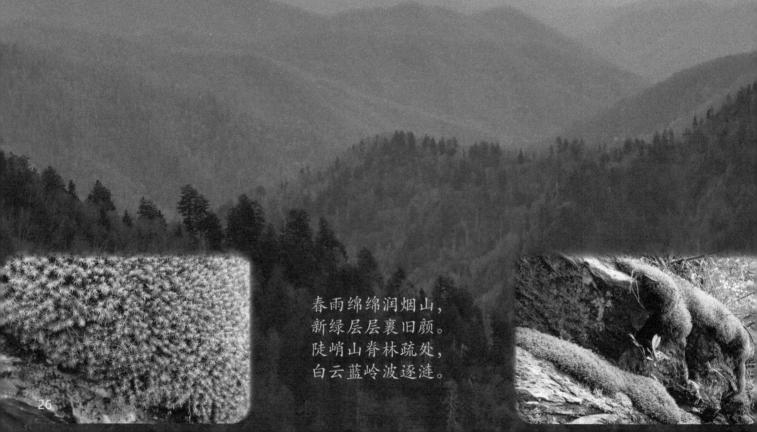

春雨绵绵润烟山，
新绿层层裹旧颜。
陡峭山脊林疏处，
白云蓝岭波逐涟。

Day 21: Living in the middle of a major storm
Sunday, April 14, 2019
Destination: *TriCorner Knob Shelter* ~ **Today's Miles:** 5.6
Start Location: *Pecks Corner Shelter* ~ **Trip Miles:** 223.0

乱风跋扈万枝舞，雾霭苍茫千里行。须眉少年同相助，坐待风雨在闲庭。

most challenging day so far! The overnight storm came in full force. The wind speed reached as high as fifty miles per hour. With the wind also came the
ing rain. In three hours, I hiked five and a half miles. Soaked from waist down plus both of my sleeves. My fingers were numbingly cold. Time to stop at the
Corner Knob shelter, I thought. Many thru-hikers had the same idea. I saw lots of people from the same shelter that I stayed in last night. My waterproof boots
ame a pair of buckets. At the shelter, I dumped almost a cup of water from them.

:ook me almost two hours to get the feeling in my fingers back after changing into dry clothes. I pulled up my sleeping bag and ate a big lunch. The wind
w across the front cooking section of the shelter, making it unusable. Thanks to a big tarp that covered the entrance of the sleeping quarter, we had a dry
a that we can hang our wet gear. But the tarp was flapping constantly in the wind, so it was still cold in the shelter. "Tutu", a hiker with long white beard,
ked tirelessly for almost two hours to get a fire going. It was a tough job since all the branches were soaking wet. He eventually pulled out his alcohol fuel
start the fire. "Slip & Slide", who stayed here since last night, also helped him. I passed my Vaseline-soaked cotton balls to him too.
I am sitting here in my sleeping bag, the rain and wind has not decreased in strength for more than 5 hours. I will just stay put and wait for tomorrow to
e again when this frenzied storm passes.

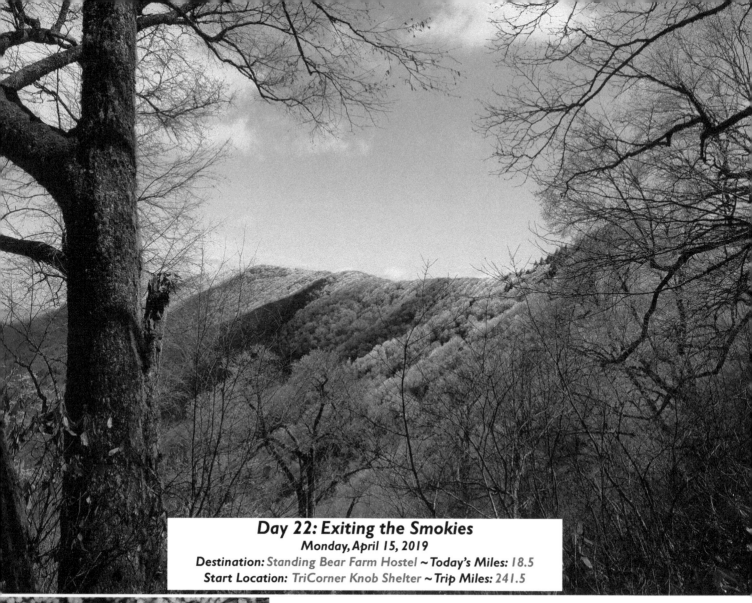

Day 22: Exiting the Smokies
Monday, April 15, 2019
Destination: *Standing Bear Farm Hostel* ~ **Today's Miles:** *18.5*
Start Location: *TriCorner Knob Shelter* ~ **Trip Miles:** *241.5*

By 7:00am I had already started hiking. There was no point in making breakfast - the bear bag tha
hung on the bear cable had been frozen solid. I could not get any food out of it.

It was extremely cold and windy. I had my warm hat, two layers of pants and three top layers all
long. I put my poncho on for added warmth and wind protection for most of the morning too.
rain was very light, but most of the rain drops turned into ice particles when they hit the ground.
temperature reached as low as 19F degrees. For the most part of the morning, I was above 5200ft.
the ridges, looking to the left, was a winter wonderland with ice, forming crystals (rimes) on every bra
On my right, a valley of green displayed a springtime scene. Wildflowers added to the list of lovely col
A couple of days ago, when I went to the Sugarland visitor center, I learned many wildflower names. A
saw them again, they became more enjoyable.

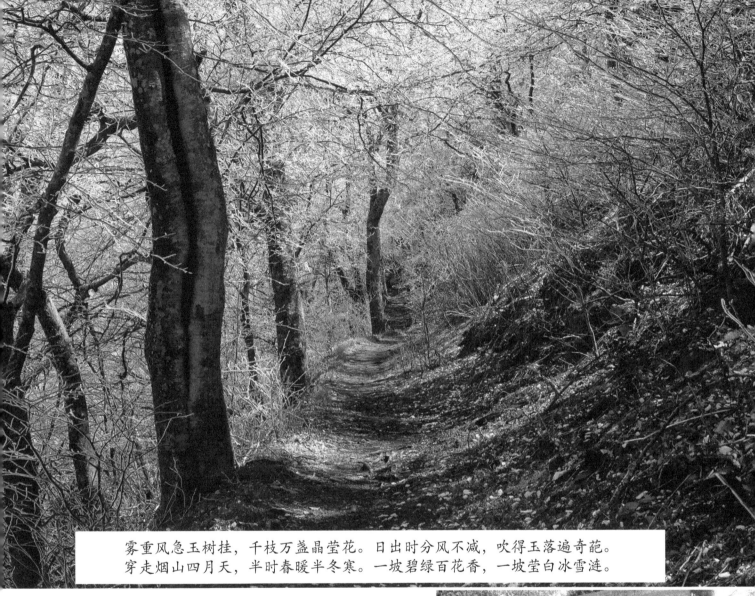

雾重风急玉树挂，千枝万盏晶莹花。日出时分风不减，吹得玉落遍奇葩。
穿走烟山四月天，半时春暖半冬寒。一坡碧绿百花香，一坡莹白冰雪涟。

the afternoon, the trail started going steadily downhill. When there were about two miles
m Davenport Gap, I couldn't help but make up a song again: "Goodbye the Smokies".

When I was entering the Smokies, it was a bad weather day.

Now I am leaving the Smokies, it is a fair weather day.

Bye bye the Smokies n' bye bye the Smokies.

I wish someday I could return to you ~ to see the FALL-COLORS day.

Bye bye the Smokies n' bye bye the Smokies.

I will return to see the Rho-do-den-dron in full blossom day.

ushed more than 18 miles today, and got to the fun Standings Bear Farm hostel for a
nk bed.

John Muir: The mountains are calling, I must go ...

Day 23 - 35: Zig-Zag between North Carolina and Tennessee

Where was I, North Carolina or Tennessee?
A confused trail with confused mind
Every day I was not just visiting two states multiple times, but also visiting in different times

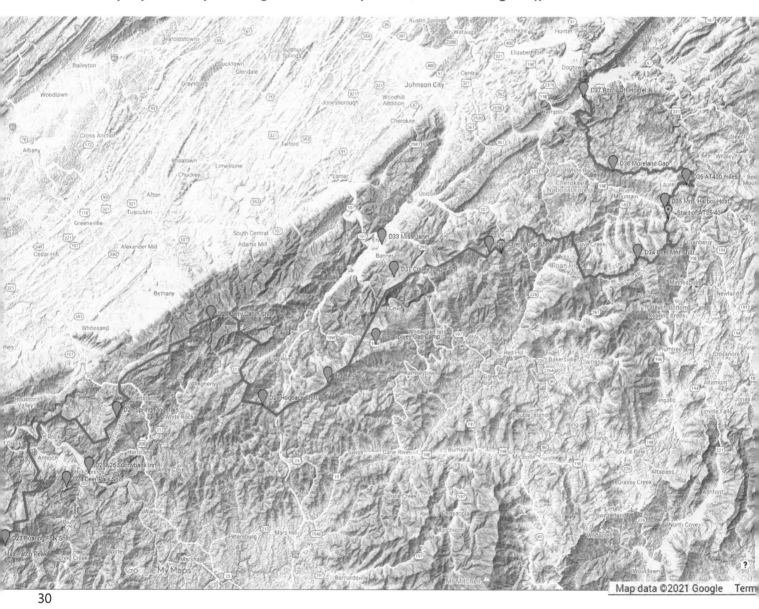

Day 23: Climbing all day

Tuesday, April 16, 2019

Destination: *Roaring folk Shelter* ~ **Today's Miles:** *15.5*
Start Location: *Standing Bear Farm Hostel* ~ **Trip Miles:** *257.0*

delays due to the storm 2 days ago was costly today. Instead of the planed 3000ft elevation gain in one day, it was actually almost 5000ft, in the course of 15.5 miles. I went through two peaks - Snowbird Mountain and Max Patch Summit.

On Snowbird, there was a cool-looking FAA station, all white, very streamlined, like a spaceship from outer space. I took a long time to reach Max Patch since it was at mile 13.6. At 0.8 mile before the Summit, SR1182 — a dirt road — intersects with the Appalachian Trail. Just when I was hungry and out of energy to finish the last mile to the Summit, there was a trail angel! It was a very beautiful young lady doing trail magic. She drove almost 11 hours from Philadelphia to here. And it was the best trail magic I have seen: grilled burgers and hot dogs, lots of fresh fruits and veggies, in addition to the usual cold drinks and sugary snacks! I ate an orange, an apple, two carrot sticks and many pieces of watermelon! The last mile to the Summit became so easy after this. Thanks a lot to the beautiful trail angel!

Max Patch is a very popular destination for locals and thru-hikers. Many hikers I met on trail decided to camp at the summit area. It's a grassy bald with plenty of space — big enough to land small airplanes. It had great views all around. Since it had no water, and it was pretty windy at the top, I pushed on in hopes of reaching the shelter two more miles down the trail. One thing I think is pretty cool: near the Max Patch are many very old wooden posts with the Appalachian Trail's white blaze on them. They were so old that lichen had grown over most of the signs, turning them grayish-green. And many posts had rotted into funny shapes.

There are also a lot more wildflowers along the trail. Some have very interesting shapes at different stage of their lives. I found lots of mint, too.

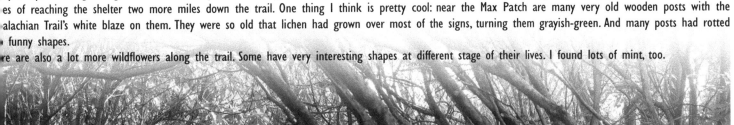

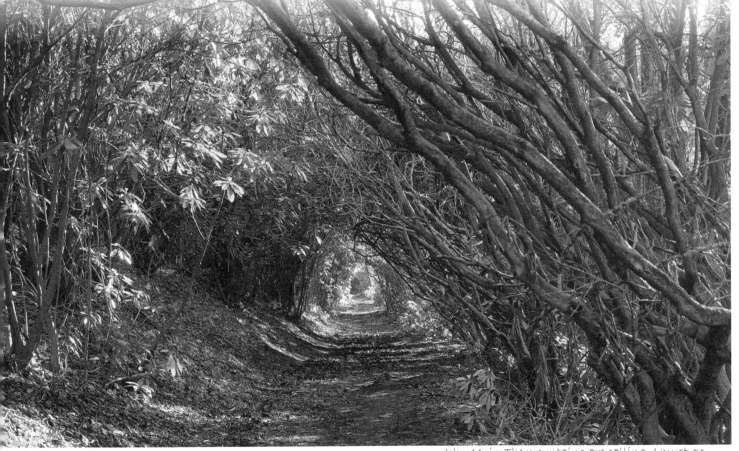

John Muir: The mountains are calling, I must go ...

Day 24: Trilliums
Wednesday, April 17, 2019
Destination: *Deer park mountain shelter* ~ **Today's Miles:** *14.7*
Start Location: *Roaring folk Shelter* ~ **Trip Miles:** *271.7*

Good weather makes an enjoyable hike day, especially in the morning when everything was fresh. Today's star was the trilliums -the wildflower with three big leaves and three petals. They covered slope after slope with their big showy flowers. Some have petals as pure white as fresh snow, while others have petals as rich red as cabernet sauvignon, all with yellow centers. There were also some greenish-yellow trilliums, but they were not abundant here as they were before and in the Smokies. When I hiked with my self-made Appalachian Trail song, they all nodded in agreement in the light breeze and patched morning sunshine.

I also saw many butterflies: big and small, white, black and blue. They all looked pretty. There were also lots of busy bees working on the flowers. Oh, and I saw a big black shiny snake. This is the second snake I've seen on Appalachian Trail. The days are getting warmer, animals are more active now. I need to watch more carefully on the trail.

When I neared the shelter in the evening, I heard sharp calls "Ah, Ah, Ah" from a bird of prey! I wish I could understand the meaning of its calls.

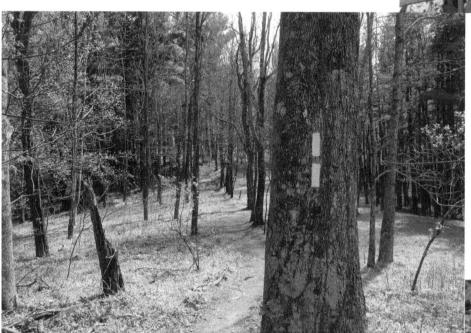

The A.T. song:
I'm marching on the A.T., I'm marching on the A.T., marching on the A.T., From Georgia to Maine!

I marched in the snow, I marched in the rain, I march under the Sunshine, From Georgia to Maine!

I slept in a tent, I slept in a shelter, I slept under the st From Georgia to Maine!

I saw wildflowers, I saw wild animals, I saw Spring, Sumn and Fall, From Georgia to Maine!

You can add more lines to this song with anything y want - the foods you ate, the drinks you drank, or new friends you made every day on the trail!

Day 25: Hot Springs
Thursday, April 18, 2019
Destination: *Sunnybank Inn in Hot Springs, NC* ~ **Today's Miles:** 3.2
Start Location: *Deer park mountain shelter* ~ **Trip Miles:** 274.9

easy morning stroll for a lasted a little more than 3 miles, brought me to the Hot Springs, NC. This is a small village type of town, Appalachian Trail centric this time of the year. I bet half of the population now are A.T. thru-hikers! From the trail, looking down to the town surrounded by trees with spring fresh es, it does look alike a lovely little village out of a storybook. I have remembered what the shuttle driver in Top of the Georgia told us: if you can reach Hot ngs, your chances to finish the Appalachian Trail thru-hike will increase significantly! Now I am in Hot Springs, at mile 275. Still has 87.45% (1917 miles) to But I am glad that I have made it so far.

re is a natural hot spring that was believed to have curable power since 1778. The hot spring still operates today, even though the old building is only a ruin . For $25, I got to use the hot tub next to the French Broad River for one hour. I checked into Elmer's Sunnybank Inn - the oldest house built in town. It a nice Victorian house with shared bathrooms. There is no laundry in the Inn, so I hand-washed a few small items and put them in the windy and sunny kyard to dry. It was a hot day in here, nearly 80 degrees in the afternoon. The owner of the inn sometimes provides legendary vegetarian meals for dinner here are more than 6 people signed up by 3:00 pm. I put my name on the signing board, but unfortunately, around 4:00pm I saw a notice that Elmer will cook dinner tonight! The Inn has also had a big black and white dog - named Jimmy Carter!

山近百里,身未沾床榻。忽闻犬吠声,知是近人家。未曾旧相识,笑颜俏如花。林间一小镇,美泉传佳话。

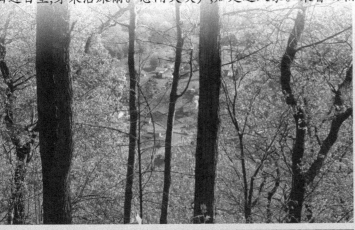

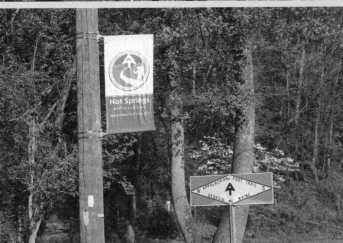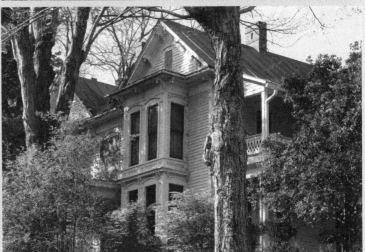

John Muir: The mountains are calling, I must go ...

Day 26: Staying in Hot Springs

Friday, April 19, 2019
Destination: *Sunnybank Inn ~ **Today's Miles:** 0.0*
Start Location: *Sunnybank Inn in Hot Springs, NC ~ **Trip Miles:** 274.9*

Rain-stuck in Hot Springs, NC. Stayed all day in Elmer's Sunnybank Inn, reading, eating and sleeping. There is a skylight in the washroom outside of my bedro The sound of rain drops splashing on it made a great argument to stay out of the wetness. It's a soothing sound one can only appreciate after the experie of being cold and helpless in the rain, when everything falling on your skin was against your continued well-being, with no place to hide from it.

Elmer and Scott prepared a big tasty breakfast for us: coffee, tea, granola, fresh cantaloupe, oranges and grapes, warm hearty biscuits, grits with gravy, all s of jams and honey, almond milk and regular milk. On top of that, for dinner, we were served brussel sprouts and mushroom soup, salad with over ten varie of vegetables and cheese, a Thai flavored vegetable stew over rice, and a dense flavor-packed lemon tart for dessert. We were pampered. Elmer has owned place for decades since 1970s. He really made it a home for all the guests. This historical place is captured in the year 2000 movie "Songcatcher". The ro #4 kept a plaque on the door for Earl Shaffer, who stayed here in that room twice: 1948 on the first ever thru-hike on Appalachian Trail and 1998 when hiked the trail second time.

In the afternoon I took a short walk in town to take some pictures in the rain. The river, which was calm and clear yesterday, has become a muddy, mad curr today, carrying lots of logs down its course. Many hiking friends who left town yesterday came back to get a break from the rain. It was nice to chat with th but at the same time, it showed how challenging the weather could be.

Thinking about the hike and camping in the wilderness (at least when it is dry); the following passage I just read described it perfectly.
"It is a kind of life that has a potent charm for all men, whether city or country-bred. We are descended from desert-lounging Arabs, and countless ages growth toward perfect civilization have failed to root out of us the nomadic instinct. We all confess to a gratified thrill at the thought of "camping out."" - Exce From [Roughing It] by Mark Twain, 1870-71.

Day 27: Lovers Leap and leaving Hot Springs

Saturday, April 20, 2019
Destination: *Spring Mountain shelter* ~ **Today's Miles:** *11.0*
Start Location: *Sunnybank Inn* ~ **Trip Miles:** *285.9*

Left Sunnybank Inn at 7:10am. After crossing the bridge over French Broad River and turning right on the Appalachian Trail, I was stunned by what I saw. The trail was a part of the river, with the water level possibly higher than my waist. It was definitely impassible! A black pickup was washed down and stuck in the river by a tree! Scouting around, I found a use trail past a barn. It was steep. A wet rope dangled down from above. I didn't know that I had any other options, so I tried going that route. Oh, boy, it was so steep. And with a big backpack on, it was not easier. I had to use all fours, pulling on tree roots and rocks most of the time. I followed the big rock - called Lovers Leap - all the way up. Based on my topographic map, the top of Lovers Leap should join back to the Appalachian Trail. After forty minutes of hard climbing, I was on top of this big rock. Around that time, a little sunshine broke through the heavy layer of clouds. The views of Hot Springs, the flooded brown river and the green hills around it looked amazing! Another ten more minutes of scrambling brought me to the junction of the Appalachian Trail, where two other thru-hikers just came into view. They told me the alternative route that going up on a paved road, then another trail. Gez, if I knew that! I promised myself that I will not climb on that type of trail ever! The climb was only about 0.3 mile, but it took me almost 50 minutes. Anyway, the distance to the shelter is about 11 miles. By 11:30am, as forecasted, a light rain came back, first as small hail, then light showers on and off for the rest of the day. I saw many edible plants along the trail: ramp, garlic chive, scallion, violet, mustard, plantains, and more. I even saw a piece of rotten wood full of wood ears. It's the first time that I ever saw fresh wood ears. On a nicer day, I might have picked up a few plants and put them in my dinner. But today, all I wanted was to get to the shelter so that I can keep myself dry.

The temperature today was low. I can see my breath. When new hikers came to the shelter after climbing up a ridge, steam rose up from their whole body!

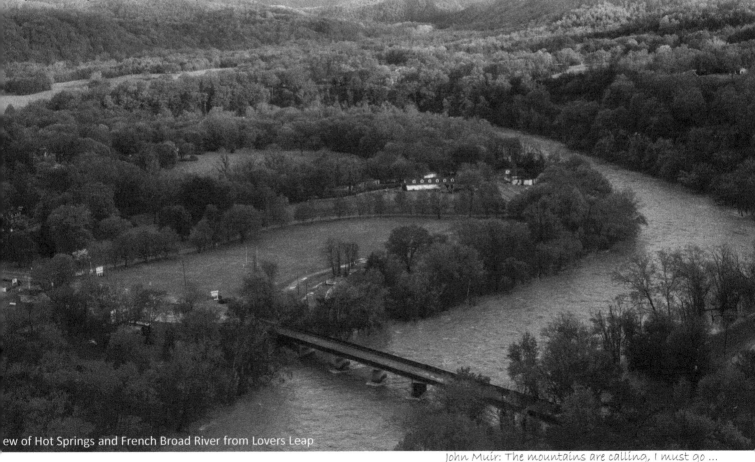

View of Hot Springs and French Broad River from Lovers Leap

John Muir: The mountains are calling, I must go ...

Day 28: Snow and fog all day long
Sunday, April 21, 2019
Destination: Jerry Cabin Shelter ~ **Today's Miles:** 15.9
Start Location: Spring Mountain shelter ~ **Trip Miles:** 301.8

The weatherman promised our hikers clouds in the morning, and sun in the afternoon. I only saw about 3 minutes sunlight by 5:00pm. The whole day was either very foggy or very dark clouds, threatening rain at any moment. There were a few drops, but never wet enough for me to put on rain gear. But the aftermath of the rain in the last two days was well noticed. Not only the trail was very muddy and watery, but for miles there were areas covered in snow. Adding the heavy fog, it was kind of creepy walking by myself in the dark and cold forest for a long time. It was also kind of cool. When the snow melts in the quiet forest, it makes lots of funny sounds, so you can imagine many different things. I did hear a big tree fall down with a loud noise.

In the afternoon, the trail went through an exposed ridge line. The section was built with lots of big rocks. It was so difficult to build, they put a plaque on the top of the ridge to honor Howard, the trail master. While I was on the ridge line, the clouds lifted a bit. I could see green plains lying below the ridge on the west side, wide and flat, very very green! I also passed 300 mile benchmark!

A few hikers asked about my hike yesterday by the Lovers Leap cliff as a detour to avoid the flooded trail. No one believed I could do that. I was actually very careful and kept a cool head yesterday. I tested every handhold and foothold of the roots, rocks and ropes before putting my weight on them. It was difficult, but not beyond my ability to do it. Besides, it was at the beginning of the day, when my body was very fresh from resting in the past two days. One young guy also took that route, and kept saying it was crazy. I totally agree.

Day 29: Sunny at last
...nday, April 22, 2019

...stination: *Hog back ridge shelter* ~ **Today's Miles:** *15.5*
...rt Location: *Jerry Cabin Shelter* ~ **Trip Miles:** *317.3*

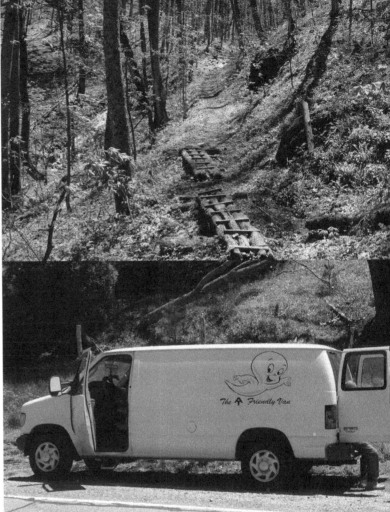

...was one of the nicer days I had on the Appalachian Trail. The morning ...cool and the afternoon was warm. Blue sky, green mountains, fresh springs ...air.

...morning I met "Quest". I have seen him at least 3 times so far, hiking with ...ay pack in the opposite direction. It turns out he has two cars, so he is ...kpacking and alternating with his cars. He plans to do this way all the way ...Maine! Wow, this is first time I met someone really doing it this way!

...unch time, I also met a guy who's a section hiker. He has also hiked over ...0 miles on the PCT and plan to start the CDT this year, too. He's the first ...on I met who is really doing the triple crown! He can go more than 30 ...s per day.

...he afternoon, across a road, Rob was doing trail magic. It was the fourth of ...e I have enjoyed on the Appalachian Trail. Rob owns a hostel that housed ...y thru-hikers for many years. He loves the Appalachian Trail thru-hiking ...munity and comes out to do trail magic often with a white van printed ...e AT friendly Van" on its side. One guy I met on trail also gave me an apple. ...nks you all trail angels!

...tonight dinner I cooked my multigrain lentil soup with some ramp I found ...trail. At the shelter, there were ramp patches near it, as well as wild basil. ...my!

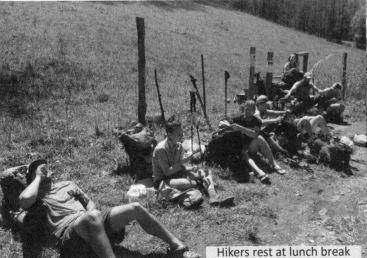

Hikers rest at lunch break

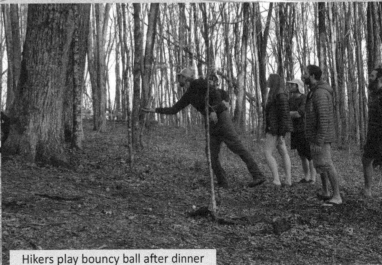

Hikers play bouncy ball after dinner

John Muir: The mountains are calling, I must go ...

Day30: 30 days in outdoors
Tuesday, April 23, 2019
Destination: *Spivey Gap campsite* ~ **Today's Miles:** *15.8*
Start Location: *Hog back ridge shelter* ~ **Trip Miles:** *333.1*

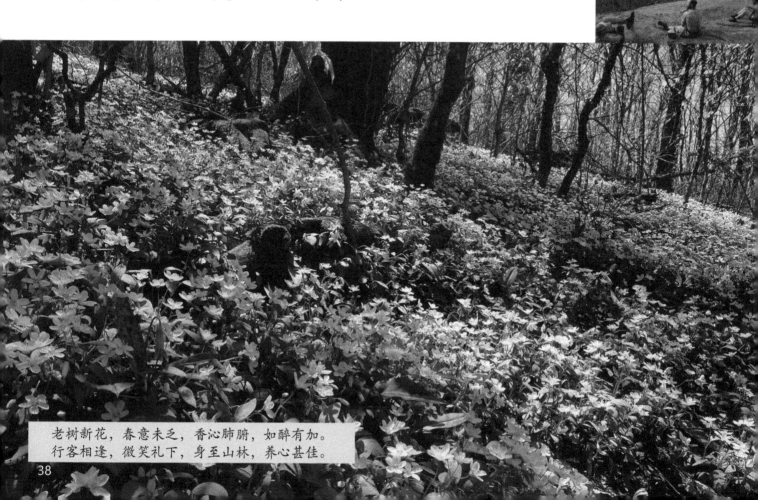

I have been living outdoors for 30 days! What's the best gift for a 30 day benchmark? There is no better gift than met my husband in the morning after 2.5 miles on the Appalachian Trail! He was visiting a customer in Asheville, NC, and drove about one hour to Sam's Gap where the trail and highway 26 intersect. He brought me lots of goodies, a week's worth of food and other needed stuff. Meeting him, even for just a little over an hour gave me big morale boost! Thanks honey, I always love you!

The food added quite a bit of weight to my backpack. I was carrying about 10 days' worth of food now! There were several tough climbs today. Fortunately, the wildflowers constantly distracted my attention. Under the warm sun, spring beauty - a small white and pink flowers - carpeted the mountains. Their perfume was so strong, it intoxicated me. I couldn't help but walk very slowly to immerse myself into the fancy world of the wildflowers. I bet it smelled better than Chanel No.9! It was a long day with a heavy pack. At the end, my legs felt like jelly. I was so tired that it was the first time that I didn't cook dinner. Just picked out the heaviest Big Sur energy bar (one bar = 3 regular bars), ate half of it, and drank some water for my dinner.

Time for a good night's sleep. I am camping near road 19. Hopefully the cars will not bother me much.

老树新花，春意未乏，香沁肺腑，如醉有加。
行客相逢，微笑礼下，身至山林，养心甚佳。

38

Day 31: First rhododendron blossoming
Wednesday, April 24, 2019
Destination: *Curley Maple shelter* ~ **Today's Miles:** 15.4
Start Location: *Spivey Gap campsite* ~ **Trip Miles:** 348.5

For most of today, the trail was hot and dry. The only reprieves were in the morning and in the evening, when the trail followed alongside creeks. In the morning, I picked a few wild scallions and garlic mustard from the side of the trail, thinking to use them in tonight's dinner. But on a hot day like this, they got mushy in the afternoon, so I ended up throwing them away.

...day I saw the first few rhododendron ...oming. Whenever the trail reached a ...k, a small wooden bridge accompanied ...ach bridge has one side exposed and ... side with a handrail. Many of those ...s had many rhododendrons. These ...few were just before the trail crossed ...stoa Bridge over the Nolichucky River. ...as not careful yesterday afternoon when ...ed my backpack, and twisted my right ...e. I had some knee pain in my left ...e two weeks ago. After a couple of zero ...s and continuous walking, my muscles ...e stronger, and it had been no issue ...the past week. But now, I have this ...blem which I cannot blame anyone but ...elf. Again, it was minor. I felt okay to ... uphill without being bothered, but I ...ved down a lot in downhill sections. I ... planning to do shorter distances in the ...t four days.

On the trail, about 2-3 miles to the river, there were switchbacks. I got so bored and started making silly songs about switchbacks, that I called zigzags. The song did not have any meaning, mostly just silly words that happened to come into my mind. And they were always linked by sound "Zi-O Geo". I started by predicting how many zigzags there would be. It had a total of nineteen zigzags, very close to the twenty that I predicted.

The views of the river and the town Erwin were best on zigzag six and eight.

When the zigzags were done, I came across a road and arrived in front of a hostel called Uncle Jonny's. I had heard its name many times in the past 3 days. Many hikers that I met on trail decided to stay there instead of their original plan to go to the next shelter. I hung out there for about an hour, had a can of lemon soda and a chili dog. "Peach", the beautiful trail angel that I met a few days ago, who did the Appalachian Trail last year was doing trail magic in here again.

When I got to the next shelter about five miles away, I had the shelter all to myself. There were only three tents at the shelter. A very quiet night it will be.

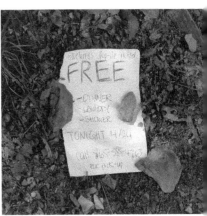

John Muir: The mountains are calling, I must go ...

Day 32: The American best values
Thursday, April 25, 2019
Destination: *Cherry Gap shelter* ~ **Today's Miles:** *12.8*
Start Location: *Curley Maple shelter* ~ **Trip Miles:** *361.3*

It was a perfect day for hiking today. As a precursor of tomorrow's storm, today was overcast with sprinkles here and there. So the temperature was low, there was no hot sun beating down on the hikers.

In the morning, at a place where the trail took an almost 180-degree turn, I missed the turn and kept straight on an use trail. It led me to bushwhack to top of a hill with large rocks. The view was great, but there was no trail in sight. Checking my Earthmate, I noticed it was off the main Appalachian Trail about 0.2 mile. So, I had to retreat my footsteps to get back on the main trail. Later at Indian Grave Gap, the trail angel "Brother Tom" told me there h been other hikers that missed that turn too. With my preoccupation on getting back to the main trail, my knee could do all the maneuvers without feeling pain. It reminded me of a hiking guru I met two years ago. This man, from Fresno, California, could hike up to 64 miles per day. When I asked him if that m his feet hurt, he answered "Yes. But I just ignored it. It's all in your mind".

Hiking on the long distance trail let me experience the most treasured ideas of America: "Liberty as in freedom, Equality as in oppotunity, and Fraternity as universal love". Freedom means that I can do the things I believe in, with proper preparation and hard work, to achieve my goal. I am not limited by my gen age, educational background, or my family's status. I observed other hikers with the same determination, enjoying their freedom too. As an immigrant to the this freedom is extra precious to me. Equality means that all the hikers are facing the same challenges and getting rewarded by the trail equally. They hear same bird songs every morning. The wildflowers bloom the same way for all. To reach their goal, they walk the same path, one step after another from Geor to Maine. Regardless of what they were before, regardless how much wealth they have, the trail let them discover themselves, and gave them the same oppotu and dignity. Love is expressed by looking after each other every day, whether they knew each other before or not, as expressed by trail angels who provided t magic out of pure kindness to strangers. I have asked many of them if they take donations. All have said no. Some told me the best donation we can give is to the same trail magic for next year's thru-hikers. Some said that if they could not afford this, they'll not be doing it. It is all just helping people with their nee the love without any expectation of return. This is the best of American values. This is the America that I always wanted to experience and introduce to peo

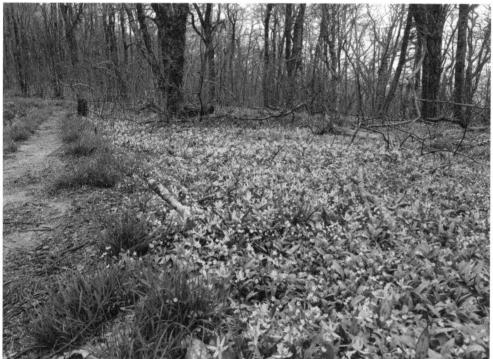

I felt very lucky to be able to do this long trail is not something a weekend backpacking trip provide. I am the privileged few who have the mea and the support to take on this journey. To forefathers who created this trail and to the pec who worked tirelessly to maintain this trail, I always grateful. Whether it's the Appalachian Trail, Pacific Crest Trail, Continental Divide Trail, or Great Redwoods Trail, they are bringing the best of America's people.

Day 33: Rainy day, comfortable night
Friday, April 26, 2019
Destination: *Hughes Gap* ~ **Today's Miles:** *12.5*

Start Location: *Cherry Gap shelter* ~ **Trip Miles:** *373.8*

challenge started after 8:00am, when the rain came and lasted for almost the entire day. It was not as bad as the last time in the Smokies, but when I hed Iron Mountain Gap, the strong wind drove the rain into my poncho as if there was nothing in between. Everything except my core got soaked in less 15 minutes. Compared to the Smokies, it was less challenging, thanks to the few breaks in the rain. The wind blow-dried my clothes somewhat in those brief ments. Near noon, there was even a moment when the sunshine, albeit weak, came through. It was a brief moment of hope. It really lifted my spirit. Yet, in a few minutes, the sunshine was gone. The wind blew in dark clouds and the hope disappeared faster than I could count to three. Then I got soaked again. s planning to stay in the next shelter nine miles away. However, when I got there in early afternoon, a man with mental problems was there by himself. I not comfortable staying there with him. So I pushed on to Hughes Gap, hoping to camp there for the night. When I left the shelter, it started hailing. I was etermined that I hiked through the hail. On Little Rock Knob, the wind sounded like hundreds of trucks on the highway. I was grateful that the trees gave some protection from the strong wind.

e backpackers I met on trail told me someone was doing trail magic at Hughes Gap. When I got there, there are another eight thru-hikers huddled under nopy, around a lit barbeque stove. Immediately, they fixed a grilled garden burger for me, and let me warm up near the fire. The best thing from this trail ic was that they called a lady named Miss Janet in Erwin. And she came with a van to take all of us into her house for the night! As I am typing this nal in Miss Janet's house, warm and clean and being fed, more than ten hikers are also here watching TV comfortably.

ing today's challenging hike, my knee kept quiet most of the time. My backpack also felt feathery light. As I wrote yesterday, it is all in your mind. The trick ow could I master the art to keep them out of my mind the entire time!

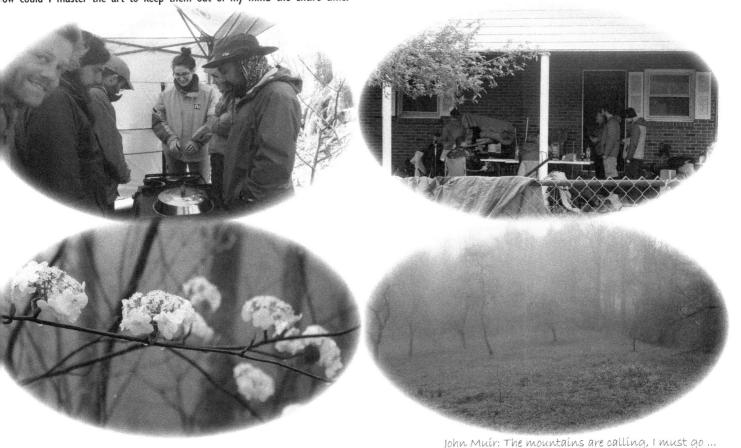

John Muir: The mountains are calling, I must go ...

Day 34: Best day on trail
Saturday, April 27, 2019
Destination: *Overmountain shelter* ~ **Today's Miles:** *12.4*
Start Location: *Hughes Gap* ~ **Trip Miles:** *386.2*

This could have been one of the best days for hiking! The air was cool and fresh after yesterday's rain. The visibility was clear for miles and miles. The section was not difficult to traverse. All climbing was done in the morning; and with lots of balds, the views really opened up.

In the morning, after breakfast, all hikers who stayed in Miss Janet's house last night took a picture together. There were eighteen of us. Some slept in her house, some camped in her yard, some slept on her porch, and some slept in the school bus that was converted into a hiker's bus. I slept in her living room on the floor. Then seven of us were delivered back to Hughes Gap by the school bus. The happy music accompanied us happy hikers all the way for about an hour. When we reached Hughes Gap, we found two groups of people doing trail magic - one group was cooking breakfast, and the other was giving hikers prepared sandwiches and goodies. I had an egg and half of a chocolate chip cookie.

The temperature was in mid-40s when I started hiking at 10:00am. The morning had about a 2000ft climb to Roan Mountain. I warmed up nicely in no time at all. Since the temperature stayed low for almost the whole day, I never got overheated. I just cruised along through the scenery: ridges, a fairytale-like camping area, a spruce forest with the most delicious smells, and later, through the views on the balds.

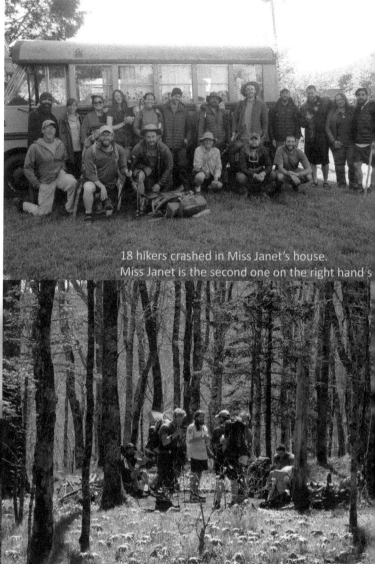

18 hikers crashed in Miss Janet's house.
Miss Janet is the second one on the right hand s

ttle after lunchtime, I reached the Roan High shelter - the so-called coldest
lter on the Appalachian Trail, and also the highest shelter at 6285ft above
level. It was a nice shelter. It was indeed very cold. I noticed lots of ice
the trail near the top of Roan High Bluff. I'm glad that I came here today
a sunny day, instead of yesterday in the rain storm.

ng this was a Saturday, there were many day hikers and weekend back-
kers on the trail. And we hit a record high of three trail magic spots in
day! The third one was near Carter Gap just off Roan Mountain, where
hikers were on trail in incredible numbers. One guy was holding a paper
a big "7". He told me he's the 7th group of hikers today who joined
organized hikes.

the end of day, many thru-hikers that I have gotten acquainted with
e to Overmountain Shelter for the night. There were also many weekend
kpackers in here - some are family with children. The shelter itself is a large
n. Apparently, it is one of the best camping areas near the Appalachian Trail.
the camping area near the shelter had very nice views. I cooked dinner
ramps found near the camp. "Robin Hood" asked me to show him what
ramps look like, and he used them in his dinner, too. A group of first
er backpackers from India came chated with us. We showed them how to
lightweight in backpacking.

r Roan Mountain, the Appalachian Trail will stay below 6000ft for a very
g time, until it reaches the Whites in New Hampshire. Does this mean it
be a little easier?

风雨过后山光秀，
松柏踏青人织碌。
雕玲玉阁今何在，
一石烟囱唯寄旧。

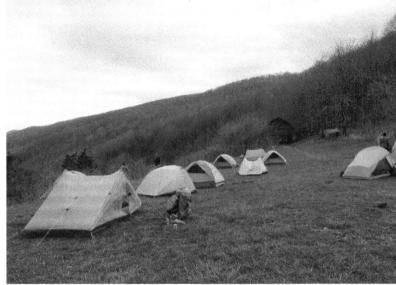

John Muir: The mountains are calling, I must go ...

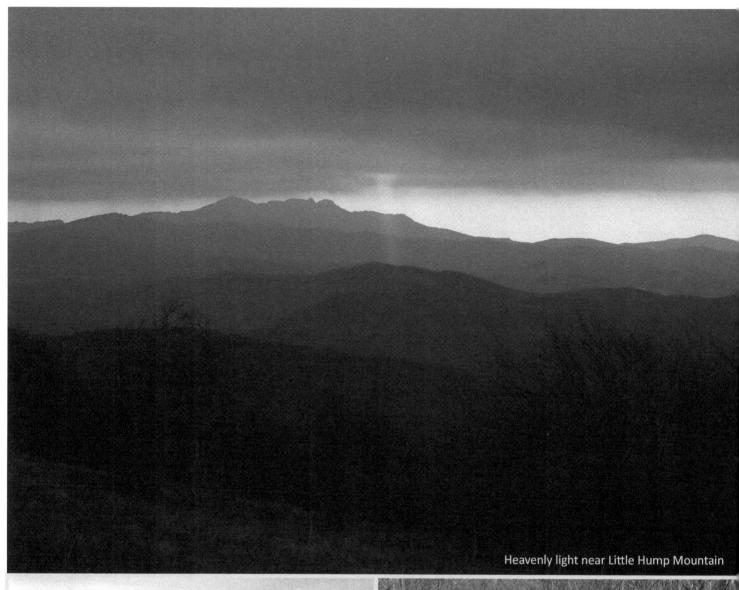
Heavenly light near Little Hump Mountain

Day 35: Leaving North Carolina
Sunday, April 28, 2019

Destination: Mountain Harbor B&B and Hostel ~ **Today's Miles:** 9.5
Start Location: Overmountain shelter ~ **Trip Miles:** 395.7

In early morning, I passed Litter Hump Mountain and Hump Mountain in cold, high winds. The sky was covered in dark clouds which threatened to rain at any moment, but never delivered a drop. I can see, far in the distance to the east, rain draft threads touching down on mountain hills. There might be rain over there. In one moment, a bright column of light pierced through a crack in the dark clouds, the light of heaven putting on a dramatic show. Most of the time on the exposed balds, I had nowhere to hide. I walked, leaning against the wind, to climb up the balds. A few times, the wind almost blew me off-balance. It was a "lone traveler in vast empty space" kind of feeling. Only cold dark rocks and a few small, lonely trees shared this harsh world with me. Yet, however sad it looked, the views to distant mountains with fast rolling clouds still provided lots of entertainment and energy to the lone traveler.

My struggle against cold wind did come to an end after I got down into the forest. By early afternoon, when I was near road US 19E, it was warm and sunny. The fresh green of the spring forest was so calming! The trails turned lazy turns. The creeks ran lazy runs. Even the sound of water trickled to the tune of river tunes. Some of my fellow thru-hikers also slowed down. They set up their tents by a creek just an hour after noontime. The breeze moved gently from the shadows of tree branches to leaves to their tents and bodies, like a caring mother's hands caressing her babies. And the trail again filled with the sweet smell of wildflowers, from those closed petals that had opened up, responding to the warmth of the Sun.

Shortly after Doll Flat, I reached the sign that said "Leaving NC". The Appalachian Trail is finally done with North Carolina! I met bunch of hikers there. We celebrated and took a lunch break just before crossing that sign. Some mentioned that crossing this line means that there would be no more privy near the shelters. No one wanted to cross that sign. Some even suggested that we walk back to Springer Mountain! After sitting there for about thirty minutes, I finally got up and left North Carolina for good! Soon all the young hikers caught up with me very quickly. For me, I was just happy to finish the section on NC/TN border. On this section, I lost the feeling of belonging. I didn't know which state I was in at any given time. Even though it didn't matter to Mother Nature, it still created a confusing state of mind to people who were used to manmade rules. By finishing that section, my sense of belonging returned. I think it also impacted me later in the forest, where I felt extra calm.

It was a sweet and short day to me. I reached Mountain Harbor B&B and hostel around 2:00pm. Resting well before returning to the trail tomorrow.

风卷乱云呈苍凉，放眼无际劲沧桑。孤行尚有同志者，唯试刃厉知锋芒。

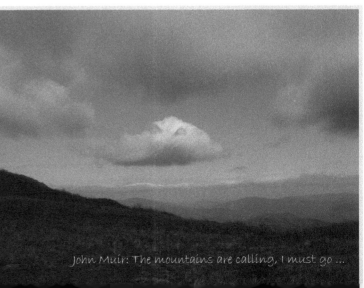

John Muir: The mountains are calling, I must go ...

Day 36 - 40: Appalachian Trail - Tennessee

idyllic trails, idyllic scenery
All in a waltz of Tennessee

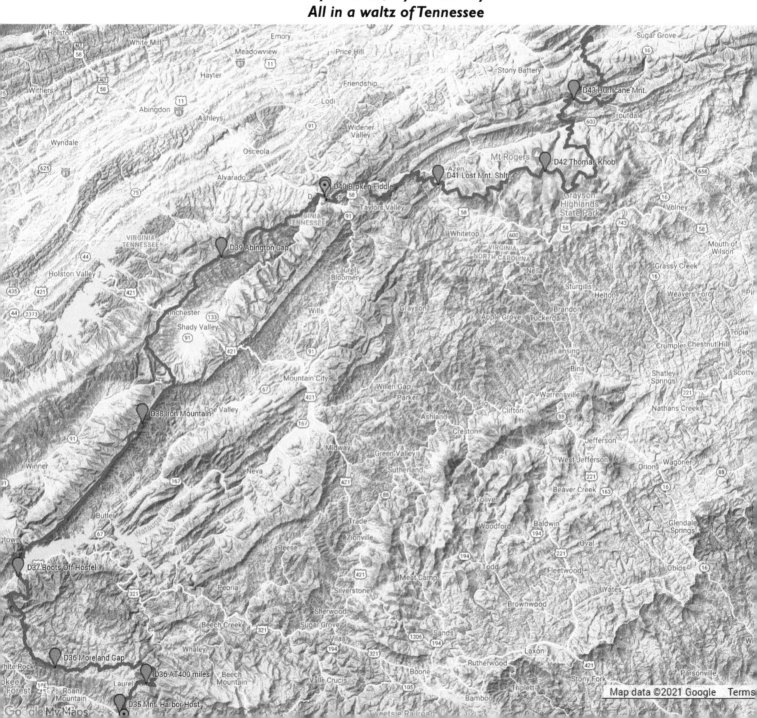

Day 36: Tennessee
Monday, April 29, 2019
Destination: *Moreland Gap Shelter* ~ **Today's Miles:** *18.4*
Start Location: *Mountain Harbor B&B and Hostel* ~ **Trip Miles:** *414.1*

ntain Harbor B&B and Hostel makes a very nice breakfast. I was thinking to skip the breakfast to leave the hostel early, due to plan for a long hike today. "Robin Hood" suggested strongly to have it. He had eaten here before, at least 3 times. So, I signed up and was very satisfied with the variety and quality he meal. By the time I almost finished breakfast, five big and hungry thru-hikers came in. They said that they heard the breakfast is excellent, so they want ee if they can have some. The owner looked at the five big guys, all over 6 ft tall, and looked at the food on the counter. "Well, we can make some more you, but not everything. Would that be okay?" All five immediately piled food high on their plates. The owner started making more egg dishes. I was amused the scene. What would I do if five hungry men came to my place unplanned?

am in Tennessee! Sure and square! To me, Tennessee is always a romantic state: the country music, the southern hospitality, and the idyllic way of life. I feel even time runs slower in Tennessee. The trail is definitely mellower. There was no killer climb today. Ups and downs still added up to about 2800ft, but I 't feel them. In early morning, the green slopes were covered with yellow, white, purple flowers. White clouds hung over the top of higher hills in the distance. soon after starting, the trail skirted the bank of a happy, clear river. Some of the campsites on the side of the trail were very inviting. Then, just a short ance after I passed the Appalachian Trail's 400-mile marker, the beautiful Jones Falls impressed and refreshed. Shortly after noon, the trail passed Mountaineer , a small but unique waterfall where the water leaped over a big rock.

ked 18.8 miles today, 18.4 of which was on the Appalachian Trail. When I finally got to Moreland Gap shelter, I had only about an hour of daylight left. re was just one guy who pushed on to the same shelter today. Many people had set up camps along the way. So, it will be a quiet night. The owls are out . I can hear their "Hoo Hoo" calls.

Day 37: Pond Mountain Wilderness
Tuesday, April 30, 2019
Destination: Boots Off Hostel ~ **Today's Miles:** 14.9
Start Location: Moreland Gap Shelter ~ **Trip Miles:** 429.0

This has to be the best scenery on the Appalachian Trail so far. Six miles into the hike, I reached Denice Cove. One lone creek bubbled and passed through flat rocks. It was a perfect place to get fresh water and rest. Then the trail flattened out, all the way to Denice Cove Road, with beautiful green leaves and bright flowers on both sides of the trail. An abandoned barn stood on its frame, blackened by the passage of time, adding to the imagination. On the roadside, Rob - the A.T.-friendly van was there doing trail magic. I had a nice cool Gatorade and a chocolate waffle cookie. He said he will be doing trail magic in these areas till June 22, then drive to Massachusetts for some more trail magic. Thank you so much, Rob!

From Denice Cove, the trail entered Pond Mountain Wilderness. That's where the beauty was. It has a flat trail following Laurel Fork River at a leisurely pace - at first. Then, it passed rocky cliffs on both sides. Many pink rhododendrons were blooming, some over the cliffs and others by the riverside. After the steep and rocky stairway, I reached the great Laurel Fork Falls. Over a huge rock, white water poured down at full force, sparkling under the sunlight. A few people were fly fishing below the white wall of water. Their dark silhouette made a nice picture against the sparkling background. Downstream, the river jumped at multiple steps in a long journey to the bottom. And the trail, at some point, hugged the river on tilted rocks. During high waters, the hikers had to use another trail. I was so happy that I didn't have to use the alternative trail; I would have missed out on the view of the falls. The trail continued on the riverside for 2.5 miles at an easygoing grade. It passed springs and two pretty looking foot bridges. At one point, a little sand beach was so inviting that I could not help but dip my feet, to feel the pleasures of cold water. This area is so beautiful that it could make a great day hiking trip by itself.

In the afternoon, I had to climb up almost 1700ft in 2.5 miles. Hot, and hard work. But that's just what's needed to be done. And I even saw orange yellow rhododendrons in this part of trail!

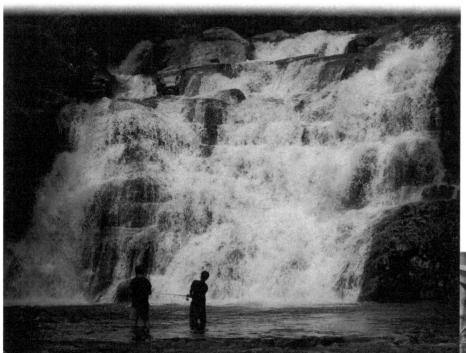

In the course of today's hike, my hiking pants received
3-inch-long gash. The solution? I cut off an unused in
pocket from my pants and mended it this evening. I w
I had the matching thread for the work, but I could o
make do with what is available. The sewing kit from he
had four colored threads. I had to use three of them sir
each thread piece was rather short.

Checked into Boots Off Hostel tonight: a nice, cute ca
Because bear activities are high in the nearby areas,
hostel sounds like a better idea.

Day 38: Shelters
Wednesday, May 01, 2019
Destination: *Iron Mountain shelter* ~ **Today's Miles:** *16.0*
Start Location: *Boots Off Hostel* ~ **Trip Miles:** *445.0*

I left Boots Off Hostel early in the morning. The Appalachian Trail along the bank of Watauga lake was still flooded. I followed a road for a little while, and reconnected with trail a little further up. Around the lakeshore, the forest ground was covered by ferns and royal purple larkspurs. They made a great combination in the shades of tall trees.

After I passed the dam that formed Watauga Lake, the trail went higher in, following the ridge of Iron Mountain for the whole day. Sometime during mid-morning, I saw a pile of fresh bear scat. This was an active bear area. The forest service closed the whole five-mile stretch to camping, picnicking, or lingering. I was on the lookout, but fortunately I didn't see any bear.

However, I saw two types of flowers for the first time on the trail: may apples and blueberry flowers. Both of them were delicate white flowers. The may apple flowers are quite large - like a small globe before blooming. I never saw them in the western United States.

For many thru-hikers, we plan each day around the shelters. A shelter provides us with a sense of community, a place for reconnecting with hiking friends that you have made along the way, and a sense of home - no matter how temporary it is. It also provides access to water, and, sometimes, bear cables and a privy - a little convenience in the backcountry. The distances between shelters can be a few miles, or up to more than eighteen. Each evening, when we reach the planned destination of a shelter, it is always a relief for the rest of the day. So, I made a shelter song today:

A little simple shelter, blended so well into the forest.
You don't see it, until you're right in front of it.
Then you see it with you own eyes, own eyes, own eyes.
A little simple shelter, some were built long long time ago.
It provided protection, especially in a storm.
It blended so well into the forest.
You don't see it, until you're right in front of it.
Then you see it with you own eyes, own eyes, own eyes.
A little simple shelter, it is far far away from each other.
It takes many hours, to walk from one to another.
It blended so well into the forest.
You don't see it, until you're right in front of it.
Then you see it with you own eyes, own eyes, own eyes.
A little simple shelter, all has three sided walls.
I am believing in you, even if you are far away.
It blended so well into the forest.
You don't see it, until you're right in front of it.
Then you see it with you own eyes, own eyes, own eyes.

The day before yesterday, it was 18.4 miles to reach my planned shelter. Today, it was 16 miles. Lots of hiking friends also congregated into the same shelter tonight. When people that arrived earlier saw others come in, there was always a round of cheering and congratulating. And that's the warmest greeting on earth.

偶见枫树露新芽，红艳醉人疑是秋。四里环望百花放，方信当今春正浓。

John Muir: The mountains are calling, I must go ...

Day 39: A cool day
Thursday, May 02, 2019
Destination: *Abington Gap Shelter* ~ **Today's Miles:** *15.9*
Start Location: *Iron Mountain shelter* ~ **Trip Miles:** *460.9*

In the early morning everyone rushed out of the campground. Many wanted get as close to the town of Damascus as possible, still about 26 miles a My only goal was to reach a shelter 16 miles ahead. Unlike the others, I plenty of time to go mellow.

Following an easy trail, I reached the old Osborne Farm by midmorning. A g "AT" marked the side of a weathered barn. In front of it, my fellow hikers a great time taking pictures and videos. After a few, a well-marked path me back into the woods.

The trail threaded on the ridges, passing an old house with only a chim still left standing. After that, I passed a former fire tower, with only a few p on its base remaining. Ah, such a bygone era in history!

By mid-afternoon, rain came. More accurately, it was a shower. I could still blue sky with white puffy clouds overhead, but the rain drops kept com getting heavier. Even with the umbrella, I still got partially wet on the s bringing relief from the heat. It was quite pleasant for a while; then, as it heavier, thunder cracked down near me. I went to a nearby emergency she and waited for about thirty minutes for the heavy shower to pass. During t time, three other hikers also came in for a break from the rain in the sha emergency shelter. The clouds moved quickly, letting the sun peek through pouring rain. It's one of the most beautiful natural phenomena; my favo of all time. The rain brought water: stored energy from heaven. The pla soaked it up eagerly; every type of plants: the trees, vines, bushes, gras wildflowers - all happily receiving their gifts from heaven. Then, another gif sunshine came, bringing more energy for the plants to grow. Every leaf dan in the breeze to welcome these gifts, shining to show their happiness. Ther nothing better than being in the middle of all this beauty - except the b flying around my face or into my ears!

Day 40: Beautiful Tennessee Waltz

Friday, May 03, 2019
Destination: *Damascus* ~ **Today's Miles:** *10.2*
Start Location: *Abington Gap Shelter* ~ **Trip Miles:** *471.1*

The early morning sun brightened my tent and the forest around the campground. In the cool morning air, I cruised through the last 6 miles of Tennessee mountains. Along the way, Patti Page's soft song "The Beautiful Tennessee Waltz" swirled on top of my tongue, a sad but beautiful lost love song that fit perfectly with the pace of my hike. For the last five days, I waltzed with the mountains, forests and small towns of Tennessee, like a hot knife slicing through a piece of butter smoothly. Tennessee will always remain sweet and beautiful in my heart.

In early afternoon, I arrived in Damascus, Virginia - the most A.T.-friendly town on the trail! Unfortunately, my guide book got me completely disoriented. After many inquiries in local shops, I finally got checked into The Broken Fiddle hostel. I thought it would be on the second block of the town, but it was actually on the second block out of the town. I cleaned and resupplied here, and had a nice dinner at Mojo's Trailside cafe. Tomorrow, despite the rain, I will continue on the long journey through Virginia.

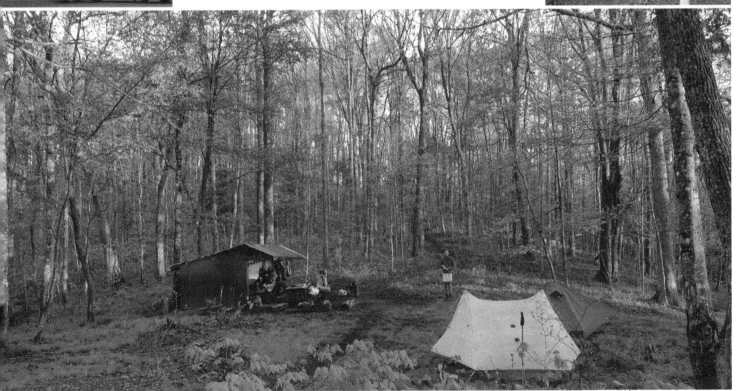

John Muir: The mountains are calling, I must go ...

Day 41 - 77: Appalachian Trail - Virginia

Long, challenging, beautiful, but hardly felt blue

Day 41: First full day in Virginia
Saturday, May 04, 2019
Destination: *Lost mountain shelter* ~ **Today's Miles:** *16.0*
Start Location: *Damascus* ~ **Trip Miles:** *487.1*

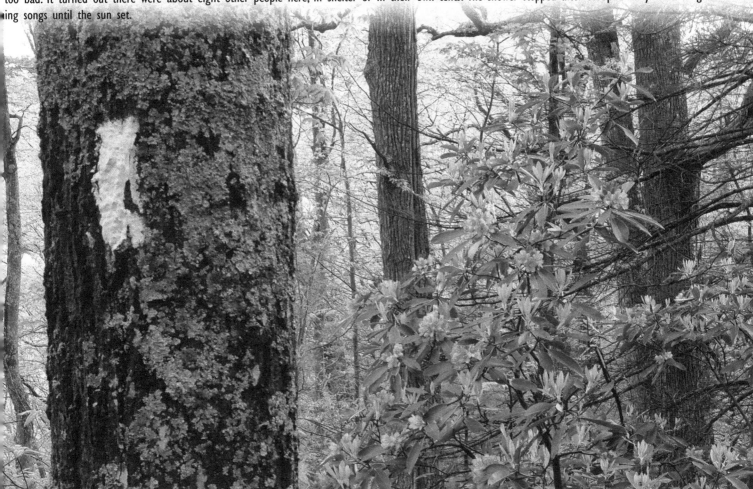

 Damascus by 7:30am. All the hikers I spoke to yesterday and this morning have decided to stay in town for a zero day. Up until mid-afternoon, I felt I was only NoBo (North bounder) on the trail. After 3:00pm, some NoBos caught up and passed me. Thankfully, I would not be the only one in the shelter by myself. trail was full of rhododendron in full bloom now. Most are pink colored. There was one tree with orange and one with white flowers. Seeing them blooming inded me of our house in upstate New York that had a sunroom, surrounded by pink rhododendrons. In spring, the woods in our backyard, filled with oak maple trees, would turn gradually green from new leaves to a darker green as they matured. Staying in that sunroom - either reading a book, drinking tea, laying with my young boys - were the best memory I had for the six years we lived there. Often I would stop doing whatever I was doing, and just stare ide at the young leaves of spring, holding that beautiful image in my mind. For the past few weeks, I have been reliving in that memory again, and still t get enough of it.

 of today's trail intersected with Creeper biking trail. That trail was converted from old railroad tracks. Since it was a Saturday, many bikers were on the . Their energy filled the air.

 as forecasted, the thunderstorm started at 4:00pm. I walked through the shower for about 1.5 hours before I arrived at the shelter - partially wet, but too bad. It turned out there were about eight other people here, in shelter or in their own tents. The shower stopped after 7:00pm. Many birds sang their ing songs until the sun set.

John Muir: The mountains are calling, I must go ...

Day 42: Fairy and rain
Sunday, May 05, 2019
Destination: *Thomas Knob shelter* ~ **Today's Miles:** *12.4*
Start Location: *Lost mountain shelter* ~ **Trip Miles:** *499.5*

It's raining all day today with very little breaks; just a few minutes for a couple of times. My plan was to hike 17 miles, but I only made it to mile 13. Beca
I was in the Mt. Rogers Area, I wanted to see wild ponies. By the time I reached Thomas Knob Shelter, I still hadn't seen any of them. I was wet, cold and hur
by the time I got there. So, a change of plan for today. I'll see if I can see ponies tomorrow morning. Apparently, they were right by the shelter twenty min
before I arrived. Other hikers showed me the video - there was even a baby pony!

However disappointed with the pony situation, I still had a great find this morning: at an edge of a pine grove, there were so many fairy slippers - a pink flo
with a cute bubble shape. This was the first time I saw a fairy slipper. I never knew they were so big. All of them were the size of chicken eggs. They made
day! For the rest of the day, I was in the fog, mist, and rain. The magical forest feeling was back again.

The trail today also went through White Mountain, where an annual ramp cooking/eating contest is held the weekend after Memorial Day. I did see many ra
on the trail. Picked three for dinner.

Day 43: 500 miles, wild ponies and Sunshine!
Monday, May 06, 2019

Destination: *Hurricane mountain shelter* ~ **Today's Miles:** *16.0*
Start Location: *Thomas Knob shelter* ~ **Trip Miles:** *515.5*

was the right decision to stay in Thomas Knob shelter last night. By 7:00pm, the
d was howling and the rain slapped against the shelter vigorously. The roof shook
heavy wind again and again. It lasted almost to dawn. Even when daylight came,
vas so cold.

kily, the wild ponies also came to the shelter. They licked everything that was
able. From hikers' boots to our backpacks - anything that possibly had salt. When I
k a video of a pony mom and baby, another pony started to lick my pants!

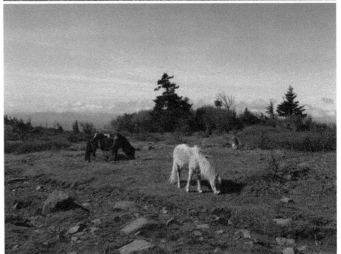

sun was bright today. Shortly after a mile and some change, I came to a junction
h trail signs and big boulders. In front of the boulders, stone-marked 500 indicated
500th mile from Springer Mountain! Yes - today I reached the 500-mile milestone!
the rest of the day that I hiked continuously through the Rogers Mountain
derness and Greyson Highlands State Park, I saw more ponies out to enjoy the sun
tasty green grasses.

&T cellphone signal is almost nonexistent in the Virginia mountains. I didn't have any
nection yesterday. In early morning, not far from the shelter, I got a tiny signal.
ore I could finish one sentence with my sister asking about my father's health, the
nection was lost. Throughout the day, I checked on every hill and ridge without
k. I was only able to get connection by late afternoon, at 6:00pm, on the final ridge
ore where I camped for the night. All hikers that have AT&T service have complained
ut it. I may have to rely more on my InReach.

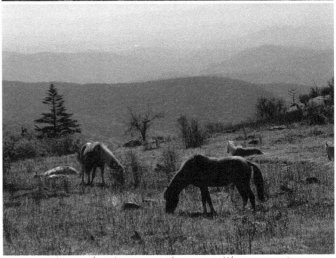

John Muir: The mountains are calling, I must go ...

Day 44: Partnership shelter
Tuesday, May 07, 2019
Destination: *Partnership shelter* ~ **Today's Miles:** *19.0*
Start Location: *Hurricane mountain shelter* ~ **Trip Miles:** *534.5*

Everyone planed to get to Partnership Shelter tonight, over 19 miles away. The big reason? Some restaurants in a town about 6 miles from the shelter do f delivery! I was also aiming for the same shelter, but only for the mileage, not the town's food. It was a long way, but for my seasoned legs and mellow tr it was not that hard. I took many rest stops and still managed to finish the hike in under 11 hours. There was, however, a minor problem. With wet socks boots yesterday, I had a couple of hot spots on my feet. So, it was not a painless day. One of my trekking poles also broke yesterday. So today, I hiked v one pole and one stick. Kind of funny.

Along the trail, I passed a pretty little waterfall - Comers Creek Falls. Next to the Falls, there was a bridge with a note posted by US forest services, stat that the bridge was unsafe. "Hikers should either ford the creek or walk around using another trail", which adds about 1.3 miles. I looked at the fast mov boulder-filled creek, and looked at the bridge carefully. I decided using the bridge is the safest option! So I crossed the bridge slowly and enjoyed the waterf from the safe end.

In the afternoon, when I was tired and slowed my pace, I noticed lots of cool patterns with different leaves, made from so many shades of green in the fo I felt as though I was set free in this world.

Partnership Shelter is the most beautiful one so far I have seen on Appalachian Trail. It was assembled from a log house, with two level floors for lodging a big picnic table on the front porch. The privy is also the best one, similar to those you'd see on roadside trailhead restrooms rather than the basic plyw constructions near other Appalachian Trail shelters. This shelter was next to the Rogers Mountains Recreation Area Visitor Center, and its big parking lot. Th why it was so nice and could receive food deliveries! Hikers tonight ordered larger pizza, huge calzones, foot long sandwiches, burgers, and large fries. I th everyone was over eating. One hiker had a huge bottle of Mountain Dew, certainly at least 1.5 liters in size - and he finished the whole bottle! I wonder if can sleep tonight.

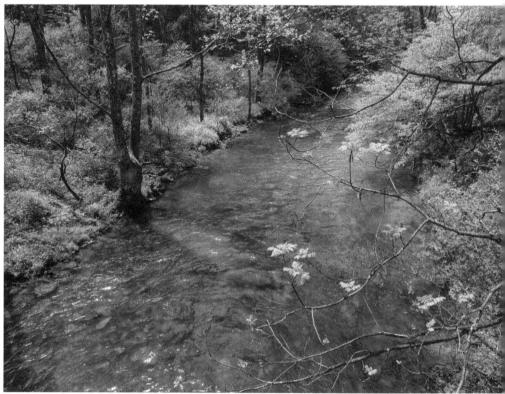

Day 45: Amazing Virginia
Wednesday, May 08, 2019
Destination: *Relax Inn near Hwy 81* ~ **Today's Miles:** *11.6*
Start Location: *Partnership shelter* ~ **Trip Miles:** *546.1*

inia has continuously amazed me. Every day there
new discoveries. Today, I saw many lily-of-the-
ys, producing flowering strings. Later, on the trail
roaching Glade Mountain, along the A.T. Line, was
area of controlled burns. While I was climbing, the
on my left sported spring green plants, while on
right was blackened soil with nothing but burnt
s. I smelled ash all the way to the top of the
ntain. The birds stayed on the green side; the
k side was completely quiet.

步穿行格菜山，半山翠绿半山焦。
边鸟儿吱啾唱，半边黑土静悄悄。

By noon, someone told me there was trail magic in the historical one-room schoolhouse next to the Settler's Museum. When I got there, I discovered four large wooden trunks of goods. There were two coolers full of chilled soda, one trunk of snacks and fresh fruits, and one trunk of supplies including medicine, sanitary items, sewing kits, and more - all provided by a local church. Thanks for the thoughtful trail magic!

At the end of my hike, in the afternoon before reaching highway 81, there was a swampy area with a boardwalk. The plants in the swamp were all huge, about twenty times of the size of the same plants I saw on the hills. As I was studying the plants, a large rock caught my eye. And then I noticed the rock was studying me! It was actually a big old turtle! Its small eyes opened to stared back at me. I was amazed by the size of this turtle. Just its shell was the length of my lower arm.

Tonight, I checked into a small motel, and kept thinking about that big turtle. Could it be over 100 years old? Was he already in this world when that one-room schoolhouse was built in 1894? It's very possible! All I can say is, "Wow".

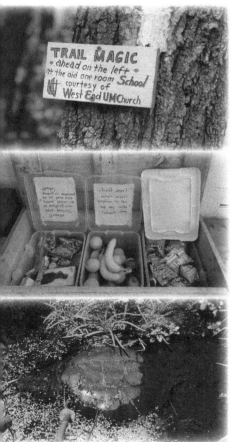

John Muir: The mountains are calling, I must go ...

Day46: Little Brushy Mountain
Thursday, May 09, 2019
Destination: *Lynn camp creek* ~ **Today's Miles:** *15.8*
Start Location: *Relax Inn near Hwy 81* ~ **Trip Miles:** *561.9*

As soon as I crossed the highway and got on the trail, a rabbit hopped about twenty feet ahead of me. I smiled - turtle yesterday, rabbit today!

While I was climbing up Little Brushy Mountain, before I was able to catch my breath, two sticks, standing upright, caught my eyes.. Next to them, stones mark 1/4 in a square of wood sticks. After a couple of seconds of staring blankly at them, I realized this marker meant that I have finished a quarter of the to distance of Appalachian Trail! Great! Now I only have 75% to go.

From there, I was walking through a tunnel of rhododendrons for miles. The trees were covered with buds and blossoms. The buds were a deep magenta, and energetic. They looked as though they could burst with high energy at any given moment. The blossoms are light pink, partially transparent, so delicate they look like made of very thin glass. With just a little touch, they might shatter. As I walked through this tunnel, my camera clicked constantly. Finally, I for myself onward, for I still needed to cover about 16 miles today. This little mountain behaved as the most responsible child of Mother Nature. When mom s "Wake up, kids. It's time for school play." This one would be the first to respond "Yes, mom." And he would be the first one to get out of bed, finish break and get ready for the show in school. His show would be always the best of the class. He might be mom's favorite, but not so among his siblings. Maybe th why he got a not-so-respectful name: "Little Brushy".

Many miles of today's trail went through the easement of private properties. It passed ranches with black cows in grassy meadows. I like the way that the cows American don't wear bells. The cows in Europe did (I saw them in the Alps last year). It's more peaceful for both the hikers and the cows. Passing through priv properties also meant that hikers had to climb many ladders over their wired fences. At first, I climbed the ladders with my backpack on. It was hard to maint balance on top of the ladder, when I had to turn 180 degrees to cross the wire. On later vaults, I took the backpack off, pushed it and my hiking poles to other side below the wire, carefully making sure the wire didn't tear my backpack. Then I climbed over the ladders. I wish there was an easier way to do t

In the evening a hiker walked into the camping area and told me he just saw a bear cub only about 300ft from here. We better to make sure to hang food bags properly tonight. I saw a huge black rat snake today as long as 3 feet, crossing the trail between patches of tall grass. I also saw many dragonf out in the meadows. I have not seen any bear so far.

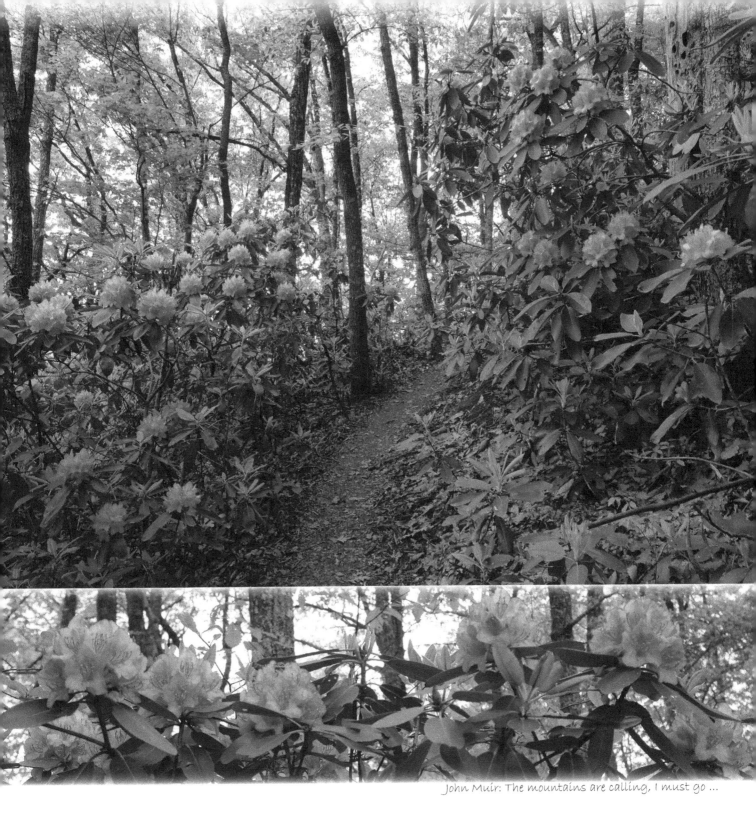

John Muir: The mountains are calling, I must go ...

Day47: 19 miles rolling
Friday, May 10, 2019
Destination: *Jenkins Shelter* ~ **Today's Miles:** *19.0*
Start Location: *Lynn camp creek* ~ **Trip Miles:** *580.9*

No bear came to visit us last night. I had a peaceful rest of nearly nine hours. I had almost the same dream for the last 3 nights: about the same food, my favorite dessert. The dish is made up of four layers of sweet rice cake, layered with sugared paste of four flavors: black sesame powder, red bean paste, green tea powder, and sweet pea paste. Some also have walnuts and peanuts inside. They were soft, cool, sweet and chewy. Similar to Japanese mochi, but with layered sweets instead of a singular filling. People say hiker's hunger would come to all thru-hikers. I might have just gotten it. I have seen other hikers, especially young ones, eating a lot of food, both on trail and in restaurants. I still only eat a fraction of their portions. However, I have noticed that I've needed more lunch snacks in the past few days. Before, it was one energy bar, a serving of trail mix, and a couple of pieces of candy. Now I need to add two servings of trail mix, and some more solid stuff for breakfast. Still, in restaurants, I can only finish one cheeseburger with some veggies — forget about fries.

The rain didn't come today even though the report said there was a 30% chance. It was good for the hike. I did nineteen miles today, with lots of climbing, in order to make it to a shelter. Almost 11.5 hours of walk. My knees have completely recovered, and the hot spots on my feet were gone, too. Still, I kept my pace slow to avoid any new injury. And at the end of the day, my muscles were still sore.

Today's first highlight was the view on Chestnut Ridge, with blackened clouds threatening rain. The Chestnut Knob Shelter is a stone building with a single door and bunk beds inside. Could be rated as the best equipped shelter so far I have seen. The second highlight was a patch of lily-of-the-valleys right after the rocky cropping on the Knob. They were in full bloom. Each string of flower looked like a string of pearls, with a very nice sweet smell. The ridge was very rocky and sported great views, but I put most of my attention to my footing and the nearby flowers, so the views didn't leave a clear impression in my mind.

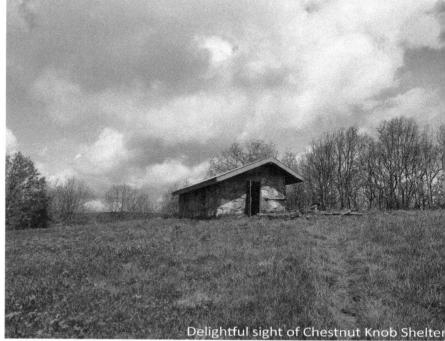

Delightful sight of Chestnut Knob Shelter

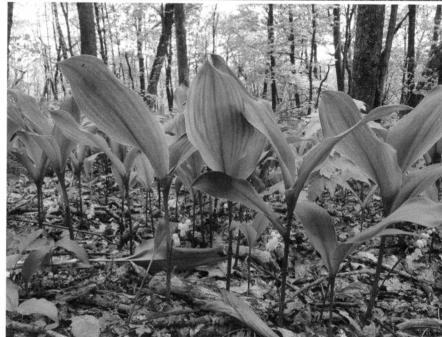

Day48: Walking in the rain
Saturday, May 11, 2019
Destination: *Helveys Mill Shelter* ~ **Today's Miles:** *13.5*
Start Location: *Jenkins Shelter* ~ **Trip Miles:** *594.4*

ead of my original plan to resupply in Bland, Virginia, I continued to the next shelter. I still have ugh food for 3 more days, just one day shy to reach next resupply town. Plus, there will be two tels on the way. Hopefully, I will save one day's worth of time and food as I find a ride into town. n 8:30am, it rained for the rest of the day. Suffered some wet boots and socks, but dryish shirt and ts from knee up. The forest in the rain was very fresh and clean looking. Underneath a foot bridge, rel Creek was happily jumping between multiple steps of flat rock beds down its course, making ll cascades along the way. Orange flowering trees - which I learned was fire azalea - showed off ly in darkened forest. When I reached VA Road 52, out of the forest, I saw white steam rising and cing all over the mountains. The green hills looked just like a landscape in a dream. As I stood, ring smells of meat led me into a little mountain outpost store. I had a cheese burger with Texas st. Totally satisfied my hunger.

trail today, I almost stepped on a cute little salamander. I moved it to the side of the trail to prevent er hikers accidentally stepping on it later. The little cute salamander had orange colored skin with en shining circles on its back. Back in California, people say salamander (newt) can represent the rall health of the environment they live in. So, I hope I will see more salamanders in the coming days. regards to Appalachian Trail thru-hikers, most of them are responsible and decent people. Many are -educated and care a lot of the environment. But in the past a few days, I met two young men that t talking about the drugs they have taken, and bragging about how they cheated and stole goods n their previous employers. I felt so sorry for them and their family. How can someone so stupid do all these things! I hope they hike faster so that I'm not in the same shelter with them again.

John Muir: The mountains are calling, I must go ...

Day 49: Happy Mother's Day
Sunday, May 12, 2019
Destination: *Trent's Grocery ~ Today's Miles: 15.2*
Start Location: *Helveys Mill Shelter ~ Trip Miles: 609.6*

A narrow path far and long,
It's curvy, winding, up and down.
I walk on the little path,
Following the northern stars.

How many more days will you walk in the rain?
How many more times will you find the path under snow?
I really have no way to know,
Just walk on the path,
Following the northern stars.

How many more days will you go?
How many more months will you endure?
I really have no way to know.
Just walk on the path,
Following the northern stars.

Till the day I see Katahdin Mountain,
Till the day a path no more.
It'll be the date my dream comes true,
Walking on the little path,
Following the northern stars.

一条小路长又长，
蜿蜒曲折，上上下下，它通向远方。
我就沿着这条小路，朝着北方的星星。

还有多少天你要在雨里行走？
还有多少天你会在雪中寻径？
我实在不知道那确切的数字，
就沿着这条小路，朝着北方的星星。

还有多少天你才会走完？
还有几个月你仍会受苦？
我实在不知道那确切的数字，
就沿着这条小路，朝着北方的星星。

直到有一天我看到卡塔丁山峰，
直到有一天小路消失不见，
我才能知道那一天我梦想成真，
沿着这条弯曲的小路，朝着北方的星星。

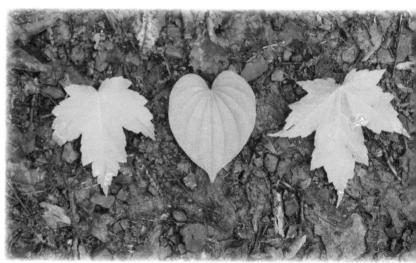

I left the shelter in the rain. Wet socks and boots don't bother me anymore. The rain-wash forest was refreshing in both look and smell. Over the day, it rained, then it shined, th rained, then shined, then rained again. The rain kept the air cool and the bugs at bay, wh added comfort to the hike. In the late morning, I passed the 600 miles marker, made sticks, a half mile from road VA611.

After I crossed that road, a familiar figure came from the opposite direction. It was "Lucky", a trail friend whom I haven't seen since the day I left Hot Springs. He was hik at about same pace as mine before. So we had seen each other for many days and acquainted. But since Hot Springs, he had been on different schedule, meeting other peo off trail. I was glad to see him again.

In fact I didn't see any other NoBo thru-hiker today in the 17 miles I hiked; only Mo, wh walking to south, one day hiker, and another slackpacking NoBo at the end of day. So, I h the whole forest to myself. To celebrate Mother's Day, I made a greeting out of two ma leaves and another leaf in the form of a heart. It spelled M❤M.

I passed long sections of the trail full of sassafras. Have you smelled their broken leav They were so sweet that I felt I was smelling flavored honey. The shape of their lea looks like cartoon drawing of a dinosaur's footprint. The roots of this plant are used making root beer. I also saw the orange newts that I wished for yesterday. When the r got heavier, the newts tried very hard to walk (or run?) for cover. It's hard not to laugh them when they "run" really hard but can't build up any speed! A big, drab green toad a jumped out from under a bush near my foot, startling me. Later, a bigger surprised awai me, when a grand land turtle, the size of two hands, stood right in the middle of the tr looking directly at me with its head tilted up, as if to say "who are you? Do you have

permission to pass this trail?" I bent down to talk to it. It didn't bother move even a millimeter. Its shell was very colorful, with bright yellow a orange patterns. I talked to it for a few minutes before moving on, leav the turtle guarding its position.

By 5:00 pm I walked into Trent's Grocery, and booked a room for night. I also got a really tasty strawberry milkshake, the first milksha since I started the hike.

Day 50: Reconnecting
Monday, May 13, 2019
Destination: Woods Hole Hostel ~ **Today's Miles:** 16.2
Start Location: Trent's Grocery ~ **Trip Miles:** 625.8

was very sad that a fatal attack happened on the Appalachian Trail on the Mother's Day in the middle of night. Our hikers had been talking about how gerous that mentally unstable person was, and felt very sad that the police couldn't do anything to prevent this from happening. While the Appalachian Trail tatistically safer, it is still not immune from crimes. Now everyone is thinking how to stay safe.

rain was light today, with only a few drizzles and short showers. The temperature had dropped quite a bit. Even when going 1200ft uphill, I didn't sweat. re was mud everywhere. Some places were so muddy that you would need a gymnast's balancing skill, plus some luck, to get through it while avoiding getting r boots submerged. It was a pretty section: lots of creeks, bridges and a peaceful pond along the trail. Mushrooms were everywhere, some defiantly growing top of very thin branches.

the end of the day, I was glad to be in Woods Hole hostel - one of the best hostels with a legendary history, organic food from its own garden and farm, a meeting spot for many thru-hikers. Some of the hikers here have stayed for multiple days. It was nice to connect with hikers, even though I hadn't met of them before. On their old fashioned scale, I measured myself, 23lbs lighter!

John Muir: The mountains are calling, I must go ...

Day 51: Cold day in the forest
Tuesday, May 14, 2019
Destination: Angels rest hiker's haven ~ **Today's Miles:** 15.0
Start Location: Woods Hole Hostel ~ **Trip Miles:** 640.8

Last night I met many hikers who stayed in Woods Hole Hostel multiple days already. I can see why so many pe do not want to leave there. It was just too cozy. The bed and beddings were soft and comfortable. While I liste to the strong wind wailing outside, the room kept me warm. The dinner and breakfast were very delicious, and m everyone feel like they belonged here.

So I swallowed hard, said goodbye to everyone right after breakfast, walked out of the house, and didn't look b It was cold all day long, either high 40s or low 50s, with wind rustling the trees. I had my fleece jacket on all time. While I walked in the forest, I listened to conversation the wind made among trees and rocks. I felt as if I an intruder in their private world - I didn't dare to interrupt them, and didn't dare to linger long at any locati

I did find interesting patterns in the trees, stones, and plants. A deer also looked at me with alarm. I didn't stop 9 miles, until about 1:00pm, when I reached a view point from where I can see the houses below the mountain. S after, I rested again at the view point for Angels Rest. At that location, the town of Pearisburg, VA was in clear v For the night, I checked into Angels Rest Hiker's Haven with a bunk bed. I bought a new trekking pole and sent broken one back home, just before the post office shut its door.

Day 52: Summer is coming
Wednesday, May 15, 2019
Destination: *Pine swamp shelter* ~ **Today's Miles:** *20.3*
Start Location: *Angels rest hiker's haven* ~ **Trip Miles:** *661.1*

79 years old "Ironman" from England my roommate in Angel's Rest hostel. He was the oldest man that I met on Appalachian Trail.

book says the trail was 20.3 miles today. However, the actual mileage that I walked was 19.3, since Angels Rest er's Haven provided a free shuttle that cut our trail distance by 1 mile. That's ok. I have walked many miles off lachian Trail that have not been accounted for.

ay was one of those perfect hiking days - not too cold, not too hot, a little breezy and low nidity. In little Goldilocks' words: "it was just right." Even with near 3000ft elevation gains, the trail passed othly under my feet. Yes, some sections were rocky, but I just went a little slower on those parts. There was a mile section without water. But since it was cool, I didn't need much water for the whole day.

many miles, the vegetation on both sides of the trail was thigh high. If you were not on the trail ady, it'd be hard to see it. The trail disappeared into a sea of greens through its many curves, but once you were it, it was not hard to follow the brown ribbon naturally. Many wildflowers of pink, white and yellow decorated trail. The fresh undergrowth is turning to more mature green now. I even saw a few wild strawberries hidden heir leaves. Summer is approaching.

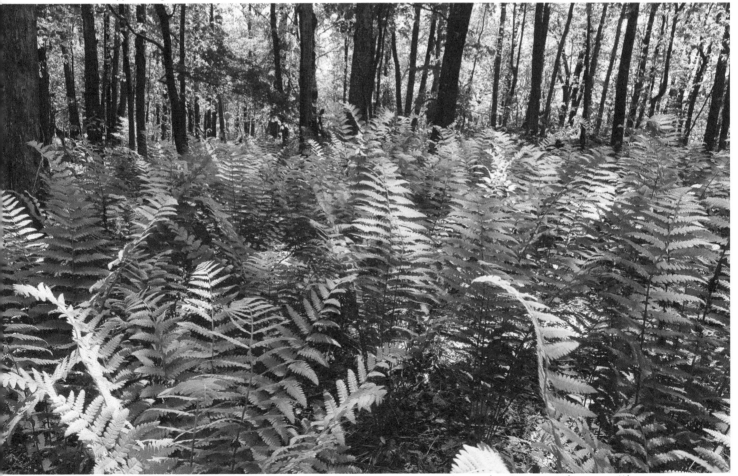

John Muir: The mountains are calling, I must go ...

Day 53: Virginia blue?
Thursday, May 16, 2019
Destination: *Laurel Creek Shelter* ~ **Today's Miles:** *18.5*
Start Location: *Pine swamp shelter* ~ **Trip Miles:** *679.6*

I heard people talked about the "Virginia Blues" on the Appalachian Trail before. Basically, it is a long stretch of the Virginia mountains that are very long (ab 1/4 the length of the whole trail) and similar - you hike up to a Knob, then follow a rocky ridge for some time, then you come down, and repeat again a again. Could it be that I have hit the Virginia Blues today? The rocky section consumed all my strength and ability to concentrate. The going was very s in the morning. So, when trail got flatter, I increased my pace. And before I enjoyed my downhill power walk for long, I tripped on a branch and fell. Near end of day, I slipped and fell again, five minutes before I reached the shelter. Nothing seriously broken, but my chest hurt and I can only take shallow brea Definitely will start taking ibuprofen tonight!

In the midafternoon, I met a few mothers taking their kids for a hike in the woods. That was very cute. At about 5:30pm, I saw a young man running to parked car. Unlike him, I can still hike for more than two hours in the beautiful late evening lights. That's the benefits of backpacking.

Day 54: Sinking Mountain
Friday, May 17, 2019
Destination: *Niday shelter* ~ **Today's Miles:** *12.8*
Start Location: *Laurel Creek Shelter* ~ **Trip Miles:** *692.4*

as so tired I fell asleep three times as I wrote my blog last night.

en I got ready to hike this morning, the lightning and thunder started. The showers followed soon after, with some
nse moments. I waited for about an hour. When it started getting lighter, I walked from inside the shelter into the
. I welcomed the change in the weather. The rain made the forest feel much more alive, with sparkling greens and
h flowers. This rain was the type that makes you smile, not scream.

er about an hour and a half, the rain stopped. At the time, I reached the edge of a grassy hill. The views opened
Green hills floated by on steamy white clouds. Quaint little houses and cows dotted the landscape. The light purple
ss heads, heavy with raindrops and seeds, nodded with the breeze. I stopped long enough to make a time lapse video.
ing a little further, the grasses had reached chest height. Blackberry plants were loaded with white flowers. I could
ell the summer.

trail today also passed the largest oak tree in southern Appalachian Trail - the Keffer Oak. I was glad that "Budhi"
"Whitey" also reached there at about same time, so that we were able to take pictures for each other. I met them
k at Woods Hole Hostel, and we kept about the same schedule ever since.

k in the forest and climbing up Sinking Mountain, the trail got even more interesting. There were many rock cairns along the trail, for almost a mile-long
tch. They looked like fallen graves from a bygone age - only a couple are still in good shape. In the silence of the forest, looking at them half-buried in the
ss, I was hoping someone could tell me the story of each one of them. Then, on the northern section of the mountain crest, the trail snaked alongside slanted
ks. I guess that's how this mountain got the name as Sinking Mountain; on the left side of the trail, a rocky cliff drops a few dozen feet straight down. On the
t side, rocks slid down into the void of the valley far below, with only a few short bushes decorating the area below the rocks. I was glad that I passed this
untain when it was not raining. This felt like the trail in Castle Rock State Park back at home - the rocky part that passes below Goat Rock. The difference
hat this one is about 3.5 miles long compared to the half mile section in Castle Rock.

alked less than 13 miles today, but it still took me about 9 hours.

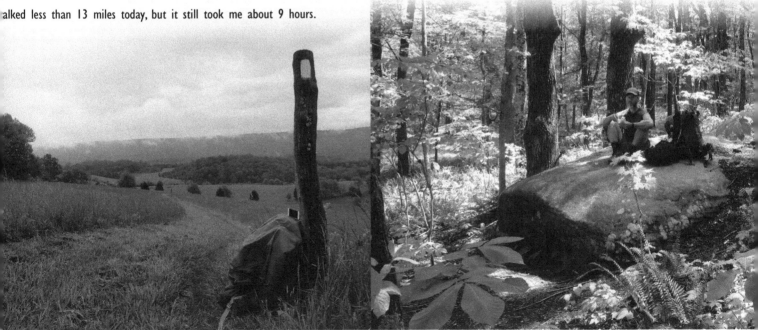

John Muir: The mountains are calling, I must go ...

Day 55: Dragon's Tooth
Saturday, May 18, 2019
Destination: *4Pines Hostel* ~ **Today's Miles:** *16.8*
Start Location: *Niday shelter* ~ **Trip Miles:** *709.2*

Virginia mountains are so much fun - and sometimes can be quite challenging! I started the day following an easy trail, at a good pace of 1.8 miles per hour. I was planning to reach 4 Pines Hostel by 5 pm, for a 17.2 miles hike. In less than three hours, I climbed up the first big uphill section of Brushy Mountain. Just before the intersection at the top, someone stacked many big bottles of Gatorade. Just what I needed! I took one bottle, and quickly finished the first ten miles by 1pm. Soon after, I hit the 700 mile marker. Yes, today, I completed 700 miles on the Appalachian Trail!

Things got tougher from there. On the trail, there is a place called Dragon's Tooth. To reach the Tooth, I needed to walk along the "dragon's" back first, then walk down from its front. This dragon was a wild one. If you have seen frills on a dragon's back, you will know why it is hard. It's just up and down, up and down for three rocky miles. Many times, I could not see where the trail went due to how steep the ridges were. When I finally reached the Tooth, it was almost 5pm. The Tooth is a fantastic rock formation, really sharp, pointing towards the sky. Totally worth the effort to get there. It's also a popular day hiking spot. Since it's a Saturday, many young people were doing day hikes there.

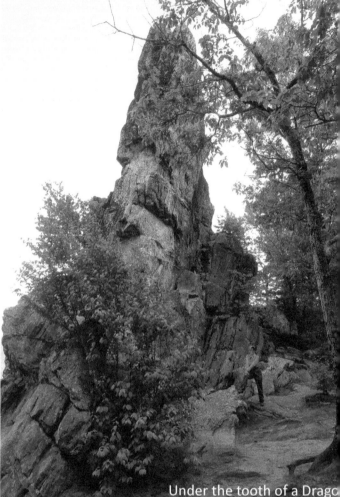

Under the tooth of a Drago

It was only 2.5 miles from the Tooth to the end of my planned hike for today. However, the one mile down from the Tooth was the hardest mile on the Appalachian Trail so far. Many big rocks, some with bolted handholds as steps— and some without. I descended the trail using every method of locomotion I could — on all fours, on my butt, with trekking poles, without trekking poles (and throwing them down to the ridge below) - whatever felt safe! So these four miles up and down the Tooth cost me 4.5 hours. I was so grateful that it was not raining when I was going through there. The forest provided much needed shade on this very warm day. When I finally reached the hostel, it was about 7pm. It was nice that they ran shuttles for dinner and resupplying at the market. I was well fed in Home Place Restaurant, a local place famous for home style southern cuisine with fried chicken, roasted beef, ham and 5 other side dishes and a desert. Tasty meal!

Today the mountain laurels were in full bloom. Many blueberries had formed nice and dense on low bushes. Some rhododendrons were already near the end of their blooming season. Bye-bye, Spring.

John Muir: The mountains are calling, I must go ...

Day 56: McAfee Knob
Sunday, May 19, 2019
Destination: Lamberts Meadow shelter ~ **Today's Miles:** 16.3
Start Location: 4Pines Hostel ~ **Trip Miles:** 725.5

I left 4 Pines Hostel early morning after a night of not-so-good sleep, due to a couple of noisy fans that stayed on all night. The country was peaceful and qu
I passed pastures where grass was chest high. The heads of grass drooped heavily with the weight of morning dew. As I pushed them apart with my trekk
pole, a misty mixture of water, pollen and grass seeds burst into the air. It looked really cool. Very soon, my pants were soaked in that mist, leaving me as
as going through a rainstorm without rain gear. There were also many wild rose bushes with white flowers. A few daisies bloomed big. Spiders had been v
busy in these pastures. Many dry twigs held well-constructed webs, all glistening with dew. Against sunlight, they looked like sails. Hundreds of sailboats in the
of grasses, ready to attack and conquer any enemy's army. When I passed the narrow walkway between the grasses, I had to push many webs away, frequen
cleaning web threads from my face. I felt sorry that I had to destroy the spiders' hard work.

It was a very warm day; but the trail going to McAfee Knob was very easy compared to yesterday's trail through Dragon's Tooth. Being a Sunday, I shared ab
four miles of the trail with many day hikers. One pair — a couple who were planning for a thru-hike in next year — chatted with me for some time. They j
came back from Trail Day, and started to prepare for their trip. It felt great to share some of my experiences with people who had similar interests.
McAfee Knob could be possibly the second most-featured image on the Appalachian Trail (the most featured might be the Northern Terminus sign at Katah
Mountain). The huge rock was bigger than I expected. It was so picture perfect! It felt great to stand on it, after more than 713 miles to get here. I sp
almost one hour at this place.

In late afternoon I came to Tinker Mountain Cliffs. Another great phenomenon on the Appalachian Trail. About 0.4 mile of the trail hugged the cliff. Sometimes
was so close to the edge that even I, as a cliff lover, wanted to get away from the trail to hug the trees on the other side. At about 6pm, the low light ma
the scenery look even lovelier. It was very windy. The tree branches near the cliffs swung to and fro swiftly. Making loud "shua, shua" sounds, as if telling a st
of their own. Against sunlight, the ridges across the green valley looked like a long wall guarding a great treasure site. A hiker, sitting on top of a large rock
the cliffs with his girlfriend, told me that hills form the Tinker Loop, which can be backpacked in a few days.
Just below the Tinker Mountain, I encountered two bear cubs and a mama bear. My first bear sighting on the Appalachian Trail. The cubs w
scrambling down two trees when they heard me approach. The mom stayed close to the cubs, and within a minute, all three disappeared.

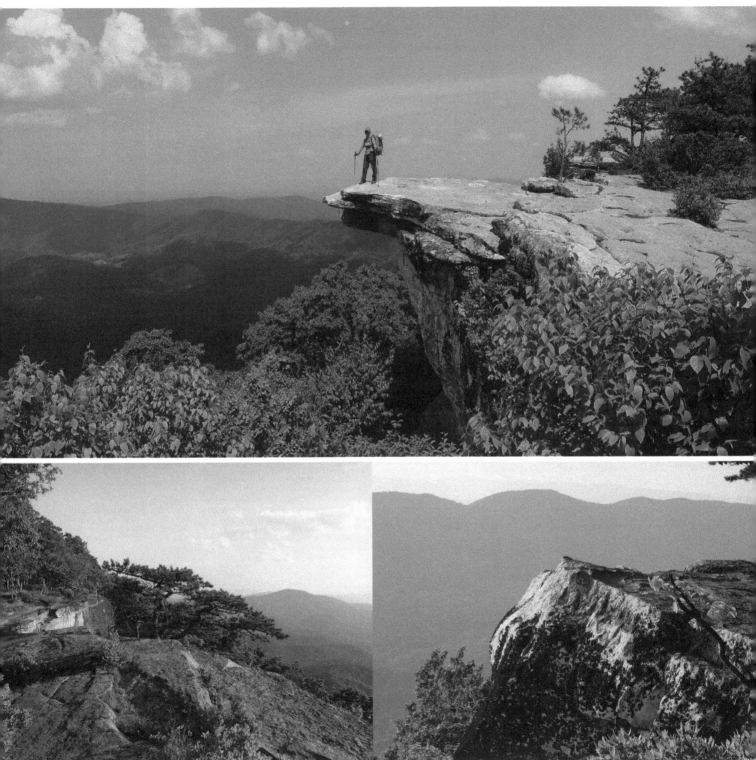

John Muir: The mountains are calling, I must go ...

Day 57: Rest in town
Monday, May 20, 2019
Destination: *Super 8 hotel* ~ **Today's Miles:** *9.4*
Start Location: *Lamberts Meadow shelter* ~ **Trip Miles:** *734.9*

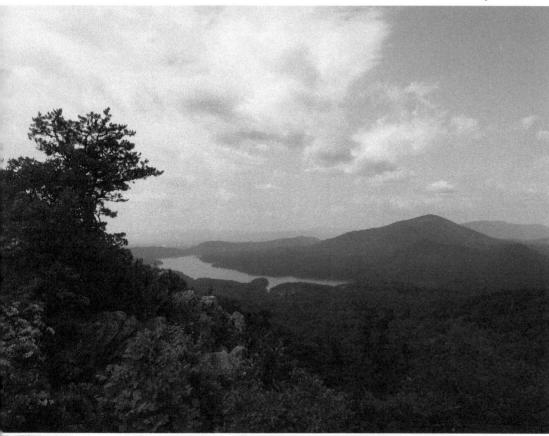

My original plan was to do a 20 m hike plus a resupply stop near noon, w crossing Road 220. However I must h overspent my energy yesterday; I felt it unrealistic to complete these in just one It was true. My energy level was low hiking pace has been slowed noticeably the past four days. So, I only reached road after 2pm with less than 10 m done. I decided to rest for the half day checked into a hotel. Looking at the n nine days' schedules, I will adjust it to ma my slower pace. Also, the weather rep showed temperature above 90s in next w It will be harder to move quickly.

Today's best views were on the ridges. was overlooking Carvin's Cove reservoir another one was overlooking the valley town below the ridge. Even though th were not hard climbs, it was still rocky many points on the ridge. I have lear that a flat profile can be deceiving. When flat and rocky, the going can be very slo

Day 58: Blue Ridge Parkway
Tuesday, May 21, 2019
Destination: *Babblet Gap Shelter* ~ **Today's Miles:** *18.5*
Start Location: *Super 8 hotel* ~ **Trip Miles:** *753.4*

eville is quite convenient. I called an Uber in the early morning and went
ctly to the Appalachian Trail trailhead on US 11, skipping about 1.5 miles
he trail where it hugged the highway. The forest gives me a quieter stroll.

noon, I stopped at Curry Creek for lunch. A big black butterfly landed on my
kpack, thoroughly checking around the zipper on the top pocket, as if trying
ind out whether the zipper is a good place for her to lay her eggs. It stayed
a long time, enough for me to take a time lapse video.

ttle after 6pm, I arrived at Babblet's Gap Shelter. Max, was thru-hiking and
ling work along the trail, built fire rings here for the whole week. The new
ring was beautiful. And he sang beautiful songs while playing guitar. A perfect,
ceful night before going to sleep.

so got cell phone signal at this shelter! Quite uncommon!

John Muir: The mountains are calling, I must go ...

Day 59: Real Heroes
Wednesday, May 22, 2019
Destination: *Foot of Floyd Mountain* ~ **Today's Miles:** *17.0*
Start Location: *Babblet Gap Shelter* ~ **Trip Miles:** *770.4*

Max was in the business of building fireplaces. He sold his business and came on Appalachian Trail. While he's on the trail, he doesn't just hiking it. He stayed in various shelters and built beautiful fire rings, voluntarily! I met him yesterday at Bobblets Gap shelter. The stone work that he did for the fire ring and channel for the spring looked like pieces of art. His 5 days of effort. He also played guitar and sang with a wonderful voice. He will continue go on to other shelters and build fire rings for them.

Natural Bridge Appalachian Trail Club maintains about 90 miles of the trail in this section. I met two volunteers fixing water bars on the trail. They also cut off the downed trees that were blocking the trail.

Max and all the volunteers who help to make Appalachian Trail better are the real heroes here! I cannot thank them enough for their contribution that allowed me to have great experience on the trail.

When I got to Jennings Creek, the shallow water looked so inviting with stones I can sit on. I enjoyed watching people fly fishing in the wide creek and soaked my feet to cool me down.

I have marched on tirelessly today for 16.5 miles. The plan was to do 13.5 and stay in Bryant Ridge shelter. But I got there at 4:30pm, still 4 hours before sunset. And the privy was swarmed with yellow jackets. So I lost my desire to stay and pushed 3 more miles, +1700ft to a small gap before Floyd Mountain to camp there. Tomorrow I will have less climbs to do!

A few weeks ago, I saw some plants looked and smelled like sweet corn. Now this plant is blooming with purple and hot pink flowers. I still don't know its name. But they are pretty.

Day 60: 60 days on Trail
Thursday, May 23, 2019
Destination: *Marble Spring campsite* ~ **Today's Miles:** *14.5*
Start Location: *Foot of Floyd Mountain* ~ **Trip Miles:** *784.9*

I've lived on the Appalachian Trail for two months now. The trail has not tired me. Even though the excitement from observing the wonders of spring has subsided, the summer growth has just begun. Many plants I saw newly emerging during spring are now bearing young fruit. Many tender shoots that sprouted a month ago have now formed beautiful flowers. Blueberries, strawberries, mulberries, even wild grapes ripened nicely already. Today I also saw a few patches of tiny little purple flowers that formed a cluster, and surrounded by spiky hairs. They looked ugly and forbidden to touch. But beauty is in the eye of the beholder. Maybe it was very attractive to some specific creatures. Nature always assigns a purpose to everything.

In the past a few days, many rhododendrons have passed their peak blooming time. A lot of petals dropped to the ground, making the trail colorful - and a little sad. But today, in James River Face Wilderness, there were still good amount of rhododendron trees at their peak.

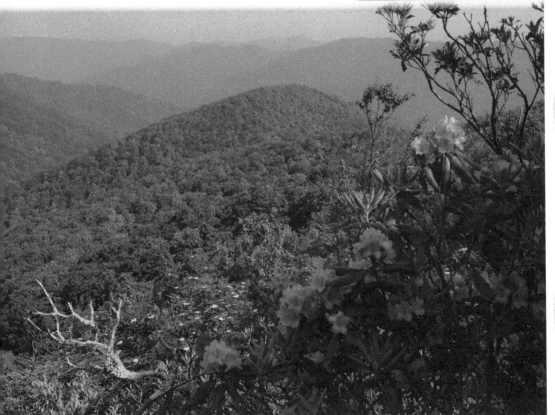

John Muir: The mountains are calling, I must go ...

Day 61: James River

Friday, May 24, 2019
Destination: *Punch bowl shelter* ~ **Today's Miles:** *18.4*
Start Location: *Marble Spring campsite* ~ **Trip Miles:** *803.3*

I passed many bridges today. The most impressive one was James River Foot Bridge, built in the year 2000 in memory of Bill Foot, an Appalachian Trail th
hiker in 1987. With his wife, they lobbied tirelessly to have this bridge built. The longest foot bridge on Appalachian Trail, a very sturdy steel, cement and w
construction for all hikers easily and safely across the wide James River. Next to it is a railroad bridge. I watched a long freight train crossing that bridge fr
the trail. It took almost a half hour to cross!

Having big climbs on a hot day is tough. Having 90% of the big climbs in the afternoon in a hot day is even tougher. That was what I had for today. I
miles to a shelter, with over 3500ft of elevation gain in the last nine miles. The shelter's name is Punchbowl. I really felt punches in my stomach as I walked
the steep hills in the hot humid afternoon. Thankfully, the trail was mostly under shade, and there was a slight breeze on the ridges.

I saw two snakes today. The first was a big black snake that just crossed trail, the tip of its tail still brushing the trail. The second was in a creek next t
shelter I passed in late morning. It swam against the current trying to go upstream. The water was a little stronger than it could handle, so the snake w
washed down multiple times. Eventually it managed to climb the rocks on the side of the creek, and managed to get upstream as it wanted to. Near the end
the day, a rabbit jumped across the trail. When it noticed I was coming, it hurried into the bushes next to the trail and stayed there, frozen. Even when I t
its picture, and walked by where it stood, frozen in place, it would still not move. Fortunately for it, I was not in the mood to eat rabbit tonight!

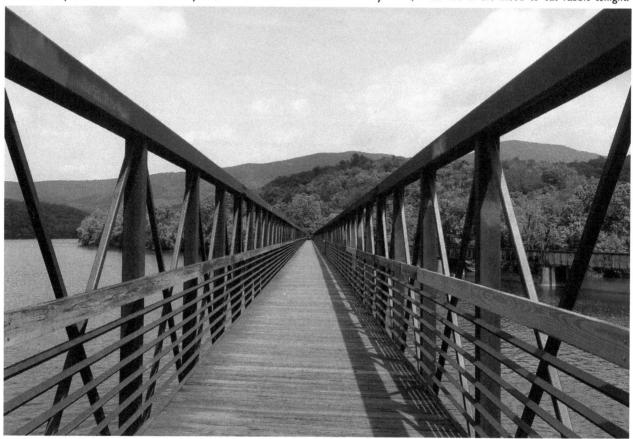

guide book says Punch Bowl Shelter is haunted by Little Ottie's ghost - a little boy less than 5 years old who disappeared and died in this mountain in 1 when he was gathering firewood for his school house. I am not sure about ghosts, but it was a heaven for wildlife. Due to the nearby pond, last night, eard a concert of birds, bull frogs, and many creatures that I just didn't know. The concert of birds went well beyond sunset for another one or two hours. r midnight, I heard loud voices of two creatures: "Ho Hoo Ha, Ho Hoo Ha..." for a good 20 minutes. It sounded like very big creatures - bigfoot?

ew nights ago in another shelter, we had birds chirping to each other in the darkness for about two hours. "Whitey" deciphered their words as coming from birds. One was shouting: "Great Fire!" The other was asking: "Where?" Over and over again. At the next shelter, there was a bird that woke up one hour ore sunrise, and started talking. I heard it saying: "I'm sorry!" in an apologetic voice again and again. Last night, I could hardly decipher what the birds were ing, with so many of them talking at the same time. The low vibrating call of bull frogs added a harmony to the chirping symphony.

en the trail crossed creeks, honeysuckles were always nearby. Their sweet fragrance filled the air, making it creamy and dreamy. The white and yellow flowers ve been used in Chinese medicine for soothing throats. I love the smell of them.

aking of creeks, there were quite a few today. Brown Mountain Creek was especially nice. Rocks formed many steps along the creek, creating cascades and ping pools. Hikers soaked their tried feet in the cool water so they didn't get overheated in the heat.

id a short eleven miles day to get resupplies from town, and to save the big climb for next morning. The afternoon shower was too short. It didn't cool down temperature at all, only adding more humidity to the air.

en though this section of the trail is said to follow Blue Ridge Parkway, we could hardly see the parkway except only a small part of it in the first day. For the e I've been on this trail, I feel like I've been in the middle of a large forest. The Blue Ridge Parkway was out of sight and out of mind for the last two days.

John Muir: The mountains are calling, I must go ...

Day 63: A relaxed day
Sunday, May 26, 2019
Destination: Seeley-Woodworth shelter ~ **Today's Miles:** 14.0
Start Location: Buena Vista Motel ~ **Trip Miles:** 828.6

It turns out Buena Vista Motel was not a good choice for me last night. They didn't have laundry services, so I had to do my laundry 1.5 miles away. One th
I liked in this small town of the same name was an ice cream shop where they hand-made rolled ice creams in many flavors. It was so much fun to see liq
cream turned into ice cream, then rolled up for each customer's order.

Due to the long weekend, there were many short distance backpackers on the trail. One of them gave me a candy sucker that I gave to another hiker. On
trail on a warm day, the food I was craving most was watermelon. But only real supermarkets have that. I'll have to wait until a supermarket is easy to rea

Overall this was a relaxing day. I got to my destination before 5:00pm and got to rest after 7.

Rock and a lone tree on Cole Mountain

Day 64: Big down and big up
Monday, May 27, 2019
Destination: *1 mile after Chimney Rock* ~ **Today's Miles:** *17.0*
Start Location: *Seeley-Woodworth shelter* ~ **Trip Miles:** *845.6*

...ing makes me feel better than a good night of sleep. It rained through the night but cleared in the morning. By then, the air was very fresh, full of moisture ...oxygen. I slept nicely from 9:00pm to 6:00am. Sleeping in my tent in the forest feels much better than inside a hotel!

...ughout the morning, I was happy and energetic on trail, singing silly songs when the trail was not steep or rocky. This easygoing pace lasted for about 4 ...rs. One of the nicer places I passed this morning was near Spy Rock. There were many blooming rhododendrons in the area, along with nice grassy campsites. ...top of Spy Rock, there were nice views and cool winds!

...r lunch the trail went straight down, descending 3200ft for about 4 miles. This slowed me down. But when it bottomed at Tye River, I came across a nice ...ing place with many rocks near the banks of the river. I cooled my hot feet in the water. There were many tiny fish there. Nothing bothered them. I observed ...r hikers swimming in the river. Later, they said it was the best feeling they've had in a long time.

...r the cool down, it's more steep climbing for another 3100ft. After dinner at the Harper Creek shelter, I continued to hike until sunset. From the shelter, to ...nney Rock, and half way to the top of Three Ridges, the trail stayed rocky and I could not find a suitable campsite for over three miles. Finally, I reached a ...e I could squeeze in a tent. Just in time to watch the sunset! Sweet dreams.

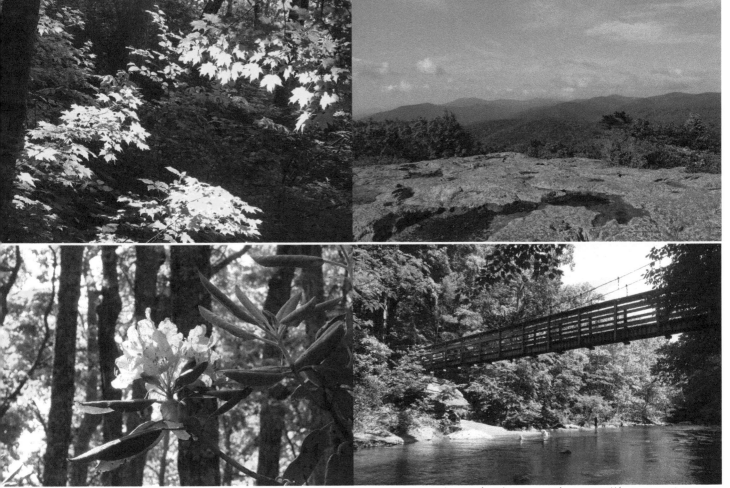

John Muir: The mountains are calling, I must go ...

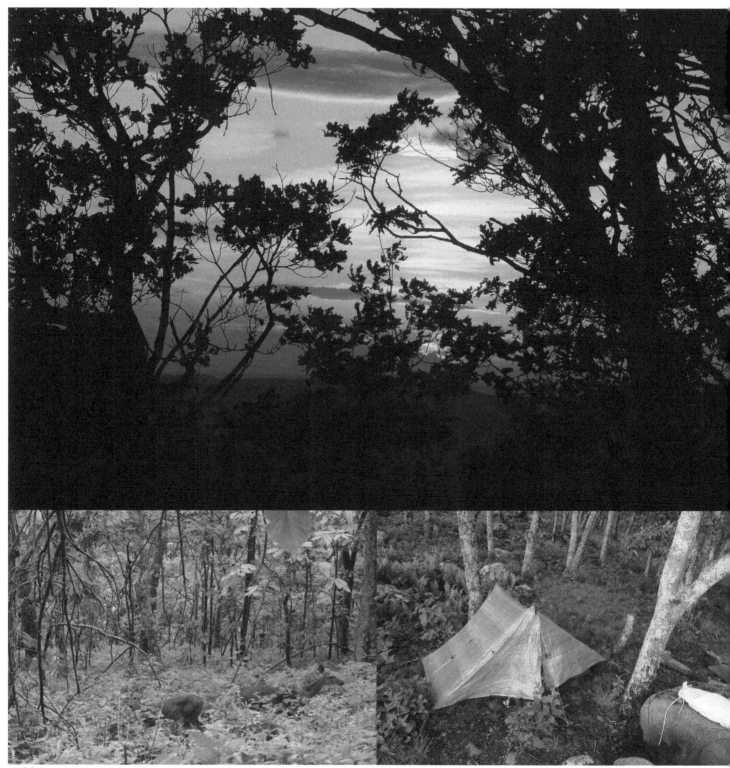

Day 65: Easy but not a short day
Tuesday, May 28, 2019
Destination: Camping spot just passed Bear Spring ~ **Today's Miles:** 15.0
Start Location: 1 mile after Chimney Rock ~ **Trip Miles:** 860.6

...st of the major climbing was done last evening, so I had an easy start today. Only a half-mile to the highest point of Three Ridges. In the forest, the most ...mmon sound are the conversations of birds. One bird kept saying "children, here." After a while, another bird impatiently disrupted the motherly call with "Zhi ..., Zhi Dao!" (知道 , 知道 Chinese for I know, I know)

...uickly reached Hanging Rock. It was so nice up there at the top of the big rock; I saw a sublime view of the lowland, flanked by the mountains I had walked ...ough in the past two days. The breeze was strong there, making it more enjoyable in the morning cool air. There was also good cellphone signal, so I uploaded ...tos and edited my trail journal, staying there for almost an hour. When I expect a shorter and easier day, I always end up taking too much time on breaks. ... a result, I have not been able to reach my destination before 6pm on almost any of those "easier" days!

... lunch, I reached Maupin Field shelter. Yes, four miles took me four hours. That's how slow I moved this morning. It was the first shelter I saw that had a bear ...e. The spring didn't have water from a pipe. So, figuring that I was going to need to filter the water anyway, I gathered water from the stream next to it. ...the afternoon, the trail joined Blue Ridge Parkway twice, and was very rocky in between. The best areas today were Cedar Cliffs and Humpback Mountain ...fs. They provided views and cool breezes.

...lso met another big black rat snake today, in the middle of the trail. This snake had its head deep inside a big hole in the ground. The rest of its body ...upied almost 2 feet of the trail. This time, I didn't bother it. Since it was busy working on its meal, I ran quickly around it. Phew!

...er crossing Humpback Mountain, I started to look for a campsite. Only after 7:00pm, almost three hours, did I find one. The next shelter was too far, so I ... happy that I could rest for the day!

John Muir: The mountains are calling, I must go ...

Beautiful Mill Creek

Day 66: Mill Creek
Wednesday, May 29, 2019
Destination: *Stanimal's Hostel* ~ **Today's Miles:** *9.0*
Start Location: *Camping spot just passed Bear Spring* ~ **Trip Miles:** *869.6*

I was planning on going to Waynesboro today - only nine miles of gentle, rolling trails to the town. I woke up extra early at 5:25am, daybreak. By 7:00 am was ready for the hike.

After a little less than 2 hours, I reached Mill Creek, and Paul Wolfe Shelter next to it. The creek was very cool. Big stepping stones ran across a wide pa forcing the water into interesting patterns. A frog jumped from under my feet when I crossed a rock, surprising me as much as the frog. When I bent down take its picture, it stayed still, handsome like a prince can be. This place is a photographer's dream.

Tonight I am staying in Stanimal's Hostel, operated by a past AT and PCT hiker. He gave me free shuttle rides from trail head to the hostel and to the sh downtown. Great service and a neat place to spend the day.

One room cabin at Stanimal's

Day 67: Entering Shenandoah National Park
Thursday, May 30, 2019
Destination: *Camping after Turk Gap* ~ **Today's Miles:** *13.7*
Start Location: *Stanimal's Hostel* ~ **Trip Miles:** *883.3*

[di]dn't know Shenandoah National Park existed until many years after I arrived in the US, even though the park was established in 1926! In my last few years [li]ving in New York state, I thought about visiting the park, but never made the trip. Now, I am walking through it.

[In t]he morning, the hostel owner Adam dropped a few of us back on the trail head. Soon, I reached the back country permit box, filled out my permit, attached [to] my backpack, and set off on my journey. As all things have a good side and a bad side, the establishment of Shenandoah NP had a yin & yang as well. [For] the few hundred families of settlers who had to be relocated from the park, it meant the loss of their lifestyle and their family's memories. For millions of [peop]le who came to visit the park, it meant recreation and adventure. For a lot of the wildlife being protected by the park, it meant regaining their habitats [and] lives. With this bittersweet emotion I entered the park - on foot. I was not in a hurry, and walked at a slow pace of about 1.5 miles per hour, following [the] spine of the park's Skyline Drive, trying to capture the spirit of these complex emotions along the trail.

[At o]ne spot, shortly after I crossed the Skyline Drive and re-entered the Appalachian Trail, a rabbit stood at the center of the trail. When it saw me, it ran towards [me,] against expectations. In four hops, it almost came to my feet while I stood there taking its pictures. Then, it realized something was not right, ran away [as q]uickly as it came, to the same spot where I first saw it. It turned its head back, looking straight in my direction and stayed in that position for almost 2 [min]utes. Only when I moved towards it did it jump away into the bushes.

[In o]ne of the gaps, in view from both sides of Skyline Drive, were pastures with grass as high as my shoulder. They swayed with the wind, making soft sounds [to t]ell the stories of people who might have planted them long ago. It felt strange knowing that the forest I saw in the park was planted by the CCC "boys" [in t]he early 1930s. One section of the Appalachian Trail was changed to a detour - a mile of gravel on a fire road. It was actually very nice detour; the road [was] easy to walk and there were many huge trees on the roadside. It was completely shaded. From time to time, honeysuckles gave away their secret location [by] emitting a sweet smell. A few apple trees had many small green apples already, flanked by lots of wild grapes. Their curly young shoots provided a very tasty [snac]k, sour and juicy, to make hiking on a warm day easier.

John Muir: The mountains are calling, I must go.

Day 68: Here comes the rain
Friday, May 31, 2019
Destination: *Loft Mountain campground* ~ **Today's Miles:** *14.4*
Start Location: *Camping after Turk Gap* ~ **Trip Miles:** *897.7*

Outdoor theater in Loft Mountain Campsite

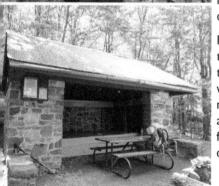

Today's trail was easy, the fifteen miles just cruising by in about eight hours - including a lunch break and many sr water breaks. It hugged Skyline Drive tightly, to the point where I lost counts of how many times I crossed the roa

Near one crossing, after Black Rock Summit, I saw a single large bear. It could have been an adult male based on size. It was foraging along the forest edge next to the Skyline Drive. A day hiker walked in front of me pointed out bear to me. Once the bear noticed it was seen by humans, it ran away from us, keeping low in the bushes.

Whoever designed or approved the design of the trail signs in Shenandoah National Park should feel very bad ab their decision. The text on the signs is tiny, not much bigger than a ladybug. It's also punctured on a narrow me strip that has no color contrast. To make it worse, the signs are all positioned below chest level. So, to read the sign had to bend over while carrying a heavy pack, and put my eyes not farther than a few inches from the words to m out what they were — and only in good lighting, too! Why the park cannot make meaningful signs is a mystery to

It's been couple of weeks without significant rain. The springs and streams have reduced in volume. At noon, when I w to refill my small water bottle at a spring near Blackrock shelter, it took about 3 minutes to fill. Speaking of rain the mid afternoon, I heard thunder in the last hour of hike. Just as I reached the Loft Mountain camp store, it rai very hard for a good hour and half. While I was waiting for the rain to stop, 3 SoBos asked me to join them for night to share a campsite. When the rain stopped, we checked into the campground, and set up our tents in a hu as the next round of thunderstorms started. We stayed in the tent for the rest of the day, hearing thunder and see flashes of lightning. Just five minutes before sunset, while there was still rain over our head, the red light from the on the far west filled the sky's cracks in the boiling clouds. Half of the sky was a bright red orange!

Day 69: 900 miles completed
Saturday, June 01, 2019
Destination: *Swift Run Gap* ~ **Today's Miles:** 16.6
Start Location: *Loft Mountain campground* ~ **Trip Miles:** 914.3

ft Loft Mountain campground early morning and took the Frazier Discovery trail instead of the Appalachian Trail, since it was more straightforward to go re from the camp store. The morning sunlight was lovely on the trail. After last night's extensive rain, everything smelled so fresh again. The rain drops were hanging on all the leaves. My boots and pants got wet in no time. This detour ended up rejoining the Appalachian Trail after a few hundred feet climbing, made the overall mileage a little less than a mile longer. But there were cool rock formations and a nice view at the top, so I enjoyed it.

tly after lunch at the Simmons Gap, I reached the 900 mile marker. Again, there were three of them close to each other. I used the one made of rocks as real one. Since the distance of the trail grows longer each year, the first one made of small sticks might be more accurate. But the rocks looked cooler!

ay was a Saturday. More day hikers and section backpackers were on the trail. I met a father with his 11-year-old son doing a two-week backpacking trip. boy was so cute. I remembered the trip we took in Yosemite when my younger son was 11 years old. Time flies! He's 24 now!

arding my hiking boots, after more than 900 miles on trail plus about 150 miles before the trip, it was still in workable condition. Both sides had big cracks r the top, but the bottom threads were still good. And my feet still felt good in them. There have been no blisters for many weeks. The only problem is that y are not waterproof anymore. So compared to others who used trail runners, I am still pretty happy with my boots. Many of them have already bought their d pairs of trail runners.

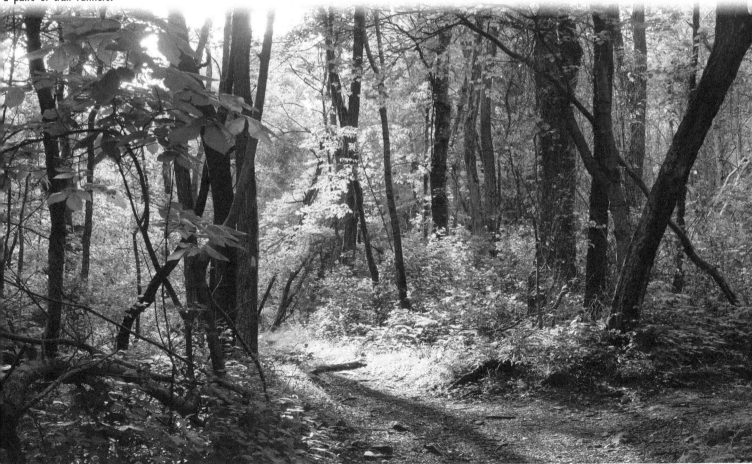

John Muir: The mountains are calling, I must go ...

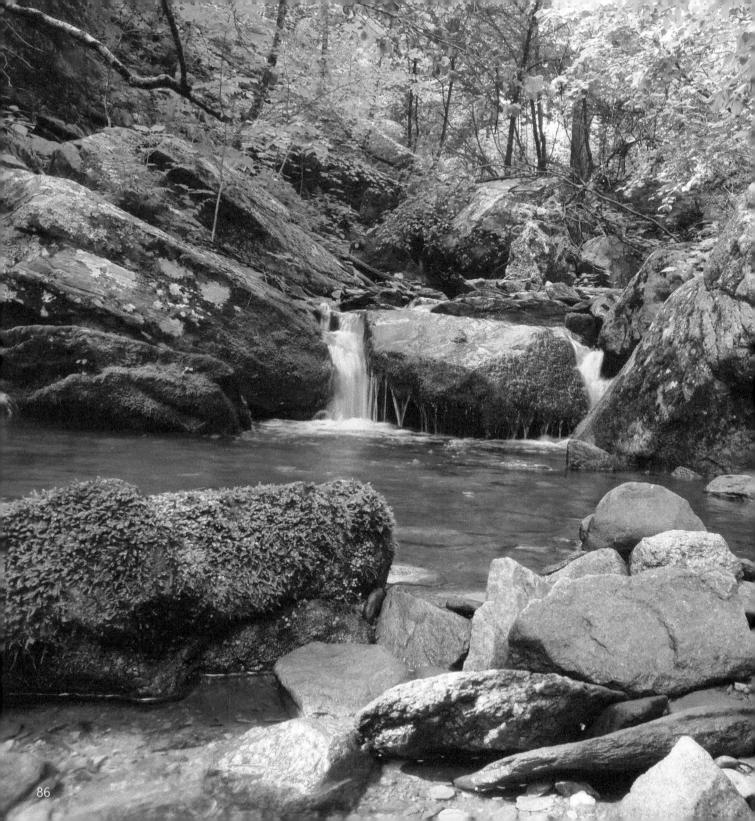

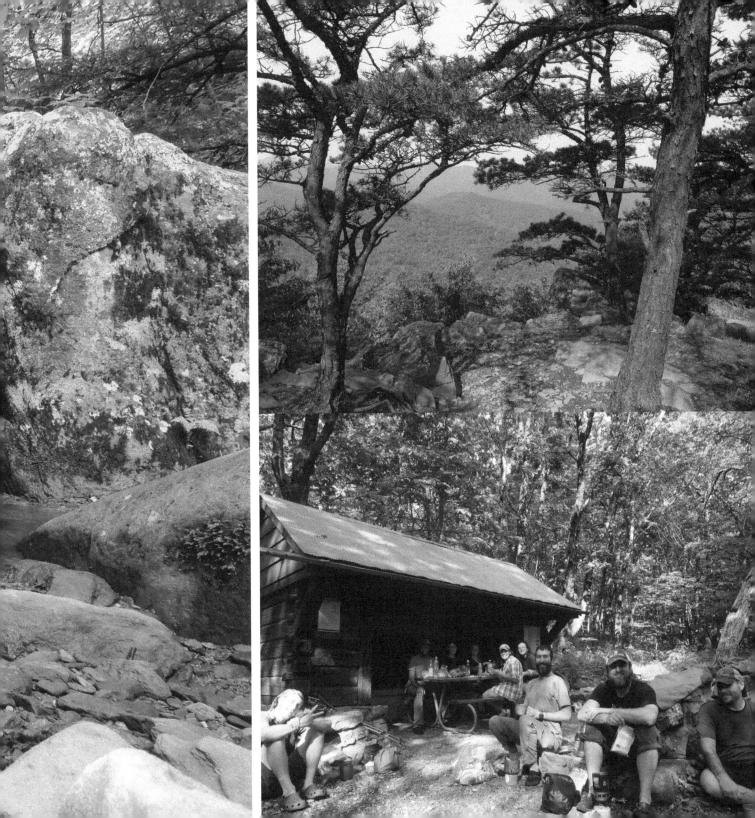

Day 70: Front country vs. back country
Sunday, June 02, 2019
Destination: Big Meadows Lodge ~ **Today's Miles:** 17.8
Start Location: Swift Run Gap ~ **Trip Miles:** 932.1

The trail zigzagged from backcountry to [f]ront country throughout Shenandoah National [Park] as I passed campgrounds and lodges. The [front] country provided all the usual comforts [for] human beings: showers, flushing toilets, s[hops] to buy snacks and quick meals. The l[odges] had a restaurant and a tap room for [full] meals and drinks. So today, I felt more li[ke a] vacationer than a thru-hiker.

The trail was also well maintained and ge[ntly] graded. Most hikers I knew did twenty mile[s or] more. Even I walked more than eighteen m[iles] without feeling exhausted. Before 4:00pm, [the] weather turned windy. It thundered for m[ore] than 2 hours, but the rain only came a[s a] few droplets. This kept the weather cold in [the] afternoon. As I checked into the lodge, I to[ok a] hot shower to get warmed up; had dinner [with] a few hiking friends; went to watch the Su[nset] and had more soup and dessert. Time for [a] comfy bed in Big Meadow Lodge.

Day 71: Easy going
Monday, June 03, 2019
Destination: *Byrds Nest Hut #3* ~ **Today's Miles:** *14.4*
Start Location: *Big Meadows Lodge* ~ **Trip Miles:** *946.5*

h the trails so easy, miles passed by quickly. I started
stioning the accuracy of the mileage in my guide
k. Of course, they were not the same as the posted
signs in the park. But who could believe those signs
way? Yesterday, one sign said a place was 1.4 miles
ad. After I walked in that direction for 5 minutes,
ther sign said the same place was 1.6 miles ahead.
ust increased by 0.2 mile! All my steps were wasted!

trail really loves the front country. I passed Skyland
rt at noon and had a sit-down lunch by a window
in their big dining room. In the National Parks
California, backcountry means half mile away from
paved road. Here, it is about 50feet away. Today,
trail went through a landmark called Pinnacle. I
expecting a needle-like rock formation. That's what
elieved based on the pinnacles in California: class 5
climbing needles! But this pinnacle was a gradual
king trail to a rounded hill, an easy stroll. On one
d, I was glad the trail was easy and good foods were
y accessible here. On the other hand, I was hoping
be more remote, away from the sounds of traffic.

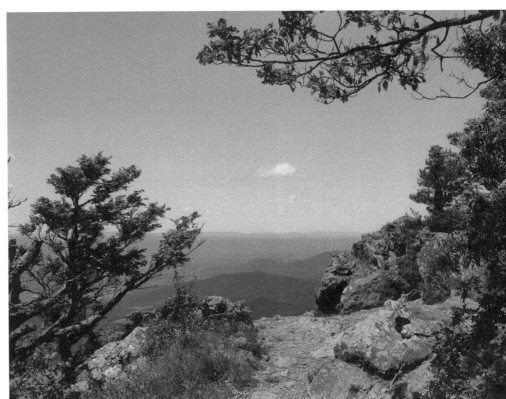

John Muir: The mountains are calling, I must go ...

Day 72: Bears, deer, and a sea of ferns
Tuesday, June 04, 2019
Destination: *Gravel Springs Hut* ~ **Today's Miles:** *17.5*
Start Location: *Byrds Nest Hut #3* ~ **Trip Miles:** *964.0*

While I was walking down from Pass Mountain, focusing my attention on my footing, a big black shadow jumped in front of me. Looking up, there was a juve bear that ran across the trail less than 20 ft from me. It was big and fluffy, chubby by any metric. It must have been well fed! Good job, big teen! You are a great start for a successful life!

Another hour passed, following some ruffling sounds from the left of the trail, I saw a yearling bear, small and skinny. By itself, it dashed across the trail hid in the grasses, but didn't run away. It just retreated a few steps each time, studying me, watching my movements. This little bear must be having a h time to find food. I wish you the best.

By 2pm, I reached Elkhollow Wayside. The country store has a grill and the park's signature blackberry milkshake. So my lunch was a cheese burger, onion ri and the milkshake. Every day is so convenient in this park!

Near Little Hogback Mountain, there was a sea of ferns on both sides of Skyline Drive. Their leaves waved with the breeze, forming dark and light patterns fans waved away still air. Large tall trees standing in the fern waves, pillars of mottled gray, pointed into the sky. Some had funny shapes.

Now under a big poplar tree, I am ready to rest.

Day 73: Last day in Shenandoah
Wednesday, June 05, 2019
Destination: Mountain Home B&B ~ **Today's Miles:** 13.4
Start Location: Gravel Springs Hut ~ **Trip Miles:** 977.4

last day in Shenandoah National Park! The creek bubbled cheerily all night near my tent. Again, deer came to the hut to say good morning just after daylight. le I was cruising down from Compton Peak, three bears, two adults and one cub ran past me through the forest, trying to put large distance between themselves the hikers. I can smell the sweet smell of cinnamon rolls from where they were running from. Maybe someone cooking at home near there attracted them? oon, I reached the registration box at the park's boundary. I put the permit tag back to the box and left Shenandoah for good. It's been an easy week he park with nice comfortable weather, a little bit on the colder side. I can see the park, being so different from the National Parks in the western states, ing a very important role on conservation, restoration, and education in the eastern US. Not all people can go to the far west to experience the wilderness e. But, being so accessible near their home, they can also enjoy the peace and awe of the outdoors.

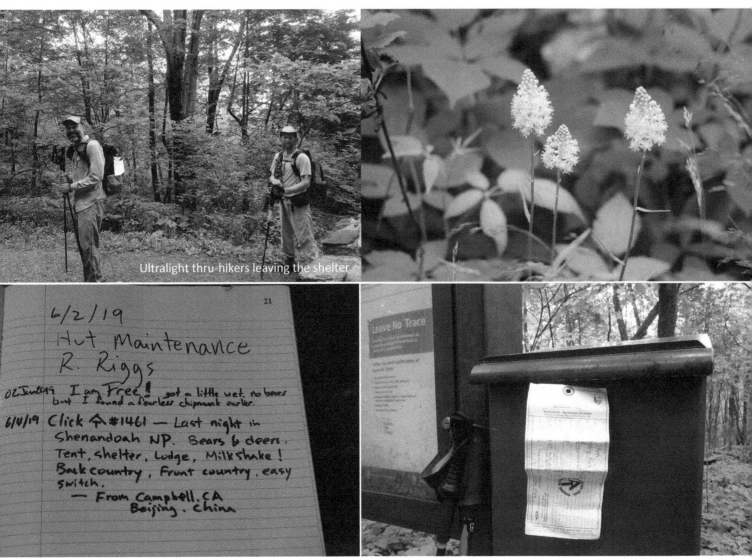

Ultralight thru-hikers leaving the shelter

6/2/19
Hut Maintenance
R. Riggs

02Jun2019 I am Free! got a little wet. no bears but I found a fearless chipmunk earlier.

6/4/19 Click ☝ #1461 — Last night in Shenandoah NP. Bears & deers. Tent, shelter, Lodge, Milkshake! Back country, Front country, easy switch.
 — From Campbell, CA
 Beijing, China

John Muir: The mountains are calling, I must go ...

Day 74: Two great hostels
Thursday, June 06, 2019
Destination: *Bears Den Hostel ~* **Today's Miles:** *20.0*
Start Location: *Mountain Home B&B ~* **Trip Miles:** *997.4*

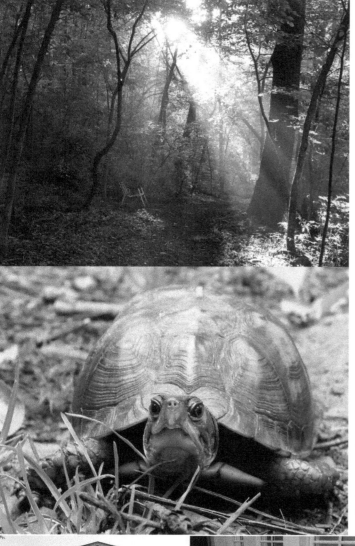

Scott, who runs Mountain Home Bed & Breakfast, was so nice to us hikers. He up at 5am to prepare our breakfast - made to order - for each individual per I loved his tea collection too. Hard to decide which flavor I should take! He shuttled us to Front Royal's downtown last night for dinner, resupply shopping, a tour of the lovely town. It had quite a few unique museums, wonderful hist architecture, and many nice restaurants. Quite a charming town, indeed. I was to have the opportunity to visit this town.

It rained last night. The air was pretty wet in the morning. The sunlight pu a nice "spotlight from heaven" effect as it shined through the water vapor in forest. At every edge of the densely vegetated forest, honeysuckles grew nicely, fi the air with seductive fragrances. Many mulberry trees sported ripe berries, creamy white, to pink, to red, and purple. I snacked on them as I walked a the trail, fingers and tongue painted purple. The berries were sweet and juicy - pleasures of living in the forest in summer. Flaming red strawberries also decor. the ground covers. But they were not as tasty as the cultivated variety. So looked great, but did not make my list of good eats. Blackberries and gooseber were not ripe yet, either. Their fuzzy fruits are quite funny looking now.

Turtles were also out today in force. I saw two; other hikers told me that saw four or five!

Expecting tougher trail tomorrow on the infamous "Roller Coaster" section, I deci to hike a little longer, past Whiskey Hollow shelter to camp somewhere between Meadows State Park and Highway 17. When I got there in late afternoon, I fo a sign prohibiting any camping in that area. So I had to push on to the high making the total distance of today's hike 20.8 miles. At that time, I decided best option for me was to get an Uber to Bear's Den Hostel for the night, slackpacking from Highway 17 back to Bears Den tomorrow. I was very happy this plan worked so nicely. Bear's Den is so special and beautiful. The volunt working there were so nice. For $30 I got a very clean bunk bed, shower, laur (which I didn't need), a large pizza, a Mountain Dew, a pint of tasty ice cr breakfast for tomorrow morning, and a shuttle back to the trailhead! What a va Oh, and did I mention the hostel is actually a European style castle which sits a hill with great views?

Mountain Home B&B Scott's tea collections

Day 75: 1000 miles
Friday, June 07, 2019
Destination: *Friend's house* ~ **Today's Miles:** *13.5*
Start Location: *Bears Den Hostel* ~ **Trip Miles:** *1010.9*

Bear's Den Hostel

…led to locate a shuttle to take me back to the trailhead where I had finished yesterday. …ecided to slackpack southbound for the day, and have my friend picking me up from … road in the evening.

…worked well. I only carried my drawstring day pack with minimal stuff. It felt so light. …n though the drawstring cut into my shoulders uncomfortably, I was able to use my …dana and puff jacket as extra padding, allowing me to still move quickly. Without the …vy pack, every step felt like walking on air cushion. I was happily bouncing up and …wn along the trail. When people were talking about the infamous "Roller-Coaster" I just …ught "where is it?" and smiled to myself. Another benefit of going southbound was that …ot the chance to say hi to the friends I made in the past a few days! Most of them …e surprised to see me walking in the opposite direction.

…ittle after noon, I reached the 1000 miles marker! A nice achievement with so little …rt today. It made me excited and motivated.

…he mid-afternoon, I reached Rod Hollow Shelter. Immediately, a rabbit came to welcome … Later, two other hikers came. While I sat there chatting with them, a large black rat …ke climbed up to the far side of the shelter, checking on the gear one hiker spread out … the platform. It took a while to convince the snake that it should hide in the grass. …I left the shelter, I spotted another snake on the trail near the shelter. This place was …nagnet for wildlife! Since it was a Friday afternoon, many boy scouts also came to the …. Hopefully they share the shelter peacefully with the snakes tonight!

… friend picked me up in the evening and took me into her home. She made so many …y dishes for me. I ate a lot! Thank you, Bin!

John Muir: The mountains are calling, I must go …

Day 76: Rest day in DC
Saturday, June 08, 2019
Destination: Friend' House ~ **Today's Miles:** 0.0
Start Location: Friend's house ~ **Trip Miles:** 1010.9

Today was my third zero day to date. My best friend from high school pic[k]
me up from the trail last evening. We went to Washington DC as a day off t[o]
rewards.

We went to the National Geographic Museum to see its history and fam[ous]
photos throughout the years, by some of the best photographers and explor[ers]
There was also the Queens of Egypt exhibition. We also visited the Smithson[ian]
Freer Museum of Art for its Asian arts exhibitions. There are so many museu[ms]
in DC. Even though I have been here 3 times, it would take at least one mo[re]
for me to visit all the museums I want to visit here. On the way back to
home, I bought a pair of hiking pants to replace the torn pants I have now, [and]
more food for the next six days.

She made wonderful food for me for breakfast and dinner. I was so pampere[d]
very nice day to see friends and relax.

Day 77: Bye bye Virginia
Sunday, June 09, 2019
Destination: *Harpers Ferry* ~ **Today's Miles:** *19.0*
Start Location: *Friend' House* ~ **Trip Miles:** *1029.9*

...id-morning, I stepped on top of a predominant rock with fine views. As I looked around, I felt that I missed something. Two day hikers asked me and the ...r two backpackers if we had seen the Virginia/West Virginia state line trail marker? All three of us looked at each other, and answered in unison: NO! I can't ...ve that after all these five hundred miles, in our eagerness to get out of Virginia, we missed that sign! We backpackers had been so focused on our footing ...we didn't look around. And yes, that sign was in the middle of a rocky field called "Devil's Race Course". While the other two backpackers continued their ...to the north, I ran down the hill, found the sign and took proud pictures.

...e May 3rd, when I entered Virginia just before Damascus, I have walked five hundred and forty one miles in this state for 38 days. I think I got some Virginia ...s when I encountered PUD - pointless ups and downs, on at least one hot and humid afternoon. But overall, I enjoyed the trails in Virginia. Now, the classic ...try song "Country Roads, Take Me Home" by John Denver filled my head.

...rain finally started in the early afternoon. By evening, it was falling at a steady rate. There were pockets of fog in the forest, reminding me of the cold ...er times in the spring. The forest became magical again. The sound of rain and wind, accompanying the rhythm of my footsteps and hiking poles hitting the ...nd, was quite calming. It also gave me expectations of reaching the comforts in Harpers Ferry very soon. Before 8:00pm, I had emerged from the forest and ...in the mighty views of Shenandoah River on the bridge. A grand river with rocks and cairns in the middle, roaring below my feet just before the trail goes ...the town - the symbol of the Appalachian Trail's halfway point!

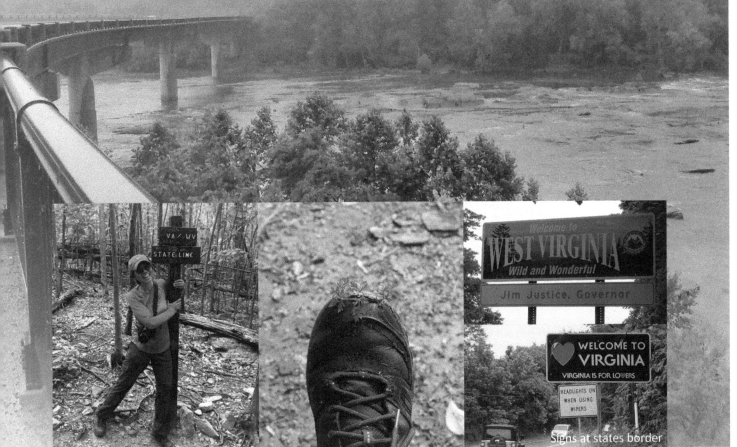

Signs at states border

John Muir: The mountains are calling, I must go ...

Day 78 - 80: Appalachian Trail - West Virginia & Maryland

Short and easy, but full of history

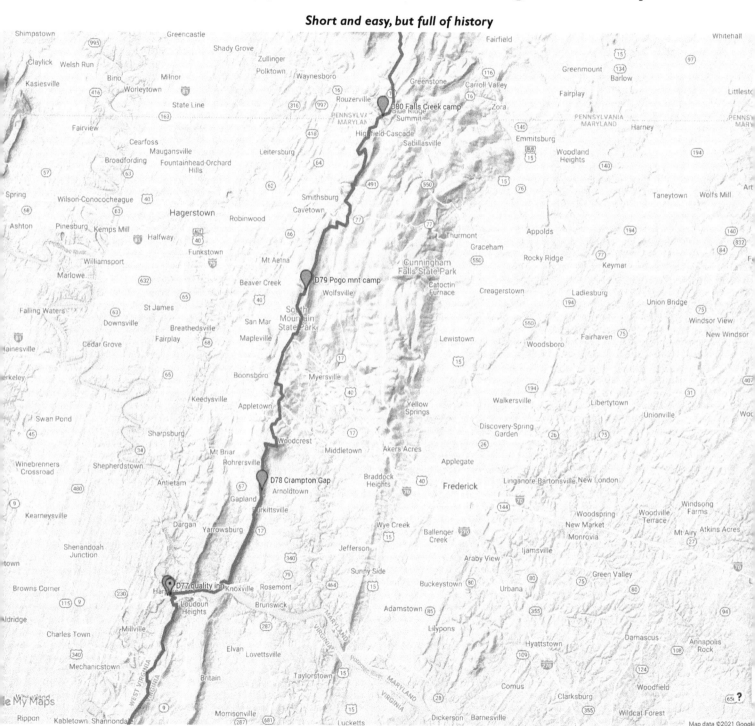

Day 78: West Virginia to Maryland
Monday, June 10, 2019
Destination: *Crampton Gap shelter* ~ **Today's Miles:** 11.4
Start Location: *Harpers Ferry* ~ **Trip Miles:** 1041.3

Before I could sing a full verse of "Country Roads", West Virginia was gone! Just like that! I had already been walking in Maryland for more than 10 miles.

I remained in Harpers Ferry for the whole morning, doing chores: got a new iPhone charging cable to replace the broken one, mailed unneeded stuff and souvenirs from Shenandoah National Park back home, dried my boots and socks, then resumed the hike. I also visited the Appalachian Trail Conservacy's office to register. They took my photo while I wrote down my information and signed a photo release.

Back on trail, I enjoyed the view of Jefferson Rock, the historical downtown, and the views of Potomac River. The downtown was very charming with many shops, restaurants and museums. I can easily see it is a place where you can spend a whole day.

Once I crossed the foot bridge on the Potomac, I left West Virginia behind. The Appalachian Trail ran flat along the river for about 3 miles, sharing the road with a nice bike trail. A small creek flowed parallel with the river, filled with duckweed and decaying branches. The whole creek was bright green. Many turtles meandered around in the creek, camouflaged with duckweed, staying perfectly still. A few little ducklings wandered around in the water. Here or there, bright red-orange day lilies stood out on the bank. Large tall trees covered with leafy vines lined up the trail. Mosquitoes swarmed in as soon as I stopped to take photos. Overall, a lovely wildlife habitat in a peaceful setting. Only a passing train occasionally broke the silence.

The hill was as flat as a trail could be again along the ridge line. I found a nice camping site overlooking the civilized world not far below. The sun set, and darkness filled the hills. A soft rain started to sing lullabies for the night.

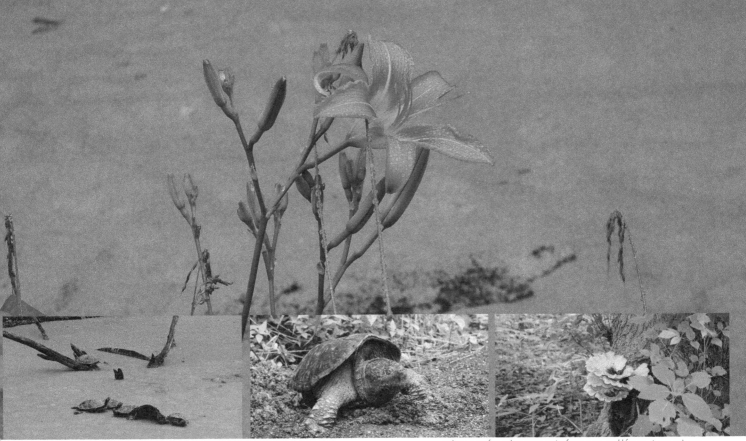

John Muir: The mountains are calling, I must go ...

Day 79: An open history book
Tuesday, June 11, 2019
Destination: *Pogo mountain camp site* ~ **Today's Miles:** *15.7*
Start Location: *Crampton Gap shelter* ~ **Trip Miles:** *1057.0*

I walked through an old battleground from the Civil War era over 100 years ago - battle of South Mountain. The battle was intense; many casualties on both si Generals lost their lives together with soldiers. In the end, the Union took control of this area. At Fox Gap, graves of General Reno and General Garland mar the battle field. I stopped there for my lunch break, drying my tent at the same time. Across the small road from the graves, a black and two white hikers young thru-hikers and one 18 years old section hiker) enjoyed each other's company, while music from their ukulele flew in the breezy air, their chatters laughters reached my ears from time to time. All of a sudden, I realized that without General Reno's sacrifice long time ago, it may not have been possible these young men could enjoy a brotherly good time together today. That was a very moving moment for me to remember.

In the afternoon I entered Washington Monument State Park, the first Washington monument built in this country. Along the walkway to the monument, woo signs listed the timeline of his great achievements. The monument was under construction, so I couldn't go up to enjoy the view. Despite this, it was sti reminder of the greatness of our first president.

There was a special kid on trail today — a fawn, maybe only a few days old. It still drank its mother's milk, and wobbled while walking every now and then was so lovely to watch them and see how caring the mother was.

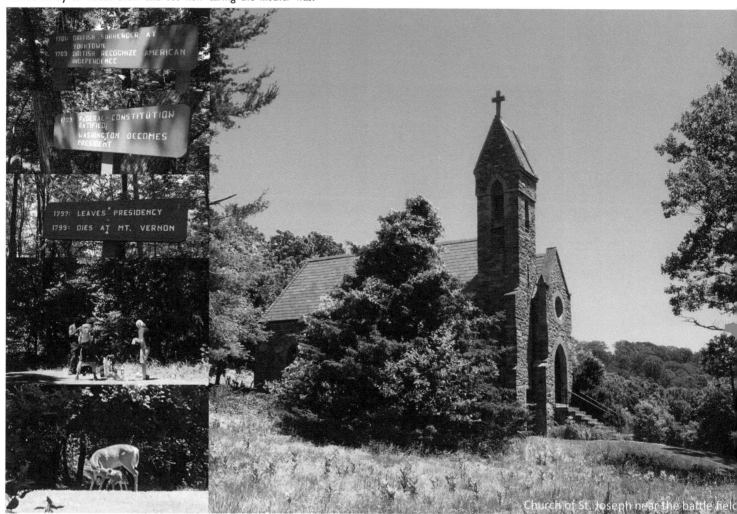

Church of St. Joseph near the battle fiel

98

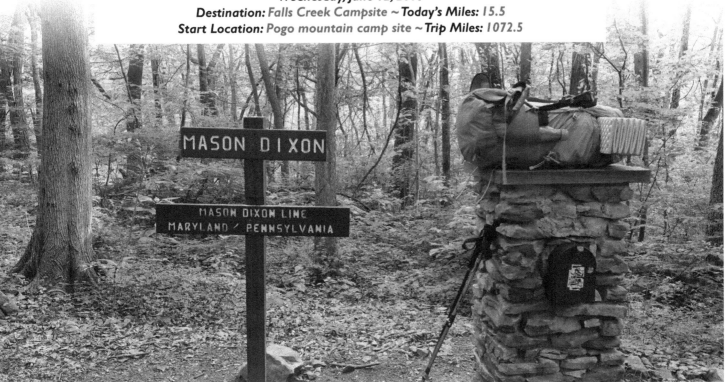

night I got lazy and didn't prepare water. By the time I finished breakfast, I had only 3oz of water left. Fortunately, there was a clear stream just a very
t distance away on the other side of the trail across the campsite. After I got water, I cruised through Maryland. The weather was cool, and the trail was
ty easy.

nile five, I reached a shelter and had an early lunch break there. Another lady was there too. "3rd Time" was from Australia, doing the Appalachian Trail for
you guessed it - a third time. She had completed this trail twice, and half of PCT in the past 9 years! It was so inspirational to learn that she was in her
y 70s!

und 5:00 pm, I reached the Pen Mar State Park picnic area. It's a huge area with excellent views of the flat land below. Built-in picnic tables and park
ches were plentiful, with many of them facing the valley below to take full advantage of the views. I took one table, cooked and ate my dinner in the park,
ed under the warm late afternoon sun, and enjoyed the view. It was a rare luxury to have a table for cooking and a bench to sit and eat while taking in
sights. To make it better, I could wash my pot in the restroom with running water after the meal. No need to drink my dishwasher water.

evening, the state of Maryland was in my hiking history! Mason-Dixon Line was crossed. Goodbye Maryland, here I come, Pennsylvania. I have completed six
he fourteen states!

Tree climbing toad

John Muir: The mountains are calling, I must go ...

Day 81 - 97: Appalachian Trail - Pennsylvania

Rocks, Rocks and more Rocks!
What is the nickname for Pennsylvania?
Rocksylvania

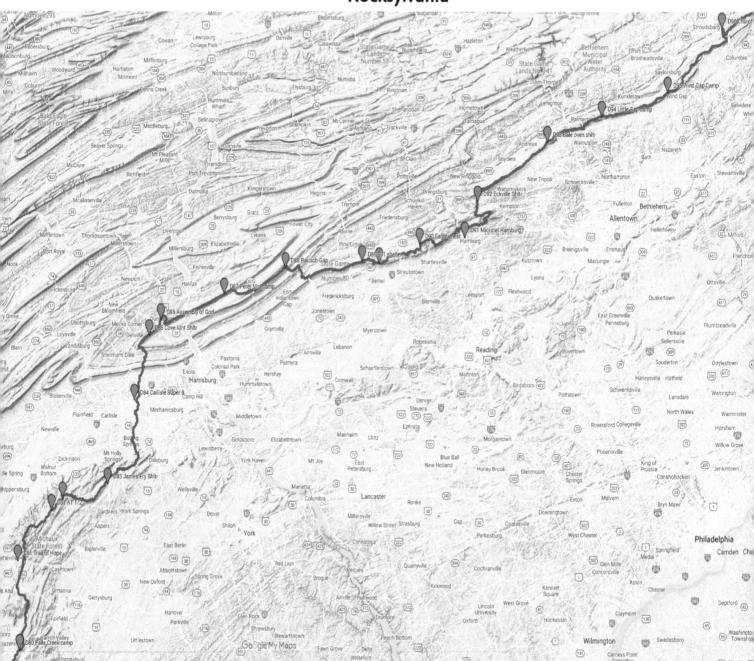

Day 81: Rainy day
Thursday, June 13, 2019
Destination: *Trail of Hope Hostel* ~ **Today's Miles:** 17.2
Start Location: *Falls Creek Campsite* ~ **Trip Miles:** 1089.7

ained pretty hard from last night through the morning. I was lying in my tent, listening to the raindrop symphony and calculating when to get up. Thanks my umbrella, I was able to get some chores done before the rain stopped at 7. By 7:30am I was ready to hit the trail.

ween 2-4pm, there were a few breaks from the rain. During those delightful moments, I was near Buzzard Peak, far from any road crossing. In the absence rainfall and wind, the forest was in complete silence. I slowed down to absorb the joyful moment. I held my breath, or said something in a whisper. The ls of rainwater stood still, too. I didn't even want my trekking pole to touch the water, for it would break the perfect reflection of the trees. Then all of a den, the rain would begin again, shattering the peace. Soon after, it would stop as abruptly as it started, bringing back the complete quietness. Intermittently, sunshine would break through the clouds and penetrate the canopy, painting the underbrush in patches of gold. These two hours brought me so much joy.

, by 4:00pm, the rain turned into a serious thunderstorm. The forest went as dark as if it was half an hour after sunset. Thunder kept rolling in, with heavy wers. The wind was strong and cold. Fortunately, the lightning was not too bad. But the trail decided to turn challenging, with many big rocks to navigate. oughout the day, I had to focus on my footing, trying to avoid the wet slippery roots and muddy pools; tiring me out. The good thing was that the rocky ions were not too long. When I reached road PA30, the sun came out again and stayed clear for the rest of the night.

ecked into a church-owned hostel, and stayed clean and dry. For dinner, I ordered pasta and salad delivered to the hostel. Looking at the food, I realized big the portion was, almost 3 times as large as my dinner on trail. No wonder I have lost weight! It took me some effort to finish the meal; so stuffed.

John Muir: The mountains are calling, I must go ...

Day 82: 1/2
Friday, June 14, 2019
Destination: *Toms Run Shelter* ~ **Today's Miles:** *16.2*
Start Location: *Trail of Hope Hostel* ~ **Trip Miles:** *1105.9*

Today was one of the more memorable days on my Appalachian Trail journey. I have been anticipating this in the last a few days. At around 3pm, I passed the midpoint of the Appalachian Trail! There was a post for year 2018's midpoint, and a stone marked 1/2 sign was seen about half mile later on the ground. There should be another halfway sign based on year 2011 mileage. I will pass that tomorrow early morning!

So, officially, I have completed more than half of the hike!

Midway point is worth celebrating,

Midway point is worth mentioning,

It took a long time to get here,

And every step from here is one less step to reach my destination.

No hurry, no worry, just live one day at a time. And I will be there!

Today's trail celebrated with me, with super easy terrain. Almost no rocky sections! At one stretch of the trail, when it passed a pine forest, the path beca covered with cinnamon-colored pine needles: soft, spongy, and very comfortable for my feet. I bet the quality of this pine needle carpet is comparable with a carpet fit for a king or queen's state visit. While I was walking on this long carpet, the birds sang welcoming songs to me. The wind, blowing leaves, clappe celebratory chant. I felt proud and happy to receive this honor.

Earlier in the morning, three sights are worth my mentioning on my blog. One was a green tunnel of rhododendron-ish trees. Wooden and stone steps led through the tunnel, climbing up. It felt like going up a stage to receive a medal. The second sight was the full blossoming of mountain laurels. Their pink and wh flowers filled the sides of the trail, brightening it as well as hikers' spirit. The third one was the beautiful Quarry Gap shelter. It was not just a well-construc and maintained shelter - it was best decorated shelter, too. Fresh flowers in hanging baskets and pots made the shelter look more like someone's well-loved cared-for front yard. Overall, all of the shelters in Pennsylvania were in much better shape than those in other states I have walked through. The PATC re have done a great job.

A few humble sticks made the 1100-mile marker. I also passed it on the trail today. I felt very energetic and ready to face the challenges of the second of my journey!

Day 83: Pine Grove Furnace State Park
Saturday, June 15, 2019
Destination: *James Fry shelter ~* **Today's Miles:** *10.9*
Start Location: *Toms Run Shelter ~* **Trip Miles:** *1116.8*

far from the last night's shelter, I saw Appalachian Trail's halfway post, established in 2011. It was more artistic and much bigger than the post made in 8. It was a little bit strange to see a post sign saying 1090.5 miles to both sides while I was actually already at mile 1100.5. Still, it was something I was glad to see.

ached Appalachian Trail Museum in Pine Grove Furnace State Park by 9:40am. The museum has cool displays for the Appalachian Trail; the one I loved most the old sign at Katahdin Mountain and the book by Earl V. Shaffer - Walking Through Spring - his experience as the first thru-hiker on the trail. At the by store, some thru-hikers were doing the half gallon ice cream challenge. It was a silly way to celebrate the midpoint! But apparently some people can do later met "Whitey", who actually completed the half gallon ice cream challenge on this cold day! He got a tiny wooden spoon as an award for finishing one box and one small box of ice cream!

cousin and her husband came over to the park to meet me today. She brought lots of yummy home cooked food. It was a great treat at the halfway point. of my favorite Chinese food and watermelon! We shared it with other young hikers: "City" and "Go Cool". Today "City" carried two red heart shaped balloons. bought them for his father. They will meet tomorrow on the Father's Day. His dad will throw a trail magic for him and hikers. How sweet is that?

we finished the meal, I packed all the goodies my cousin brought to me, and we hiked together for about a mile. They got a baby-sized taste of what the and backpacking are all about. I was happy to have their company. We walked by the lake, beautiful creek, and a small swamp area. We also climbed a bit, up through downed trees. The forest was peaceful and enjoyable.

I said goodbye to my cousin and her husband, I continued for another three and half hours to reach James Fry Shelter. It was still early for the day. But, g stuffed with food, I was sleepy. So I settled in my tent for the night. As a day hiker passed me today said that he will pray for his god to bring me good and protect me. I felt very blessed by my family and fellow hikers today.

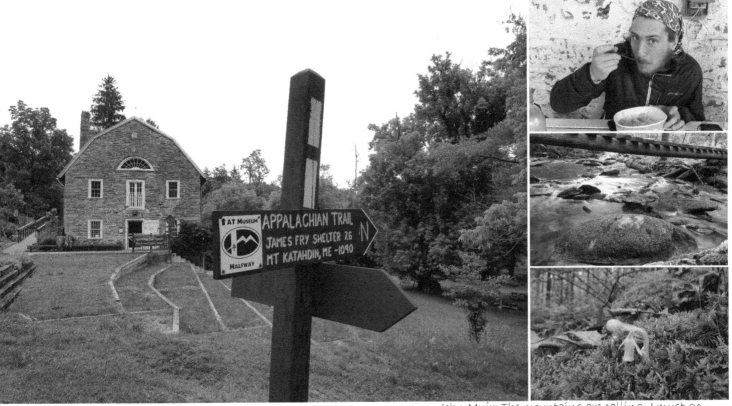

John Muir: The mountains are calling, I must go ...

Day 84: "Fun" day
Sunday, June 16, 2019
Destination: *Super 8 at Carlisle* ~ **Today's Miles:** *20.0*
Start Location: *James Fry shelter* ~ **Trip Miles:** *1136.8*

I had lots of "fun" on today's trail. In the morning it started as easy going. The cell signal has been great. Even though I planned to do more than 20 miles today, I was still very relaxed and had a long video call with my sister and parents. Then, I reached the Rocky Ridge. It is true to the name. I called it rocky ridge, rocky maze! At no less than two locations did I have to remove my backpack and camera, set aside my hiking poles, and pull myself up or get down the trail. It was only with the help of white blazes that I could find my way out of the maze. Sometimes I stopped, looked carefully around me, and made sense of the code by white blaze. So this was the real fun part of the day.

The reason why I had to make a twenty miler was because in the last ten miles, the Appalachian Trail went through farmlands and highways. There was no good option for camping. So I had to make it to a hotel. By the time I left the small town of Boiling Springs, the rain started, but there was still 8.5 miles to the hotel. The rain came in full force. In just 5 minutes, my pants and boots were soaked. The trail became a small muddy river. Previously muddy sections became differently-sized mud pools. At multiple points, there was no way to avoid stepping in them. So I had no choice but to wade right into the ankle deep muddy pools. This reminded me of my childhood. During summer, Beijing usually had late afternoon showers every day. One of my favorite things to do was to wear a pair of plastic sandals and splash around in the rain pools - of course, without being seen by my parents. So, to make the best out of the muddy situation, I sang silly songs about my favorite activity in the past. I slipped and slid through the trail for about 4 hours. This made the 20 miler day much longer than I anticipated.

The last "fun" was in my last mile of hike. An old guy appeared abruptly in front of me. He carried an old gray backpack which looked as if it was made out of canvas. He was tall, with long white hair and a long white beard. He had a long, eagle-beak nose. Something about his skin color made me wonder if he was a real person. His skin looked like porcelain. He spoke to me in a rather fast tune that was hard for me to understand. He asked me about the camping situation in the next many miles before the shelter, which was not good. Then he asked me if I came from far away, and if I will stay in the Super 8 Motel tonight. He had met three other hikers who all will stay in Super 8. Since it was late, he sensed that I wanted to reach the motel as soon as possible, so he let me go. I could tell that he wanted to ask a lot more questions. I also wanted to ask him where he would stay tonight, since there was no good camping option for more than 10 miles and the nearest town to find a hotel in his direction would be 7 miles away. But in a hurry, I didn't chat more with him. After I parted with him, I kept thinking that I might have missed the opportunity to know a true forest wizard. As a punishment, in the last half mile in the woods, I walked right into a mosquito kingdom. In thirty minutes, mosquitoes swarmed around me. My hands and hat danced violently around my face, neck, shoulder, back and arms, trying to slap them away. When I finally reached the highway that led to the Super 8 motel, I had been bitten more than twenty times by those hungry mosquitoes!

Such a "fun" hike in the Father's Day. I did see many fathers and kids hiking together today. So happy Father's Day!

...ay 85: Passing the farmlands

...nday, June 17, 2019

*...stination: Cove Mountain shelter ~ **Today's Miles:** 13.6*
*...rt Location: Super 8 at Carlisle ~ **Trip Miles:** 1150.4*

...sing through the valley, I saw fields.
...d was mature wheat, green the young corn.
...ed brown was hay feeding the cows.
...n a far distance I also heard a rooster calls.

...sing through the valley, I wondered what the life was about.
...s the work hard on your body but good for your soul?
...u got it in your blood; you got it in your family.
...r more than two hundred years, you must have it in your heart.

...sing through the valley, I tried to figure it out.
...at's it like working for no one but yourself,
...at does it feel listening to no call but that of the Nature God?
...w does the outside world change what you do, for better or worse on the land you own?

...sing through the valley, I thought of the future.
...uld your children help you when they finish school?
...w would they value this land vs. their video games?
...uld they stay or eager to leave the land in your family that might pass down to them?

...sing through the valley, the grasses were tall.
...ple, pink, yellow and white, flowers mix-in all.
...y fingers slid through the leaves, touching the time of gone-by.
...s are so different, yours and mine.

...not met you, or may not ever know you.
...t when I'm passing through the valley, interacted we have.
...eeked through your window on this land of your life.

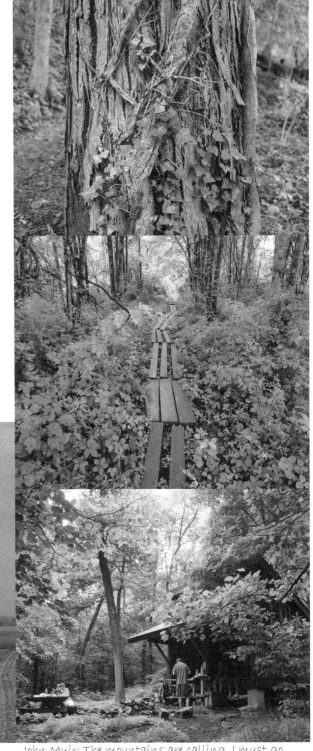

John Muir: The mountains are calling, I must go ...

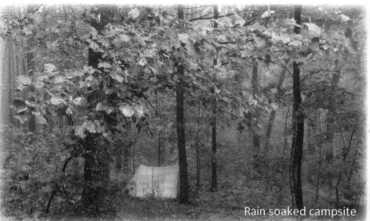

Rain soaked campsite

Wall painting in Duncannon

Day 86: Where to stay?
Tuesday, June 18, 2019
Destination: Basement in Assembly of God, Duncannon, PA ~ **Today's Miles:** 4.0
Start Location: Cove Mountain shelter ~ **Trip Miles:** 1154.4

Earlier today, I was awakened by the heavy rain in early morning, a little after 3am. Then, I hi[ked] through the rain and fog for about two and a half hours to get into town. The trail down from mountain was steep but sported nice steps built with rocks. Foggy forests are always my favorite t[ype] of forest, even when walking through them with wet socks and boots.

It was hard to decide where to go for today. My plan kept changing. That's what life on the trai[l is] like when you need to consider weather, distance, resupplying, and your ability to walk for the day[. It] also depends on if there is a decent place to stay for the night. So as I hiked down to Duncan[non,] I decided to stay in town at first. Then I heard bad reviews of the hotels, so I thought to go to [the] next shelter. Then, at a gas station near the town, a lady told me and other two hikers that there[is] a church that opens its basement to thru-hikers. That place had a very good reputation. So, the p[lan] changed again. I stayed in the basement of the church, on the floor with other 6 hikers. I also got supplies for the next 6 days, and had my lunch with a sandwich and watermelon! Later, in the to[wn,] I did a walking tour to see the historical buildings and ate a cup of ice cream. Duncannon is a t[own] that needs some TLC. It's bordered by a beautiful river with mountain views. But, many businesses [are] closed, no hotel has a decent reputation.

Day 87: Pushing more miles before thunderstorm
Wednesday, June 19, 2019
Destination: *3 miles after Peter Mountain ~* **Today's Miles:** *14.0*
Start Location: *Basement in Assembly of God, Duncannon, PA ~* **Trip Miles:** *1168.4*

follow the white one,
w the white blazes.
road is rocky,
road is curvy,
if you just follow the white blazes,
will get to your places.

t a town to get your resupplies,
t a camp to rest an aching body,
t a shelter for protection from the weather,
a place for meeting your friends.
follow the white one,
w the white blazes.

y from busy highway,
y from noisy world.
ill bring you to a world of wonder,
ill guide you in a world of your dream.
follow the white one,
w the white blazes.

may not know anyone on the trail,
they all have the same dream as you.
may become good friends,
may become soul mates,
will truly find yourself,
en you just follow the white blazes.

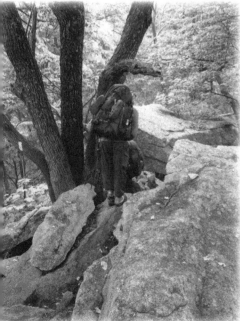

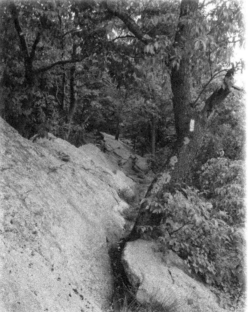

For most of the day, the weather reports said there was a chance of rain. But the rain didn't come until evening after I had found a place to camp. All of the hikers pushed to trek beyond Peter Mountain Shelter today. We were expecting intense thunderstorms, hail, and high winds tomorrow afternoon. Since the shelter for tomorrow is 18.3 miles past Peter Mountain, we wanted to hike a lot more today to shorten tomorrow's distance. At the end, I stopped at a ridge campsite that would have been 15 miles from the next shelter. So, tomorrow will be a slightly shorter walk for me.

Last night a South Bounder (SOBO) told us the trail condition for today was very bad. But I found he was making extravagant claims. There was only a small section that was rocky - and I did use my all fours to get through that one - but it was very short. Most of the trail was reasonably easy to walk on and keep balance. I hope tomorrow's trail doesn't get worse.

John Muir: The mountains are calling, I must go ...

Day 88: Watery Mountain
Thursday, June 20, 2019
Destination: *Rausch Gap shelter* ~ **Today's Miles:** *15.0*
Start Location: *3 miles after Peter Mountain* ~ **Trip Miles:** *1183.4*

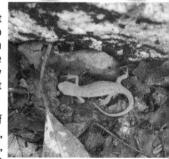

Today was the earliest I have ever started hiking. By 6:20am, I was on trail. Last night's campsite was very nice; flat, dry, all to myself. It rained in the night. So when I woke up before dawn, I saw many large spiders hidden beneath my rain fly, keeping dry. There was a game of chasing between me and the spiders before I dared to unzip the tent. I had heard from at least two hikers that they got very sick after a spider bitten them, and had to recover off trail for a week. I don't want that happen to me.

Due to the rain, the forest was foggy all morning and early afternoon. Getting off Peters Mountain was pretty fast and easy. But, when I started on Stony Mountain, the trail became very muddy. At first, I could still walk on the sides of the trail, avoiding mud and water. But just after I finished lunch, the promised heavy shower arrived. For an hour, it poured buckets of water from the sky, and the mud-laden trail became a river. At many spots, there was nowhere to walk - except to go straight through the mud and water. Even when the rain stopped, the river-trail didn't change. I walked through ankle deep water and mud. It remained this way until I reached the side trail to Rausch Gap shelter. I think this mountain should be named Watery Mountain, instead of Stony Mountain. Later, when I read other thru-hikers notes in the shelter's registry, I saw the river-trail was there even before the rain today. It could be this trail's normal conditions. Well, my boots will not dry overnight since the humidity is so high here. So it should be okay to hike in river again tomorrow!

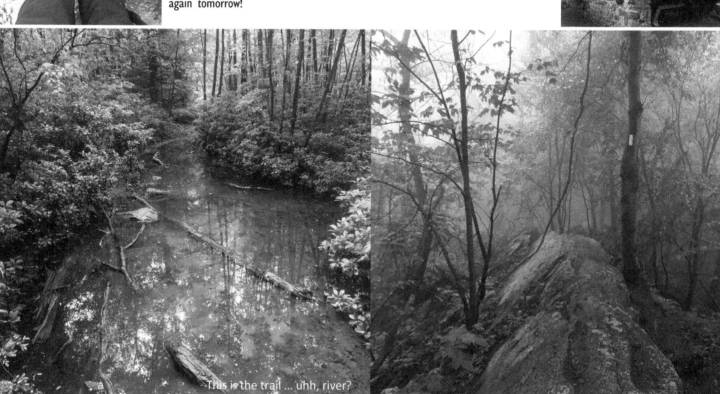

This is the trail ... uhh, river?

Day 89: If only I was a frog
Friday, June 21, 2019
Destination: *501 shelter* ~ **Today's Miles:** *17.5*
Start Location: *Rausch Gap shelter* ~ **Trip Miles:** *1200.9*

501 Shelter

...shed I was a giant frog for the last two days. It would be so much easier as a frog to hop through the pools of water and mud on the trail. It rained ...ugh the night and morning. When I left the shelter at 7:30am, the rain was still going strong. Much like yesterday, the trail was still full of water. Rausch ...k, along the trail, was roaring. When I crossed the bridge over it, I could see the water as a brown torrent with white foam cascading down the creek. Very ..., I reached a junction with a plaque stating "Beaver dam ahead". Another sign next to it pointed towards another direction, for a drier route. I decided to ... the beaver dam route since I wanted to see the dam. Also, if the water was high near the dam, I could always turn around. On the way there, a tall guy ... a very light backpack ran very fast past me. Before I could ask him if he could wait for me at the dam in case the water was high, he already charged far ...ad. He might have been trying to break the Appalachian Trail thru-hiking record! After about a half-mile from the sign, I reached the beaver dam. I was just ...ime to see the runner past a long waterlogged trail at the dam. The water level looked ok. So I carefully forded the water, placing my feet on the branches ...he water as much as possible, testing the depth of the water with my trekking poles before placing my feet on the spots. The water at its deepest part was ...ve my ankle. This was a huge beaver dam. I can tell it took generations of beavers to build and maintain this dam. In the rain and under the dark sky, ...rything looked black and white, except for a few patches of leaves. The water looked as black as ink. Just after I crossed the dam section, a family of five with ...e kids came behind me. They were section hikers on the trail, not sure for how many days. The youngest boy was the most energetic one. In early morning, ...w him carry 5 empty bottles from their campsite to get water from the shelter 0.3 mile away. He was the one running through the water trail in front of ...family. It took me almost 20 minutes to cross the dam carefully. It took him less than 5 minutes to run through the same section!

...ouple of hours after I passed the dam area, the rain stopped and the sun came out. I entered Swatara state park. Just when I thought the trail conditions ...roved in the state park, I came to a small creek with brown roaring water and no bridge. There was a log over the creek at a dangerous sloping angle. ...ween the bank of the creek and the log, someone placed a wooden plank about 10 feet long to close the gap. If it was dry, and I could see the bottom of ...creek, I might have considered crossing it. But the 2x4 was still wet and the log still held puddles of water, so I didn't dare take the risk. I turned around, ...d an additional mile back to the road, and followed the road to the next section of the Appalachian Trail. This put my total distance for today at 19.2 miles.

...the rest of the day, the trail was either boring with overgrown plants and muddy pockets, or it was rocky, with a mix of big or small rocks that always ...your trekking pole stuck and your footing unsteady. But at the end of the day after 7:20pm, I finally pulled into 501 Shelter. When night fell, I came out ...he sleeping building, and saw fireflies everywhere. They were dancing around between the trees, above the grasses, and all around me. It's been so long since ...time I saw fireflies in such large numbers! I stood there in the darkness, eyes following one firefly, then another, then another, round and round, I felt as if ...as dancing with them, dancing with many spirits!

...he beaver dam

Rain soaked grass field 1 hours after beaver dam

John Muir: The mountains are calling, I must go ...

Day 90: Boring trail
Saturday, June 22, 2019
Destination: *Eagles Nest shelter* ~ **Today's Miles:** *15.1*
Start Location: *501 Shelter* ~ **Trip Miles:** *1216.0*

Wow, I just realized that I have been on the Appalachian Trail for 90 days today. I now feel as if I can call the forest my home. Also, I passed 1200 miles marker this morning! From today, the remaining distance to Katahdin is less than 4 digits! According to my guide book - based on the 2018 mileage - I have 981 miles to go!

That's all the excitement for today. The rest was pretty boring. The trail was either mud or rocks. Uninteresting mud and uninteresting rocks. Both made me walk like a drunkard. Thank god there was no police patrolling the trail, or they might have sent me home to sober up.

There was a pretty pond formed by a very small man-made dam. After I went to see the pond, I missed the turn back to the Appalachian Trail and arrived at a road. This detour cost me about 0.6 extra mile on the rocky trail. Every thru-hiker said they wanted to get out of PA as fast as possible. Same here. I have never felt so bored by the trail as today's. Can't wait to meet my friend tomorrow for some change. Maybe I will feel better when I come back to take on the challenge next week.

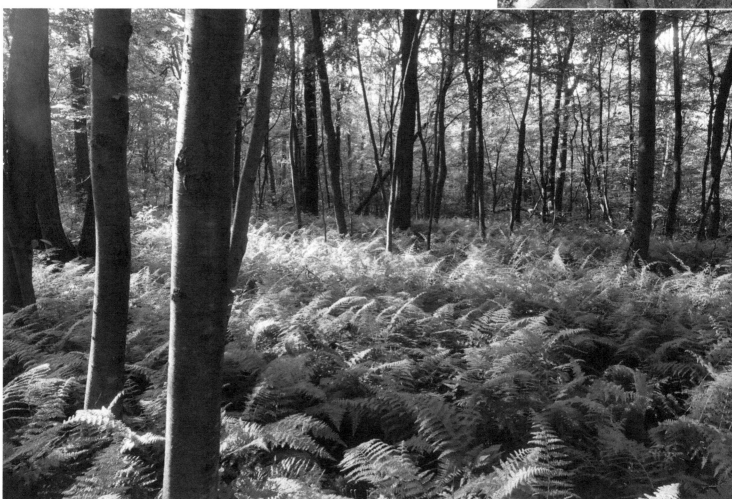

Day 91: Farewell old boots
Sunday, June 23, 2019
Destination: Microtel in Hamburg ~ **Today's Miles:** 9.5
Start Location: Eagles Nest shelter ~ **Trip Miles:** 1225.5

as a very pleasant day today. Finally, a break from the rain, mud and rocky trails - at least, for a few miles. The erature was also great for hiking.

n I was in 501 Shelter, the caretaker warned us about the steep and rocky trail on the last half mile to Port Clinton. as not too bad. Even though it was steep, it was well constructed with rock steps for the most part, so the footing was t. Just as I arrived at the railroad crossing in Port Clinton, there was a family doing trail magic, with hot dogs, hamburgers shrimp pasta, plus many drinks. Since I left Tennessee, this was the first real trail magic I came across. The parents drove their home in New York to support their sons doing a thru-hike. So sweet!

I enjoyed the lunch with them and five other hikers, I met a friend from high school in the peanut shop down the street. brought me the new boots that my son sent to her earlier. Going to the next rocky section, I can be more confident he footing. After we resupplied, I said the last farewell to my old faithful boots, placed them tenderly in the trash can.

dinner, my friend treated me with a Pennsylvania-Dutch style restaurant, plus my favorite - watermelon.

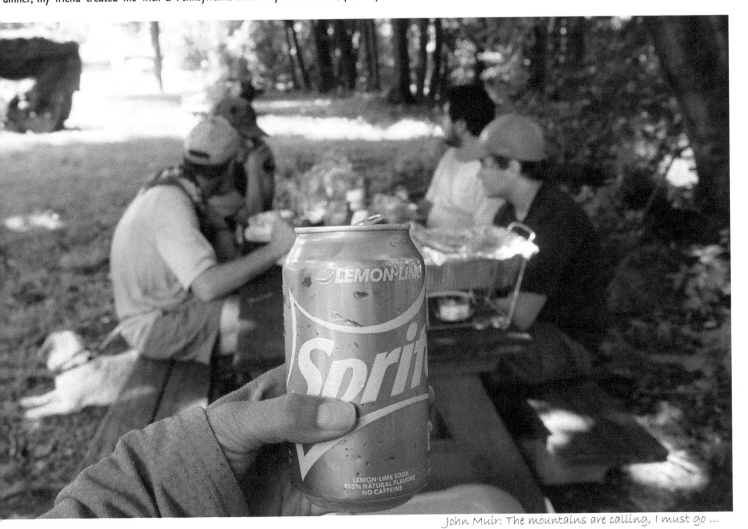

John Muir: The mountains are calling, I must go ...

Day 92: Hiking with my classmate
Monday, June 24, 2019
Destination: *Eckville shelter* ~ **Today's Miles:** *9.3*
Start Location: *Microtel in Hamburg* ~ **Trip Miles:** *1234.8*

What a wonderful day today. My high school classmate accompanied me for a slackpacking day. We had a great time hiking to Pulpit Rock and Pinnacle Overlooks by the Appalachian Trail. The hike was a lot easier during the rocky trail sections compared to the days when I was carrying my heavy pack. The views on both rocks were great. On Pinnacle, there was a great bird of prey (can't tell exactly what was it) circling around the tree tops just below the rocks. Earlier in the day, a hiker showed us pictures of venomous snakes hidden in the rocks near these areas. I looked carefully for them, but didn't see any.

We had a lunch break on Pinnacle rocks. Since we only carried one lunch, we pampered ourselves with lots of fruits and cherry tomatoes, Hong Kong pastries, fresh cheese, and many other treats. One of the most delicious lunches I have had on the trail!

This evening, I am staying at Eckville Shelter, where the fireflies continued to show me their magical dance in the darkened sky.

Claiming victory on a big rock
photo credit to Yun Liu

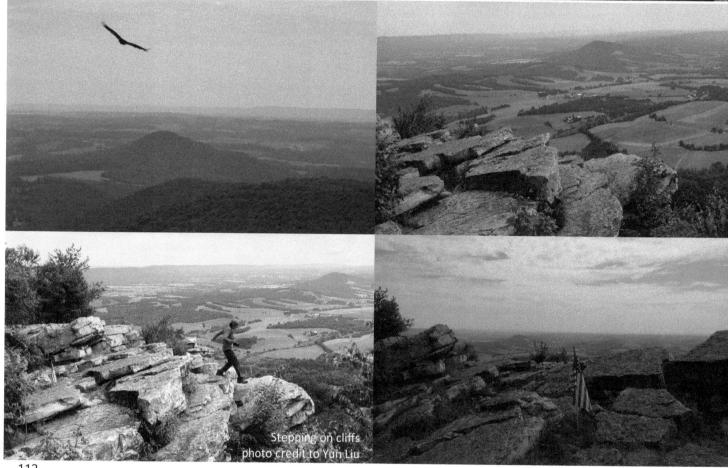

Stepping on cliffs
photo credit to Yun Liu

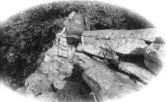

Day 93: Rocksylvania
Tuesday, June 25, 2019
Destination: *Bake Oven Knob shelter ~* **Today's Miles:** *17.4*
Start Location: *Eckville shelter ~* **Trip Miles:** *1252.2*

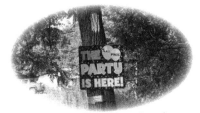

re was rain throughout the night and early morning. So when I started at 7:30am, the trail was very wet. The dirt paths were muddy with gathered water, the rocks were slippery. Then, at 9am, the rain stopped. The sun cracked open the clouds, gradually pushing away the fog, and played hide and seek until rnoon. It was sunny for the rest of the day.

the most part, the trail today was not difficult at all. Some sections on the old fire roads were very easy. Then, I came to Knife Edge Cliffs. All rocks decided spring to life. They stood up, pointing their sharp edges towards the sky. Like plants, they competed against each other to reach the sunlight, young shoots stone pushing out of the soil and dead leaves. Nothing can stop them. The trail went through these living rocks, dropping precipitously on both sides, forming 'Cliffs'. It lasted about a half mile. I went very slowly and carefully. Most of the time, I found my trekking poles were in the way; it was better to go through on all fours. Sometimes, my bottom was much more trustworthy than my feet. And that was how it was done. Once I passed this section, I cruised to Bale n Knob Road, found some lovely trail magic waiting for me! Many young hikers that had passed me on the trail got to the road earlier, and told the trail els that I was coming.

trail angels were "Mountain Goat" and "Chopper"s families. The two brothers thru-hiked the Appalachian Trail in 2016. They drove eight hours from Virginia to two days of trail magic. Immediately, I got a place to charge my phone, and was served a hamburger, a cold drink and potato salad. Later, sitting comfortably a chair with my shoes off, listening to the brothers' and other hikers' stories, I was given more fruits. Before I arrived here, I was so tired that I was thinking finding a camping spot near the road for the night. But I rested well, and was encouraged by the experienced thru-hiker brothers to walk one more mile to e Oven Knob Shelter - one of the originals built in 1937. That one mile also had a big rocks section similar to the earlier one, only slightly easier. I was not only one wishing for longer legs today. But, I made it through safely. I was so tired after these 17.5 miles, I fell asleep before finishing two sentences in my rnal. The rest was done the following morning at 5am.

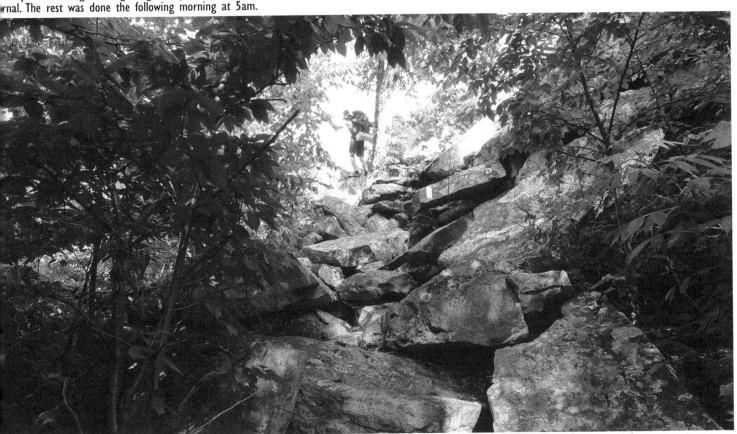

John Muir: The mountains are calling, I must go ...

Day 94: Alternative route
Wednesday, June 26, 2019
Destination: *Near Little Gap* ~ **Today's Miles:** *12.2*
Start Location: *Bake Oven Knob shelter* ~ **Trip Miles:** *1264.4*

In my plan for today's trail, I saw there was little elevation gain for this section, and arrogantly anticipated 23.4 miles as the expected distance. As today proached, however, there were quite a few warnings from my fellow hikers about the rocky sections near here. My plan changed to split the 23.4 into two d each about 12 miles. With the shortened distance, I started a little later than normal. I hit the trail ten minutes after 8am.

I slowly climbed through the rocky sections. They were not as bad as yesterday's knife-edge ridge. The bigger challenge was lying ahead, at Lehigh Gap - said be the worst before the Whites in New Hampshire. People warned me that I needed to team up with others to get through this. As I rested in a shelter, a ri runner "Lucky", came. He told me that there was an alternative route that was being used as a route for the Appalachian Trail in winter! I was so relieved hear that and immediately decided to take the winter trail.

The trail ran through an old zinc mine, so, the water was contaminated. It was suggested only use it in an emergency situation. In order to have enough wa for a dry camp, I loaded up with more than 3 liters. My bag became very heavy - over 35lb. As I was walking down the rock-filled trail, I thought about h to find this alternative route, and didn't pay enough attention to my footing. Before I knew it, I was flying into the air. My knees hit something, and my ch kissed a rock with a loud bang! And there I was, lying on the trail! Fortunately, I checked carefully and no bone was broken!

My new hiking pole was also giving me trouble earlier. The lower section became too loose to stay connected with the rest of the pole. So with these two setba I was in no condition to hike the rocky ridge.

The alternative route was not bad at all. The afternoon was very hot, so the going was slow. After it went around the rocky section, it merged with the Appalach Trail. I found a good opportunity to try many blueberries, along a fire road that seemed to go on and on forever. As the day wound to a close, the humid weath turned into an evening thunderstorm shower. I hurried and scrambled through even more rocks before finally finding a nice camping spot amongst the pine

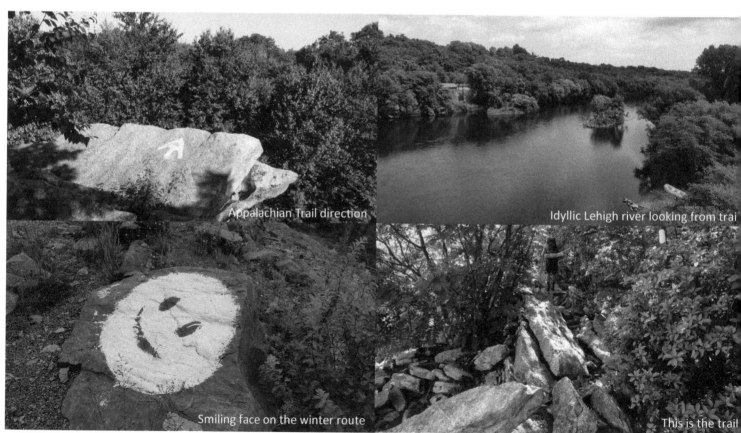

Appalachian Trail direction

Idyllic Lehigh river looking from trai

Smiling face on the winter route

This is the trail

Day 95: Dry trails
Thursday, June 27, 2019
Destination: *A mile from Wind Gap* ~ **Today's Miles:** *13.5*
Start Location: *Near Little Gap* ~ **Trip Miles:** *1277.9*

though it was humid and hot today, the trail was almost flat. Small rocky sections, but very
ageable.

tly after I left the camp area, I found more blueberries along the trail. I grabbed a handful of
n, their sweet taste making my breakfast complete. A few miles later, a day hiker named Shara came
behind. She asked my trail name, and told me that "Anchor" - a fellow thru-hiker who slackpacks
"Quest" - mentioned to her that I had a bad day yesterday. So Shara wanted to give me home
ed chocolate chip cookies, raspberries and cherry tomatoes. What a trail angel! The raspberries were
weet and juicy. The cookies were delicious! I saved tomatoes for lunch. Thanks a lot, Shara! I hope
can fulfill your thru-hiking dream soon.

biggest issue in this section was water. Springs were far from each other, and always far from the
trail, down steep side trails. So I carried enough water yesterday for the trail today, until I can
h the shelter about 11 miles away. I got there at 3pm, with only 3oz of water left. The spring near
shelter was also dry; it was a ten minute hike to get to the available spring. The water from the
ng was cool and sweet, quenching my thirst. From the shelter, it would be another 13 miles to go
the next water source. So I loaded up again, enough to cook dinner and brush my teeth tonight,
enough to last me through tomorrow's demands. I hiked 3 more miles after eating dinner in the
ter before settling down at a campsite with nice views.

et dreams.

John Muir: The mountains are calling, I must go ...

Day 96: Last day in PA
Friday, June 28, 2019
Destination: *Delaware Water Gap ~ Today's Miles: 18.1*
Start Location: *A mile from Wind Gap ~ Trip Miles: 1296.0*

Everybody wanted to get out of Pennsylvania as soon as possible! No matter how they planned it, everyone said they'd push a few extra miles today to get Delaware Water Gap. It felt like this little town had the power to stop the Pennsylvania rocks spilling over into New Jersey's mountains.

I pushed too. For additional two reasons: both my phone and battery power bank were dangerously low on power. In this modern world, even in the wilderness we still rely on the information our digital devices provide. It's a shame, but it is how it is today. The second reason was that I want to find a place where could order long noodles for dinner. It was my father's 95th birthday. Even though I could not go back to Beijing, I still want to follow Chinese tradition eating long noodles on a loved one's birthday. So I hiked a little over 18 miles on a hot day to reach town. 6.5 more miles than I planned.

The first 6 miles on today's trail were rocky and rockier. I needed to watch every step, placing my foot in the right spot. A couple of young men hopped, jumped and ran past me. I didn't know how they could possibly do that without falling or twisting their ankles. I knew one of the guys was a hockey player and marine. Maybe his training made him this capable!

After the rolling rocks came bigger rock piles of Wolf Rock. Compared with the others we had passed in the last two days, this pile of rocks was much ea to pass, though it still needed focus, puzzle solving skills and a good sense of balance. The trail gave me a small break after Wolf Rock with a mile of fire r followed by more rocky sections. In the last 6 miles before the town, the trail became pretty nice. In one section, the trail formed a pathway between rhododend blossoms. Not sure why these were blooming later than the ones I saw in Tennessee and Virginia, but they were sure very pretty. It was as if PA was trying leave us with some nicer memories before we leave it. Thanks for the beautiful flowers, but, no thanks, Pennsylvania, I will not miss your mean rocks and m

By 7:30pm, I rolled into town, had a dinner of Japanese ramen, showered, and stayed in the hiker's center at the Church of Mountain. Tomorrow, I will cross state line. The locals already set the July 4 celebration in full swing. Fireworks mixed with the sound of traffic and the dancing of fireflies.

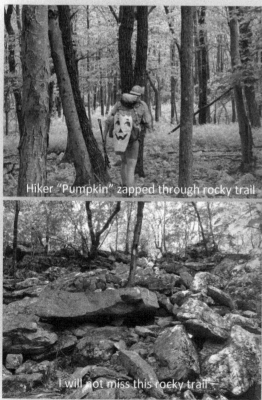

Hiker "Pumpkin" zapped through rocky trail

I will not miss this rocky trail

Day 97: Leave PA behind
Saturday, June 29, 2019
Destination: *Friend 's house* ~ **Today's Miles:** *1.2*
Start Location: *Delaware Water Gap* ~ **Trip Miles:** *1297.2*

was a sweet and short hiking day today. I only walked 1.2 flat miles to meet my friend from elementary school. So I got a late start, had breakfast with ce of apple pie, a fresh lobster roll, and some milk at the county bakery before I packed anything.

as Founders 's Day, a day for celebration. In this small town, they celebrated with a classic car show and craft show. I walked through these and passed from ntown to the bridge. In the middle of the bridge laid the sign of state line! I officially completed Pennsylvania and began my trip into New Jersey! I was so to leave the big rocks and mud behind in Pennsylvania!

friend picked me up from Kittatinny Visitor Center, which was closed. She took me to Edison for an afternoon of a relaxed spa trip, an Asian lunch, and a pping trip to resupply. Then we met another elementary school classmate for dinner! What a nice zero day!

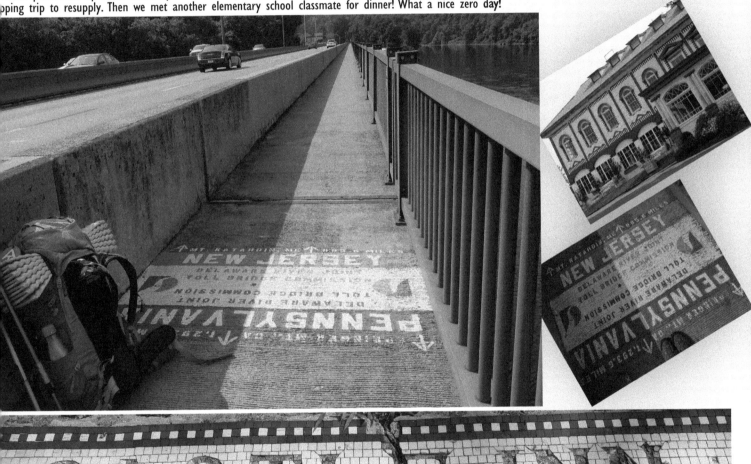

John Muir: The mountains are calling, I must go ...

Day 98 - 111: Appalachian Trail - New Jersey, New York, and Connecticut

*The easy & idyllic New Jersey, the grand & graceful New York, and the short & sweet Connecticut
Friends and families, wilderness mingled with social life*

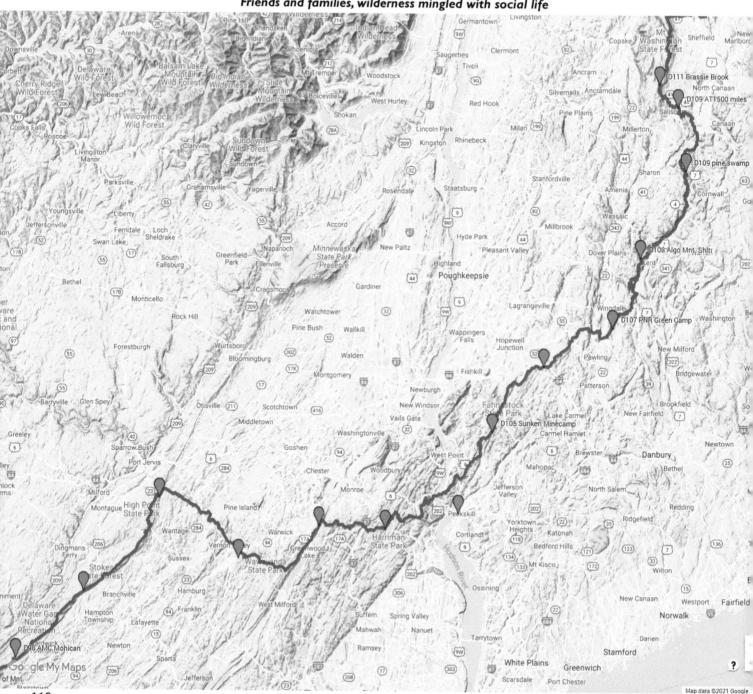

Day 98: Delaware Water Gap NRA
Sunday, June 30, 2019
Destination: AMC Mohican center ~ **Today's Miles:** 9.5
Start Location: Friend 's house ~ **Trip Miles:** 1306.7

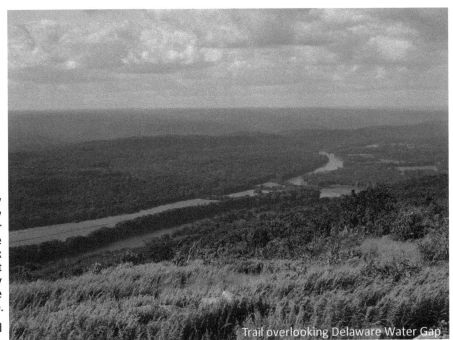

Trail overlooking Delaware Water Gap

sweet New Jersey!" That's what all thru-hikers say when they done with Pennsylvania and resumed their hikes in New ey. The trail did get better and was substantially less rockier the first full day of my Jersey hike. There were also some e interesting scenes along the way. I started alone on a bank creek, and as soon as I entered the forest, it felt at least degrees cooler. As the trail went higher, the shade gave way illtops with open views and blueberry bushes. Most of the es were not ripe yet, but there were some tasty ones for me.

rted late from my friend's home after 10:00am. We reached trailhead just before 12:20pm. With only nine miles of hik- I felt it would be an easy day. Halfway through the hike, I hed the Sunfish Pond - the first glacially formed pond on the alachian Trail, from the south. Piles of rocks formed its lake- trail, picturesque but hard to negociate. From the view on hill, the Delaware River curved in a slanted "S" on the left. A formed a lake and a few irrigation ponds on the right-hand . The wind blew loudly, keeping unwanted bugs away from face. Even though it was still rocky at some points, it was e than manageable to go through. By evening, I checked into Mohican Outdoor Center, where many families with children rent houses for their lakefront vacations. After a hot shower, as ready to go to sleep.

A resort camp at AMC Mohican Outdoor Center

John Muir: The mountains are calling, I must go ...

Day 99: Trail magic and wild lives
Monday, July 01, 2019
Destination: *Blink Shelter* ~ **Today's Miles:** 14.3
Start Location: *AMC Mohican center* ~ **Trip Miles:** 1321.0

This was the first day of the second half of the year. It started out pretty cool. I wore a polar fleece jacket in the morning. Only after climbing up a hill, sweating and out of breath, did I need to remove it.

I reached Catfish Fire Tower in about 1.5 hours. On top of the tower, the views were wonderful, and a cool breeze permeated the atmosphere. I was refreshed and rejuvenated by the time I decided to move on.

A couple of hours later, a neon green sign at the trailhead announced trail magic up ahead. On the other side of the road, three ladies set up tables, chairs and a grill. I was directed to sit down, and was presented with first class service: they grilled a cheeseburger, filled a glass with orange juice, and handed me a plate with fresh berries and a piece of pound cake. I was also served with deviled egg and potato chips. The Hunterton Hiking Club has been doing the trail magic for 20 years. I was their first hiker for the day. Thanks so much for the treat! I had my lunch really early today with all the food they served. I didn't feel hungry for the full day.

A little trail challenge in New Jers

Shortly after I left the trail magic spot, a lily-choked pond came into my sight. Frogs could be heard croaking loudly in the water as salamanders dipped in and out. The pond was calm, its reflections forming still paintings of the scenery above. Further up the trail, fallen leaves displayed the beginnings of the fall colors, adding to the warmth of the green forest. Suddenly, a family of wild turkeys came out near me, a mother with four chicks. The mother stayed cool while I videotaped them, not running around in panic. Later, the trail also climbed up a rocky ledge with big steps that forced me to use my hands to climb. It reconnected to a fire road very shortly. I was wondering if this was a fun way to show a little bit of the challenge of the Appalachian Trail. Up on the open ridge, there were so many blueberry plants. Most of the berries here were not ripe yet, either; it took me a few moments of digging to forage two handfuls of sweet berries.

By the time I reached Blink Shelter, I decided to stay for the night. The bear box and privy were too convenient to leave behind.

Day 100: 100 Days
Tuesday, July 02, 2019
Destination: *High point shelter* ~ **Today's Miles:** *19.6*
Start Location: *Blink Shelter* ~ **Trip Miles:** *1340.6*

days has significant meaning in Chinese culture. For a newborn baby, once he or she has survived the first 100 days, it is incredibly likely for that child
urvive to adulthood. Therefore, there is always a big celebration once a baby is 100 days old. For me, being on the Appalachian Trail for 100 days means
ving in the forest. It has been my home and my spiritual garden for the past 100 days. It can be simple, humble, beautiful, and sometimes even hostile. But
we loved each of the past 100 days. And I will continue to love it for many days to come.

ecting a long day of hiking today, I started very early. By 6:30am, I had left the shelter. It was a peaceful and beautiful sunny morning: the air was cool,
sunlight was gentle and streaked down from the heavens in soft gold. Very soon into the day, I came upon a viewpoint with big rocks and a shining lake
w: Culvers Lake. Its water surface reflected the sunlight like stainless steel. Shortly after, I came across a fire tower with a picnic table on the side of a cliff,
reat viewpoint that I could enjoy my break at. By noon, I reached Sunrise Mountain Pavilion. A family was doing trail magic there, with cold drinks, cookies,
kers and bananas. I stopped to enjoy the goodies and found a comfortable chair to rest my tired body. There was still 10.6 miles to go. The blackberries on
rise Mountain were very ripe now. I picked handfuls of the sweet berries. Further down from the Sunrise Mountain, another trail angel loaded 5 large bottles
drinking water at a shelter. He did this once every four days; the water source near that shelter was rather stagnant water, not good for hikers.

he afternoon, the trail entered High Point State Park. For a few hours, I suspected someone had gone back to Pennsylvania with a big truck, and transported
signature Pennsylvania rocks here. My pace slowed down. By 6pm, I reached the park headquarters, but the visitor center had closed. I missed a free soda
e, but was able to refill at a drinking fountain. I got the needed water, cooked and ate my dinner before going forward to High Point Shelter. Of these last
miles, the highlight was the monument for the highest point of New Jersey - a slightly smaller version of the Washington Monument in DC.

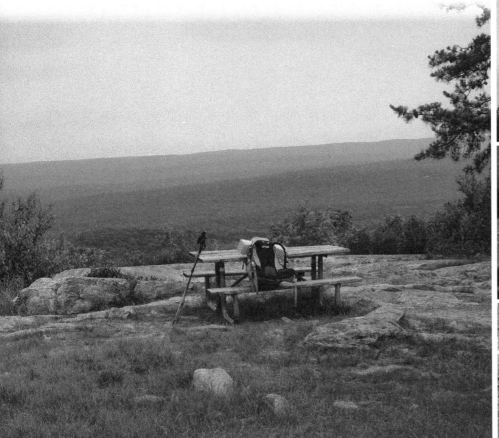

John Muir: The mountains are calling, I must go ...

Day 101: New Jersey's swamp
Wednesday, July 03, 2019
Destination: Appalachian motel ~ **Today's Miles:** 19.0
Start Location: High point shelter ~ **Trip Miles:** 1359.6

New Jersey, in its Chinese transliteration, contains the character "泽", means water, or marshland. Such a description was very suitable for today's trail. I walked through marsh and swamp on both temporary wooden boards and on beautifully constructed boardwalks. There were also lots of bugs. I wore my bug net for almost the entire day, and still got bitten on my hands, arms and legs - which were covered in clothes. There is no winning against bugs!

The forest and swamp were definitely pleasant for the native wildlife. I constantly heard birdsongs and frogs croaking. A frog with a shiny green top and brown bottom hopped near me. It froze for a very long time as I photographed it.

It was a hot day for hiking. It was a day better spent swimming in a pool, or napping at home. Even the maple tree under the sun had retracted its leaves to prevent evaporation. As the trail went through uncovered areas - which there were plenty - I could feel the heat coming from both underneath and overhead. My clothes were constantly wet with sweat. So drinking water occupied the forefront of my mind. It was fortunate that I carried enough water today from my last shelter. Maybe not all fortunate - it was quite a heavy load!

At the end of the day, I checked into a motel for the chance to get more food and cool drinks.

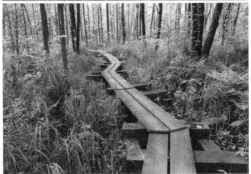

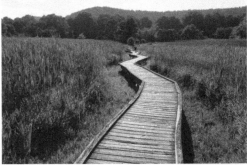

John Muir: The mountains are calling, I must go ...

Day 102: 4th of July
Thursday, July 04, 2019
Destination: *Wildcat shelter* ~ **Today's Miles:** *17.1*
Start Location: *Appalachian motel* ~ **Trip Miles:** *1376.7*

Happy 4th of July! I got on the trail by 8:00am. The hotel owner provided a shuttle for me to the trailhead. It was a very nice hotel, newly renovated with upscale fixtures, a large shower room, and built-in USB charging outlets. Though, I wish the laundry could be a little cheaper than the $10 it was, and have tea as an alternative to coffee.

The first two miles were steep climbs through rocky terrain. It was good that I was able to get this done before it got too hot. At the first crossroads, a cooler with many cold drinks sat alone, an offering by trail angels. I was hot and thirsty from the hard climb earlier, so I was really happy for the cold drinks. Then, at another road crossing, another cooler full of cold drinks greeted me again. I grabbed a piece of string cheese and another cold iced tea! Thank you to all of the wonderful trail angels providing us with much needed drinks!

Before 2:00pm, after scrambling up a few purple rocks, I arrived at the state line between New Jersey and New York. It was an emotional crossing for me. My family had lived in New York State for about 6 years before moving back to California. It's been almost 19 years since I left. It felt like coming back to my hometown! After crossing the state line, I sat there for some time, just to let the nostalgic feelings wash through my mind before moving on - mostly moving onto large rocks. It went on for a long time, some sections more challenging than others. The rocks all had a purple color, with white crystal inserts embedded. An American flag was set on top of a larger rock, contributing to the 4th of July atmosphere.

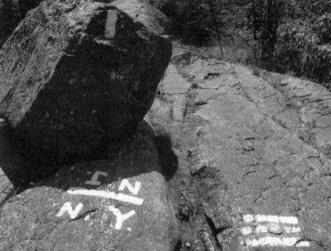

While I was briskly walking through an easy section of the trail in the afternoon, a loud rattling sound made me almost jump. A large rattlesnake was right there, about a foot from my left in the fallen leaves by the side of the trail. It was well camouflaged in the leaves. I must have surprised it too, as its rattling warning was the most earnest I had ever heard! I quickly moved away from it. It slithered forward to further investigate me - a large object that could mean extreme danger to the snake sized creature. I carefully backed out, keeping my eye on it and my distance. Its skin had a beautiful shine, and its belly bulged with its latest meal. A well-fed, healthy, large, and beautiful rattler! My first encounter of a rattlesnake on the Appalachian Trail.

By evening, I reached Bellvale creamery for a tasty ice-cream before hiking two more miles to Wildcat Shelter.

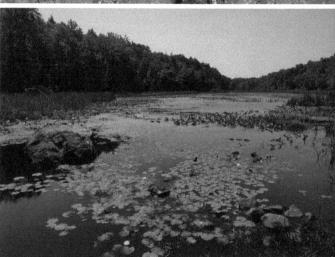

Day 103: Challenge trail on a hot day
Friday, July 05, 2019
Destination: *Fingerboard shelter* ~ **Today's Miles:** *14.3*
Start Location: *Wildcat shelter* ~ **Trip Miles:** *1391.0*

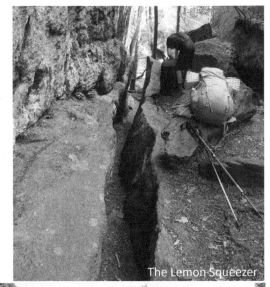
The Lemon Squeezer

was a hot and humid day. For the first time in a long while, my sweat ran down my face constantly.
the end, my skin chafed from constant drying with my bandana. The trail was challenging, too -
y large rock scrambles. The trail itself was built on those rocks! Sometimes, it felt the challenges
e put out here on purpose - to make it tougher. At a place called Lemon Squeezer, an AT-goer had
squeeze up and out from two rocks that formed a narrow crack - barely enough space to get one
son through without a pack. Fortunately, "Moon Walker" was there when I got there. He helped me
d my backpack so that I could walk through the crack with no problem!

this hot day, thru-hikers relied on the good will of local mountain club people. They put drinking
er at the trailheads and crossroads. Without them, I don't think I could have made it through - and
rried about 2.5 liters of water to start! I added at least a liter more from their bottles. Fingerboard
ter didn't have any reliable water nearby. I hope my water will last until tomorrow morning, when
t to the first water source. This shelter also had bear problems. I saw a bear trap set up here. The
r cables were nice to have.

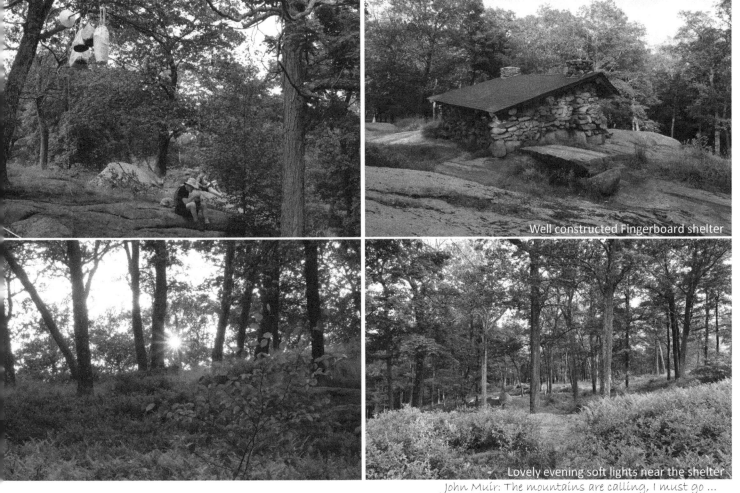
Well constructed Fingerboard shelter

Lovely evening soft lights near the shelter

John Muir: The mountains are calling, I must go ...

Day 104: Bear Mountain State Park
Saturday, July 06, 2019
Destination: Bear Mountain Inn ~ **Today's Miles:** 14.7
Start Location: Fingerboard shelter ~ **Trip Miles:** 1405.7

I planned to meet my classmate after about fifteen miles of hiking today, so I started early. Even the morning, it was hot and humid. The shelter didn't have any water nearby, so I planned to re at the public beach on a lake about a mile into the hike. When I reached the road that would to the beach house, I saw bottles of spring water at the trailhead, put there by the mountain volunteers. What a nice gift for the hikers! It saved me at least forty minutes of travelling to back from the lake.

Just before noon, a thunderstorm rolled in. The shower brought a nice relief from the heat. Instead covering myself with poncho, I let the rain soak my shirt and pants, leaving me feeling refreshed renewed. The sticky layer of salt and sweat washed away. The forest became alive again, as did I. showers came and went several times, breaking with beams of lovely sunlight dancing in the bre leaves. At lunch break, I cooked pine needle tea. My heat-clogged stomach instantly felt better. It a Saturday; many day hikers were on the trail. As they learned that I was thru-hiking the "WH THING", their eyes opened big, and words of admiration and encouragement were delivered. I proud and blessed.

In the early afternoon, I entered Bear Mountain State Park. For the next four miles, I walked al the best constructed trail on the Appalachian Trail up until now. This is the New York State th remembered: sophisticated and beautiful. Man-made beauties blended nicely with nature's wonders. state tax dollars were not wasted when I was a resident here. Even after I left this state for 19 ye I still feel lots of love for it.

My friend took me to her house for a yummy Beijing-style dinner, including a dessert of sweet juicy watermelon. It was wonderful to meet her whole family and see her grown children. What a tr

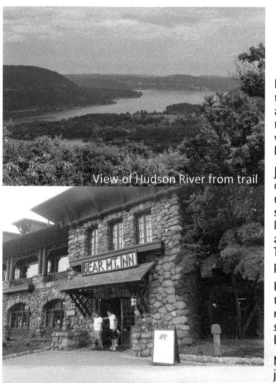

View of Hudson River from trail

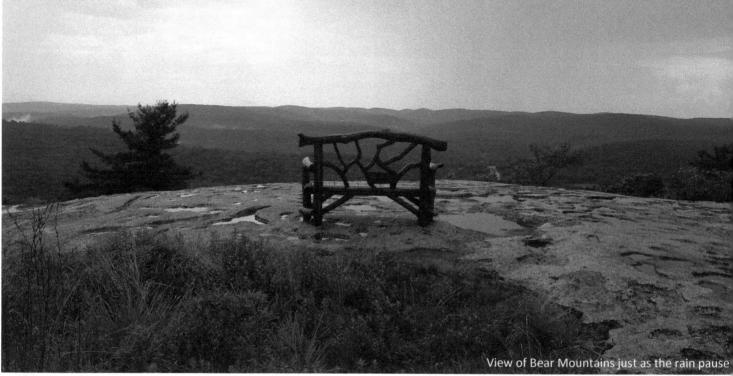

View of Bear Mountains just as the rain pause

Day 105: Slackpacking with a family of relative
Sunday, July 07, 2019
Destination: *Sunken mine road* ~ **Today's Miles:** *16.5*
Start Location: *Bear Mountain Inn* ~ **Trip Miles:** *1422.2*

What a relaxing day! The shower from yesterday cooled down the temperature. My consin's family, living near New York City, came to visit me and we day hiked together. So, my heavy backpack was in their car. The day was just twelve miles of light cruising through the forest. We picked blueberries and tasted some blackberries during the hike. There were a few short rocky sections and three hills on today's route, but all were very manageable. The bugs were still problematic in some areas, though.

Even though there weren't many great vistas today, I liked the company, and was happy to share anything they wanted to know about the Appalachian Trail.

For dinner, we went to a Spanish restaurant in the lovely downtown of Peekskill. Very tasty dishes with salads, seafood, cheese and meat platter.

After dinner, I went back on trail, hiked for about an hour more before settling down for the night next to a creek. Sweet dreams.

John Muir: The mountains are calling, I must go ...

Day 106: God bless America
Monday, July 08, 2019
Destination: New York Road 52 ~ **Today's Miles:** 14.3
Start Location: Sunken road ~ **Trip Miles:** 1436.5

It drizzled in the morning; not enough to make hiking difficult, but enough to get my gear and clothes wet. By noon, the sun came out, and it was hot humid again. A typical summer day on the east coast.

I came to Canopus Lake in the drizzle. The water was quiet and gray. A sign showed a side trail to a beachfront campsite. Going uphill, the panoramic view the hill hugging the lake was more impressive. From up on the hill, I could see the beach and people canoeing down there. It was very tempting, but it w. long way down. I kept walking.

Up on a hilltop, a large American flag was painted on the rocks. God bless America! I felt patriotic hearts beating here. Nobody loves their country as much the Americans do. We proudly and deliberately put our beautiful flags on everything, everywhere, and in every imaginable form.

In the early afternoon, I reached RPH shelter. It was a pretty property with cozy lounge chairs and picnic tables. There were two bird houses on a post in lawn. Orange day lilies and purple basil decorated the garden area. I wish I could have stayed for the night, but it was too early to stop hiking. Plus, five m down the trail awaited a pizzeria. I wanted pizza for my dinner.

I was not disappointed. The pizza, with its crispy thin crust, tasted so good. Last time I ate pizza was more than a month ago, and it was frozen.

After dinner, I hiked a little more and settled in an area between two busy roads. Hopefully the highway noises would die down in the night.

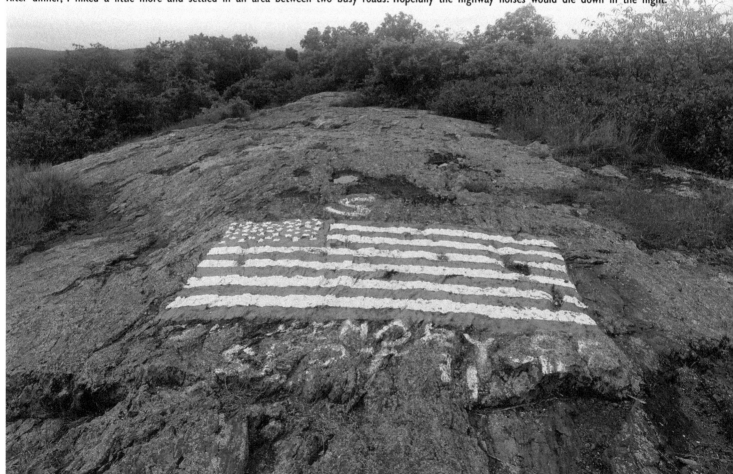

Day 107: Last full day in New York
Tuesday, July 09, 2019
Destination: *Pawling Nature Reserves* ~ **Today's Miles:** *17.0*
Start Location: *New York Road 52* ~ **Trip Miles:** *1453.5*

t out of my tent by early morning and saw the forest draped in fog. The canopy acted as a trap for the fog as I hiked through. The cool air felt good for
skin and lungs. By 8:00am, the sunlight warmed up the mountain, and heavenly lights broke through the fog. Lots of birds began singing their morning songs,
:alizing the forest. "Here, children, heeeeere!", they called earnestly.

ral large oak trees stood out on the trail. Unlike the one called "Keffer" in the south, these ones didn't have a name - but they were comparable in size.

r noon, I reached the Nuclear Lake - a clear lake with an alarming name due to its history of hosting a nuclear fuel processing research facility at the
tion. Most lakes and ponds I've seen in New Jersey and New York were overly nutritious and choked with waterborne plants. This lake was relatively clear
a mostly open surface. In the sunshine, it shined a pleasant blue.

ed an old-fashioned hand pump to refill my water at Morgen Stewart Shelter. It reminded me of a similar pump I used in the 1970s back in Beijing. I had
using it here.

late afternoon, I reached New York's Road 22. I got a cold outdoor shower and refilled my drinking water again from the Native Garden Center next to the
. Their garden was very beautiful, and their ice cream and iced tea were quite satisfying.

y I was planning to hike 15 miles, and ended up with 17. Not tired at all.

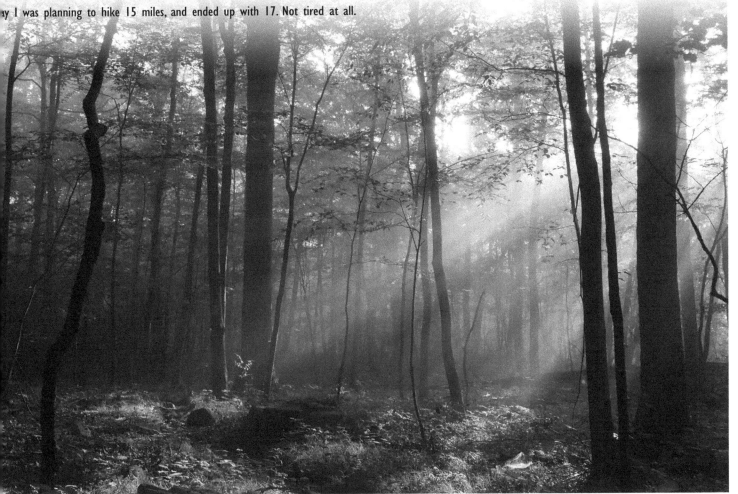

John Muir: The mountains are calling, I must go ...

John Muir: The mountains are calling, I must go...

Day 108: Entering into Connecticut
Wednesday, July 10, 2019
Destination: *Algo Mountain shelter* ~ **Today's Miles:** *15.0*
Start Location: *Pawling Nature Reserves* ~ **Trip Miles:** *1468.5*

The last four miles in New York State were easy and peaceful. At one point, in the quiet of the forest, I saw a half-dead tree with the profile of a joker's in black. It made my heart jumping, and at the same time made me laugh at myself.

By 10:00am, I arrived at the Connecticut State line. Nine states done, five more to go!

From there I climbed up and down Ten Mile Hill, the trail following a lovely creek that later turned into a river. The song of water accompanied me ac Bulls Bridge - a covered bridge. Along the river, cascades flowed through boulders, forming deep pockets of water in many places. I can tell it's a local favo recreation spot. Trout and bass are managed here for fishing. In a country general store, I bought cold drinks and a sandwich for lunch. A nice change f my usual energy bar and trail mix snack.

The weather was pretty hot, with highs of 88F degrees. All the serious climbs were in the afternoon. For me, the climbing part was not too bad. The real challe began after the climb. From the top, the trail started to go up and down, up and down countless times, across rocky and steep hills. Thankfully I had bo some Gatorade at the store and put most of it in my thermos bottle. It helped a lot.

By 7:00pm, I reached Algo Mountain Shelter to rest my tired body and feet.

Day 109: Rocks and river
Thursday, July 11, 2019
Destination: Pine Swamp Brook shelter ~ **Today's Miles:** 17.0
Start Location: Algo Mountain shelter ~ **Trip Miles:** 1485.5

was humid and buggy today, even in the morning. I was sweating hard the whole day. The going was rough for the first a few miles, especially following a b down a large boulder after St. Jones Ledge. As a person with short legs, I needed to use all fours - and sometimes my butt - to reach the carved staircases w. Two men passed me on that section, their long legs allowing them to deftly navigate the steps, one after another. It also didn't help that my left knee ted to feel funny during the climb down. Fortunately, as soon as I reached the river, the road became pleasantly flat. The following five miles were all that I ded to make up for time lost on the descent and complete my seventeen mile hike by twilight. The walk along the meandering river was also very soothing. g the way, I met an older gentleman who spent his time cutting branches at a couple of sections of this trail. I thanked him for his kind work.

most of the afternoon, I was on a trail with many ups and downs. For the last mile before I reached the Pine Swamp Brook Shelter, I had to traverse a ter version of the Lemon Squeezer. As I went through the cracks, I kept checking for snakes. If there was one, I'd be doomed; fortunately, there wasn't. I en't seen as many snakes in New York and Connecticut as I had in the southern states.

ade it to the shelter before 7:10pm, much faster than I thought.

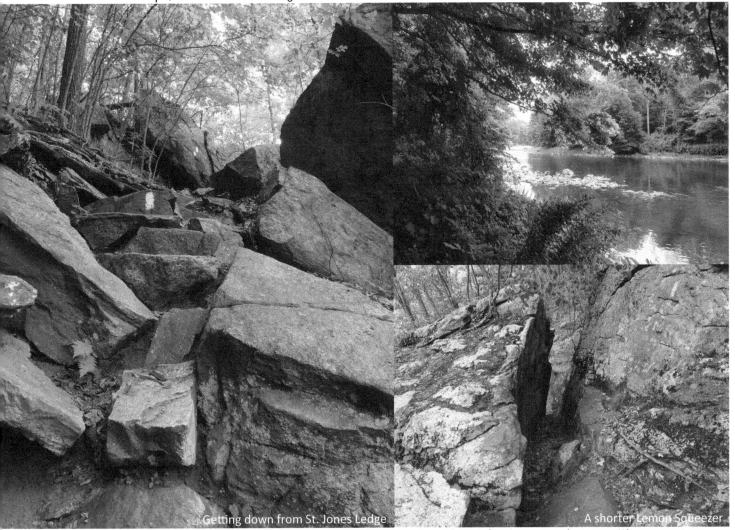

Getting down from St. Jones Ledge

A shorter Lemon Squeezer

John Muir: The mountains are calling, I must go ...

Day 110: 1500 miles
Friday, July 12, 2019
Destination: *Salisbury, Connecticut ~* ***Today's Miles:*** *15.0*
Start Location: *Pine Swamp Brook shelter ~* ***Trip Miles:*** *1500.5*

It was still humid in the morning, but at least it was on the cool side. So, the going was easy. In less than four hours, I had finished more than six miles and came to Mountainside Cafe. I ordered four different things: two pastries, a fruit cup, and a milk tea - and still felt empty after I finished. I requested a roasted cauliflower salad with tofu. Only after eating that, I felt full. It kept me from feeling hungry for the full afternoon.

For the next two hours of hiking, the trail was almost flat as it wandered along the Housatonic River. It was a well-maintained trail in the form of an idyllic boulevard lined with benches. It led me to a hiker-friendly hydroelectric plant. A cold outdoor shower head and a portable water faucet stuck out of the thick vines lining the brick walls of the plant. A few thru-hikers were sitting there for their lunch break. An iron bridge was saddled nearby, marked by the Appalachian Trail builders as a way to cross the river. I followed it to Amesville, a small helmet Falls Village. A man-made waterfall flowed nearby on the river generating electricity, partly utilizing the natural rock formation in the river itself. It was a q impressive waterfall. Up on Prospect Mountain, I could see a race track down below. The noises from race cars constantly disturbed the beautiful bird so sometimes unbearably loud. Half a mile from road 44, I reached the 1500 miles marker! Another milestone for my trek!

I had a nice sit-down dinner in Salisbury before my friends ferried me to their home about one hour away. Salisbury is a lovely little town. Well-kept buildi were decorated nicely with plants and crafts. I will take a break this weekend and next week from the trail.

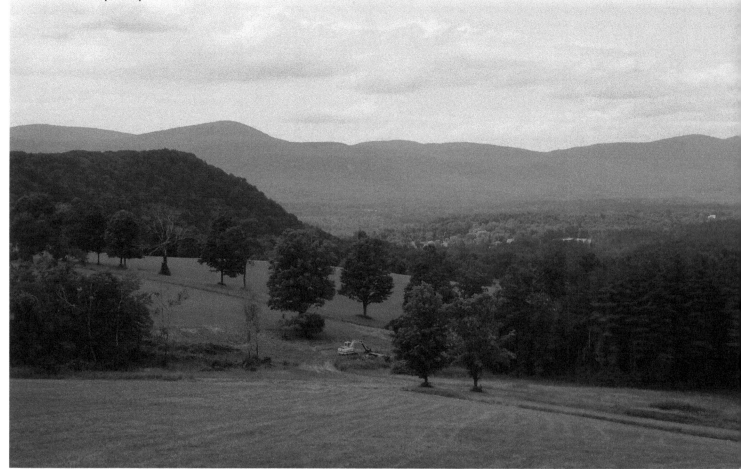

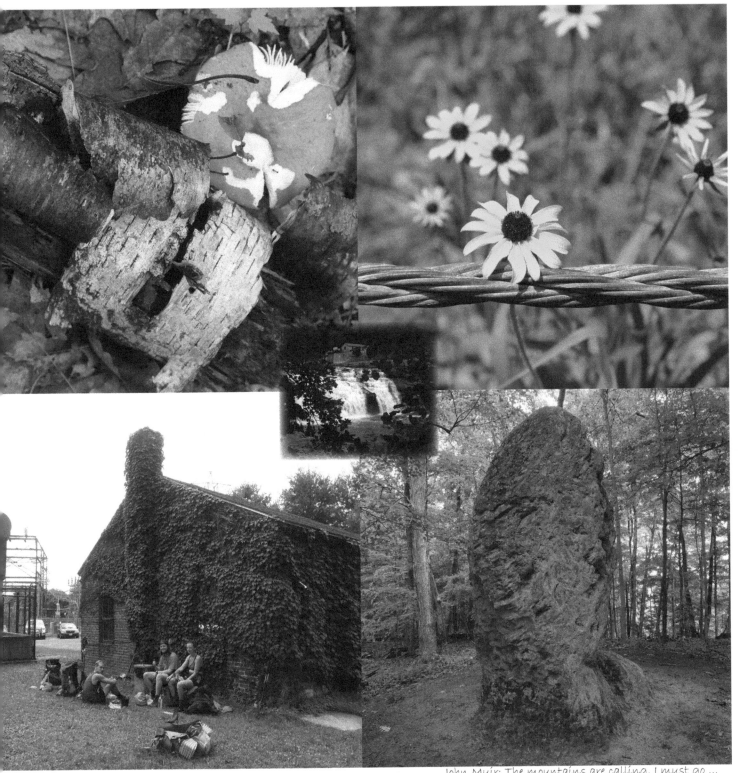

John Muir: The mountains are calling, I must go ...

Day 111: Space warp
Sunday, July 21, 2019
Destination: *Brassie Brook shelter* ~ **Today's Miles:** 4.9
Start Location: *Salisbury, Connecticut* ~ **Trip Miles:** 1505.4

In the past week, I warped through space and time to Beijing to visit my hospitalized father. Leaving him there and knowing that he will be released from hospital lifted a heavy stone from my heart. My friend in Albany, New York helped me a lot to make this trip possible. I cannot thank her and her husband enough!

Today, I came back onto the trail to continue my Appalachian Trail journey. Being confined in the airplane for more than fifteen hours made me sick. My throat hurt, I lost my voice, and had a fever for the most of the day. It was like walking on a soft cotton mattress with sore joints. So I only did less than five miles today, and pulled into Brassie Brook Shelter around 2pm. The trail was very easy today. I am glad that it stayed that way. My friends day hiked with me to Lion's Head before they turned around. The heat wave that had gripped the Northeast was waiting for me to return to the trail. By chance, I had avoided the heat wave up until this very last day. Tomorrow, the rain will bring much-needed cooler temperatures.

I met "So Far So Good" at the shelter. She's also just back on trail after a two weeks break recovering from an illness. It's nice to meet a lady with so many things in common between us. Later, a young "Pegasus" walked into the shelter. I had seen him in Woods Hole hostel two months ago. Being off trail gave me the opportunity to meet hikers whom I had passed long ago. He planned to continue to hike, even after dark!

An early good night today!

Lion's Head

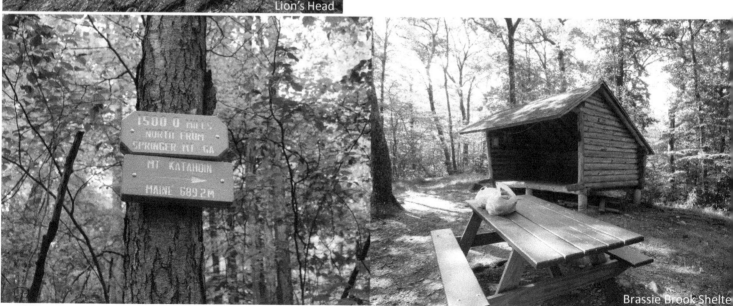
Brassie Brook Shelter

Day 112 - 118: Appalachian Trail - Massachusetts

Culture and forests intertwined; Massachusetts is a place appealing for everyone

D120 Goddard Shltr

D119 Congdon Shltr

D117 Green Vly motel

D118 Sherman Brook

D110 Xueyin home

D116 St. Mary Church

D115 Blueberry farm

D114 Webster Rd camp

D112 Road MA41

D111 Brassie Brook

D109 AT1500 miles

John Muir: The mountains are calling, I must go ...

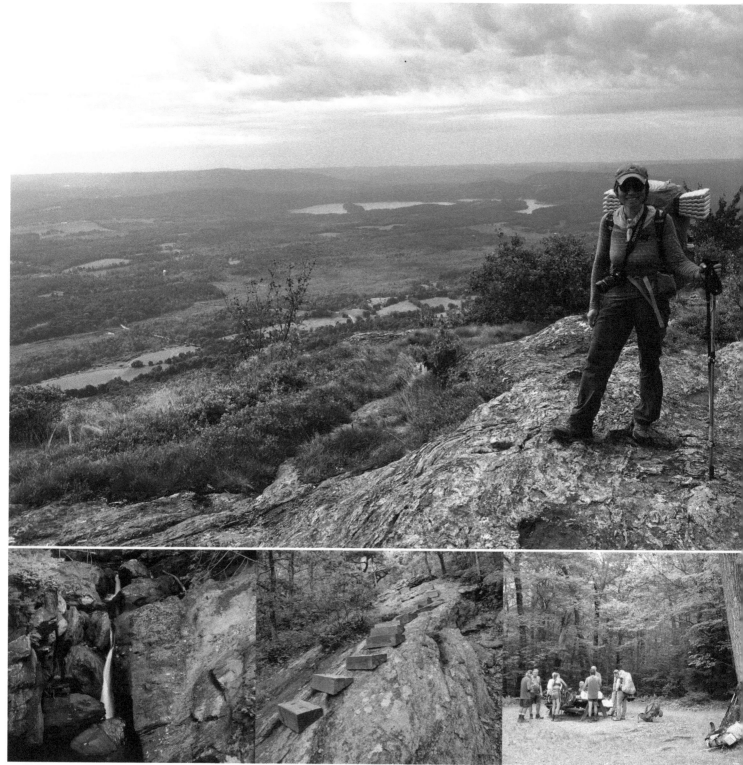

...pt for 10 hours, from 7:00pm to 5:00am. The rest was great for me, allowing me to recover from traveling and from my sore throat. Fully rested and ...shed, I started hiking by 6:10am.

...as much cooler today. Humidity was also down. It was a very pleasant hike all morning. Shortly after leaving the shelter, I came to a junction; Bear Mountain ...g the Appalachian Trail in one direction, and a detour around Bear Mountain in another. I chose the longer but easier option: going around the mountain ...I still didn't trust my knee to handle going down steep rocks. If there's an alternative, I'll choose that. So, I went to the side trail. It was almost flat, passing ...ugh a bog, an AMC cabin, and a path following a small creek parallel to the Connecticut-Massachusetts state line. After about thirty minutes, it rejoined ...alachian Trail right before the state line - but there was no official marker! Only a line drawn by a hiking pole on the ground marked the crossing. Later, I ...erstood why. The trail went along Sage Ravine Brook for about 1.5 miles. Even though most of that area is within Massachusetts, it is actually managed by ...necticut. Therefore, the Massachusetts message only appeared when the trail left Sage Ravine Brook. This area was a fragile environment: a bubbling creek with ...y swimming holes, dense forests, and twisting roots wrapping around mossy rocks; cool, dark, and with that "magical fairy tale forest" kind of atmosphere. As ...ssed through it, I held my breath unconsciously, afraid of making unnecessary sounds that could break the magical spell cast upon that area.

...magical place was followed by open views on Race Mountain. The Appalachian Trail ran along open ledges, where I saw green forest and shiny lakes, rocky ...s with narrow cliffs on one side, weather-beaten pines and oaks only grown to dwarf size, all from up above on the perch above trail. Blueberry bushes ...e at ankle height and loaded with ripe berries, so tasty and sweet. I put my backpack down to go berries picking. In just five minutes, I got many handfuls ...uicy berries.

...re noon, I reached Mt. Everett. A few cement posts of a fire watch tower marked the top of the mountain. The tower burned down in 2002, leaving the posts ...good benches for hikers to take a break. When I got down from Mt. Everett to Guilder Pond Trailhead parking, a few day hikers were doing trail magic with ...cold water and cookies. It was very nice to have the fresh water available when the water from nearby creeks was all brown.

...d my lunch at Glen Brook Shelter's tenting area. This was my planned camping location. But since it was both so early in the day and the rain hadn't started, ...ecided to hike more, down to road 41. Fortunately, I was not tired at all.

...hour later, the rain started, first light drops, then steady rain. I was looking for camping spots, but didn't find anywhere good enough to stay. So I kept ...ng until I reached the road at 4:30pm. By that time, I was pretty wet. Even though I was not tired, I had given up on camping and booked a hotel about ...niles away in the town of Great Barrington. Getting to the hotel was a lot more difficult than I expected. After more than 10 calls to the hotel and a taxi ...pany, three tries on Uber, and more than thirty attempts to hitchhike, I was still at the trailhead with pouring rain two hours later. In desperation, I called ...en - an Appalachian Trail thru-hiker of 1994, who was listed in the Appalachian Trail guide book. I contacted Karen earlier today at noon, hoping she would ...e an available room for rent. But she had a full house today and could not spare any room for me. When I called her again after 6:20pm and explained my ...kward situation, she immediately came to my rescue! In five minutes, I was in her truck on the way to my hotel. She's not only helped me today, but also ...nged for her partner to pick me up from the hotel tomorrow morning to send me back to the trail head. What a wonderful trail angel she is! Thank you ...much, Karen! With Karen's help, I am now dry and comfortable in the hotel room, ready to have a good night's sleep.

John Muir: The mountains are calling, I must go ...

Day 113: Quiet and wet
Tuesday, July 23, 2019
Destination: *Tom Leonard shelter ~* **Today's Miles:** *10.0*
Start Location: *Massachusetts road 41 ~* **Trip Miles:** *1528.2*

My experience in last night's hotel was awful. The people who run the hotel were either cold-blooded or had hatred towards hikers. I wrote my review on TripAdvisor and sent an email to Appalachian Trail Conservancy requesting them to remove this hotel from future hiker's guide book. To be brief, they said my backpack was ugly and cannot stay in their front porch for even less than 5 minutes. Their breakfast was so lean, only half-sized bagels and some cereals. Anything you ask for a little bit help from them, they kept repeating that it is not their job to help you. Anyway I will never stay there again.

To talk about something positive, Karen's partner David came this morning to help me get back to the trail head. He told me that Karen was a triple crowner, and an author of many award-winning books on hiking and music. I was honored to meet Karen and David. I also read one of her books about the Pacific Crest Trail a few years ago. What a great person she is.

There was a chance of rain for most of the day. But all it amounted to was just a few drops here and there. Not even worth putting on my rain gear. Despite this, the trail was still pretty wet, slippery, and full of mosquitoes. In the first hour of my hike, I collected more than twenty mosquito bites. The forest was so beautiful. Lichen and moss-covered rocks and trees, making the forest very verdant and interesting to look at. It was dark and quiet. Wet leaves, shining brilliant green, made my clothes wet as I brushed along them. In the afternoon, I traveled along the eastern side of the mountains. It was a monotonous trail, with low bushes lining both sides, and many small ups and downs for a long time. By 4:00pm, I reached Tom Leonard Shelter. Throughout the day I only came across three hikers in the early morning, until more hikers showed up at the shelter after 5:30pm. For most of the hike today, I walked in solitude.

Day 114: A perfect hiking day
Wednesday, July 24, 2019
Destination: Webster road ~ **Today's Miles:** 16.0
Start Location: Tom Leonard shelter ~ **Trip Miles:** 1544.2

It was a perfect day for hiking! It's been a long time since I had such a good hiking day. Temperatures were between mid 50s to 70s. It is sunny and low humidity, with a little breeze throughout the day. I left the campsite before 7:00am. The first mile was filled with the fragrance of an unknown wildflower. Sunlight filtered through leaves leaving patches of gold, making moss so brightly green that their verdancy blinded. A couple of hours later, I came to Benedict Pond. A few large rocks were half-submerged in clear water, making a great spot to rest and catch a little breeze. Mosquitoes didn't like the wind, which gave me a nice reprieve. Blueberries were abundant here. Very soon my hands were busy picking them.

Near the Wilcox South shelter, I met a group of teenagers. They call themselves "Greenagers" - a volunteer organization to fix the trails. They are the hope for the future of America.

When I reached Jerusalem Road, I found a trail stand from Running Spring Farm. It had soda, snacks and FRESH EGGS! I bought one can of Mountain Dew and two eggs. Right there I hard-boiled them on the spot by the roadside. They tasted so delicious! As I write about them, I wish I had ordered double. The extra food and drink gave me more power. I continued for an additional three miles with 1000ft of elevation gain before calling it a night.

Bye for now, sweet dreams.

John Muir: The mountains are calling, I must go ...

Day 115: Ponds
Thursday, July 25, 2019
Destination: *Cookie Lady Blueberry Farm ~ **Today's Miles:** 16.1*
Start Location: *Webster road ~ **Trip Miles:** 1560.3*

The trail went around so many lakes and ponds today. They reminded me of a movie "On Golden Pond" from the early 80s. It was one of the few Ameri movies shown in China in the immediate period after the country opened its doors to foreign culture. The beautiful scenery was very memorable to me, e though I did not fully understand that movie. For all the ponds I have passed today, if I had to pick a favorite, it would be the Finerty Pond. Near the sh pink flowers grew in the water, while plants with spiky fruits and water lilies rested on its surface. Blue dragonflies darted to and fro, from one plant to anot The shore was full of flat rocks, so walking through it was effortless.

The trail had many muddy sections. Some of them reminded me of the sections in Pennsylvania, but people in Massachusetts have done a better job v maintenance. They lined the trails with wooden planks or stepping stones, so my boots remained dry.

My favorite activity happened near evening. I came to a hiker-friendly blueberry farm near the trail. I picked a bucket of blueberries - much larger than the v ones found on trail. I ate half for dinner and will have the rest for tomorrow's breakfast. Part of my dinner was fresh eggs, also courtesy of the farm. I ate meal on the farm's lawn - breezy, and mosquitoes at a minimum!

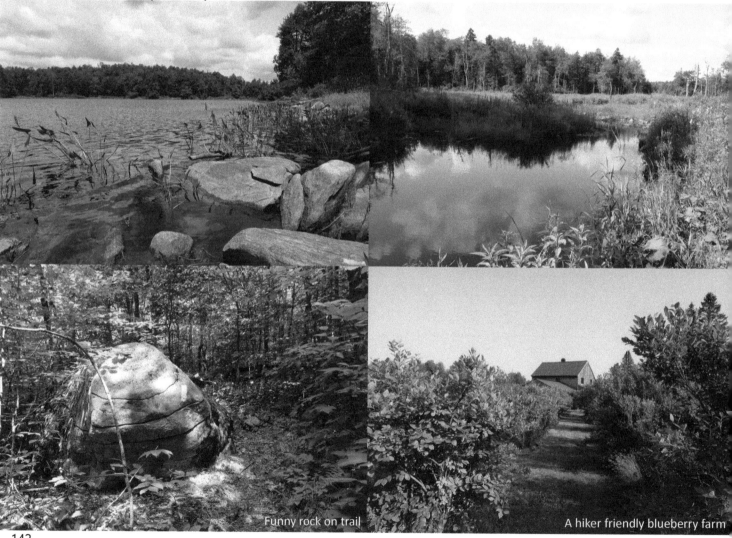

Funny rock on trail

A hiker friendly blueberry farm

Day 116: Calories intake
Friday, July 26, 2019
Destination: *Cheshire, Massachusetts* ~ **Today's Miles:** 18.6
Start Location: Webster road ~ **Trip Miles:** 1578.9

the shelter's registry book, a hiker wrote that he saw a moose with its baby yesterday. I didn't know moose lived so far down south in Massachusetts. I did see something that looked like moose droppings in the past couple of days - maybe they are around here. You never know what is hiding among the dense forest.

the evening, the trail passed a cobblestone hill. The whole hill was made of white marble, a very impressive size, too. I visited a marble museum in Vermont y years ago. The texture and patterns on those marvelous stones gave me great memories. Now, thinking about this whole mountain containing these transparent rocks made me smile as I walked on it, even though it was not as well-polished as the ones I've seen in palaces. Some parts of the path were red with marble sand, pure white, sparkling in late afternoon sunlight.

y I also crossed Dalton, Massachusetts at noon. Its community recreation center allowed hikers to take a shower with a $5 donation. I took the advantage t. Once cleaned, I ate a nice lunch at Dalton Restaurant across the street. This satiated my hunger for the whole afternoon, much longer than what energy and trail mix could. Also, it pushed me to hike an additional 4.4 miles to reach the little town of Cheshire. As I walked into the town, I heard music blast. seniors stopped their car to chat with me about my hike on the Appalachian Trail. They told me the town was hosting a block party tonight. After I set my tent in the lawn of the Saint Mary's church, I went to join the party. A band was playing music, kids with painted faces and hands were running and cing while holding balloons. There was also a food truck selling burgers, hot dogs and sodas. An ice cream stand was next to the truck. I had a dinner with eseburger and ice cream! I got a lot more calories today. There was also a day hiker doing trail magic in the morning. I took one blueberry donut from stock. In the evening, at the church, a 12 year old boy also did trail magic. He gave me an apple and filled my water bag. So my intake of calories today ld definitely be close to the recommended amount - five thousand calories!

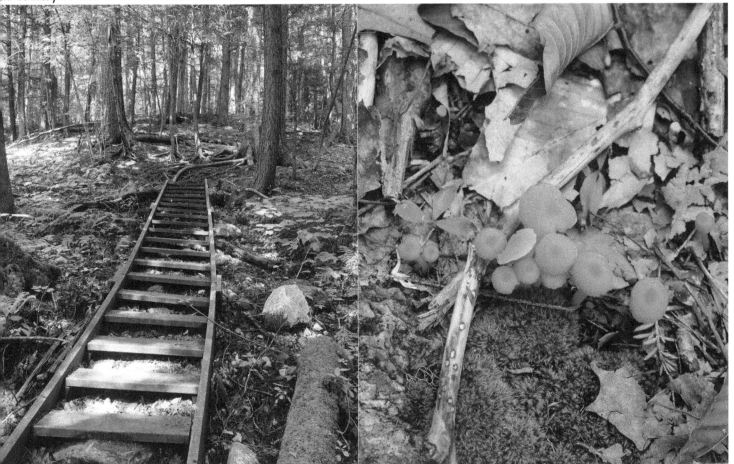

John Muir: The mountains are calling, I must go ...

Day 117: Great summer fun
Saturday, July 27, 2019
Destination: Route 2 near North Adams ~ **Today's Miles:** 14.5
Start Location: Cheshire, Massachusetts ~ **Trip Miles:** 1593.4

Even though Cheshire is small, one of its residents had great influence in American history. Elder John Leland played an important role in the creation of the first amendment of the constitution: the freedom of speech! In the lovely morning sun, the star-spangled banners lined up on the street near its elementary school. Walking on the Appalachian Trail sometimes feels like reading an American history book brought to life.

The Massachusetts section of the Appalachian Trail is well graded and maintained. Walking in its forest is an enjoyable experience (minus the bugs). It has enough ups and downs to keep one's heart pumping, but without too much worry about a twisted ankle or a broken leg.

Since I left Shenandoah National Park, today was the first time that I went to a peak higher than 3000ft. By noon, I was standing on Greylock Summit, the highest point in Massachusetts. The war memorial was the most artfully designed and best-constructed monument on Appalachian Trail that I have seen. Compared to this, Clingman's Dome in the Smokies feels so raw! In the (comparably) grand building of Bascom Lodge next to the tower, I had a sit-down lunch with a grilled cheese sandwich and some cool orange juice. One guy, who was day hiking in the state park, kept asking me questions about my Appalachian Trail thru-hike. Recently, I have gotten a lot more compliments from people when they learned that I have been walked to "here" from Springer Mountain in Georgia. It was too far to walk from and was almost unimaginable for many of them. Most of the people wished me the best on my journey. To all of the strangers who made well-wishes and wonderful comments, thank you.

An encouraging sign by trail

There were also many south boun[d] now. Just today, I saw about ter[n] them. In the campsites where hi[kers] congregated, we swapped informa[tion] and stories.

Right before 5:00pm, I reached R[oute] 2 near North Adams and Williamst[own.] My college classmates picked me [up.] They drove more than three h[ours] from Boston to meet me. With t[he] car, we checked into a motel [near] the border of Vermont, showered, [did] laundry and ate a good dinner. In [the] evening, we learned that there [was] a fireworks show in Pownal, Verm[ont] and went to join the party. The s[how] was great. Party food, cotton ca[ndy,] night-illuminated toys made the [kids] and kids-at-hearts so happy. The b[and] played very nice country music as [we] danced to the music along with [the] locals. When the darkness fell, firew[orks] began. All the oohs and ahhs c[ame] in rhythm with the lights in the [sky.] The kids went wild! It was suc[h a] wonderful night, in the cool sum[mer] breeze on the expansive lawn at [the] heart of a small town.

Day 118: Natural Bridge and Mass MoCA
Sunday, July 28, 2019
Destination: *Sherman Brook Campsite ~* **Today's Miles:** *1.8*
Start Location: *Route 2 near North Adams ~* **Trip Miles:** *1595.2*

this zero day, my classmates and I visited Natural Bridge State Park and Massachusetts
seum of Contemporary Art (Mass MoCA for short) in North Adams after I did shopping for
upplies. Natural Bridge is next an old marble quarry. The quarry had stopped production and
been converted into a nice-looking U-shaped marble cliff, over a green lawn lined with bushes
flowers. The titular Natural Bridge is over a water pathway flowing down a marble dam - yes,
only dam in North America completely made of marble blocks! The water generated was for
istorical mill that had been destroyed in a fire more than seventy years ago. The power of
current created deep chasms with circular pools and cut under the marble to make a bridge.
ges of green from lichen, moss, small plants; yellow and cinnamon from minerals depositions
combined with the white and gray from the stones, creating deep and curvy chasms in nice
trasting patterns. A short trail in the woods nearby added a more relaxed atmosphere in the
k. We had a snack break before noon under a shady tree in the cool breeze.

the afternoon, we spent about four hours in Massachusetts Museum of Contemporary Art - a
y large museum spanning multiple brown stone buildings, converted from an old electronic
ory. There were many exhibitions with different media, all modern and expressive. It was also
opular place here, with restaurants and coffee shops close by. We had a late lunch there, then
vas back to the trail by 4:30pm.

friends offered to carry my backpack for a while to "experience the A.T." as they said. Then
said goodbye and went our separate ways. I hiked alone again. The sound of thunderstorms
rted to roll in closer. At close to 6:00pm, I reached the campsite for the night. I was just
e to set up my tent before the showers began pouring water from the sky. What a great
ing - I was lucky enough to keep dry for the day!

Some exhibits in Mass MoCA

The marble dam

John Muir: The mountains are calling, I must go ...

Day 119 - 128: Appalachian Trail - Vermont

Very green and muddy. Here is the side of Vermont that I didn't know before

D128 happy/hill shlt

D129 NHit 20

D124 Minerva Hinchey

D123 Lost Pond shltr

D122 Sutton place

D121 Stratton Mount

D120 Goddard Shltr

D119 Congdon Shltr

D117 Green Vly motel

D118 Sherman Brook

Map data ©2021 Google

Day 119: Soggy trail
Monday, July 29, 2019
Destination: Congdon shelter ~ **Today's Miles:** 12.5
Start Location: Sherman Brook Campsite ~ **Trip Miles:** 1607.7

In the morning at 10:00am, I said goodbye to Massachusetts and stepped into Vermont. Eleven states done, three remained. Today's trail looked damp and muddy. Not long after that state line, a stick marked 1600 miles of the Appalachian Trail; less than 600 miles to go! In this section, the Appalachian Trail follows another famous one: The Long Trail. It was actually the inspiration for the Appalachian Trail.

To summarize today's trail, I will use just one word: soggy. Most places had mud two to six inches deep. Even though the terrain was not difficult, I walked very slowly, picking my way through the mud. The twelve miles today lasted so long. I spent almost nine tiresome hours trudging through it, not counting the time spent resting or eating. Every dry stretch was a blessing. Here, toads, big and small, called it home; some as small as my thumbnail. They hopped around on the trail, getting in the way of my feet.

Finally, I pulled into Congdon shelter just before 6:00pm. There was no energy left in me. Sweet dreams!

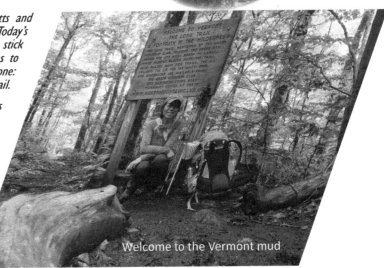

Welcome to the Vermont mud

Typical Vermont Trail

John Muir: The mountains are calling, I must go ...

Day 120: Finally some dry trails
Tuesday, July 30, 2019
Destination: *Goddard shelter* ~ **Today's Miles:** *14.4*
Start Location: *Congdon shelter* ~ **Trip Miles:** *1622.1*

I knew I was in Vermont when every direction I looked, I could see marble. Even some of the gravel roads are made of crushed marble. Many of the stepping stones on the trail were the same - smooth, polished rocks that looked slippery and wet. Automatically, I began watching where I stepped.

There was less mud on the trail today, so my traveling speed improved. For 14.4 miles, I spent less time on the trail than yesterday, despite the higher elevation gain. I hope this condition holds for tomorrow - I need to hike more than 17 miles to get a good camping place.

Still seeing lots of jumping toads and frogs. Some parts of the trail passed by stagnant pools of water. Wooden boards were placed over swamps. There were no good views of any pond today, as overgrown forests and bushes blocked all the views. In the morning, it was humid and warm. In the afternoon, however, a slight breeze came over the ridges and made climbing so much enjoyable. I am expecting rain tonight. The sound of rain drops will make me sleep better.

Day 121: Enchanted forest
Wednesday, July 31, 2019
Destination: *Stratton Mountain* ~ **Today's Miles:** *16.6*
Start Location: *Goddard shelter* ~ **Trip Miles:** *1638.7*

enchanted forest had many characters: trees, carpets of moss and flowers, eks and springs, and large, interesting rocks. The foliage of this forest was so se that sunlights could only sparsely penetrate through canopy. Green Mountain in Vermont was the ne of this forest. Its canopy forever kept sunlights away, leaving the ground ist and the air damp. The fallen ves made the ground so spongy, king on it felt as if I was uncing. Its green mosses w long, with their spurs king out on hair-n stems that made m look as if they re floating in the . Its springs were cold that when I shed my feet in e water yesterday, could only stand temperature for few seconds.

lking through the est, especially after t night's rain and the zzle at noon, brought joy. The shining clean ves, nodding wet flowers, d orange spotted salamanders distracted me from concentrating my footing. There was mud, mud and d everywhere.

The only good thing about the trail itself was the lack of bugs due to the cool temperature. One less thing to distract me from my focus.

Stratton Mountain holds a special place in the hearts of all Appalachian Trail thru-hikers. It was here, more than eighty years ago, that Benton MacKaye's idea of a very long trail to link all Appalachian peaks was formed. It is a sacred mountain to behold. The trail to the peak was well maintained and easy to walk. The 1700ft elevation gain from the trailhead didn't feel difficult at all. It was late afternoon when I reached the fire tower at the peak close to 6:20pm. Thunder could be heard roaring nearby. The trees were shrouded in fog. It was too late to go down the mountain to the shelter three miles away. I decided to stay overnight near the spring, a short distance from the peak. After I set up the tent, the late afternoon sun peeked through clouds for a short hour before sunset. The enchanted forest around my campsite felt magical once more. I am lucky to be able to stay on the very mountain where the Appalachian Trail was born.

John Muir: The mountains are calling, I must go ...

Day 122: Going to Manchester Center
Thursday, August 01, 2019
Destination: *Manchester Center ~* **Today's Miles:** *13.0*
Start Location: *Stratton Mountain ~* **Trip Miles:** *1651.7*

In the morning, I found three large crickets and about a dozen slugs on my tent and backpack. That was quite a rich environment that I spent the night in.

Today was a super easy day with perfect weather. I hiked into the town of Manchester Center in about thirteen miles. It was mostly downhill on gentle grades, with not much uphill. However, I still had to pick my way through the muddy trail - and there was a lot of mud. The Green Mountain Club that maintains the trail has their work cut out for them.

At noon time, I reached Prospect Rock, which had wonderful views of the town below. It looked so far away from where I sat, but within two hours of leaving the area, I reached the town. It was not big, but was very quaint and had everything people need to live comfortably. Abby from California, who was doing summer work on a farm here, saw me walking on the busy road and offered me a ride for the last mile into the town center. She used to work in Hidden Villa, 16 miles from my home, one of the local farms in San Mateo county where I had hiked many times. What a small world.

In the afternoon, I did laundry, resupplied, visited their farmer's market, and had dinner at a local ingredient-only taco restaurant. All set to go back to the trail tomorrow.

150

Day 123: Trail story
Friday, August 02, 2019
Destination: Lost Pond Shelter ~ **Today's Miles:** 14.5
Start Location: Manchester Center ~ **Trip Miles:** 1666.2

he early morning, "Wheels" shuttled me back to the trail head. Her husband ddy long legs" was with us, doing the thru-hike "flip-flop" style. They are h from Georgia Tech. He retired earlier this year and planned to do this , but in the spring, found out that had cancer. A surgery was scheduled months later. Instead of waiting at ne for his surgery, he did over six dred miles of the Appalachian Trail, ng north from Harpers Ferry until he ded to be back for his surgery. After recovery six weeks later, he was back trail, trying to finish the rest of the thern section, then flipping over to pers Ferry to walk south, back home. heels" meets him every week to give support and making sure he's taking est day. I happened to stay in the e rental house with them last night. y were so kind to give me a lift to trail head.

e and a half miles into the hike, when pproached an unpaved forest road, potted a trail magic sign. "Spineless gar" from Albany, New York was there, ng out watermelon slices, oranges, anas, donuts, cookies and cold drinks. has been doing this for five years since retiring. I was hot and sweaty ing just come down from a peak; the cool watermelon was the best sible food for that moment. Thanks for the magic!

In the early afternoon, I reached Peru shelter. This shelter was first built in 1935, and rebuilt twice, with the last remodeling in 2000, a well-constructed sturdy shelter with a stream burbling happily next to it. Half a mile later, I was at a lake. Like most lakes in the northeast, it was always crowded with aquatic plants.

After a few hours of ups and downs, the last climb of the day was Baker Peak, before the trail descended to my planned campsite at Lost Pond. Near the top of Baker Peak, suddenly around a corner, were big, slanted rocks making up the pathway of the trail, as if they dropped out of the sky. I hadn't seen this type of rocks since Pennsylvania. It was so different from the soft muddy peaks in Vermont so far. After climbing the rocks and taking in the nice views around the peak, I saw a sign pointing out a "bad weather route". I have not seen such a sign before climbing the rocks on the other side of the peak. Was the sign only there going down through these rocks, because they would be a lot more dangerous than going up?

There were more than ten people in the Lost Pond shelter area. I have gotten to know many of them on trail. It was nice to chat with them, and exchange knowledge and information.

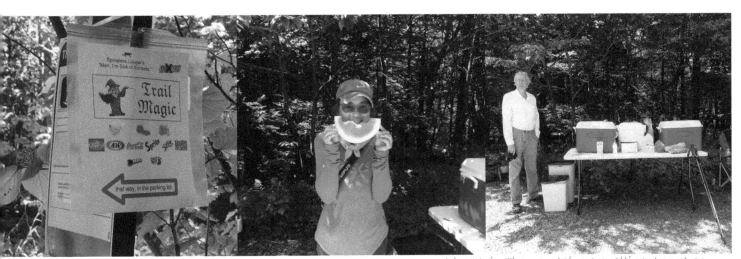

John Muir: The mountains are calling, I must go ...

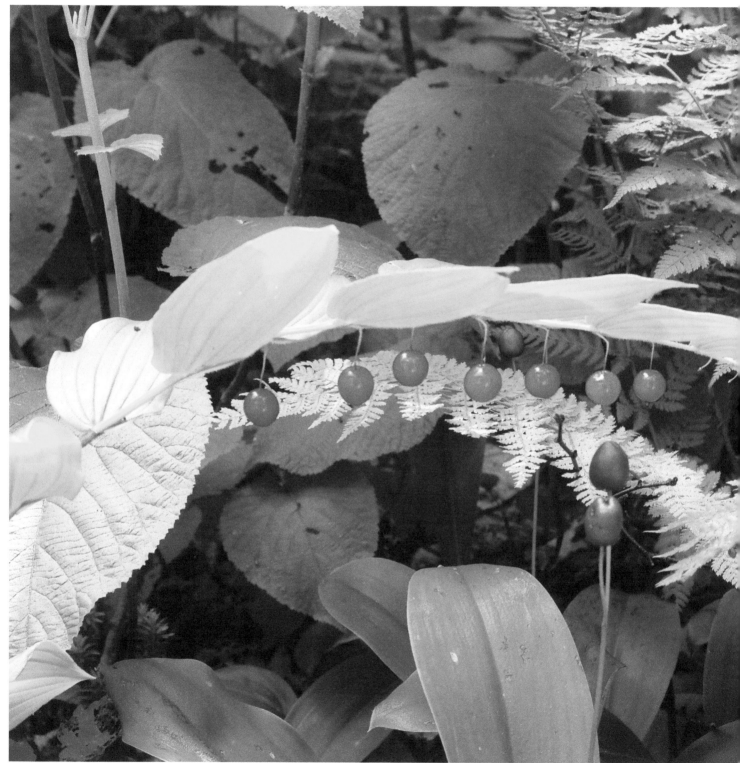

John Muir: The mountains are calling, I must go ...

Day 124: Triple trail magics
Saturday, August 03, 2019
Destination: Minerva Hinchey shelter ~ **Today's Miles:** 14.9
Start Location: Lost Pond Shelter ~ **Trip Miles:** 1681.1

The rain came quickly in the morning, just before I packed my tent. After I started hiking, the rain left as quickly as it came, and the sun was out again. Yet due to the rain, and the humidity, I had to carry a wet tent for the rest of the day.

I started hiking with "Stripe", who carried am American flag on his backpack. He proudly told the hikers that at his home - which was close to an airport, he made sure to hung a huge flag so that every plane passing overhead could see it.

Before 10:00am, I reached Road 10 where there were two spots of trail magic going on. The first one was by a guy from the Syracuse, New York area. His decorations were very cute with colorful tablecloths, lots of toys, and flowers. I ate

a lot of food there, including two fried eggs, some potatoes, a sausage, t large pieces of bread, and two pieces of watermelon; a hearty breakfast. mile later, another group of locals also set up trail magic cook a full breakfast and lunch. Despite their hard effo to offer me food, I only took a few gummy bears and to a picture of the set up.

In the early afternoon, the trail passed an area with la boulders. People put many rocks on top of the boulders some meditative hoodoo-building. It looked cool.

After a hard climb in the afternoon, I was ready to set my tent and settle for the night. A group of young B Scouts nearby cooked too much food, and gave each hik at the shelter a portion of their bean and rice burrit Consider this as the third bit of trail magic for today!

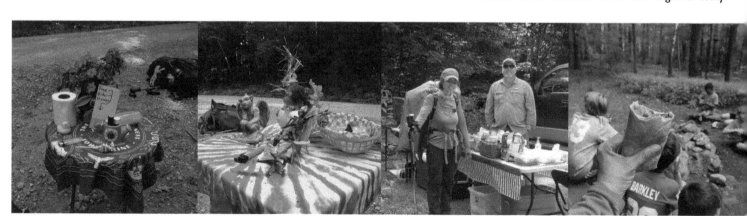

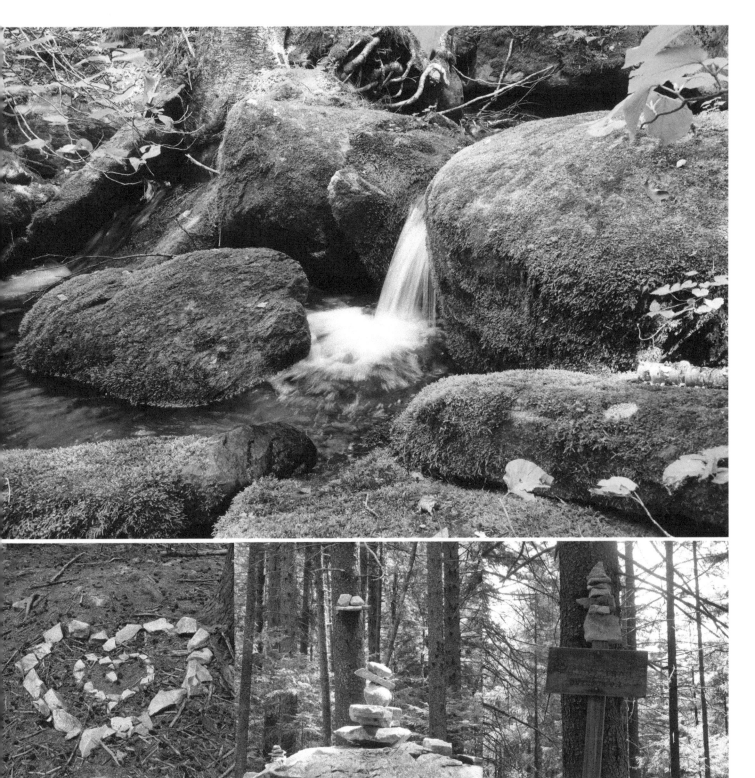

John Muir: The mountains are calling, I must go ...

Day 125: Killington
Sunday, August 04, 2019
Destination: Copper Lodge ~ **Today's Miles:** 14.1
Start Location: Minerva Hinchey shelter ~ **Trip Miles:** 1695.2

...ay I expected big climb, going up ...Killington Peak - but even before ...t 2200ft climbing, there was a steep ...cent into a gorge and back out in the ...rning. This, plus some minor ups and ...wns, made the total elevation gain for ...ut 3700ft for today. It turned out to ...completely manageable. Though it was ...ep, there were hardly any large rocks ... navigate through along the route. I ...: spent my time taking baby steps to ...it done. Along the way there was a ...e view point over the Rutland regional ...ort. It was fun to look at it from ...e ridge, go around, climb up a hill, ...n look at it from another angle. There ...re quite a few of bridges to cross ...ay, over several clear, happy creeks. ... big boulders in the creeks were nice ...d round.

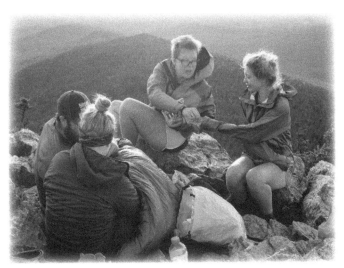

... final 2200ft climb was mostly made up of walking through roots. Roots ...m both live and dead trees created a narrow pathway on steep slopes. I ...d the company of a young lady "Orange", chatting along the way. Time ...sed quickly. By the time we stopped for a break, we only needed to climb ...ut 500ft to reach the top!

There were also two stops for trail magic today. One was made up of two coolers at a road crossing with cool soda and cookies satisfied my energy needs. Later on, a guy with a truck had moved from his trail magic spot yesterday to a later road crossing today. Thanks for the nice treats!

After I reached the Cooper Lodge shelter near Killington Peak, I was informed that the water source has dried up there. Two young boys told me there could be water at the peak lodge. I climbed the short but very steep spur trail to the peak. The views wowed me. At over 4200ft, on large rock bed, every direction was filled with mountains dotting the landscape below. Late evening sun lit the rocks a soft gleaming yellow. I walked to the peak lodge, but after searching for half hour, I found no place to get water. However, the views were still worth the effort to get up there. On top of the peak, there were 12 NoBos sitting there waiting for the sunset and sharing their favorate treats. Some of us might go together all the way to Katahdin. This thought made me smile.

John Muir: The mountains are calling, I must go ...

Day 126: 1700 miles
Monday, August 05, 2019
Destination: Stony Brook Shelter ~ **Today's Miles:** 16.3
Start Location: Copper Lodge ~ **Trip Miles:** 1711.5

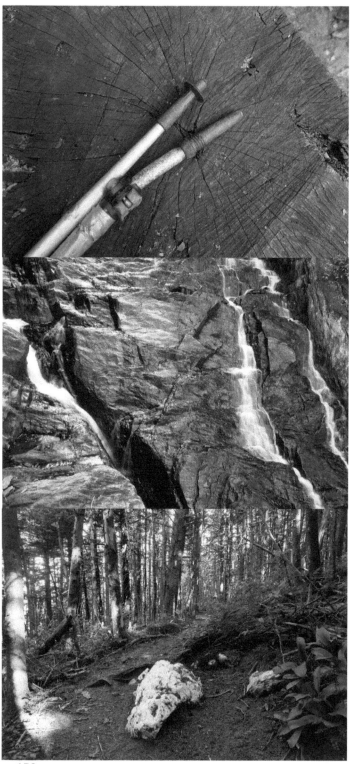

It was pretty cold throughout the night. I can feel the nippy air from north. Wh I started hiking, I wore three layers. Since there was no water at the shelter night, I had only 4oz of water left this morning. As a result, I didn't cook break until I reached a stream twenty minutes into the hike. It was fun to cook and a hot meal on the trailside, especially at a place carpeted with hemlock dry lea and velvet cushions of moss.

A few miles into the hike, I saw a stone marked 1700 on the ground. I h completed 1700 miles of Appalachian Trail. Yeah!

Even though climbing up to Killington Peak yesterday was steep, coming down fr it today was more easygoing. The real hard work was in the afternoon, after trail passed Thundering Falls. The ice-cream and the sugary lemonade I ordered Gifford Woods State Park before climbed the Quimby Mountain helped greatly. Th were so many peaks and ridges on this mountain that I lost count. I climbed after another, and another, and another. By the time I reached Stony Brook she I was tired, so were my trekking poles. The new one that I bought in Damas bent when I accidentally stepped on it, and the old one that I brought from ho had hardly any of its tip left. Time to shop for a new pair of poles.

Day 127: Obsessed with food
Tuesday, August 06, 2019
Destination: *After Dana Hill* ~ **Today's Miles:** 16.3
Start Location: *Stony Brook Shelter* ~ **Trip Miles:** 1727.8

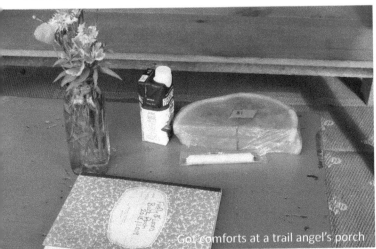
Got comforts at a trail angel's porch

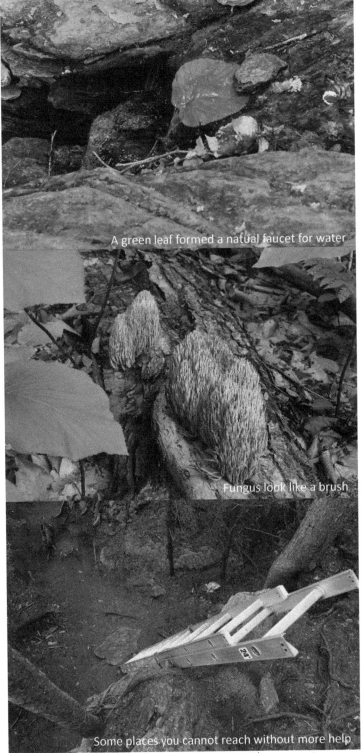
A green leaf formed a natural faucet for water

Fungus look like a brush

Some places you cannot reach without more help

John Muir: The mountains are calling, I must go ...

Recently, I have become more and more aware of just how obsessed hikers are with food. Not all types of food, but food cooked by a human, unprocessed, or naturally edible, such as fresh fruits. I observed this behavior in not only other hikers, but also myself. Yesterday, in Gifford Woods State Park, a camper offered me two peaches. He said that I could eat one now, and carry the other one with me. I ate both on the spot. Peaches have never tasted so good. Secretly, I wished he could give me more. If he gave me five, I would have eaten them all immediately! Throughout my hike, especially in warm weather, I craved watermelon. If any spot of trail magic that had watermelon, believe me, I wanted to kiss the trail angels.

Similarly, a hiker would also walk multiple extra miles in order to reach a restaurant or a farm stand for cooked food and fresh produce. Today, a guide book said that "On the Edge" farm stand was only 0.2 mile from the Appalachian Trail, crossing a road. Every hiker I met today planned to go there. Unfortunately, it was not open today. When I heard this information, my heart sank so much that I felt my stomach churn. As I relayed this sad news to other hikers, I could see their expressions were the same as mine: disbelief, denial, sadness, maybe a little bit of anger, then withdrawal. Everyone's dinner plan was ruined! Fortunately, there will be another farm stand open tomorrow, six miles further, at another road crossing. The very thought of this lifted everyone's spirit. It was amazing to see and realize how our life depends on and is controlled by food. It is built into our DNA. We just can't help it. Hiking for many months had robbed our easy access to home-cooked meals and fresh produce. Our body reacted naturally.

For today's hike, it was mostly small ups and downs in batches of a few hundred feet each time. Some were steeper than others. But all-in-all, not too bad. Trail conditions were also nice, with little mud and small rocks. A few places were blocked by broken trees that I was forced to traverse. The next few days look like a similar profile. The eye of the storm before we head out into the vortex of the White Mountains.

Day 128: Last full day in Vermont
Wednesday, August 07, 2019
Destination: *Happy Hill shelter* ~ **Today's Miles:** 15.1
Start Location: *After Dana Hill* ~ **Trip Miles:** 1742.9

Turns out, Cloudland Farm's market was a disappointment. They only stocked some jerky and one single flavor of ice cream. Their restaurant is for reserved dinner only. Later that evening, on the trail at a road crossing, a yellow sign pinned on a tree led me to "Firefly & Loon"'s back porch, an Appalachian Trail thru-hiker from 2016. They bought this property two years ago, only a hundred yards from the trail. On their back porch, they stocked lots of goodies and drinks, including hard-boiled eggs and fresh fruits for very reasonable prices. I bought sweet watermelon, chocolate milk and a cheese stick for $3.50. I took my time eating my meal on their nice porch, overlooking their beautiful yard with many colorful flowers and well-nurtured vegetables. Their young baby boy tailed his father in the vegetable patches, wobbly with a toy truck in hand. A swallowtail butterfly danced in their daylily patch while I was eating the watermelon. This was a pleasant treat for today's hike.

In the afternoon, the trail led me through the town of West Hartford. There was a nice river in the town; many people were swimming there. A sign nearby announced a farmer's market today, but there was only one guy selling a few vegetables. A village store was closed for good, and the church looked very sad too. I really hope the town can do better in the future.

In the late afternoon, just as I started to climb the last hill for the day,

a shower brought thunder and r If you have not hiked in a sho in a forest before, you are re missing out! In a thunderstorm, forest becomes dark and quiet, a tle bit frightening, but full of ene and excitement. The only sounds can hear are the roaring thun and rain. As you walk through forest, all the green leaves beco wet and shiny, looking cleaner a greener. You can see small, fra salamanders wandering out to s in as much of the moisture in air as they can. You may discover colors of mushrooms: white, yel orange, red, brown, black, or e green, eagerly pushing out throu the damp soil. The rocks glisten the grey sky, reminding you to careful when traversing their surfa Their colors are more intense, darker blacks and brighter whites. In contra the green moss is even greener. Of course, it would be best if it was a f moving storm as today's was. In a short while, the Sun broke out and sho its golden rays onto verdant leaves. For our listeners at home, next time wh there is a shower, don't run back home; take some rain gear and go fo walk in the woods.

Today was my last full day in Vermont. On a hill, under a big apple tree, th was a bench. The following words were carved onto it: "VT Relax and Enjo It summarized the entirety of my experience in Vermont. It's been great Vermont's Green Mountains.

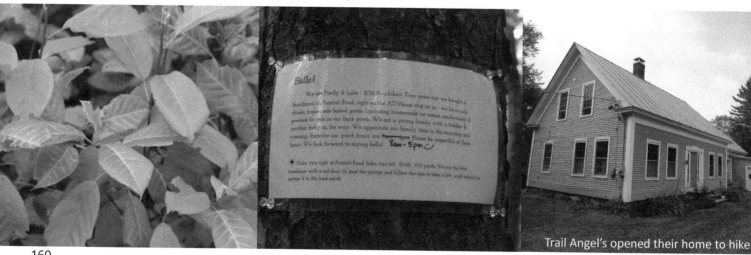

Trail Angel's opened their home to hike

Day 129 - 144: Appalachian Trail - New Hampshire

Let the game begin!

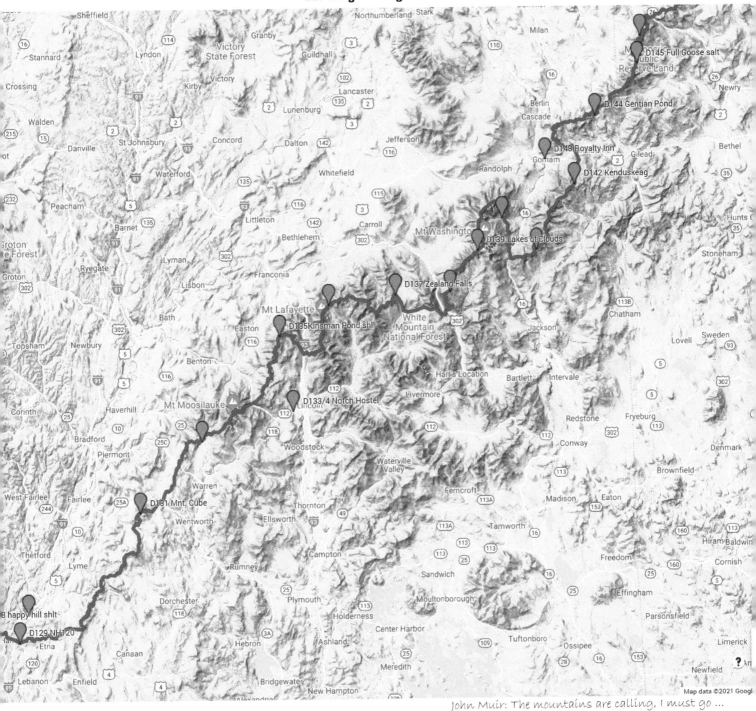

John Muir: The mountains are calling, I must go ...

Day 129: New Hampshire, Here I come
Thursday, August 08, 2019
Destination: *In the Woods outside of Hanover ~* **Today's Miles:** *6.5*
Start Location: *Happy Hill shelter ~* **Trip Miles:** *1749.4*

It drizzled last night into the morning, through the last five miles in Vermont. Along the damp trail, I noticed there were many orange spotted salamanders. I started to count them. Over three miles of forested trail, I saw 31 salamanders! They were really out in force. Please slow down for them. They looked so cute, but helplessly fragile.

By mid morning, the trail arrived on Elm Street in Norwich - the last town in Vermont. It was so hiker-friendly. Many homes had hiker trail magic boxes and coolers at the entrance to their driveway. Chairs, candies and drinks were provided. It was raining hard as I walked through, so I only stopped for a piece of candy. I had a good breakfast break in Blue Sparrow Kitchen while waiting for the rain to clear. Sadly, I didn't have more time to visit the other side of town. But from the street that met the Appalachian Trail, I could see this was a town with lots of history and charm.

Before noon, I crossed the bridge over the Connecticut River. The VT/NH state line was in the middle of the bridge. Now that Vermont is done, New Hampsh here I come!

The road that led to Hanover was busy. Traffic and constructions were over the place. The town of Hanover itself was nice and hiker-friendly. $5, I got a show and laundry do in their commun center, which a serves as a dayca center. The peo on the street a in the town h were all very n to hikers, helpi me with directio and restaura choices. I wan to spend some ti in the art museu However, after I supplied and sorted all of the stuff I washed and bought, it was too late the museum. I only had time to have dinner with two fellow hikers in a Th restaurant before going out of town for camping.

Just by a soccer field at the edge of the town, where the trees conceal everything from the hustle and bustle of the place, I found a nice spot to s up my tent. Tonight was a night of sweet dreams accompanied by street nois

Day 130: First full day in New Hampshire
Friday, August 09, 2019
Destination: *Lyme-Dorchester Rd, Skiway ~* **Today's Miles:** *18.4*
Start Location: *In the Woods outside of Hanover ~* **Trip Miles:** *1767.8*

...ay was the first full day in New Hampshire. My original plan was to go into the woods for five days, then check into a hostel. But, I met two hikers along ...way and they asked me to join them for slackpacking. So, today was a slackpacking day.

...alked 0.8 mile back into downtown Hanover. At the post office, the hostel driver picked up my heavy backpack, leaving me, "Brave Heart" and "Cowboy" with ...y daypacks. We walked into the forest, with our packs so light we thought we could fly. A few hills later, we had walked nine miles. They walked much faster ...n I did, so I always lagged behind. It was nice to have some company, and someone close by to take pictures. We also admired New Hampshire's trail signs. ...y were cute and clear!

...5:00pm, we came to a road and found our driver had been waiting for us.

...re were lots of discussions about slackpacking tonight. In the end, we decided to go back to backpacking for tomorrow.

John Muir: The mountains are calling, I must go ...

Day 131: Smarts Mountain
Saturday, August 10, 2019
Destination: Mountain Cube ~ **Today's Miles:** 13.0
Start Location: Lyme-Dorchester Rd, Skiway ~ **Trip Miles:** 1780.8

Back to proper backpacking today. It will take two days to reach the next hostel. The weather was on the cold side - great for hiking and literally bug-free! I loved it. We got a late start since "Brave Heart" needed to return her tent at the post office. We only started hiking after about 9:00am. In a couple of hours, we started to climb Smarts Mountain. It became steeper towards the upper half of the mountain, but still manageable. At one point there was a great area with boulders on the trail, from which vast views of the surrounding landscape could be seen. The first boulder field was sunny, where rolling clouds formed dramatic shapes. The second boulder field had many blueberry shrubs; small berries, but very tasty. By the time I reached the third boulder field, it started drizzling, if only for a few minutes.

On the top of Smarts Mountain, there is a fire watch tower. At its windy peak, I could see mountains after mountains in layers of green, blue and grey, in all directions! An old fire warden's cabin had been converted into a shelter for hikers. On the way down from the mountain, I found a rabbit hole fits straight out of "Alice in the Wonderland". Next to it, I saw a fuzzy green puppy (a tree trunk covered by a layer of green mosses) waiting patiently for his master to come back home.

Just before we reached the intersection to Hexacuba Shelter, a shower suddenly started. It was a very cold shower. Within a few minutes, my fingers were nur
We decided to hike another 1.6 miles to stay on top of Mount Cube to watch the scenery since the showers were predicted to pass quickly. It was a hard cli
with many boulders, slick and wet. Slowly, we pushed to the top whilst admiring the grandeur of the rolling clouds along the ridge. Before we could reach
night fell. It's time to stop going and settle down for the night. Amidst the deep forest, putting my wet clothes away, I rested and was grateful for the vie
and the fine hike. Sweet dreams.

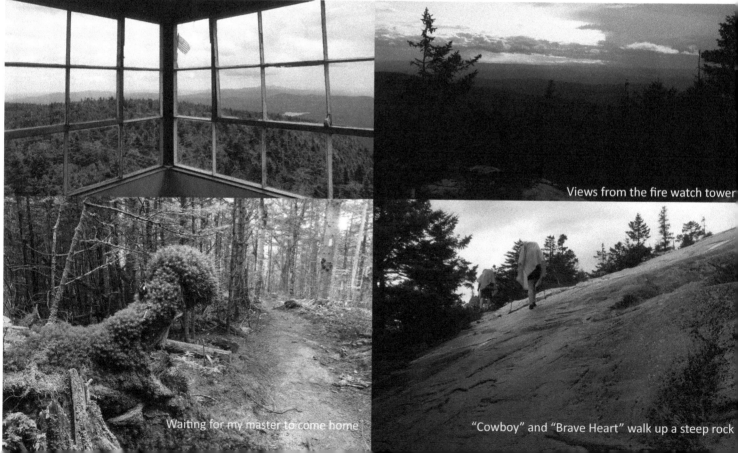

Views from the fire watch tower

Waiting for my master to come home

"Cowboy" and "Brave Heart" walk up a steep rock

Day 132: Mountain Cube
Sunday, August 11, 2019
Destination: *Hikers Welcome Hostel* ~ **Today's Miles:** 13.2
Start Location: *Mountain Cube* ~ **Trip Miles:** 1794.0

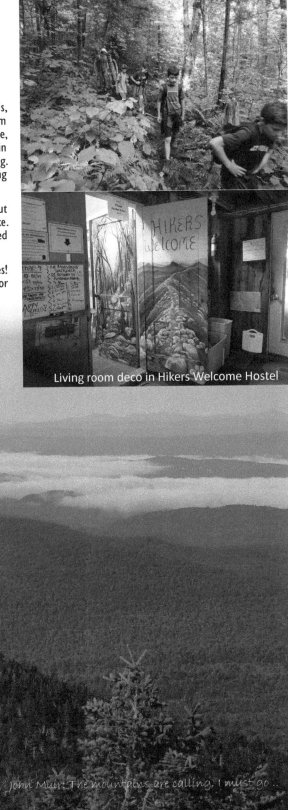

Living room deco in Hikers Welcome Hostel

woke up late today, at 6:30am. By the time I hit the trail, it was already 8:00am. Despite this, was chilly. Everything was still wet from last night's rain. My pants and socks, still wet from esterday, felt cold. It reminded me of those wet days in April. When I got to the top of Mt. Cube, e views were incredible. White clouds sprawled across the low valley like a white river. Rain ashed sky and peaks were clear and clean. I breathed in the cold air, and felt my soul renewing. sign at the top said it was only 2909 feet. It definitely felt much higher among the surrounding ountains, viewing the tops of clouds in the frigid air.

rom there, I went a long way down, followed by more ups and downs for the rest of the day. But here were no difficulties. Near Mt. Mist, I met many kids doing a 17 mile hike over Mt. Moosilauke. ven after the long and hard day of hiking, the kids were in good spirits. Some of them looked ke they were less than ten years old - superhuman boys and girls! I was very impressed.

checked in at Hikers Welcome Hostel after a 13 mile hike. The staff even fixed my hiking poles! liked their outdoor shower and restroom with all the hot water plumbing, but rustic outdoor etting. Great place for hikers.

Views on Mountain Cube

John Muir: The mountains are calling. I must go ..

Day 133: Mt. Moosilauke
Monday, August 12, 2019
Destination: *Notch Hostel* ~ **Today's Miles:** *9.5*
Start Location: *Hikers Welcome Hostel* ~ **Trip Miles:** *1803.5*

Last night's stay in the Hikers Welcome Hostel was nice. "Buffalo" - the staff member there - was so helpful in fixing both of my trekking poles. The tip of the pole was replaced, and a bent section was exchanged with another. The outdoor plumbing shower and restroom were also cool. Sleeping was not the quietest, since some hikers kept walking on the squeaky floor all night long.

I am officially in the Whites now! And I reached the 1800 mile marker! Today I climbed Mt. Moosilauke - the first peak above the tree line in the Whites. I teamed up with three other hikers, going north to south to be on the safer side. The large rocks on the north side of the mountain were steeper and wet year-round. At some points, there were wooden blocks installed, and others had handrails too. As we climbed up, it was strenuous, but less scary than going down. I could picture the hikers coming down, looking at the path dropping precipitously downward for at least fifty feet with only wet wooden blocks for footing with nothing to hold on. I would have gone down that mile on my butt the whole way! When we were at the top of that section, we met "Doc" and "Champy" - two NOBO thru-hikers we had seen earlier. "Champy" just had a fall on the rocks. His leg was bleeding. It was lucky that he didn't get hurt more seriously.

In about three hours, we reached the top of the mountain. All of a sudden, the trees became short and gnarled. Branches grew parallel to the wind in stunted shapes. Large piles of rock canine marked the trail to the wind-swept summit. Even on a sunny summer day, I put on a fleece layer and a windbreaker. The summit offered stunning, 360-degree views of the mountain peaks, rivers, lakes, and forests below. The landscape reminded me of the wild west alpine peaks of Colorado and California. I felt at home here.

At the summit, many hikers enjoyed themselves. We took turns taking pictures with the signpost. Even though it was a Monday, a line still formed for picture taking. One guy was doing a "50 at 62" challenge. In other words, fifty miles of trail in 24 hours, at a ripe age of 62. A group of his friends were there to support him. He was steaming when he came up to the summit, wearing only a pair of shorts!

Going down from Moosilauke was relatively easy. There was a gentle, mile-long slope that also went to the south peak, followed by a mile and a half of steeper - but not challenging - trails, and a stretch of strolling-grade slopes back to the trailhead. All done before 2:30pm. A very rewarding and beautiful first day in the Whites.

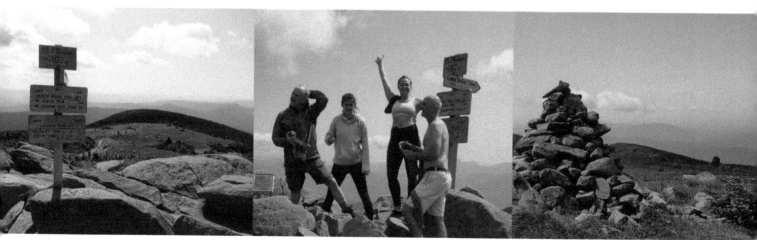

Day 134: Zero day
Tuesday, August 13, 2019
Destination: Notch Hostel ~ **Today's Miles:** 0.0
Start Location: Notch Hostel ~ **Trip Miles:** 1803.5

Took a zero today in Notch Hostel and went to North Woodstock and Lincoln, New Hampshire. The two little towns were connected by a sidewalk, separated by Highway 93. They are resort towns for winter sports and summer activities. "Brave Heart" and I walked the 2.5 miles stretch through both towns, exploring the shops along the way. We resupplied, went to multiple outfitters, and watched Hobbs & Shaw - an action movie.

The little town of North Woodstock has a very efficient government. In one small building, it housed its police department, town offices, clerk and tax collector, and library. At the Roadside Rest Graveyard, a beautiful poem was written as shown here. It is one of the most heartfelt poems I have read.

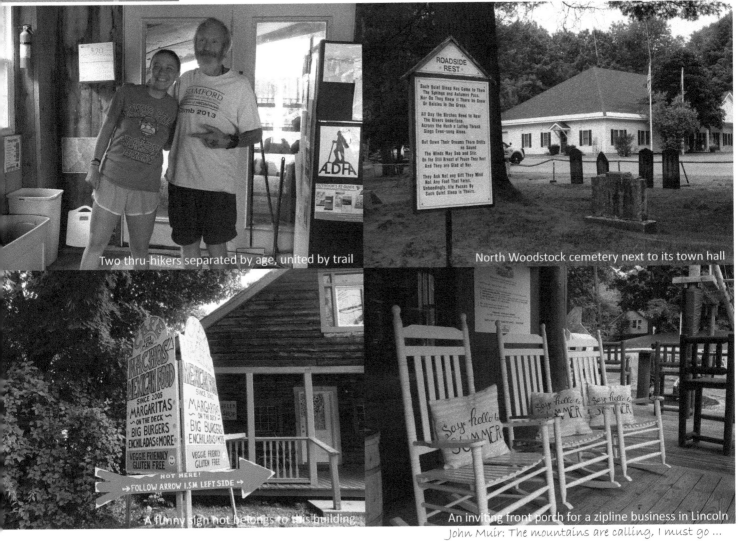

Two thru-hikers separated by age, united by trail

North Woodstock cemetery next to its town hall

A funny sign not belongs to this building

An inviting front porch for a zipline business in Lincoln

John Muir: The mountains are calling, I must go ...

Day 135: Kinsman Peak
Wednesday, August 14, 2019
Destination: *Kinsman Pond shelter ~ Today's Miles: 11.4*
Start Location: *Notch Hostel ~ Trip Miles: 1814.9*

Perfect backpacking day in the Whites today. I left Notch Hostel's cozy house at 7:00 am to start the hike. Immediately, the trail rose steeply. Before I left hostel, I weighed my backpack: 33.5lbs, including the camera. Heavy for the Whites!

Off we go, "Brave Heart" and I backpacking, and another lady, slackpacking. From Kinsman Notch, it was steep, but made easier with carved steps. Then a ge[n]. trail for a couple of miles. When we neared Wolf Mountain, it became steep again, with lots of mud. That slowed us down. We got to Eliza Brook Shelter just p[ast] noon for a lunch break. There were many creeks near the shelter with pleasant water. By this time, the slackpacking lady had long surpassed us.

For the next 2.5 miles, the trail was easy. About a mile before Kinsman south peak, we were met with lots of boulders, which required me to use both of hands to pull me up. It was exhausting with a heavy pack. But at the same time, it definitely wasn't boring. I kind of liked it. Some places were steep. At m[any] points, we felt we'd walked almost a mile, only to find out that we only progressed about a third of that!

Finally, we pulled ourselves up to the south peak, clocking in at exactly 2.5 hours for the 2.5 miles. The views on the peak were nice, but not as spectac[ular] as those on Moosilauke.

The hike from South Peak to North Peak was mostly flat and easy. Only the last stretch required scrambling over rocks. Then, it was the dreaded descent. had to butt slide a few times, to avoid overtaxing our already worn legs and knees. Finally, we reached Kinsman Pond Shelter just before 6:00 pm, leaving with no desire to push to Lonesome Lake two miles further downhill from the shelter.

The water for the shelter came from the titular Kinsman Pond. It was murky and brown, and looked very unpleasant. But, after filtering or boiling, it was o[kay] mostly tasteless, and didn't make me sick. Setting up ZPacks' duplex tent on a wooden platform was tricky. After a few tries, we were settled. At the shelter I [met] a guy - 70 years old. He had decided to go home. After 1800 hard miles, he had enough. I thought the fun had just begun.

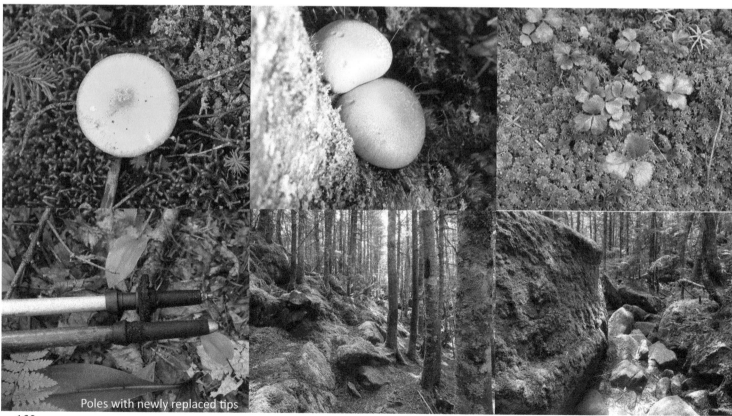

Poles with newly replaced tips

Day 136: Presidential range
Thursday, August 15, 2019
Destination: A mile south of Garfield Pond ~ **Today's Miles:** 13.0
Start Location: Kinsman Pond shelter ~ **Trip Miles:** 1827.9

the morning Kinsman Pond was very peaceful. I
nd a mother duck and her two ducklings wel-
ning me when I reached the shore of the pond.

wing this is a hard day (though, hardly any day
ld be called easy by now), we started at 7:00am.
two miles to Lonesome Lake was like the last
f mile yesterday: steep and rocky enough that
as forced to crawl on all fours many times. It
k me more than two hours to complete those
miles. The area around Lonesome Lake Hut was
very pretty setting. The hut itself was beautifully
igned. Many years ago, I read an article about the
s in the Whites and their caretakers. I was very
ited to be able to enter one today. The caretakers
re all handsome young men and beautiful young
ies. They were very nice to us. Though I had
filling breakfast of oatmeal in the morning, I
s very hungry again by the time I entered the
t. They gave us their leftover breakfast: oatmeal,
ambled eggs and sausage patties. Yesterday, at the
npground, the caretaker there gave us an orange
d after registration. With this orange card, thru-
ers can pick up two free baked goods and a soup. So, I got a piece of tasty
fee cake for free, which I enjoyed with a cup of tea. Sitting in the sunlight-
ed dining room, and later at the picnic table on the front porch, looking

out to the lake and its forest, I felt I was enjoying a true
piece of paradise!

The bulk of the hard climbs were after lunch, once we crossed
Highway 3. At first, the slope was gentle, which only served to
make me more anxious. The gentler it begins, the steeper it
gets later. As predicted, the last mile to the top of Mt. Liberty
was very steep. It went up more than 2000ft. Fortunately,
there was little scrambling over rocks like so many of the
other peaks; it was just a steep slope. I was tired, but not
over spent. We made good progress and reached Liberty
Spring Campsite, pushing further. Once we reached Franconia
Ridge, the views were incredible. Blue skies with puffy white
clouds were floating above Little Haystack Mountain and Mt.
Lafayette. A nice gravel path on the ridge threaded through
the peaks. Ankle-deep bushes of blueberries covered large
areas on the ridge. They tasted sweet and juicy. Later, after
we summited Mt. Lafayette, I saw Mt. Lincoln, threaded by the
nice path over its three peaks.

It took us some time to get down from Mt. Lincoln and below
the tree line. Looking at the clouds, I imagined the sunset
would be spectacular. But alas, we had no time; we needed
to get down to the protective shelter of the tree line. Finally, at 7:30pm, just
before the sunset, we found a good camping spot and settled for the night.

John Muir: The mountains are calling, I must go ...

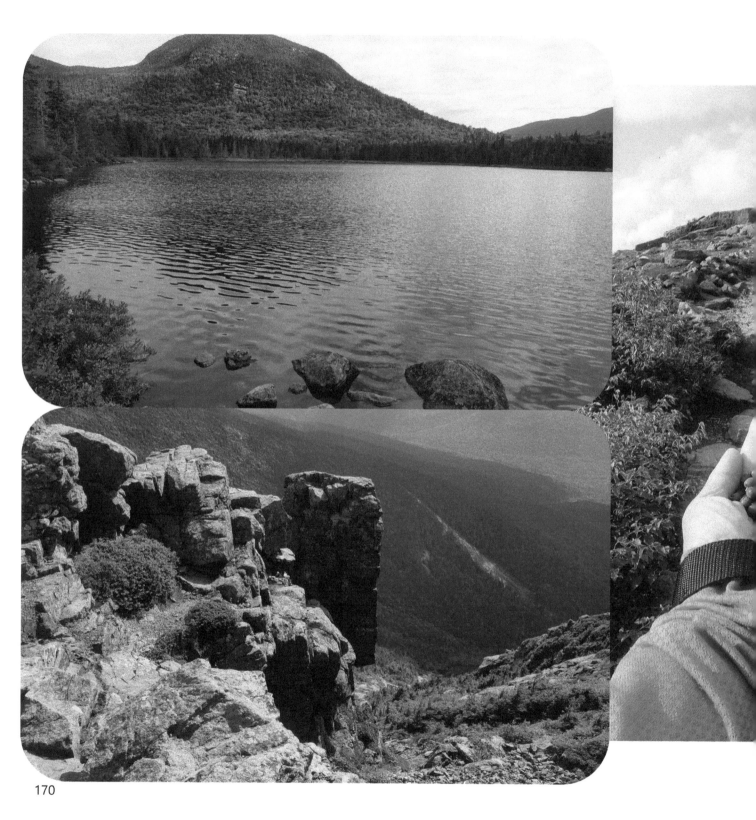

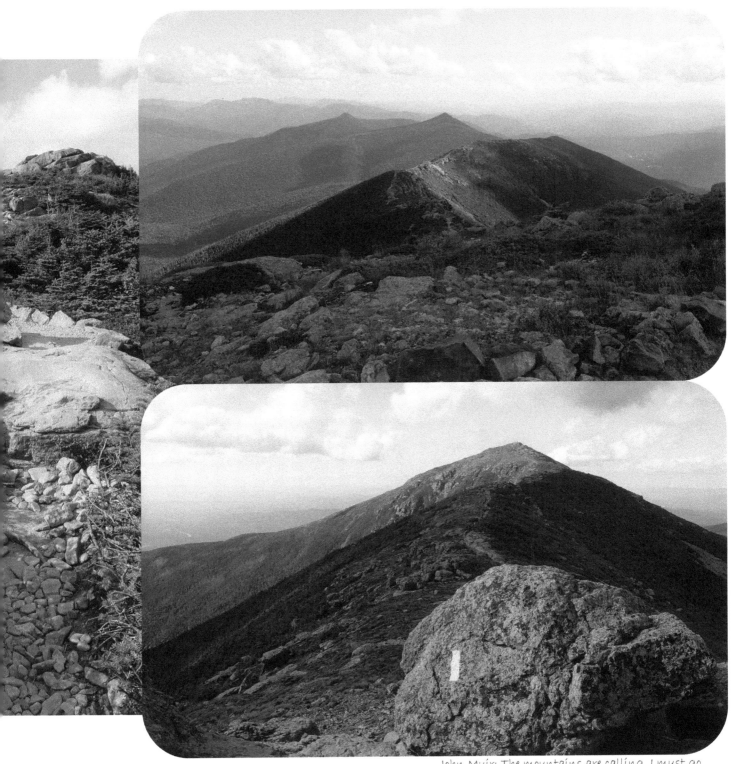

John Muir: The mountains are calling, I must go ...

Day 137: Slowest record
Friday, August 16, 2019
Destination: *Zealand trail junction* ~ **Today's Miles:** *11.8*
Start Location: *A mile south of Garfield Pond* ~ **Trip Miles:** *1839.7*

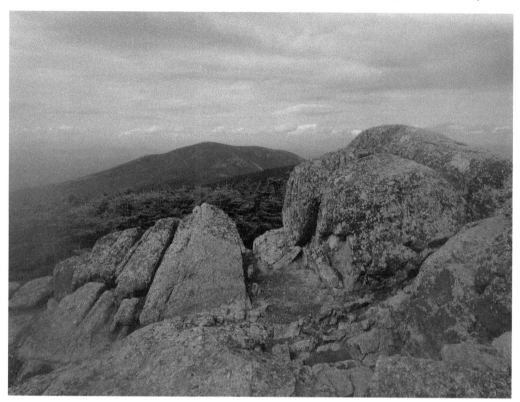

I finished writing last night's journal ten min[...] after midnight, dozing off a few times. The [...] and wind started after that, and lasted a [...] hours. By 6:30am, the rain stopped, but [...] wind did not. I packed everything and left [...] campsite by 7:45am.

Our first peak today was Garfield Mountain [...] small hump on the map, but a tough challe[...] on the trail. With wet conditions, I needed [...] pay extra attention to roots and rocks, wh[...] covered the whole trail. At a few spots, I nee[...] to pull or push off the ground hard to get [...] the next big step. One of those cliffs was ab[...] fifteen feet high; I had to put my whole we[...] on two fingers that were gripping a crack on [...] rock. On the top of Garfield Mountain, my rew[...] was a thick fog enveloping any view I hoped [...] see. The going down was even harder than go[...] up. Right after Garfield Shelter and its camp[...] the trail went through a waterfall, with its sp[...] turning the steps into a river. At some secti[...] I had to sat in the little river to slide do[...] the trail. Here, I set the slowest record yet[...] 15min I hiked a tenth of a mile! By the t[...] I reached AMC Garland Hut, less than five m[...] from last night's campsite, it was a quarter [...] one! In other words, it took me about five ho[...] for five miles!

We had a bowl of rice and bean stew for lu[...] in the Hut. There was no bread left, so I didn't get the chance to use my orange thru-hiker card on the free baked goods. There were seven miles before [...] could reach the next huts in our itinerary. Considering my speed, I was eager to resume hiking.

The next steep climb was on Twin Mountain, the trail rising about 1200ft in 0.8 mile. It was rough, but nothing I hadn't seen. So, I made "good" progress [...] the afternoon. The trail was also easier on the down section for once, I only needed to scramble across rocks a couple times. It even had a couple miles of [...] road! By 6:50pm, we got to Zealand Falls Hut. The hut was full and there was no good work & stay option in there. All other paid guests had already finish[...] their dinner. So, I hiked another short distance, and camped near the same named waterfall. Now, I am listening to the song of the falls as I slowly drift to sle[...]

Wet trail near Garfield Mountain "Easier" trail in the Whites A young caretaker at Zealand Falls Hu[...]

Day 138: Mt. Webster
Saturday, August 17, 2019
Destination: Mt. Jackson ~ **Today's Miles:** 12.0
Start Location: Zealand trail junction ~ **Trip Miles:** 1851.7

Webster Cliff

John Muir: The mountains are calling, I must go ...

It rained again last night. By 6:00am, the rain stopped, and I started the day with the view and sounds of beautiful waterfalls next to my tent. While I was getting ready, I left my phone on a rock and did a lovely time lapse video of the falls.

For the first five miles, I walked a flat trail. Yesterday, a southbound hiker told us to expect it, and I got very excited at the news. For many days, I had forgotten what a flat trail was. It was truly smooth; at least, for a good part of it. One section was over a ledge with pleasant views. So many blueberries grew along the ledge. I ate more than I should, and picked two handfuls for later. I put them in a small plastic container that I used for oatmeal. Though we had to traverse some sections of mud and rock, we still loved it and maintained a good pace in the morning.

By noon, we ("Brave Heart" and I have hiked together for a few days now) came to Crawford Notch. The Appalachian Trail thru-hiker class of 2017 was there to do trail magic! It was one of the best I have ever had - a cornucopia of healthy food: oranges, apples, watermelon, pasta salad, vegetable chili, kombucha, pancakes, stir-fried potatoes with onion and bell peppers, plus the hiker staples: beer, soda, lots of sweets, and more. There was even pecan and apple pie! I ate and rested for a good hour before continuing my hike.

The trail magic did a wonder to boost my energy. From hard hikes in the past week, I was dragging my feet all morning. Even on a flat trail, I felt tired and thought about getting off-trail for the rest of the day. But after the good food, I gained my energy back. The climb to Webster Cliff was very steep, going up 1750 ft in less than a mile. The profile in my guide drew a vertical line for this part. But I felt strong as I climbed. Once I got to the cliff ledge, I was rewarded with excellent views. Fogs blowing from the right, across the rocks. Nearby mountains dipped in and out of the fog. Short trees added to the mystique.

From the cliff, it was only 500ft to reach Mt. Webster's peak. The profile looked reasonable in the book. But in reality, it was an endless series of scrambling up rocks. I think there might have been more than ten big rocks and cliffs we need to pass. Every one of them required pushing and pulling myself up. By the time we finally stood on top of Mt. Webster, we were exhausted and steaming in the cold weather. We realized that we could not make it to Mizpah Hut before dark. So, we started looking for a camp spot. The vegetation on these mountains was so dense, and the flat sections were so damp and muddy, it took us more than an hour to find a small place on Mt. Jackson, that could hardly fit two tents. This place, in the middle of nowhere, would be our home for the rainy night.

Lovely waterfall near my ten

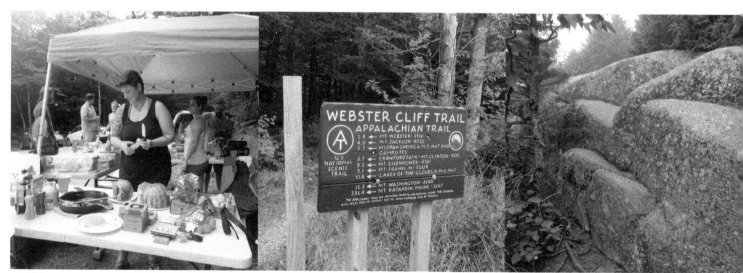

Day 139: Mount Washington

Sunday, August 18, 2019
Destination: *Lakes of the Clouds Hut ~* **Today's Miles:** *9.0*
Start Location: *Mt. Jackson ~* **Trip Miles:** *1860.7*

ept well listening to the raindrops splashing on my tent last night. The soft
r of fallen leaves from hemlock and fir was at least a foot thick, making
e most comfortable mattress in the world.

oke in the morning to find a thread of sunlight hitting a corner of the
painting it golden. It was a bright day - partially cloudy with a good
unt of sunshine. As I walked below the tree line, the golden sun rays shone
ugh the rain-washed forest as if it
from a fairy tale. Everything was
new and clean. The forest smelled
ice, scented by pines and firs. Still,
trail was muddy and rocky, so my
e was still slow. I was making slow
gress in a Wonderland.

r spending most of the morning
er the tree line, we finally rose
ve it. The trail got easier there - no
mbling over big boulders anymore,
the views were fantastic! Low
ds lazed around in valley crevices
below us. Verdant mountains nearby
stunted trees layered on top of
another into a blue haze far away.
nt Eisenhower, Mount Franklin, and Mount Monroe came and passed by our
one by one. The clouds over these mountains also gradually moved away
he air got warmer. After a while, the peak of Mount Washington appeared,
its communication towers into view. The clouds just loved to play with
nt Washington's peak. I was excited and felt lucky to see the peak at all.
said to be visible only 45% of the time.

hiking plan changed many times as I walked. The terrain and weather
ermined how far I could go for each day. In the past five days, only one
, I was able to complete the distance I planned. Today was no difference.
ad no chance to reach Madison Hut as I originally planned. After I got
Lakes of Clouds Hut, just 1.4 miles before Mount Washington's summit, I
ussed my options for tonight with the very friendly caretaker at the hut.

In the end, I decided it was best to stay here tonight and do a short hike
to Mount Washington in the afternoon. It was a good decision. We put our
packs at the hut and carried only a daypack to the summit. I felt like I was
flying through the trail without my big backpack. In a little over an hour,
I reached the summit. By that time, we had been in the clouds for at least
forty minutes. The clouds broke only for a few seconds during that time, but
it was just enough to see blue sky. I
only had the time to take a picture
of a tower. There was a long line of
people (tourists) taking photos at the
summit sign. We waited about twenty
minutes for our turn. Then, we visited
the historical hotel building and visitor
center. In there we got soup and pizza
as dinner - real food! After almost an
hour and a half at the summit, we
went back to the hut. We took the
Appalachian Trail down the north side
of the summit, then took a side trail
back to the hut. Tomorrow, we plan
to use the side trail and continue our
hike without the need to summit again,
saving us a half mile in distance and
1000ft in elevation gain.

There were so many guests at the hut, with a surprising number of children.
They paid about $150 for a bunk bed, breakfast, and dinner. The hut allowed
thru-hikers to pay $10 to sleep on the dining room floor. There were about
twenty of us that took this option. Some hikers choose to work for a stay,
to save their cash. However, our group wanted to get going early tomorrow
before the work shift. So, we paid that $10. At least I will be dry if it rains
again tonight.

The cloudy sky gave us a fantastic show for sunset. It's been a long time since
I have seen a sunset this nice. This was the first time I camped above the tree
line on the Appalachian Trail.

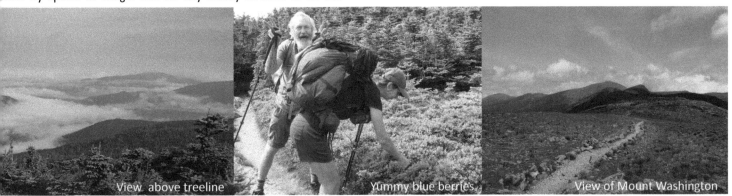

View above treeline

Yummy blue berries

View of Mount Washington

John Muir: The mountains are calling, I must go ...

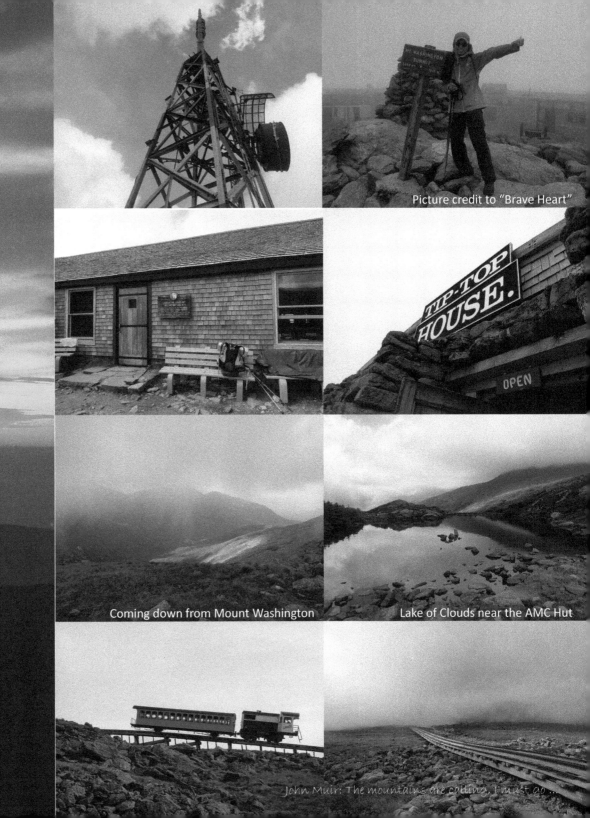

Picture credit to "Brave Heart"

TIP-TOP HOUSE.

OPEN

Coming down from Mount Washington

Lake of Clouds near the AMC Hut

John Muir: The mountains are calling, I must go ...

Day 140: Rocks, Rocks, and more Rocks
Monday, August 19, 2019
Destination: *Campsite on Madison Gulf trail* ~ **Today's Miles:** *10.3*
Start Location: *Lakes of the Clouds Hut* ~ **Trip Miles:** *1871.0*

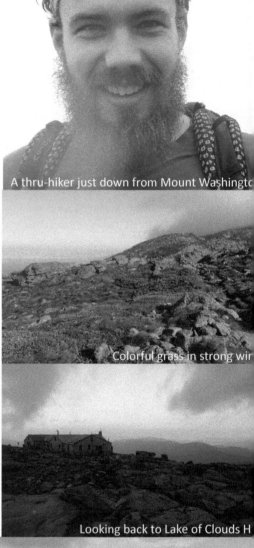

A thru-hiker just down from Mount Washingto

Rocks, rocks, and more rocks! Today is rock day all day - rough, gnarled, pointed rocks for almost eight miles. Fogs and high wind on the open trails above the tree line forced me to focus on my footing. Like solving puzzles, every step I took required me to find the next one amongst a field of jagged granite. The gusty wind made aiming my trekking poles uncertain. The wind threw me off-balance and I bumped my arm more than once against the large rocks next to me. At one point, the wind assisted me and my backpack on to the rock effortlessly. Most of the other times, however, the wind and the rocks kept me in a drunken stupor and prevented me from moving at a reasonable pace. Yet, a lot of Northbounders passed me effortlessly, as if defying gravity. This section took me six hours. I planned it to be only four and a half!

The landscape itself was stunning, both in fog and under the Sun. The fog moved quickly; I started just under the edge of it. I could see mountains with tops hidden amidst the clouds, but sunlight shining around its base, like a ship slicing through waves. When I was completely immersed in the clouds, it was dark and grimy. The wind rustled brown grass in a sea of black rocks covered with yellow green lichen, forming waves of motion. The vast emptiness of this rocky sea was very powerful. I felt humbled and at peace in it, never fearful.

Colorful grass in strong wir

For lunch, I ate black bean soup with a thick piece of bread and a large piece of lemon bar when I finally reached Madison Springs Hut.

The three miles after Madison Spring Hut were still filled with rocks. I never worried about climbing the rocks in uphill sections, but going down slowed me to a snail's pace. Those three miles took me four hours. So, instead of reaching Pinkham Notch, I camped next to a beautiful rushing river for the night four miles prior to it. Another day that came up short compared to my plans. The sound of the cascades and rustling leaves will rock me into a sound sleep tonight.

Looking back to Lake of Clouds H

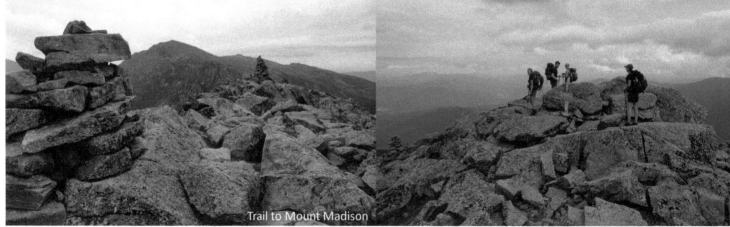

Trail to Mount Madison

Day 141: The Wildcats
Tuesday, August 20, 2019
Destination: *Carter Notch Hut* ~ **Today's Miles:** *10.5*
Start Location: *Campsite on Madison Gulf trail* ~ **Trip Miles:** *1881.5*

campsite I stayed at last night was very nice; dry and breezy. When I woke up in the morning, all of the soggy items I had from the last few nights of had dried.

as a beautiful day. The sunlight pierced the foliage around me at 6am. Walking through a light-patched forest in the morning always cheers me up. I think the most wonderful thing to see.

ked about four hours to reach Pinkham Notch. At the lower elevation, the trails were much easier to walk on. After I came into Vermont and New Hampshire, I ced how silent the forest was. In the southern states, there were so many birds chirping throughout the day, even through many hours in the night. Squirrels, munks, snakes were a common sight. Here, they were hardly present. On the way, I met two college students doing research on squirrels. They confirmed that year, they had not seen many squirrels either. Their theory was that the squirrel population changes every year - a year of boom, followed by a year of m. This year has been the doom year. I hope their theory is right. A silent forest is not a comfortable forest.

ached Pinkham Notch AMC visitor center before 10:00am. I plugged my charger in, took a much-needed hot shower, packed up my meals for the next three , and ate a nice lunch of real food, all within less than 2 hours. By 11:45am, I was on the trail again to take the Wildcats.

peaks to the north of Pinkham Notch are called the Wildcats - four peaks labelled D, B, C, and A. Peak D is a ski mountain with a gondola. The trail of dcats Ridge up to Peak D had been the most challenging one (technically) with great cliffs and huge vertical boulders. In two miles, the trail rose more 2000ft. At least three boulders of 20-40 feet each were exposed, requiring mountain-goat-like navigation skills and a camel's endurance to climb up. I was glad that I didn't need to go down this trail. It would have been pretty terrifying. I reserved full sympathy and respect to the Southbounders who did this.

gondola runs in summer to bring visitors up the hill for a view, but there were no other service at the top. So, after resting a few minutes, I continued ike the rest of the Wildcats. Each had a few tough spots for a wild and exhausting climb. By 5:30pm, I reached peak A, the last one of the four peaks; in ther hour, after endless stairs, down 1100ft, I finally reached Carter Notch Hut, sitting by two pretty little ponds. One was half-covered by water lilies with w flowers and cool grass, the other littered with large brown rocks, looking more like an alpine lake. I happily found that the hut still had room for more sts. I checked in, and had dinner right away. The lentil soup, bread and butter, vegetables, Mexican lasagna and lemon cake tasted wonderful. It's a nice treat me after a week of hard climbs in the Whites.

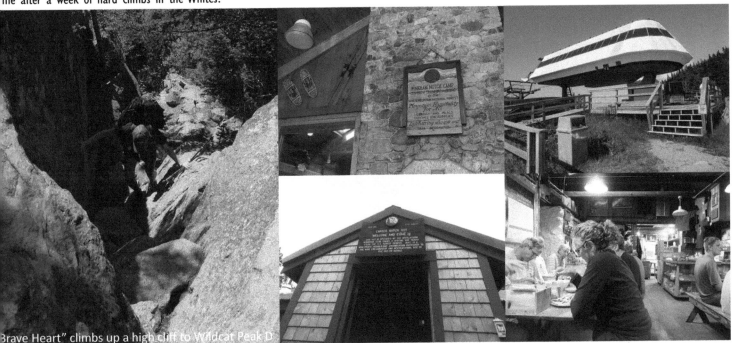

3rave Heart" climbs up a high cliff to Wildcat Peak D

John Muir: The mountains are calling, I must go ...

Day 142: Hike in the rain again
Wednesday, August 21, 2019
Destination: *Camp above Rattle River* ~ **Today's Miles:** *11.0*
Start Location: *Carter Notch Hut* ~ **Trip Miles:** *1892.5*

The Carter Notch Hut crew were awesome. They prepared a tasty breakfast, performed a funny yoga routine to educate guests, folded blankets, cleared out all trash, left tips, and entertained kids. I loved my hut stay! One more satisfied customer.

The hike to Carter Dome and the rest of Carter mountains were steep, but not too difficult. The downhill section from North Carter Mountain to the Imp campsite, however, required lots of butt sliding, and really slowed me down. In the afternoon, there was one last climb to Moriah Mountain, just as it began to rain. Fortunately, for most of the ascent, it was a light rain. On top of the Moriah Mountain, the rain paused. I was presented with flowing white clouds among the hills below and valleys far away. That was a fantastic sight.

Then, the rain resumed and picked up power, became a downpour on the descent. Soon my clo[thes] were soaked. I chose not to w[ear] my poncho, fearing that it w[ould] cause me to trip on this steep t[rail]. I used it as a cover for my p[ack], wearing a rain jacket on top. W[hile] this was perfect for light rain, it [was] useless now. I felt cold, worried ab[out] hypothermia, and eager to find [a] spot to camp. I forced myself to [] drink water and eat as much [] mix as possible to keep me hydra[ted] and stay warm. After almost [] hours, I finally found a spot good enough to set [up my] tent by a stream. Soon I changed into dry clo[thes], cooked and ate dinner, happy to stay warm and [dry] in my tent. Tomorrow, I will be getting into Gorh[am] before noon. All the wet dirty clothes will be d[one] with by then.

~ The Whites ~

Franconia Ridge,
Wildcats peaks,
Tallest Mount Washington,
Presidential Range.

Huff I went up,
Puff I went down,
Walk in the Whites,
With a heavy pack in toll.

Hot when I move,
Stop and I'm cold,
Confused my jacket,
It's been torn.

Cliffs are high,
Rocks are big,
Climb as a goat,
Slide as a snake.

Ridges with views,
Homey in woods,
To complete A.T.,
I need them both.

Carter Norch Hut, my sleeping un[it]

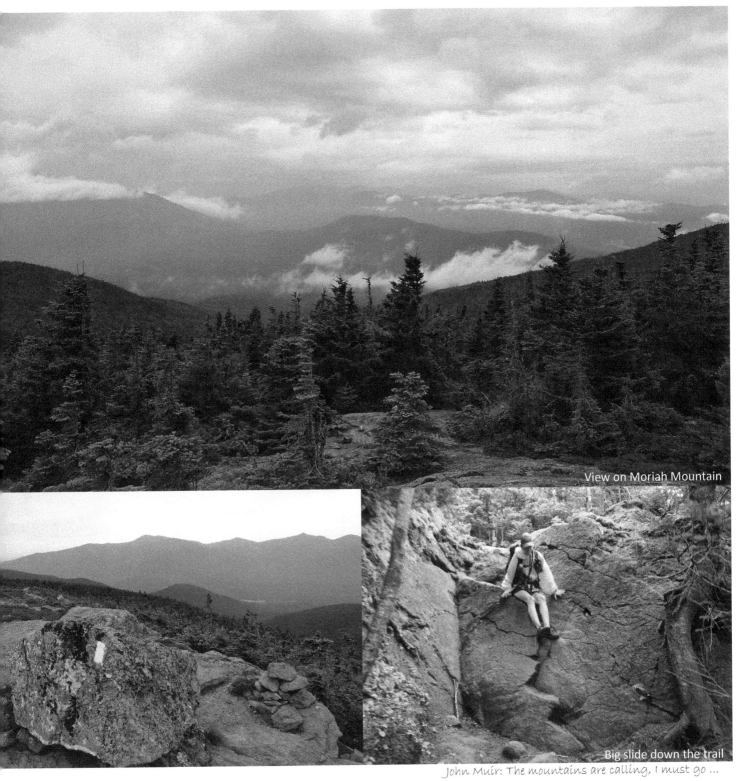

View on Moriah Mountain

Big slide down the trail

John Muir: The mountains are calling, I must go ...

Day 143: Less than 300 miles left
Thursday, August 22, 2019
Destination: Gorham, New Hampshire ~ **Today's Miles:** 4.2
Start Location: Camp above Rattle River ~ **Trip Miles:** 1896.7

Today was a resupply day in Gorham with only a 4.2 miles hike in the morning. I was lucky that the rain stopped before I woke up. The early morning allowed me the luxury of making breakfast and packing in dry condition. Of course, everything I packed was wet. Despite the damp gear, I was so happy to take the trail down more than 2100 ft to Road 2. The trail was slippery and steep for the first two miles, but nothing requiring crawling like Spiderman. The last two miles were very smooth and gentle. I really enjoyed it. It followed the Rattle River all along. There were many beautiful swimming holes and large flat rock slabs in the river. It would have been a wonderful place to take a weekend trip relaxing along the route.

There was a 300-mile mark on the trail [this] morning, indicating the distance to Kata[hdin] was only 300 miles! It made me excited.

I checked into the Royalty Inn in Gorh[am], a small town stretched long along Road [2]. Finding a ride to resupply was not very e[asy]. With some luck, a Tricounty transit driver w[ent] out of his way to take me to Walmart, [and] made sure the local bus driver picked me [up] when he ran the last round from the st[ore]. The hotel people were also very nice. T[hey] allowed me to use their laundry room a[nd] club center to shower before the check in ti[me]. They also got my room ready more than [an] hour before their normal check in time. All [is] well. I'm ready to go for the next leg of [the] Appalachian Trail.

Met a Korean thru-hiker at the hostel near trail head

Lovely Sunshine in the fores[t]

Day 144: Last full day in New Hampshire
Friday, August 23, 2019
Destination: *Gentian Pond shelter* ~ **Today's Miles:** 11.0
Start Location: *Gorham, New Hampshire* ~ **Trip Miles:** 1907.7

t back on the trail at 10:00am. The mild temperature and low humidity le this a perfect hiking day. At the trailhead, I ran into mby" doing trail magic there. I had not seen him since -May! It turned out that he didn't like the heat in inia and came back home, which is only a 10-minute e from here. He was very happy to see me again. As over of photography himself, he always talked about eras on the trail with me. It's great to see him again.

was the last full day of hiking in New Hampshire. The was a lot easier than any section in the past week. It like the state wanted to leave a gentle impression on ers on the last day. Just before Trident Pass, the usual

sticks-formed 1900-mile marker made me proud and excited. I had walked 1900 miles so far! A long way indeed. The trail passed several ponds today. At the outlet of Dream Lake, there were lots of aquatic plants with fuzzy dried flower heads. They looked amazing, back lit by the sun, too cute to pass by quickly without admiring them. That's the sort of things that can make you forget that you're on a schedule.

A little after 7:00pm, I arrived at Gentian Pond Shelter for the night. The opening side of the shelter had views of mountains and the sky, full of bright stars. One object stood out brightly - too low for a planet, too high for an airplane. I guessed it could be the space station.

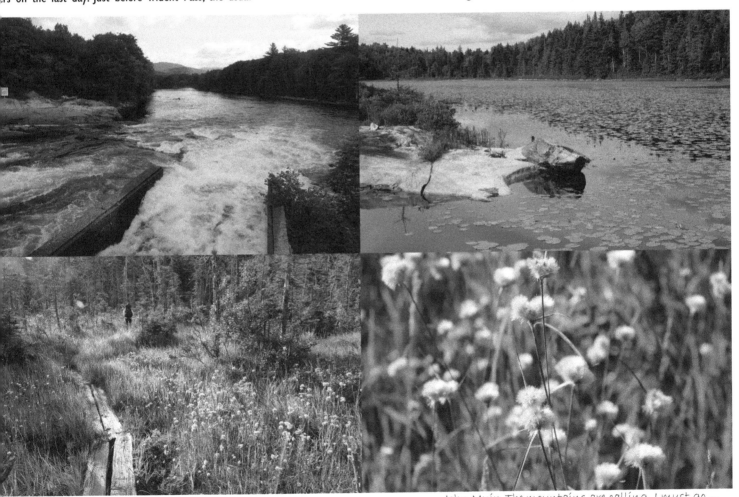

John Muir: The mountains are calling, I must go ...

Day 145-168: Appalachian Trail - Maine

The best is at the last.
A lot more challenging than I expected, as well as a lot more fun, lusher and more beautiful than I had imagined

Day 145: Into Maine
Saturday, August 24, 2019
Destination: *Full Goose Shelter* ~ **Today's Miles:** *9.6*
Start Location: *Gentian Pond shelter* ~ **Trip Miles:** *1917.3*

last mountain in New Hampshire is Mt. Success. It was not a very difficult peak, but not an easy one either. e were the usual rock scramblings at several locations and as many as four false summits. I walked to the real mit in heavy fog. The pictures I took of the peak in heavy fog attempted to capture my feeling of satisfaction nally summiting it.

oon, I passed the New Hampshire/Maine state line and had a nice long lunch break there. One last state to go!

e's trail was just as hard as New Hampshire's! In the first five miles of trail today, I have encountered the same unt of scrambling, with the addition of many metal bars, ladders and boards. Some of the latter were placed in weird angles, making them difficult to traverse. ly hiked a little less than 10 miles today, due to the slow pace. "Brave Heart" commented on my skill as spider-woman as I went up the large boulders, I was little more than an awkward turtle when I went down. There were some notches cut into rocks to help hikers climbing down, but they were sparse.

forest had more wildlife today. In the morning, a chipmunk was on trail eating blueberries. In the late afternoon, I spotted a big bird walking on the trail flying around. It sat on a tree branch two feet from me, frozen in place for more than five minutes. I also heard lots of what sounded like turkey noises he late morning. Not sure what they were.

h 277 miles to go in Maine, some say it would take a month, some wanted to finish in two weeks. I hope to finish it in 23 days. It is a tough state for Appalachian Trail.

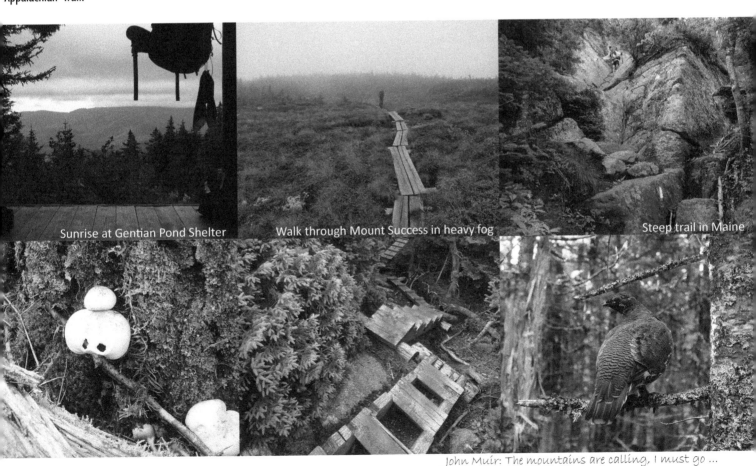

Sunrise at Gentian Pond Shelter Walk through Mount Success in heavy fog Steep trail in Maine

John Muir: The mountains are calling, I must go ...

Day 146: Hardest section on Appalachian Trail
Sunday, August 25, 2019
Destination: *Speck Pond shelter* ~ **Today's Miles:** *5.1*
Start Location: *Full Goose Shelter* ~ **Trip Miles:** *1922.4*

I set a record for my slowest pace today! To traverse Mahoosuc Notch (covering a distance of 1.1 miles), I spent 4 hours and 10 minutes. That was 3.8 hours per mile! Instead of just walking, I spent most of the time using my upper body strength to crawl, push and pull. I went under, over, and around big boulders, passing my backpack and trekking poles to "Brave Heart" many times, to get to the other side of the rocks. Without her, it would have taken me much longer to go through that difficult stretch. It was deep and cold in the Notch. I saw snow and ice in some crevices down there. The sunlight might never hit those spots. Many rocks were wet and slippery. I was thankful that it was a nice sunny day today. There were many beautiful looking wild star flowers in the areas where sunlight hit, blooms that usually exist only in the cool spring of mid-April. Some hikers call it the "Notch Jungle Gym". Many of the young hikers passed me quickly. On one slippery big rock, I slipped while squatting on it, hitting my tailbone. I had to hike with pain in my tailbone for the rest of the day, including most of the Notch and the following steep climb up to Mahoosuc Arm. People I met on the trail coming from the north all said Mahoosuc Arm was really bad, but I did not feel it was any more difficult than any section in the Whites. It was definitely much easier than the Notch I passed today. For 1.6 miles, going from the end of the Notch to the summit of the Arm, it only took me 1 hour 40 min.

Once I got up to the summit, I was greeted by wonderful views and curious dragonflies while I sat down on the warm rock, sunbathing. It was wonderful to have the most difficult part of the Appalachian Trail behind me. I also took some painkillers to reduce the pain caused by hiking, crawling, pushing, pulling and slipping. I think I will be on them for a few days. Shortly after the summit, there was a vast bog, lined with wooden planks. One of the planks lurched sideways when I stepped on it. I lost my balance, with one foot sunken into the mud - a bottomless mud, quicksand! In a blink of an eye, my knee went under. I still felt emptiness under my foot. Quickly, I rolled over to the side on grass to pull my leg out. Luckily, the grassy area was solid. I was safe, but my boots and pants were covered in mud.

In the early days on the Appalachian Trail, I only heard the Whites are tough. When I was in the Whites, I started to hear that South Maine was tough. Now I really think South Maine is tougher of the two. For today, I only travelled 5.1 miles, with nine hours of hiking. When I saw the first shelter after Mahoosuc Arm, I was mentally ready to stop for the night.

I cooked and sat at a bench next to Speck Pond. The warmth of the sun dried my pants and socks. The water in the pond was sparkling under sunlight - all perfectly beautiful and peaceful. The hardest section was in the past. I am looking forward to starting the rest of the journey tomorrow.

Cold loving star flowers in the Notch

This is the tra

Yes, this is the trail, to

Day 147: Baldpate
Monday, August 26, 2019
Destination: *Frye Notch Lean-to* ~ **Today's Miles:** 10.4
Start Location: *Speck Pond shelter* ~ **Trip Miles:** 1932.8

Looking at Little Baldpate Peak from the East Peak

onto the trail by 7:25am. It was a nice walkable trail for a while, until I was faced with a 500 foot
tical slope from Old Speck Summit. It then turned into an easy rock-climbing route with exposure
a granite dome. The view was great on the route up. Low clouds filled the valley like a layer of
e white liquid. A sea of green hills spread out from my feet, forming layers after layers of mountain
es - green in front of the blue, blue in front of the gray. The few hikers in front of me looked like
e ants, crawling hand over hand on the exposed slope. From afar, it looked scary and risky. But I
this type of climbing. In Yosemite, every time I had to do this, I got excited. The dry rock gripped
well under my hiking boots; not even slightly slippery. My hands touched the cracks and notches
the rocks too. I felt in tune with the rocks.

ee and half hours later, I reached a nice creek and filled my water bottle with sweet stream water.
n after, I reached road 26 and had a lunch break there. Someone left cherry tomatoes and a bottle
grapefruit juice at the parking lot. I assumed it was for trail magic and had some of each as part
my lunch.

r lunch, the next leg of the journey was the climb to Baldpate mountain: over 2200ft. The trail was
excellent condition with well constructed stairs. Even though it took time to reach the west peak, it
a smooth sailing. From the west peak, I could see the east peak, bald and bare, not far from me.
lt alive again and enjoyed every step on the exposed rocks. A wind farm was in view as I walked.
blueberries were everywhere on these peaks, bearing large ripe sweet berries everywhere my eyes
d see. Right after the east peak, there was the Little Baldpate Mountain, with another exposed top,
y slightly lower. From the east peak, this little bald looked like a cream-colored chess board sitting
a green carpeted field, waiting to be played by giants. I enjoyed all three baldpate peaks. They are
favorite things on the trail.

ting down from Little Baldpate Mountain was a little nerve racking, as the slope was steep and there
e not many good things to hold onto. The going was slow from there. By the time I reached Frye
ch Lean-to it was almost 6:30pm. Another day that was short of my planned distance. It has been
ly hard to plan for any day since the Whites. It all depends on the trail conditions.

Granite steps on Baldpate Mountain

John Muir: The mountains are calling, I must go ...

Day 148: A mellow trail
Tuesday, August 27, 2019
Destination: Black Brook campsite ~ **Today's Miles:** 14.6
Start Location: Frye Notch lean-to ~ **Trip Miles:** 1947.4

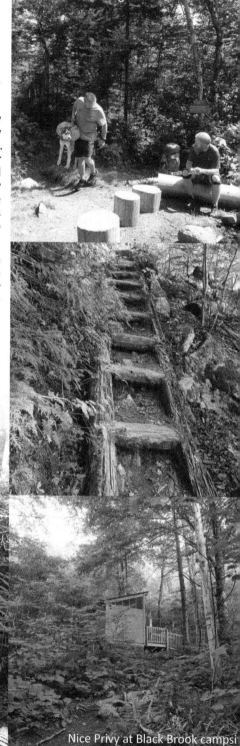

This dog's trail name is "Suitca...

After I emailed my friends that I hiked into the last state, Maine, a lot of support messages came in. I was so blessed and moved by their encouragement and support. Hey, all of you, thanks so much! I really cannot do this without you!

Finally, Maine showed its gentler side, or rather, showed me some mercy. Today's trail was so lovely: mellow rolling hills, no rock scrambling. Some sections were even paved with soft and spongy dirt, putting my weary feet at ease. Plus, low humidity and cool air for most of the day. I could not ask for a better condition. The easy strolling in the morning made me sing along with a Taiwanese campus song that was popular in the 80s after I saw a few fall-colored leaves in the otherwise green forest. It is translated as such: "I walk on the side of fields. The fields are filled with fall color. ... How big is the blue sky, floating a few white clouds. Blue mountains have no boredom, flowing clear brooks in them...". These mellow trails gave me a feeling of wellbeing, a feeling of making good progress towards my (goal) destination. I was not as helplessly weak as a couple of days ago when the hard trail beat me as bad as it could. I could set up my goal for the day and get it accomplished. I journeyed 14.6 miles today, back to my normal range.

Two things on trail caught my attention today. In a section about a half-mile long, moose droppings were littered throughout. I named it the moose privy section. The droppings were dry and old. Moose were nowhere to be found. Where could they hide? The other curiosity was the lovely neon-green moss under trees. Uniformly carpeting the forest floor, not leaving any area uncovered, dry to the touch, and spongy when pressed. It gave me the desire to walk on them with bare feet.

I have to admit, the last hill, Moody Mountain was no joke. Somehow, I misread it and thought the climb would only be 500ft. It was actually about 1500ft, and very steep. It was also in the late afternoon, when my body was already tired. So, I dragged my body onwards and upwards, all while wondering why this 500ft was so hard and so long. One section of the trail was a mess. Trees were in every direction, alive and dead. Rocks were in every form but flat, dirt was dusty and loose. It looked like a bomb was dropped here not long ago. My hiking buddy commented that the metal bars on the rocks were nice to have. But I looked at her blankly: "Bars, what bars? I did not see any."

By 6:00pm, I reached Black Brook campsite, ready to catch the morning shuttle from a nearby road to a hostel tomorrow to resupply for the next five days of food and medicine! The campsite looked very cozy in the late afternoon sun, next to the quiet brook in a young hemlock grove.

Nice Privy at Black Brook campsi...

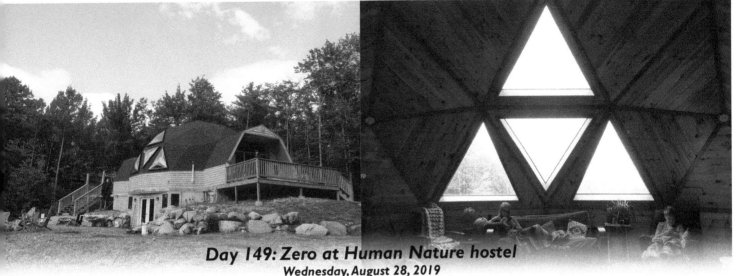

Day 149: Zero at Human Nature hostel
Wednesday, August 28, 2019
Destination: *Human Nature Hostel* ~ **Today's Miles:** *0.1*
Start Location: ~ **Trip Miles:** *1947.5*

Signed up for hiker trading card

Met "Quest" again far north

I arrived at Human Nature Hostel for a zero day, relaxing and resupplying. It didn't have to be a full day off. But the weather was expected to be bad for the night, and taking a day off after those hard sections was so appealing. I am glad I made this decision now. As I am writing the journal, the outside is just pouring with cold water from the sky.

The hostel is very nice. It sported a unique design of a dome-shaped three-story house, with so much detailed craftsmanship inside, from the restored cool stove, customized countertops and tables, posts and stairs with sailor's rope railings, and handmade pouches and necklaces. Very artistic and in great taste. Even the pancakes had an "AT" symbol to decorate. The owner has plans to make this place a full service resort. I wish him success.

Today was a true zero day, not planned, but worked out this way due to the shuttle schedule.

John Muir: The mountains are calling, I must go ...

Day 150: Old Blue Mountain
Thursday, August 29, 2019
Destination: *Bemis Stream* ~ **Today's Miles:** *12.5*
Start Location: *Human Nature Hostel* ~ **Trip Miles:** *1960.0*

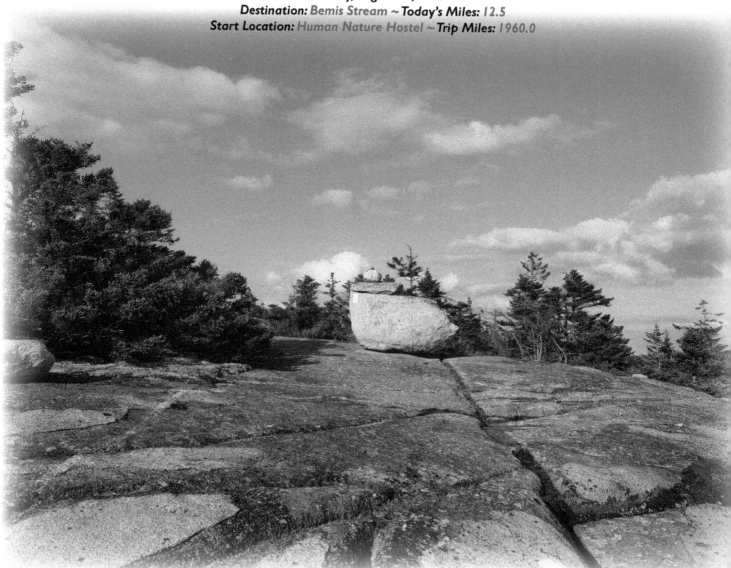

I got a late start since the hostel shuttle only reached the trail head a little before 9:00am. One SoBo hiker said Old Blue Mountain was the toughest for hi in Southern Maine. I found it was quite manageable. The climb was 2200ft. But I was well fed in the hostel with gigantic pancake, blueberry source, map syrup, butter, biscuit, meat gravy and sausage in the morning. So, the hike to the top of Old Blue was pretty easy. Once I got to the top, I was above t clouds and had a great open space with flat rocks to sit on. I took a snack break there.

By lunch time I came to a view point before Bemis Mountain. There is even a real bench to sit on for the lunch break. That was a rare find.

The plan for today was to hike to road 17 and camp near the overlook point to watch sunset. However, from Bemis Mountain the trail got a little mor challenging. There were lots of muddy pockets which needed extra attention. Then the downhill got worse with long slippery slopes with nowhere to hold o These trail conditions slowed down my pace considerably. At the end by 7:00pm, I was tired, didn't want to climb the 700ft on to road 17, but ready to cam by a nice creek, one mile short of my planned destination.

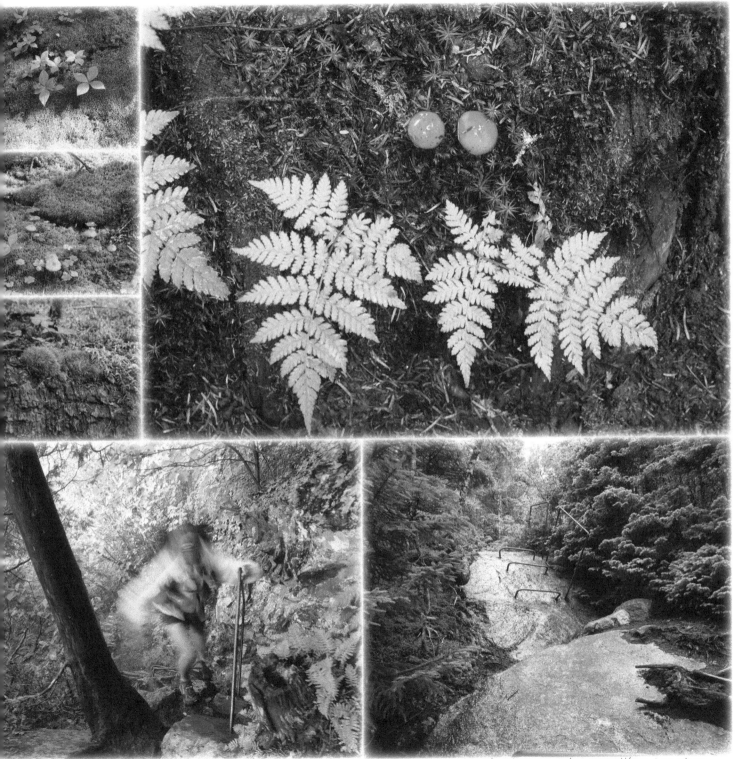

John Muir: The mountains are calling, I must go ...

Day 151: Paradise view & Hiker Hut
Friday, August 30, 2019
Destination: Hiker Hut ~ **Today's Miles:** 13.9
Start Location: Bemis Stream ~ **Trip Miles:** 1973.9

The first thing on this morning's itinerary was to climb 700 ft to reach Height of Land Scenic Overlook. I couldn't reach it to watch the sunset last night, but the overlook this morning more than made up for it. It was lined with fields of flowers. The lake of Mooselookmeguntic sprawled out under the overlook to the right, paired with the hills I hiked yesterday on the left. The sky was filled with cotton ball clouds. The morning sun gradually moved the shadows of hills to reveal the green of the trees and bright pastel shades of the flowers. Cool winds brought the freshness of the forest to fill up the air. Sights of paradise might only just compare to the sights I saw this morning.

For the whole day, I had fairly mellow trails. It was a great break for my tired body. It was not the type of smooth trail where one can walk fast and worry free; there were still many pockets of bog and mud to watch for, and still many gnarled roots that could cause one to fall unexpectedly. But, by Maine's standards, this was as good of a trail as it could get. The last mile before reaching Road 4 was the best part of all of this. For a while, it was very smooth and very pleasant to walk on. I even purposefully slowed my pace just to enjoy it longer. By the end of my hike, I had done almost 14 miles in 10 hours, including all the resting times. Knowing there will be another five days of tough mountains ahead of me, I was very happy with today's progress.

I met a group of trail builders. They were setting rocks for a water runway on the trail. They told me it would take them two to three days to build a ten-foot length of stairs for the trail. I was shocked to hear it would take that long for just ten feet! That's a ton of work to make the trail safer and "easier". I noticed many spots on the trail that would be better for hikers with heavy packs if there were stairs to assist them.

Mushrooms on tra

Trail through bo

The sign to Hiker Hu

For the night, I checked into Hiker Hut with tenting. They provided a warm outdoor shower by the creek (or rather, sandy river), hot dinner and tea, and solar powered charger for my phone. The property was off-grid and well-kept with beautiful flowers, a campfire ring and picnic table. I loved their outdoor shower. The water was from the creek. You use a bucket to fetch water and put it into a container. A tankless water heater heated the water when turned on. The dense trees along the road blocked the view from the passing cars on the road.

Sedated outdoor shower at Hiker Hut

Outdoor dinning at Hiker Hu

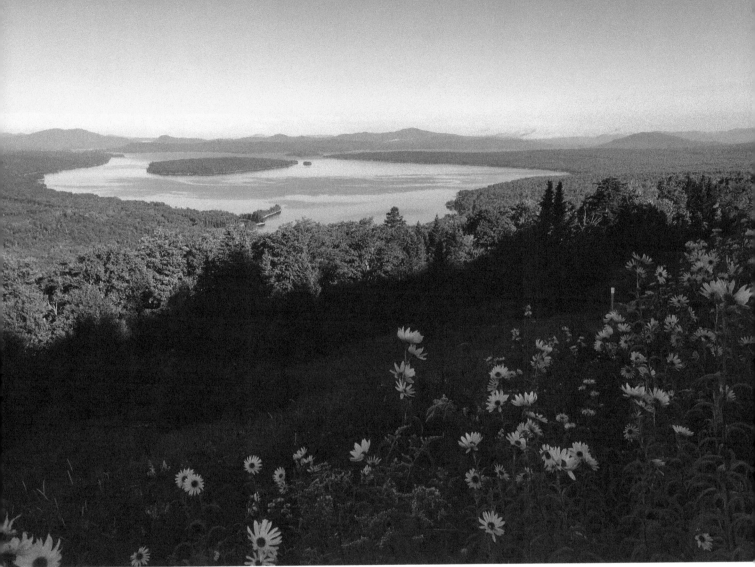

Can you pronounce the name - Mooselookmeguntic Lake

HEIGHT of LAND

John Muir: The mountains are calling, I must go ...

Day 152: Saddleback Mountains and the Horn
Saturday, August 31, 2019
Destination: *Old rail bed* ~ **Today's Miles:** *13.5*
Start Location: *Hiker Hut* ~ **Trip Miles:** *1987.4*

I left the Hiker Hut at 7:00am. The owner, Steve, fed me hot tea, an egg & cheese sandwich, and a sweet donut. I was full of energy, ready to climb Saddleback Mountain - a very challenging one, according to many hikers I had talked with. It turned out to be not as difficult as people said. Though the route was steep and the climb was high, nothing was hand over hand. I ended up at the summit by 11:15am, still feeling energetic. The weather on the exposed ridge, on the other hand, was another beast. The windchill felt as if it were ice, and I kept moving to keep myself from freezing. There was a small circular rock shelter for blocking wind. I went there for the lunch break, put my fleece jacket and down jacket on, as well as gloves. I snacked on blueberries I gathered on the ridge, and mixed them with my trail mix inside a tortilla for a snack wrap. They were so delicious. I finished 3 for my lunch.

The next peak was The Horn. It was lower than Saddleback Mountain, but I guessed getting down from it could be hard due to its profile. Unfortunately, my guess turned out to be correct. Descending The Horn took a longer time than I would have liked due to the larger boulders and mud pits. While trying to avoid getting my shoes wet at one of the sinkholes, I lost my balance and fell backwards into the watery mud! As a result, my clothes, boots, and socks were dripping wet. In the howling wind, I had to change into dry socks, a t-shirt and pants - not a pleasant thing to do. Fortunately, I had all my supplies in waterproof bags, so I had enough dry clothes to keep me warm and comfortable until I reached town in two days.

After tackling The Horn, there was still Saddleback Junior Mountain to go over before the day ends. Someone told us it was all stairs going up to this peak - it was not. The last mile had lots of gnarled rocks. Going down from it was also slow, navigating a maze of stones. By 5:20pm, I reached a shelter. Yet I still had energy. I pushed for another two hours to a river, down almost 2000ft. I was happy to complete this section today and save some time tomorrow.

The top of Saddleback Junior looks like out of Kung Fu Panda's practicing field

Day 153: 2000 miles!
Sunday, September 01, 2019
Destination: 1.5 miles north of North Crocker Mountain ~ Today's Miles: 15.1
Start Location: Old rail bed ~ Trip Miles: 2002.5

...ck can only click her iPhone today. My camera has been dead since yesterday ...ternoon when it was accidentally submerged in water and mud. I thought it would ... ok since it was waterproof. I was wrong. The camera was more than 6 years old, ... the sealant was already weak. When I get to town, the camera will be sent home. ...rtunately, in just a few days, my husband will be re-joining me for the final leg on ...e Appalachian Trail. I am sure we'll have a nice and hi-tech camera by then.

...day was easy sailing. Going up to Lone Mountain and Sprawling Mountain in the ...orning took some effort, but wasn't particularly difficult. Even in the afternoon, when ...am usually a little tired, I felt much better going up to the two peaks of Crocker ...ountain.

...ter I came down from Crocker, two signs arranged with stones were there, pronouncing ...le 2000! I was very excited to see them! Earlier there was a sign telling us that ...ere was only 200 miles left to Katahdin! How cool is that?

...ar the signs, there were some flat spots in the woods. Because the sun would be ...tting soon, I wanted to look for good camping spots. Big mistake! Since my eyes were ...inted downward, I didn't notice the huge wasp nest hanging over my head. With ...sharp buzz, a wasp stalked me and stung my right ear. Immediately, I reached my ...enadryl. Hopefully the swelling won't be too bad to require more medicine.

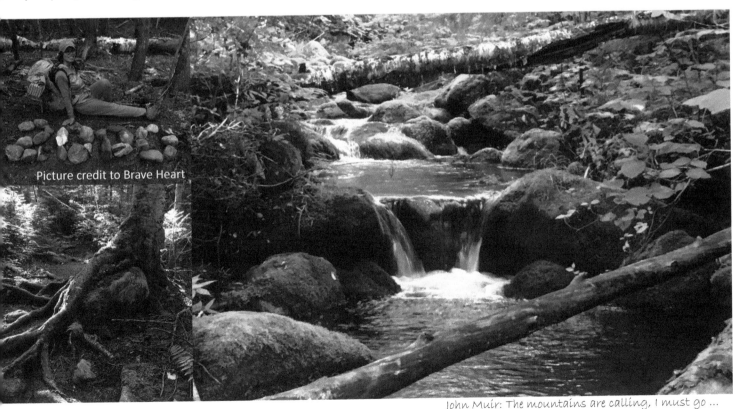

Picture credit to Brave Heart

John Muir: The mountains are calling, I must go ...

Day 154: It's September
Monday, September 02, 2019
Destination: *Stratton motel and hostel* ~ **Today's Miles:** *3.7*
Start Location: *1.5 miles north of North Crocker Mountain* ~ **Trip Miles:** *2006.2*

"Sketch" from Japan showed his water color to me

Falling leaves in the cold rain

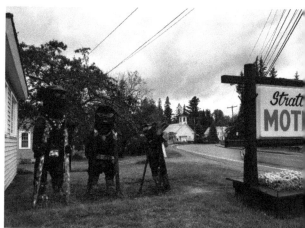

Oh babe, the rain is cold. So come here, we'll snuggle together.
Oh babe, the wind is strong. So come here, let me hold you tight.
It's September, and we're still in the woods of Maine.

Oh babe, the trail is long. So hold on and be strong.
Oh babe, the cliff is high. So hold on and I'll pull you up.
It's September, and we're still in the woods of Maine.

Oh babe, I felt the cold air on my face. So end is near for us to touch.
Oh babe, I saw red leaves falling by my feet. So autumn is near for us to celebrate.
It's September, and we're marching to the end of A.T. in the woods of Maine.

I marched along the trail in the cold rain this morning all the w
to Road 27. The wet and shiny leaves were not all green anymo
Some had turned yellow, orange, and even red. The wind blew, se
ing colorful leaves swirling down beside my feet. Each raindrop
colder than the one before. At Road 27, the chill drifted deeper i
my bones after I stopped moving. Huddled underneath the inform
tion signage, with another hiker's Verizon service, I connected w
the owner of Stratton Motel and Hostel. Chris came 15 minutes la
shuttling us into town. Tonight, I am away from the cold rain;
warm, resupplied and well-fed. Ready to be back on trail tomorr
188 miles from the finish line!

P.S. After carefully checking my camera in the hostel this afterno
I found that the main functions of my camera were still operatio
It will stay and finish the journey together with me!

Day 155: Bigelow mountain
Tuesday, September 03, 2019
Destination: *Stratton hostel* ~ **Today's Miles:** *16.7*
Start Location: *Stratton motel and hostel* ~ **Trip Miles:** *2022.9*

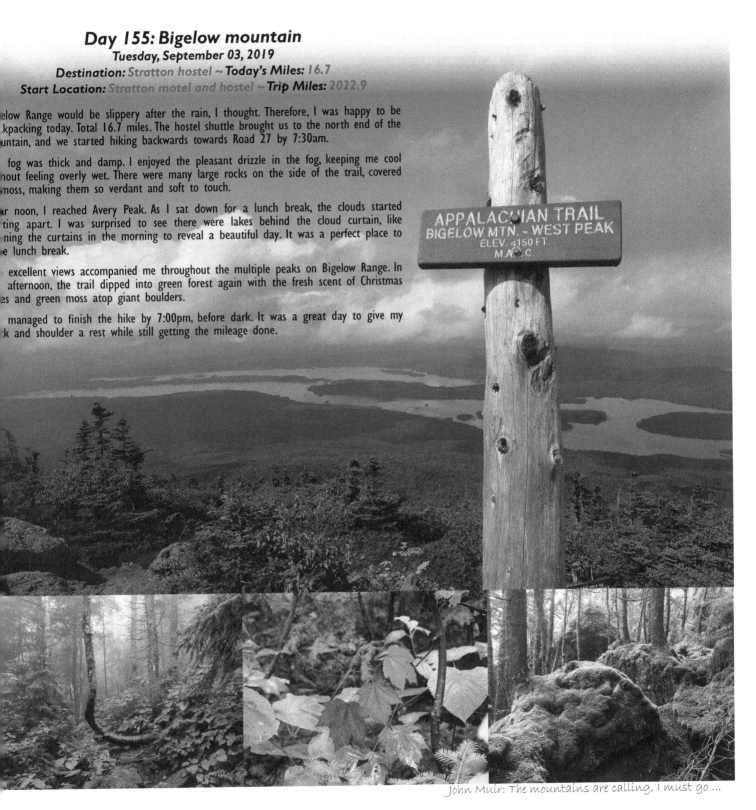

elow Range would be slippery after the rain, I thought. Therefore, I was happy to be
kpacking today. Total 16.7 miles. The hostel shuttle brought us to the north end of the
untain, and we started hiking backwards towards Road 27 by 7:30am.

fog was thick and damp. I enjoyed the pleasant drizzle in the fog, keeping me cool
hout feeling overly wet. There were many large rocks on the side of the trail, covered
moss, making them so verdant and soft to touch.

r noon, I reached Avery Peak. As I sat down for a lunch break, the clouds started
ting apart. I was surprised to see there were lakes behind the cloud curtain, like
ning the curtains in the morning to reveal a beautiful day. It was a perfect place to
e lunch break.

excellent views accompanied me throughout the multiple peaks on Bigelow Range. In
afternoon, the trail dipped into green forest again with the fresh scent of Christmas
es and green moss atop giant boulders.

managed to finish the hike by 7:00pm, before dark. It was a great day to give my
k and shoulder a rest while still getting the mileage done.

APPALACHIAN TRAIL
BIGELOW MTN. - WEST PEAK
ELEV. 4150 FT
M.A.T.C.

John Muir: The mountains are calling, I must go ...

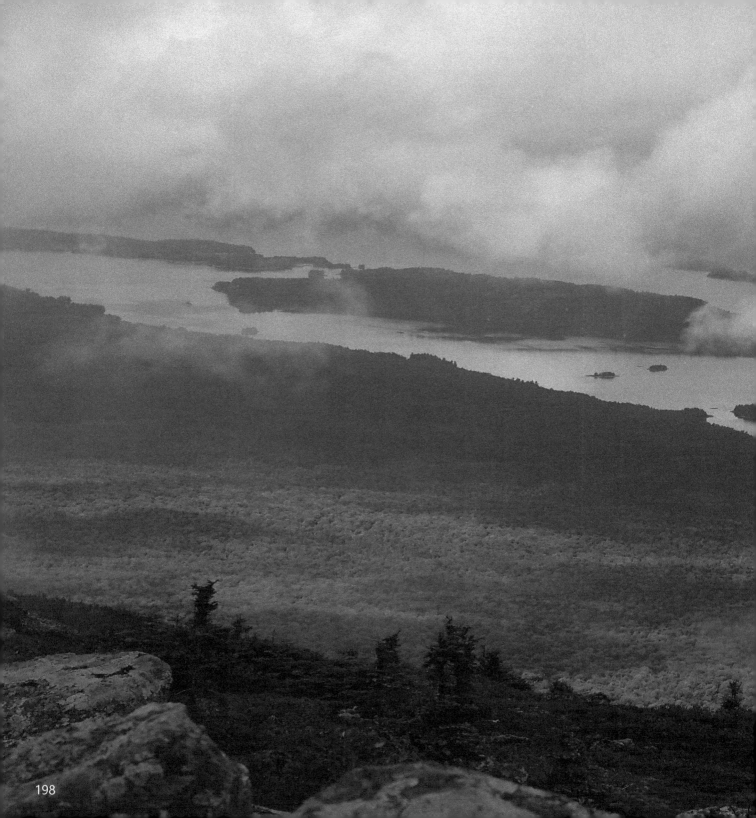

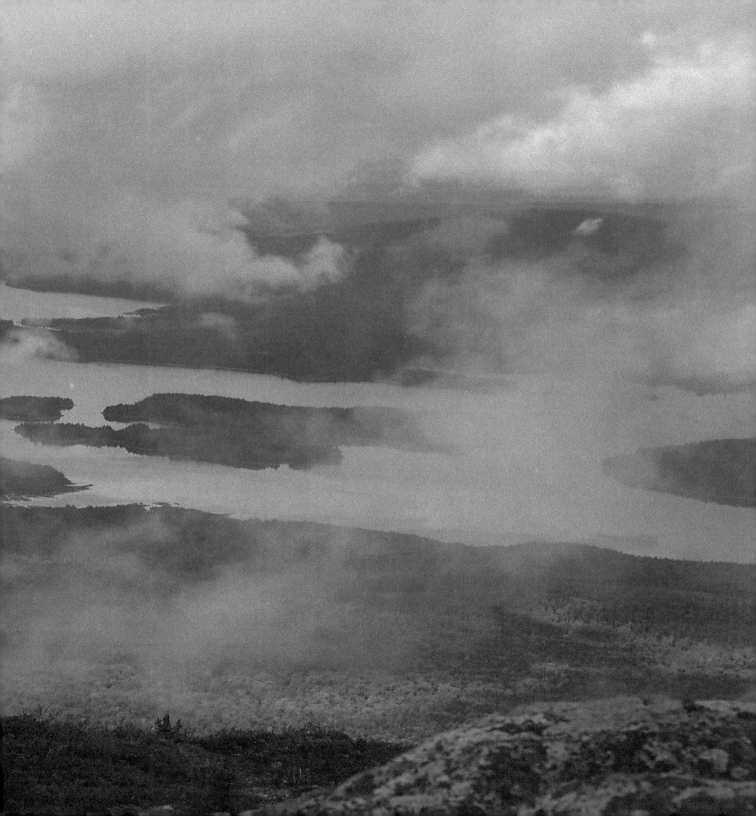

Day 156: Short day, shower day
Wednesday, September 04, 2019
Destination: West Carry Pond shelter ~ **Today's Miles:** 6.3
Start Location: Stratton hostel ~ **Trip Miles:** 2029.2

The weather report for today was really bad. 80% chance of thunderstorm and chances of hail throughout the afternoon. I decided to hike only in the morning, to the first shelter 6.3 miles away, and stay there to wait out the storm. I arrived at the shelter by 11:30am. It rained hard for a couple of hours. Then, strong winds just blew the dark and stormy clouds away from our area. I felt like I was chickening out this time since I really didn't want to get my boots soaked wet. They had just dried last night after they got soaked on Monday. After 6:00pm, a fellow hiker said that she heard thunder. In a couple of minutes, the storm hit our shelter hard with pouring rain. You never know what can happen on the trail!

I had passed the most difficult part of the trail. Today and tomorrow are 'easy' sections - at least, that is my expectation from looking at its profile in the guide book. But, I can only find out what truly lies in store for me on the road. There will be lots of roots and swampy areas on the trail, which could be hard to navigate when wet. I noticed more and more leaves have changed color or fallen. Each day, Nature is trying to give me hints about the upcoming autumn. Keeping warm will be my concern from now on.

West Carry Pond looked hug

Day 157: Cross Kennebec River
Thursday, September 05, 2019
Destination: *Caratunk Hiker B&B* ~ **Today's Miles:** *19.3*
Start Location: *Stratton hostel* ~ **Trip Miles:** *2048.5*

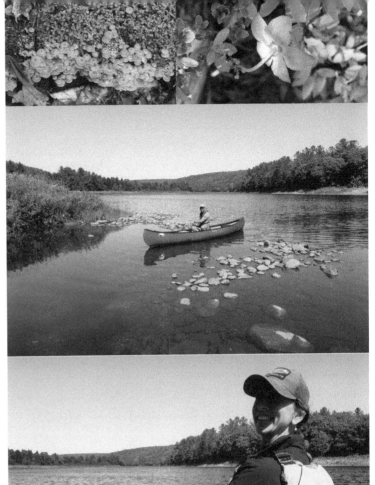

...ll asleep before the rain stopped. Sometime in the night, the wind started ...howl loudly. I opened my eyes but couldn't see anything. It was pitch black. ...oked over to the backpacks hanging in the entrance of the shelter, but saw ...hing there - the blackest black I had experienced. The whole world was just ...sounds of wind and tree branches drumming against the roof of this tiny ...ter. I felt the cold air on my head. I buried my face deeper and deeper into ...cozy envelope of my quilt, dozing in and out of sleep through the windy ...nt.

...en daylight broke just before 6:00am, the wind was still very strong. I was ...d that the wind had dried everything. In the chill, I got dressed quickly, had ...varm breakfast of oatmeal and started hiking by 7:00am.

...ng the edge of the pond, the wind turned the pond into a little ocean, with ...ves pounding and splashing the rocky shore. As soon as I turned away from ...pond, the wind had disappeared. The violent rustling of leaves was replaced ...the chirping of songbirds.

...was a fast march to the end of the 13.7 miles, before boarding the official ...alachian Trail ferry to cross the Kennebec River at 2 pm. For almost seven ...rs, I raced across unstable wooden boards on rocks and over mud. I only took ...heavy backpack off my aching shoulder once. I reached the ferry crossing ...nty minutes before the official closing time. "Brave Heart" was waiting for me. ...was very happy to see I made it. Once I boarded the boat, I felt relaxed ...relieved. The saying is that if one missed the last boat run of the day, you'd ...d to wait for next day ferry.

...er disembarking, we walked a short distance to Caratunk Hikers B&B. There I ...rned that they offered slackpacking about five miles to the north for free if ...tayed at the hostel. After a milkshake and a pulled pork sandwich, I was on ...il again to slackpack the last 5.3 miles. It was a pleasant walk, no big ups ...downs. And in the cool forest, I didn't feel any humidity nor hot air, the ...fect hiking condition. By 6:00pm, the hike was finished, and we were shuttled ...a local restaurant for dinner.

John Muir: The mountains are calling, I must go ...

Day 158: Mushrooms
Friday, September 06, 2019
Destination: *Bald mountain stream road* ~ ***Today's Miles:*** *17.5*
Start Location: *Boise Cascade logging road* ~ ***Trip Miles:*** *2066.0*

Instead of opting for a tasty breakfast in Caratunk House B&B, I decided to get an early start. Before 7:00am, I was on the trail to climb the mountain. Halfway up, I stopped for a break to cook my oatmeal breakfast. I had more food than I could finish before entering the next town, Monson - my last full resupply location on the Appalachian Trail.

The way up was smooth. Even though I was tired from yesterday's big mileage, I still kept a good 1.5-mile per hour pace. There have been so many varieties of mushrooms today. I found a picturesque huge orange-red one with yellow speckles on it, straight out of Alice in Wonderland. The yellow speckles looked like sesame seeds on top of a giant cheeseburger bun. There were so many different shapes and colors of mushrooms; some were really cute; some were impressively huge. I also saw a family of grouse today morning, including a chick. The mom was trying to protect her child from acting stupidly in front of humans. It felt like I could catch her with my bare hands if I tried. In the evening, I saw a few moose tracks in the mud, but still no moose sighting.

In the afternoon, I climbed to the top of Moxie Bald Mountain. There were many glacial rocks. The open summit was long with great views in every direction with lots of tasty blueberries scattered throughout the mountaintop.

Back down from the summit, past Bald Mountain, there were many rocks lined perfectly on trail to form a rock-hopping path. This path made walking on the trail so easy. Thank you to all the trail builders.

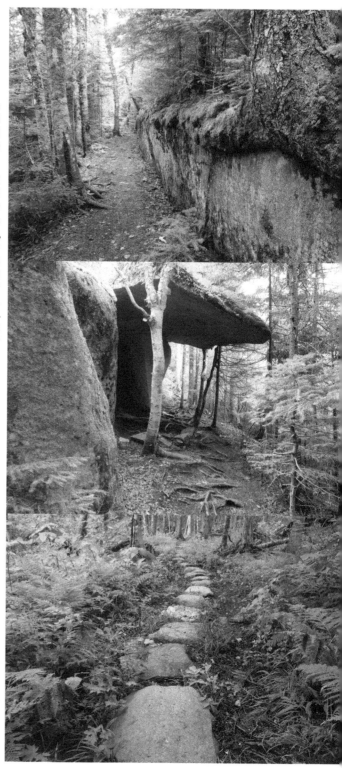

John Muir: The mountains are calling, I must go ...

Day 159: Monson
Saturday, September 07, 2019
Destination: Shaw's ~ Today's Miles: 13.0
Start Location: Bald mountain stream road ~ Trip Miles: 2079.0

As usual, I started hiking at about 7:00am. I want to reach Monson, Maine - the last resupply location on the Appalachian Trail as soon as possible. My husband should have arrived in town yesterday, but I haven't been able to contact him yet. There were small ups and downs on the trail. Nothing was really hard. However, after more than five months of walking day in and day out, my body was tired. Plus, I was approaching the end of the journey, and psychologically my body gave out signals to slow down. Now more than ever, I needed to focus on my goal and remind myself to hold on and be strong.

On this section of the trail, there were even more interesting mushrooms than yesterday. Some were like mother and child, some were as round as pearls, some were upside-down bowling pins, some were silvery-gray, and some were orange-red. They were everywhere, in abundance. I also noticed big moose footprints - but still no sight of the shy giant.

There were two spots on the trail today that I needed to ford, where the water level was high: the west and east branches of Piscataquis River. Some

hikers left comments about the water, warn that it could be as high as their waist. Th comments made us nervous. I crossed river with the water level below my calf. water was cool, but not too cold. I actu found it was quite nice to have my soaked for a while.

When I reached the shore of the east bra someone was calling me from across the ri I looked up, on the bank of the river, my h band was smiling and waving at me! It tur out that he had arrived in town yester afternoon. This morning he walked six m to meet me. It was such a happy surp With him leading the way, we walked toget back to town. When we were still about a away from the town, a red pickup stop next to us. They offered to give us a ride Shaw's Hostel. We gladly accepted their o and climbed up on the back of the pickup with no guarding frame, sitt nervously but happily with our packs.

In Monson we resupplied, found out hiking information in Baxter State P from a visitor's office, and had a late, but tasty dinner. Tomorrow we'll setting our feet on the last one hundred miles of wilderness!

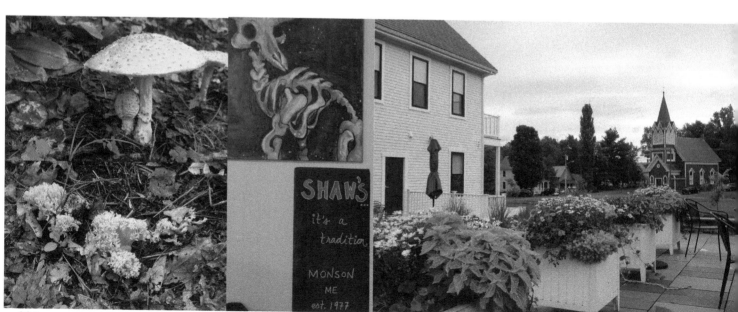

Day 160: Into 100 miles wilderness
Sunday, September 08, 2019
Destination: A mile before Wilber Brook ~ **Today's Miles:** 12.2
Start Location: Shaw's ~ **Trip Miles:** 2091.2

We got a late start to the trail this morning due to the number of hikers lined up for the shuttle. We went on the second shuttle and only started walking at about 9:00am. So, I expect that we will not reach our planned destination 15.1 miles away. Even with a relatively moderate trail, doing fifteen miles with a heavy pack full of seven days' worth of supplies would not be easy, especially for my husband on his first day. By the end of it, we hiked about 12.2 miles and stealth-camped about a mile and half shy from Wilber Brook.

This section was not as easy as yesterday's trail, but still quite manageable. Nothing was technical. I did slip once on a slanted rock and ended up landing on my left buttock. Having my husband here with me had some advantages. When the descent got difficult, he would lend me his hand to help me get down big steps. When the ascent was difficult, he would give me one extra push upward. But later, he got tired and had to walk slowly. He was not able to keep up with me since I was used to walking eleven or twelve hours every day for the last five months. Nonstop traveling around the global in the past two weeks didn't help him either.

In addition to the mushroom potpourri I've become accustomed to seeing, I also saw a cute little waterfall today. A few day hikers crossed the river above the waterfall area. I would never do it. Always do water crossing below a waterfall. Any misstep could be fatal. I have heard too many accidents in Yosemite's Vernal Falls, in the Emerald Pool. We ended up following the trail and crossed the river about half mile below the falls, on Little Wilson river. Our big challenge today was fording Wilson River. The current was quick, and the water level was up to my thighs. When I crossed the river and looked down into the water, I felt dizzy, and unstable even with my hiking poles. It took a while for me to get across. Glad that my husband was here with me.

Tomorrow we'll get an earlier start as we'll have another river crossing. Then there will be more climbing of mountains. So sweet dreams for now, at 9:15pm. The half-moon shines brightly above my tent.

John Muir: The mountains are calling, I must go ...

Day 161: Rivers and mountains
Monday, September 09, 2019
Destination: West Chairback Pond ~ **Today's Miles:** 12.1
Start Location: A mile before Wilber Brook ~ **Trip Miles:** 2103.3

We were on the trail before 7:00am. It was easy for a couple of miles; we saw many nice campsites along the Long Pond stream. Much better than the site we stayed at in a hurry last night. If only we could have made this far! Two hours in, we crossed the stream. I changed into my sandals for a wet crossing. The current was strong, but I managed to stay on high rocks (for the most part). Overall, it was easier than yesterday's Wilson River crossing. My husband managed to hop from rock to rock over this stream and kept his boots dry.

After that, the climbing began. We climbed about 2100ft to the top of Barren Mountain, and had a relaxed lunch near the old fire lookout tower. I even made mushroom soup for my husband, who had sweat a lot and lost lots of salt. At that time, I realized that we may not get to any water source till late afternoon. I rationed my water until a few hours later, when we saw a small stream with clear water. This water source and another usable one less than half a mile later were not in my guidebook.

The trail conditions changed after the stream crossing to something rougher. We were again slower than I expected. Now it looks like we'll need four days to finish the 43 miles in the wilderness, instead of the planned three days. By 6:00 pm, we made it to West Chairback Pond Falls, 1.7 miles away from the Chairback Mountain lean-to. In total, we only did 12.1 miles today. After we crossed West Chairback Pond Falls, we saw a nice stealth camp site, enough for our tent and "Brave Heart's" tent. So, we are settled for the night. The rushing sound of the waterfalls will rock us into pleasant dreams.

A usable flat spot for tenting before night fall

Water loving pitcher plants near tr

John Muir: The mountains are calling, I must go ...

Day 162: Chairback mountain
Tuesday, September 10, 2019
Destination: *Carl Newhall lean-to* ~ **Today's Miles:** 11.6
Start Location: *West Chairback Pond* ~ **Trip Miles:** 2114.9

Today was a lovely day for hiking. From early morning, the birds sang happily, sunlight lit up the forest, and light breezes kept me alert and moving fast to keep warm. We had Columbus Mountain under our feet within an hour. The view from the mountain top was awesome. There were not many clouds in the clear sky. It's hard to believe the forecast predicted rain tonight and tomorrow. It felt like there would be no trouble at all for eternity - well, at least until we finish our hike on Katahdin.

Many people warned us about the difficulty going down the north side of Chairback Mountain. However, except for a short section of less than a hundred feet with manageable rock scrambling, the mountain was actually quite easy to go up and down. "Brave Heart" said, "for us pros, this is nothing"! Ha! I felt the same.

We were still moving at a slow pace and only did 11.6 miles today, stopping before the four peaks in the next six miles - the last major obstacle before Katahdin in the 100 miles wilderness. One thing holding us back was that we didn't want to rush, another thing was that my husband still wasn't feeling well. He had lost appetite and threw up after eating. So, for us to do 11 to 12 miles a day was already a lot to ask for him. I think all the around-the-world traveling for him in the last two weeks had put his biological clock in a confusing state. He really just needed more time to adjust. I have been making hot soups for him at lunch time. Hopefully with time and better rest he could recover soon.

I took more pictures of lovely mushrooms today. They were not stopping to amaze me with their various shapes, colors and variety. In addition, I saw a nice little frog in a stream. It had a green head and upper body, but brown lower body. Shiny and slimy. It tried very hard to hop away from me; poor little creature got scared. Then, in a dark forest of hemlocks later, two jumpy squirrels, one was riding on top of another, looped around a big tree trunk. They noticed me coming, stopped for a second, separated, and jumped around for a while. I tried to capture them in my photos, but mostly just got blurry images. They were so fast! Even later, when I was filtering water at a creek near my campsite, another squirrel skirted across boulders littered in the steam. The gaps between the boulders were much longer than its body length, but it crossed them so fast and easily like there was nothing in-between. I was so jealous of the squirrels, so easily maneuvering around boulders and rivers.

The rain actually started at 7:00pm, just as the forecast said. In my cozy tent, I hope everything will be kept dry. Hope the rain would stop by next morning so that we could have a good day to move on.

The trail down from Chairback Mountain

Day 163: White Cap Mountain
Wednesday, September 11, 2019
Destination: *East Branch Lean-to* ~ **Today's Miles:** 10.8
Start Location: *Carl Newhall lean-to* ~ **Trip Miles:** 2125.7

The rain lasted throughout the night and morning. It was the type of rain that made you want to stay at home, lazily wasting the whole day indoors with a hot beverage and an open book at one's lap. I imagined myself sitting by a window, looking to the outside from time to time, watching the rain sprinkle on the window and be thankful that I would not need to go outside. Unfortunately, I had to bring myself back to reality. We started packing after 8:00am and were on trail before 9:00am. The rain had already delayed our start time by almost two hours. We need to get moving and get going, or we would not have enough food to reach the next store at Abol Bridge Campground, over 63 miles away. After a couple of hours, my boots and socks were soaking wet. My pants and underwear were also damp despite my multiple layers of rain gear. My husband had newer gear, with waterproof boots and heavy-duty gaiters. He was able to keep his feet dry.

We have four peaks to pass for the day, the last major obstacles before Mount Katahdin: Gulf Hagas, West Peak, Hay Mountain, and White Cap Mountain. All of the peaks had moderate grades and relatively easy trails. We reached Hay Mountain when there were a few minutes of break in the weather, long enough to allow us a peaceful lunch break. But only a few minutes of the lovely sunshine. When we reached the White Cap - highest of the four - there was a brief respite from the dark clouds that gave us a fantastic view of the sunny valley and lakes down below. A range of mountains also appeared behind the curtains of flying clouds, all looking too low to be Katahdin. We were told that Katahdin could be seen for the first time for NOBOs on this peak. Unable to identify it, I felt disappointed. The break was too short for me to check my topo map. In just a few minutes, the dark gray clouds rolled in and not only did all mirages of mountains and lakes disappeared, but also heavy rain rushed in and whipped us with threads of wind and water. Rain drops as heavy as soybeans pelted our body. "Brave Heart" wanted to dry her tent in the wind before the rain took over. Her tent was wetter than before. I tried to pull my poncho over me. In the two minutes that followed, the water had already soaked through my pants, boots and socks. I had to walk with buckets of water sloshing in my boots for the next hour. On the stormy mountaintop, my only thought was to get down below the tree line as quickly as possible, for it was the worst place to be if the storm became a thunderstorm.

No matter how tough it was today, I was still very happy to have a brief moment of seeing the miraculous views of the mountains and valley under the sunlit clouds. In the rain, the forest was more lovely. All colors were enhanced by the wet condition. The red was redder, the green greener, and the yellow yellower. On the ridge where the trees thinned, many ferns had turned into cinnamon color. They had nice contrast with neighboring green ferns, making patterns as if the foliage were an abstract painting. All the red berries were so bright among the green leaves.

After 3:30pm, we were done with the mountains! Our last 4 miles were "all rolling hills" as we were told to expect in Northern Maine. Though the elevation was low and trails were flatter, there were still mud to be avoided at all cost, and slippery roots to watch out for. We are expecting to hike more each day in the next three days, though we'll have to do it in the rain for some days. It was a relief to put the big mountains behind us, and only to worry about Mount Katahdin as our final challenge.

John Muir: The mountains are calling, I must go ...

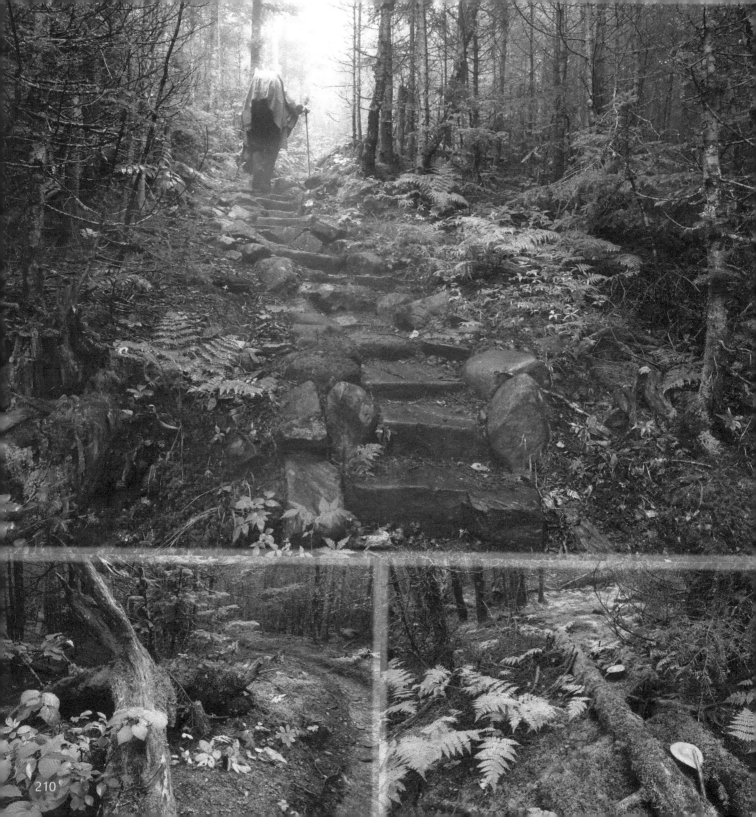

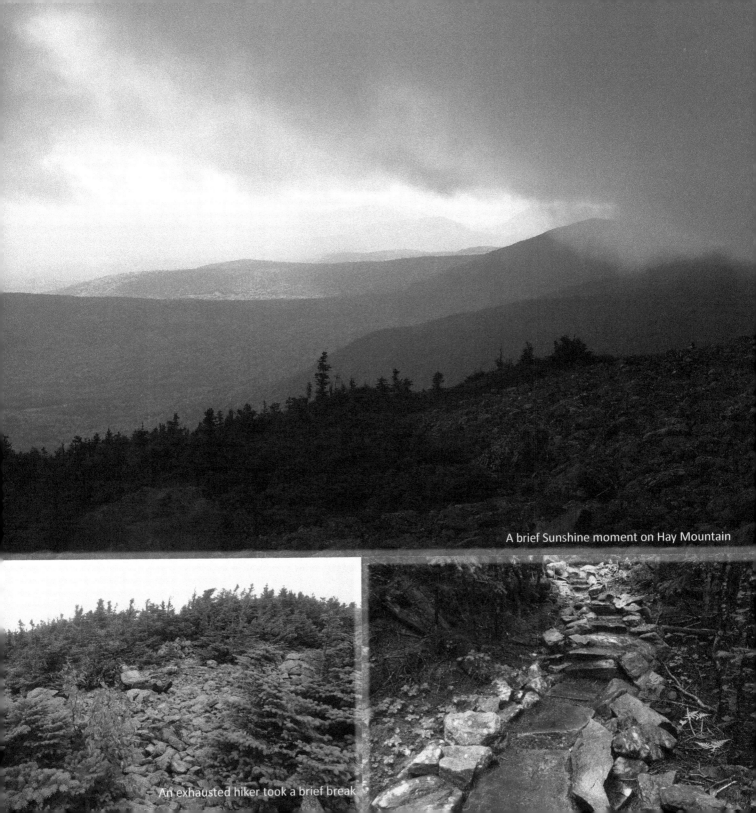

A brief Sunshine moment on Hay Mountain

An exhausted hiker took a brief break

Day 164: Sunset and Moonrise at Antlers Campsite
Thursday, September 12, 2019
Destination: *Antlers Campsite* ~ **Today's Miles:** *16.0*
Start Location: *East Branch Lean-to* ~ **Trip Miles:** *2141.7*

What a difference an easy trail can make! Today we only had a small hill to climb in the morning with the rest either gentle downhills or flat stretches, without many roots or rocks. Finally, we got what people had told us weeks ago: the rolling hills of Maine. We easily walked sixteen miles to reach our campsite at about 5:00pm. Even my husband, who was still suffering from a food digestion problem and was running on low fuel, said today was finally an enjoyable day. People say "no pain, no rain, no Maine" about Appalachian Trail thru-hiking. My husband tripped on roots and rocks today, fell and hurt his hand. Yesterday he got poured on by raging rain on top of White Cap. Therefore, he experienced the full glory of the Appalachian Trail. We joked that he's now part of us, the A.T. thru-hikers.

We crossed so many creeks and passed many ponds today. Many of the nice streams flowing with clear water were not listed in the guide books. We loved these water sources. For many of the water sources near ponds and brooks that were in my guide book, we felt they were not as clean as the stream water. Maybe those ones are more reliable in drier years.

Our campsite was at the west side of Lower Jo-Mary Lake, also named Turkey Tail Lake on my topo map. We set our tent near the tip of a little peninsula. It only took two minutes, walking, from the west-facing shore to the east-facing shore of the peninsula. At sunset, it was very beautiful. Once the sun had set, a bright full moon rose from the east. It was so surreal to see the full moon rise above the peaceful lake that was still clinging onto its dusky indigo hues. In the quiet hours at night, the shallow water lapped softly at the shore, making bubbling sounds while the moon shone over the forest at our campsite. Dark shadows of pines patched holes on the ground and on our tent. Time stood still.

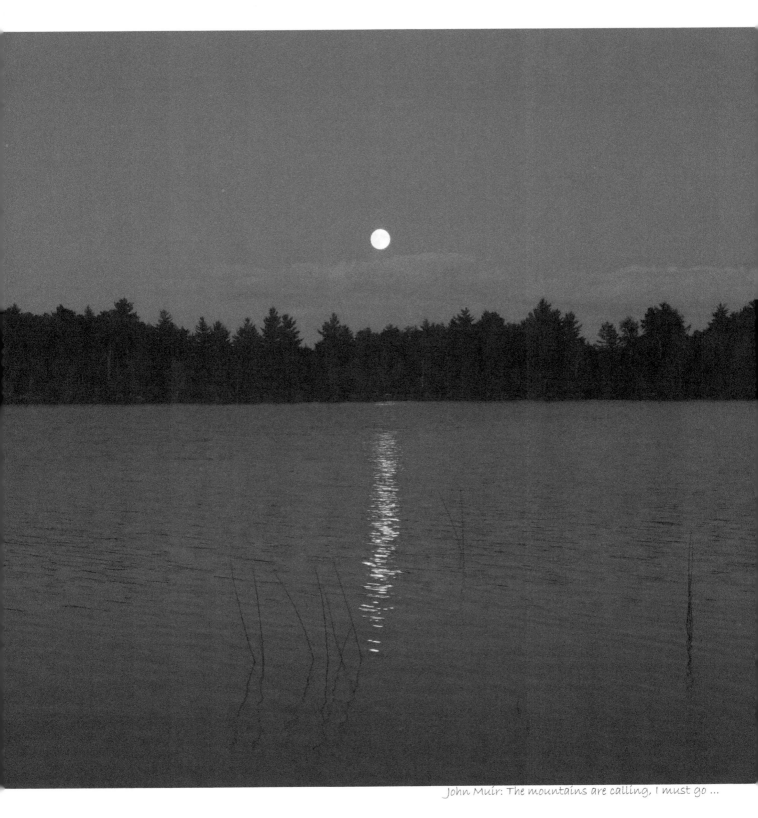

John Muir: The mountains are calling, I must go ...

Day 165: Potaywadjo Spring
Friday, September 13, 2019
Destination: *Gravel logging road* ~ **Today's Miles:** *16.7*
Start Location: *Antlers Campsite* ~ **Trip Miles:** *2158.4*

Our camp, sitting at the tip of the little peninsula, was perfect for watching the sunrise. Before 6:00am, the eastern sky was a bright vermillion. The flat lake surface was as smooth as silk, occasionally rippling due to a stray insect or fish. I watched the ripples quietly enlarge, till it quietly dispersed enough for the lake to return to its placidity. White vapor from the lake slowly rose up, drifting slowly to one direction in an invisible breeze. Gradually the sun came up, turning the silky lake into radiant glass, orange reflections fading gradually to blue towards us. Everything above the lake could be seen reflected in the water. Us, watching the sunrise, were draped in golden hues, faces turning bright, full of hope, excitement and energy. A beautiful new day was ahead of us. We had breakfast at the camp, and warmed up nicely by the morning sun. It was hard to pack and leave.

Nevertheless, we had a long distance to travel and there was no time to waste as we started to hike. In the morning, we climbed up a little hill to get to a shelter (called lean-to in Maine) in two hours. Near this lean-to was a large spring, flowing with tasty water. Moss filled the path where the spring flowed. It looked as if it came straight from a lovely little fairy tale. Someone commented that it was the best water on the Appalachian Trail. I don't know if it was really the best, but it was at least one of the best. We loaded up here. I got three liters to carry. It was heavy, but worth every drop.

The trail was more challenging than yesterday. Lots and lots of roots. The roots in the forests of Maine were gnarled, slippery, and frequently latched onto our boots to trip us. We combed through the roots and rocks and mud for almost all 16.7 miles of today's section. At one point, I got so annoyed I almost screamed at them. A few minutes later, I came to my senses: there was no point of screaming at roots, since they wouldn't care anyway! Of course, there was also a little mountain to climb near the end of the day. We were very tired by the time we reached a logging road to camp. Maybe tomorrow some smooth trails will be there for us.

We had seen so many big moose footprints in the past two days, on trails, near a shelter, and on a sandy beach by a lake. Still, we had not seen any moose. A big rabbit was running around near us today. I had not seen a rabbit for months. In the late afternoon and after dark, we heard some animal calls. Could they be from owls or water birds in the lake nearby?

At the viewpoint of Nesuntabunt Mountain, I think I saw Mount Katahdin cross a lake. It dominated the skyline of all mountains in my view. But somehow, I didn't feel the excitement or intimacy towards that peak. It felt like just another mountain that I needed to climb. "Poet", a thru-hiker who operates the Shaw's hostel in Monson, told us that he had the urge to touch the peak when he first saw it on White Cap. I only felt it was a normal mountain.

John Muir: The mountains are calling, I must go ...

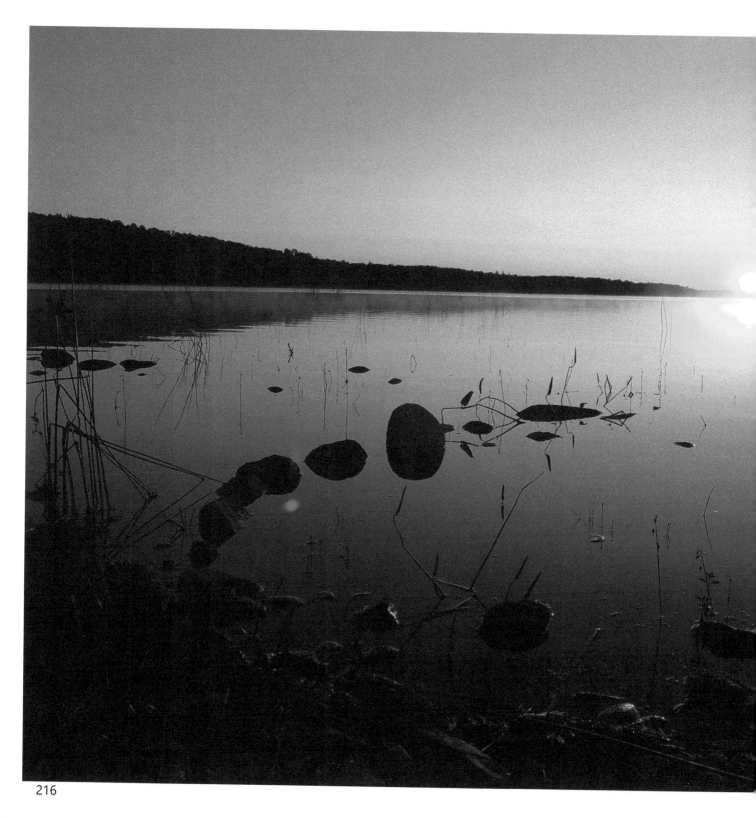

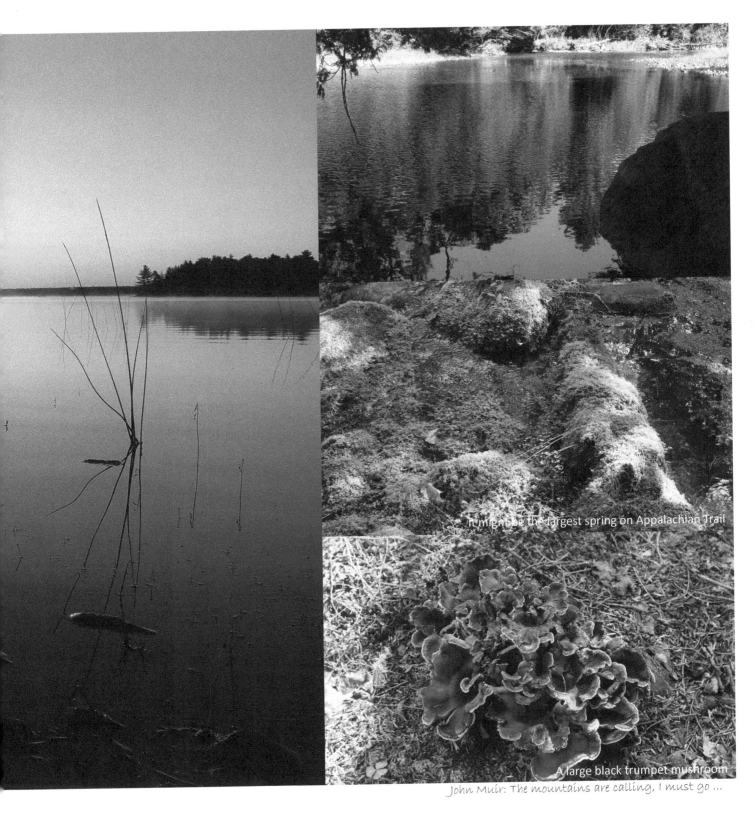

It might be the largest spring on Appalachian Trail

A large black trumpet mushroom

John Muir: The mountains are calling, I must go ...

Day 166: Rainbow ledges
Saturday, September 14, 2019
Destination: Hurd Brook lean-to ~ **Today's Miles:** 16.5
Start Location: Gravel logging road ~ **Trip Miles:** 2174.9

This was a special day for me. I realized that tonight might just be the last night that I'd sleep in the forest on the Appalachian Trail. We walked 16.5 miles, just 3.5 miles shy from the car-accessible Abol Bridge Campground in Baxter State Park. Tomorrow, we'll be out of the wilderness with only fifteen miles to the finish line. It will be done as a day hike.

Throughout the day, it was dreary and dark, under the threat of rain. But it really rained very little. I was very glad that my boots and socks were kept dry, but the rain was enough to make the trail wet and slippery. The clouds cover also made the forest darker. By mid-afternoon, it felt like dusk. There were again many ponds and lakes we passed today. At Crescent Pond, a large slab of rock was used by people as a boat landing. A few kayaks and a rowboat sat there, a rare sight in the wilderness. Rainbow Lake was so big. It had a 5.1-mile trail from the west to the east, all following the Appalachian Trail with many small ups and downs. We had our lunch break at a campsite near the lake. In the rain, I set up a tarp using my poncho, and cooked soup for my husband.

In the afternoon, we came upon Rainbow Ledge - a beautiful rock garden crafted by nature. Maples started to show off their bright red outfits, and ferns were a cornucopia of greens, oranges, yellows, reds, and browns. Blueberry bushes were turning red and mahogany, resting among cream-colored cotton balls. Another type of bush was full of bright, bubblegum-pink berries. Lichen and moss hung on tree branches in the air, light green, creamy white or bright yellow. The plants were divided into garden beds with granite rocks paving the walking path. Under the gloomy sky, the rock garden felt uplifting and magical, so different from the dense forest below. All of a sudden, I had forgotten the hard walk over those roots. Life is good here; I have to say.

By 6:00pm we made it to Hurd Brook Lean-to. No one else was there. The shelter has a sleeping floor made of round sticks - a so-called baseball bat floor. It wasn't comfortable - maybe that's why nobody else wanted to stay here.

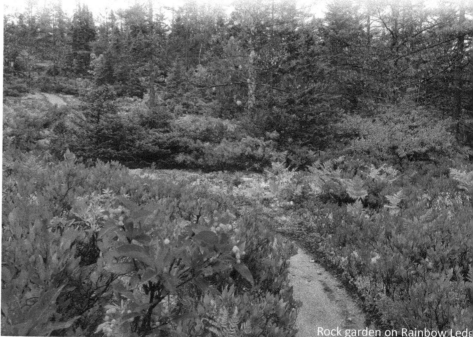

Rock garden on Rainbow Ledg

Day 167: Baxter State Park
Sunday, September 15, 2019
Destination: *Katahdin Stream Campground (AT Lodge)* ~ **Today's Miles:** *13.4*
Start Location: *Hurd Brook lean-to* ~ **Trip Miles:** *2188.3*

night was the LAST night that I slept in the forest, and today was the last day that I hiked a full day through the trees. We woke up early before sunrise; need to cook breakfast, for everyone wanted to get to Abol Bridge Camp Store to eat the "real" breakfast. By 8:15am, we came out from the hundred-mile erness' north boundary and walked into Baxter State Park. The paved road led us to the bridge over the Penobscot River. Autumn colors were on full display he trees along the banks. Across the river, the green slope of Mount Katahdin rose into a white cloud cap, hidden from view - a mysterious world to me.

he camp store, we ate lots of food, bid goodbye to my husband who went to the Appalachian Trail Lodge in Millinocket for the rest of the day, leaving me ackpack the last 9.5 miles of the Appalachian Trail to Katahdin Stream Campground.

ter State Park was such a treasure worth the generations of protection it had. The trail from Abol Bridge to Katahdin Stream Campground's ranger station filled with countless treasures. There were all types of mushrooms, some as black as ink, others orange and lavender like a Halloween display. The smooth was like a melting chocolate river, flowing effortlessly through the green moss carpeted forest floor. Mushrooms sprouted out of the carpet in groups, giving the impression of a quaint little village. Birch leaves drifted to the ground, dotting the chocolate river with golden yellow. Yearling maples with bright red ets invaded green mounds of moss-covered logs, hoping to get a foothold in the soft surface. Along the Penobscot River, and later the Nesowadnehunk Stream, maples framed waterfalls and cascades, sometimes making soft songs, sometimes roaring. The water in many streams was so clear that I just wanted to stare hem to see if I could spot any fish in there. I took tons of photos, hoping to keep this treasured forest in my memory and capture the full glory of the derland. I was walking in a dream world today, a sweet dream world. I will definitely miss it.

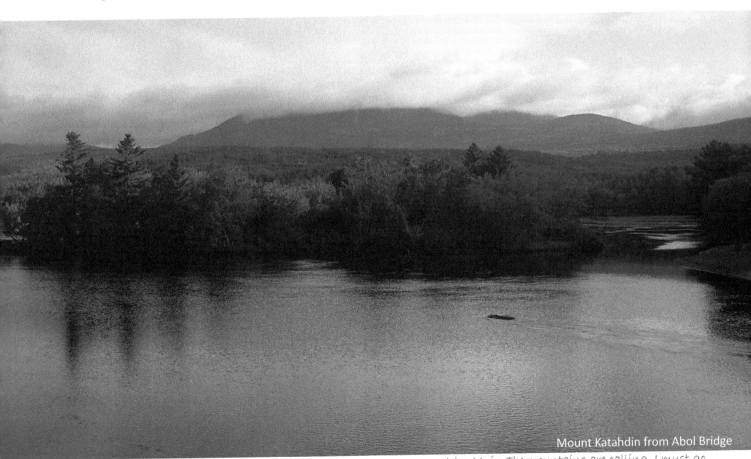

Mount Katahdin from Abol Bridge

John Muir: The mountains are calling, I must go ...

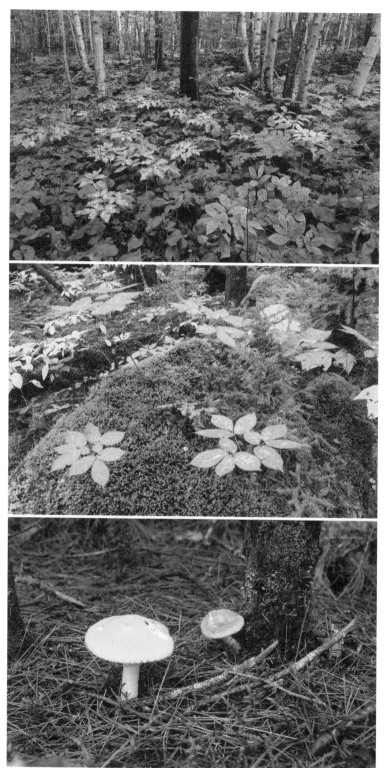
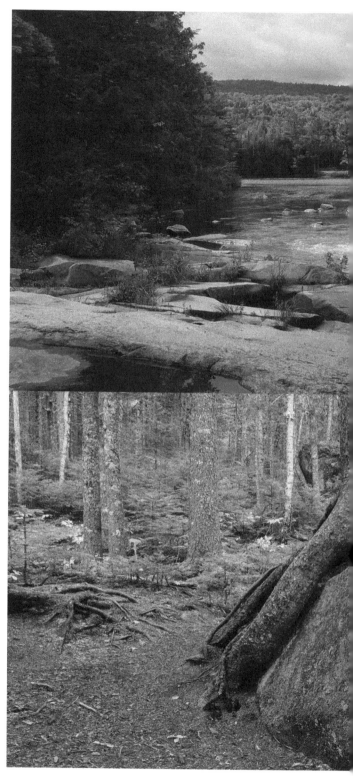

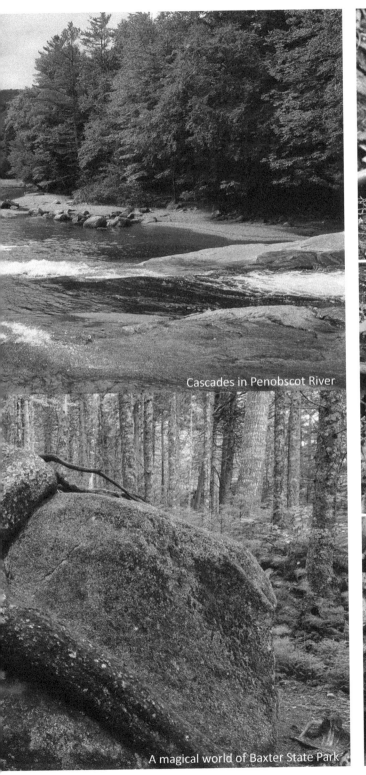

Cascades in Penobscot River

A magical world of Baxter State Park

John Muir: The mountains are calling, I must go ...

Day 168: Mount Katahdin - completion of Appalachian Trail
Monday, September 16, 2019
Destination: Mount Katahdin (AT Lodge) ~ **Today's Miles:** 5.2
Start Location: Katahdin Stream Campground (AT Lodge) ~ **Trip Miles:** 2193.5

In the high wind and swirling fog, I summited the last mountain on the Appalachian Trail, Mount Katahdin, and reached the northern terminus of this great t
I COMPLETED the Appalachian Trail! I am a proud 2000-miler now!

In the past unforgettable one hundred and sixty-eight days, I lived in the woods, drank spring and lake water, and walked 2192 miles (3654km). I loved ev
moment on my journey. Thanks to every loved one and friend for the support. Without you, I could not have done this. Special thanks to my dear husband v
walked with me on the first and last hundred miles together.

Similar to the past month and a half, today's trail was not a piece of cake. 2.5 miles before Katahdin peak, the trail turned vertical. Rock climbing and gymnas
skills were the most valuable things to have here. Without my heavy backpack, I actually enjoyed the hand-over-hand exercise. My arms and legs were as str
as my mind. I was aware of safety tolerance and kept cool when other hikers hesitated to move into the cold gusts of wind. I felt like a mountain goat
steep terrain, confident with my every move. I was slow, but steady, just like other times on the trail: set my goal, set my safety boundary, and work to get
where I wanted.

The last day was challenging, the last day was fun, the last day was how I wanted, and it was never hard!

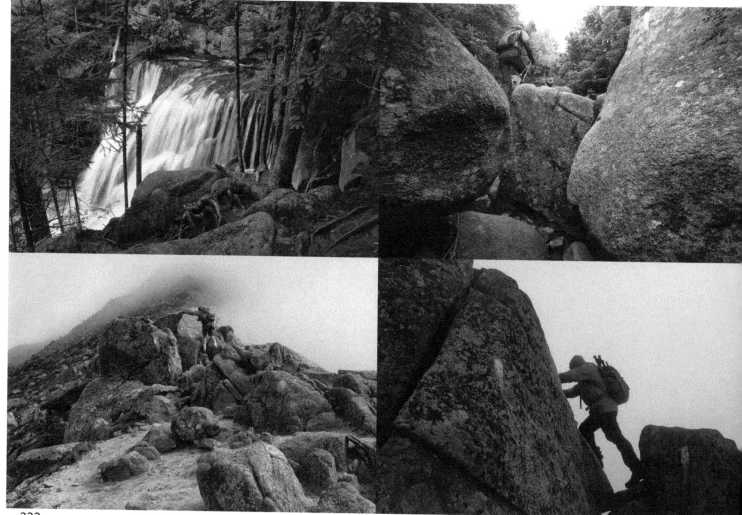

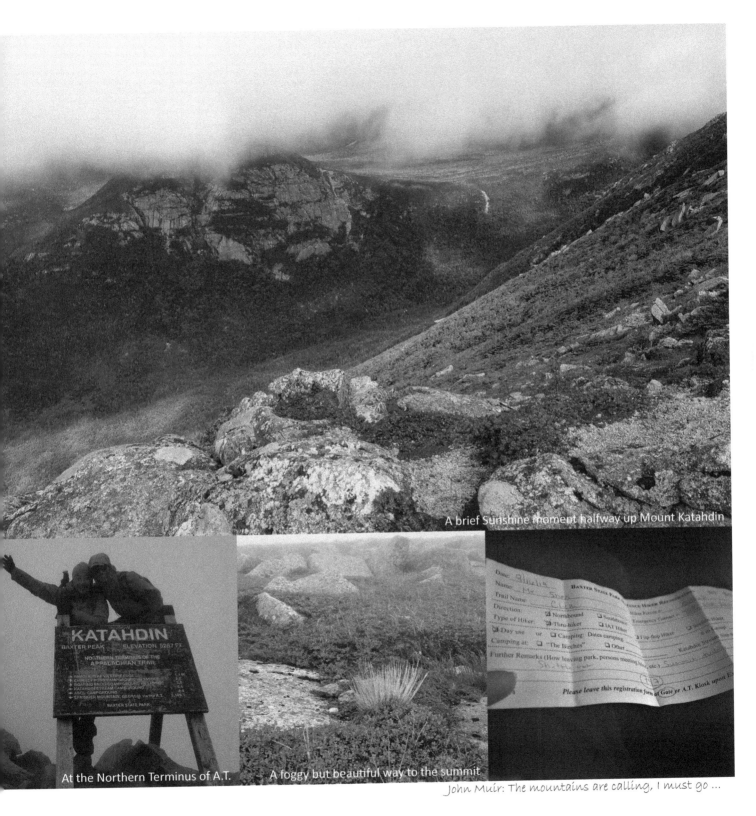

A brief Sunshine moment halfway up Mount Katahdin

KATAHDIN

BAXTER PEAK ELEVATION 5267 FT

NORTHERN TERMINUS OF THE
APPALACHIAN TRAIL

BAXTER STATE PARK

At the Northern Terminus of A.T.

A foggy but beautiful way to the summit

John Muir: The mountains are calling, I must go ...

Appendant: Gear Notes

Getting ready part 1 - Gears
Monday, March 11, 2019,
14 days before the start date

Tonight I packed all the gears that I plan to take with me. When I laid them out on the floor, first reaction was "Gee, why so much stuff?!" 21lb for my summer gear, and 24lb for my winter g I know, I know. I have been trying to practice lightweight backpacking for a few years. But I never been able to let go of a few heavier items - the Olympus OM-D E-M1 mirrorless camera is of them! Plus, I don't feel comfortable without microspikes for winter travel.

The good thing is that I am not a person who can consume 2lb of food on backpacking trips least not at the beginning! So my food weight will be lighter. I estimate my max pack weight will about 35lb at the start, which is heavy, but still manageable.

In the past few months, I have practiced snow camping, hiking in the rain, and hiking with san for stream crossing. Yet I am still nervous for the trip, especially with the cold and snowy wea reports in last month.

Regardless, I am ready!

In the next two weeks, I will prepare food for the first week. And my dear husband can join me the beginning of the trip.

Getting ready part 2 - Food
Thursday, March 21, 2019, Food to start with: 2 people for 6 days
4 days before the hike ...

In the last two weeks, I have been doing some final preparations for this trip. First off was my hair. I cut it very short, to commit myself to this journey.

I also did meal planning and gathered all the food for the first 6 days of hiking. The food I prepared for my husband and myself are simple meals, not much different from what we'd bring for weekend backpacking trips. For breakfast (B in picture at right), I prepared oatmeal, milk powder, cocoa powder and crackers. We'll add some bread or bagels before our start date. For lunch (L), we'll have energy bars, dried fruits and nuts. Most of these were the things I brought from Beijing earlier this year. Even though I don't mind eating the ones available in the US, a change of flavor is always nice. For dinner (D), we'll have angel hair pasta with homemade seasonings and dried vegetables; lentils, quinoa, and some dried pork sung and salmon sung, Chinese specialities, to add flavor. We'll get a few small packages of pickled vegetables later from an Asian market. My plan is to hike about 8 to 14 miles for the first week, aiming to resupply first time in Hiawassee, Georgia. From there, I expect no exotic Asian food in our diet for quite some time.

Many of my friends invited me for lunch and wished me good luck. Thank you every one! Your encouragement meant so much to me.

As time gets closer and closer to my departure date, I feel calm and peaceful. The nervous feeling in my stomach that I experienced a month ago has subsidized. Reading trail journals of the hikers who have already started their journey before me helped. Knowing the weather will be getting better by the time I am out there in the open also made me more comfortable.

Now, I am ready!

...me away from home – Gear List

...e old pals

...t: ZPacks Duplex -- The tent only weights 21oz. I have used it in winter camping as well. It could be difficult to setup in high wind. ...s debating with myself for a long time trying to decide taking the tent or a tarp. In the end, the tent will go with me, mainly for the ...protection. In the rain, the tent would be much better, too. When needed, my poncho will work as a small tent for cooking in the rain.

...eping bag: GoLite 20F degree quilt -- It is like a blanket + a foot box. I like the warms and puffiness of this light weight quilt, ...about 1.3lb. Together with a winter hat and clothing, it is quite nice for 3 season backpacking. In cold night, I can wear my down ...t to add more warmth.

...eping pad: A closed cell foam pad similar to Therm-a-Rest Z lite. -- I cut off about 1 foot from it, creating 2 sit pads. It is soft, ...r breaks, and can be easily used anywhere as a seat on both dry and wet surfaces. I had it for so long that I have already lost one ...ad. The sleeping pad still in great shape after hundreds nights of usage.

...ckpack: Lowe Alpine Zepton ND50 -- This woman specific backpack is a lightweight internal frame pack. It was the only lightweight ...that fit me when I was in the market shopping for one 8 years ago. I bumped into it in a local sports store that has been permanently ...d its door. The bag is very easy to fit a full sized bear canister horizontally. The super strong dyneema fabric hardly show much of ...and tear. I used it from Tanzania to Patagonia, it endured the journey on JMT. I used it in both summers and winters. The heaviest ...was 42lb on a snow climbing trip. There are only a few small holes in the side soft pockets. I attached a small nylon zipper bag on ...ip belt to put small items in there for easy access. The pack is about 2lb and 3oz in weight.

...tchen: JetBoil Flash cooking system -- I choose this only because I saw posts online saying that the fuel (canister) is easy to find ...g the trail resupply stores. Normally I use a tiny Esbit titanium folding stove (only 0.4oz) for my backpacking trips. including the JMT ...for my family of 4 for two weeks. But the fuel would not be always available on A.T.. So JetBoil goes into my pack. Adding to this I ...a fuel canister stand, one pair of shortened chopsticks, one large spoon, biodegradable soap repacked in a small hotel sized shampoo ...le, a cut off section of wash sponge, some tiny containers with salt and seasonings. Total of the cooking system is about 1lb.

...othing: A non-brand down jacket, a thin polar fleece pullover, one pair of hiking pants, one running short, 2 quick dry long sleeve ...irts, one quick dry buttoned shirt, one quick dry long john, 3 pairs of wool socks and underwear. One winter hat doubles as camera ...a pair of thin gloves, a bandana. For the protection from the rain, I will carry an umbrella, a poncho (also works as a tarp), a pair of ...s" (rain pants with only the leg section), and a pair of short lightweight home made gaiters.

...rsonal Hygiene: To keep me civilized, I have a Ziploc bag of toothbrush with shortened handle, a small bar of soap, dried tooth ...te cut into small drops (see picture at right). I can chew one drop when brush the teeth. I used these many times in backpacking trips. It's ...eating a jelly bean with tingling, quite nice as long as you don't swallow it. I also carry a small comb. It is good that I cut my hair very ...rt so that I can just use the soap to wash my hair, saving the weight of shampoo and conditioner. A large roll of toilet paper goes to a ...tic bag with tent stakes as diggers. I also carry a 2 gallon plastic Ziploc bag for wash my cloth and a tiny folding bucket to fetch water.

...rst aids: Home assembled Band-Aids, medicine for pain killer, diarrhea treatment, tapes for preventing blisters, electrolytes, rubber ...es, keen band, etc. in a nylon flower print bag. Total weight about 8oz. Also I will carry a double layer orange colored emergency blanket.

...ectric Gadgets: OK, I have to admit that going on the trail for many months does not mean I can cut off from modern world ...d by electronics! The list of my gadgets is long.

...InReach -- The communication tool that allows me to tell my loved ones about my location, text messaging by satellites, and a ...button that connects to search and rescue management center. It provides peace of mind for my loved ones and friends, as well as ...myself. I have use it for over 3 years and loved the low monthly cost. Together with its free topo map EarthMate on my phone, it also ...ps me with navigation on the trail.

...iPhone SE -- This is a small phone with a big storage of 128GB. It will be my pad for writing and reading. I have downloaded ...ny books on it. I will also use the EarthMate topo map. And communicates with my folks.

...Olympus O-MD E-M1 + 12-40mm lens -- I cannot go on a trail without it. In the past 4 years, it had accompanied ...to so many places (also with different lens). It is water proof, dust proof, drop proof and freeze proof. In my test, the freeze proof seams ...r rated, but the other 3 have been well tested on trails year round, from below sea level to above 19000ft. It's about 3.5lb. The only ...wback was the short battery life. So this means I have to carry 4 additional backup batteries, a charger and cable. It can take a large ...ce in my pack. And total weight about 4lb.

New stuff ...

Bear bag: Between Bear canister and Ursack, I finally decided to buy the Ursack mainly for the packability and weight savings. Plus a 50ft of bear bag rope. This cut at least 1lb from my Wild-Ideas bear canister. It can hold our 2 people's 6.5 days of food. I got to practice more on bag hanging technique on trail.

Boots: My current Keen is at the end of its life. So last year during the holiday season, I bought two pairs of boots -- Keen and Merrelle. The Keen has lived well with its reputation in terms of waterproof. The Merrelle has been a disappoint. So I will start with Keen first. If it can last long, I don't need to replace it with the Merrelle. Both have been broken-in in the past two months. For water crossing, I have a pair of Merrelle sandals which I have used for a year and had good results for creek crossing.

Folding bucket: I have to brag on this find. Sea-to-Summit ultra folding bucket. It is so cute, only 1.5"x2.5" in size when folded, with 10L capacity and weights less then 2oz. I like it. I'll see how good it is when put in use on trail.

Stuffs left at home ...

Microspikes -- Now that I read more blogs from trail (Thanks everyone who posted pictures), I don't think I will need them. Winter puffy sleepin socks, hand and toe warmers, and extra down vest are all moved out of my backpack.

GoalZero solar charger + flip 30 -- It is heavy! But it has kept my phone charged everyday on other long trips. However after careful consideration of the trails with lots of leave coverage, I left this device at home, and never missed it on trail. I ended up using 3 battery power banks with total of 16000mA capacity. It lasted 9 days with full charge on trail.

CPSIA information can be obtained
at www.ICGtesting.com
Printed in the USA
JSHW010237071221
21030JS00008B/13